modern contemporary

ART SINCE 1980 AT MoMA

modern contemporary

EDITED BY KIRK VARNEDOE • PAOLA ANTONELLI • JOSHUA SIEGEL

THE MUSEUM OF MODERN ART, NEW YORK

The first edition of *Modern Contemporary: Art Since 1980 at MoMA* was made possible by The International Council of The Museum of Modern Art. • Produced by the Department of Publications, The Museum of Modern Art, New York • Edited by Harriet Schoenholz Bee; Cassandra Heliczer • Designed by Steven Schoenfelder • Production by Marc Sapir; Christina Grillo • Color separation by Barry Siddall, MR Reproduktionen, Munich; Oceanic Graphic Printing, Inc. • Printed and bound by Passavia Druckservice, Passau; Oceanic Graphic Printing, Inc. • Set in Officina and Bell Gothic, the first edition is printed on 135 gsm Galeria Art Silk; the second edition is printed on 128 gsm Japanese New-G Matte Artpaper • Printed in China • © 2000, 2004 The Museum of Modern Art, New York • Certain illustrations are covered by claims to copyright cited in the Photograph Credits. All rights reserved. • First edition 2000; second edition 2004 • Library of Congress Catalogue Card Number: 2004108976 • ISBN 0-87070-491-5 • Published by The Museum of Modern Art, 11 West 53 Street, New York, New York 10019. www.moma.org • Distributed in the United States and Canada by D.A.P./Distributed Art Publishers, Inc., New York • Distributed outside the United States and Canada by Thames & Hudson, Ltd., London.

MODERNCONTEMPORARY

ARTSINCE1980ATMoMA

Contents

Neil Winokur
Chris Killip
Francis Ford Coppola
Martin Scorsese

1991 | 291
Toshiyuki Kita
Annette Messager
Peter Eisenman
John O'Reilly
Boris Mikhailov
Shimon Attie
Julie Dash
Toyo Ito
Warren Sonbert
Ernie Gehr
Annette Lemieux
Oliver Stone
Tom Dixon
Dieter Appelt
Jean-Michel Othoniel
Vito Acconci
Felix Gonzalez-Torres
Tejo Remy
Enzo Mari
Abelardo Morell
Zaha M. Hadid
Glenn Ligon
David Wojnarowicz
Allen Ruppersberg
Raymond Pettibon
Christopher Wool
Frank Gehry
Brice Marden
Robert Gober

1992 | 316
Robert Gober
Cindy Sherman
Janine Antoni
Paul McCarthy
Mike Kelley
Roy Lichtenstein
Christopher Connell
Ben Faydherbe
Ingo Maurer
Guillermo Kuitca
Willie Cole
Arata Isozaki
Richard Serra
Peter Campus
Rudolf Bonvie
Santiago Calatrava
José Leonilson
Louise Bourgeois
Rody Graumans
Christopher Bucklow
Terence Davies
Sigmar Polke
Philip-Lorca diCorcia
Juan Sánchez
Raymond Pettibon

Rosemarie Trockel
Mark Steinmetz
Gabriel Orozco
Donald T. Chadwick
William Stumpf
Neil M. Denari
Simon Patterson
Chris Burden
Clint Eastwood

1993 | 344
Clint Eastwood
Reiko Sudo
Helen Chadwick
Chris Marker
Zacharias Kunuk
Anselm Kiefer
Glenn Ligon
Rosemarie Trockel
Brice Marden
Herzog & de Meuron
 Architects
Ellsworth Kelly
Roni Horn
Robert Therrien
Derek Jarman
Fernando Campana
Humberto Campana
Antonio Citterio
Glen Oliver Löw
Jean Nouvel
Rachel Whiteread
Ian Hamilton Finlay
Martin Scorsese
Ximena Cuevas
Charles Ray
Rirkrit Tiravanija
Cheryl Donegan
Jos van der Meulen
Nam June Paik

1994 | 367
Hal Hartley
Quentin Tarantino
Lorna Simpson
Renzo Piano
Takeshi Ishiguro
Kim Jones
Andreas Gursky
Mona Hatoum
Teiji Furuhashi
Bill Viola
Jenny Holzer
Robert Gober
Ann Hamilton
Ross Bleckner
Michael Schmidt
Thomas Roma
Richard Artschwager
Uta Barth
Cy Twombly

Philippe Starck
Rineke Dijkstra
Marlene Dumas
Hella Jongerius
James Turrell
Jeff Scher
Barbara Kruger
Louise Bourgeois
Bob Evans
Roni Horn
Jean Nouvel
Alberto Meda
Glenn Ligon

1995 | 399
Carrie Mae Weems
Louise Bourgeois
Marcel Wanders
Tom Friedman
Peter Halley
Toba Khedoori
Ellen Gallagher
Toyo Ito
KCHO (Alexis Leyva
 Machado)
Doris Salcedo
Laurie Anderson
Joel Sanders
Herzog & de Meuron
 Architects
Sigmar Polke
Chuck Close
Matthew Barney
cyan
Sheron Rupp
Stan Douglas
Jasper Johns
Inoue Pleats Co., Ltd.
Luc Tuymans

1996 | 421
Luc Tuymans
Ethan Coen
Joel Coen
John Sayles
José María Sicilia
Flex Development B.V.
Mona Hatoum
John Armleder
David Hammons
KCHO (Alexis Leyva
 Machado)
Gary Simmons
Gabriel Orozco
Chris Ofili
Jeanne Dunning
Thomas Demand
Andrea Zittel
Werner Aisslinger
Franz West
Al Pacino
Toray Industries, Inc.
Ken Jacobs

Igor Moukhin
Kiki Smith
Raymond Pettibon

1997 | 438
Kara Walker
Arthur Omar
Kristin Lucas
Vik Muniz
Fred Tomaselli
Chuck Close
Arnulf Rainer
Martin Puryear
Stan Brakhage
Reiko Sudo
Daniel Libeskind
Willie Cole
Kiki Smith
William Kentridge
John Baldessari
Rachel Whiteread
Franz West
Lewis Klahr
Sue Williams
Yukinori Yanagi
Zhang Peili
David Williams
Pipilotti Rist

1998 | 462
Fiona Banner
Konstantin Greic
Julia Loktev
Paul Winkler
Charles Long
Aleksei German
Richard Serra
Anish Kapoor
Terry Winters
Gerhard Richter
Gabriel Orozco
Christian Boltanski
Jia Zhang Ke
Matthew Barney
Kara Walker
Luc Tuymans
John Madden
Robert Rauschenberg
Chris Ofili
Enrique Chagoya
Lisa Yuskavage
Elizabeth Peyton
Philippe Starck
Ralph Schmerberg
Mariko Mori
Cai Guo-Qiang
Rachel Whiteread
William Kentridge

1999 | 486
William Kentridge
Phil Solomon

Julian Opie
Andreas Gursky
Barbara Bloom
Jean-Marie Straub
Danièle Huillet
Carroll Dunham
Damien Hirst
E. V. Day
Chris Ofili
Richard Serra
Shahzia Sikander
David O. Russell

2000 | 500
Laurence Attali
Faith Hubley
Ellen Gallagher
Jean-Luc Godard
Giulio Iacchetti
Matteo Ragni
Pandora Design
Jake and Dinos Chapman
Bertien van Manen
Glenn Ligon
Maarten Van Severen
Beatriz Milhazes
Tokujin Yoshioka
Michael Wesely
Matthew Barney
Arturo Herrera
Shirazeh Houshiary
Peter Fischli
David Weiss

2001 | 516
Jorge Pardo
Jeff Wall
Katharina Bosse
Thomas Demand
Vija Celmins
Orlando Mesquita
Ellen Gallagher
John Currin
Kim Young Jin

2002 | 525
npk industrial design b.v.
Edward Ruscha
Alessandra Sanguinetti
Seoungho Cho
Bill Morrison
Yoshitomo Nara
Jürgen Mayer H.
Sebastian Finckh
Sarah Lucas

2003 | 533
Guillermo Kuitca
Charles LeDray
Richard Tuttle
Nathaniel Kahn

Foreword

When *Modern Contemporary* was first published, in 2000, it was meant to complement *Open Ends*, the third in a trilogy of exhibitions presented by The Museum of Modern Art in recognition of the millennium. Conceived as a compendium of works of art in the Museum's collection made since 1960, *Open Ends* provided a glimpse into the Museum's substantial holdings of contemporary art. *Modern Contemporary*, which focuses exclusively on the period after 1980, is being reissued now, with significant new additions by artists as varied as Tokujin Yoshioka, Glenn Ligon, Ellen Gallagher, Thomas Demand, Guillermo Kuitca, and Nathaniel Kahn, in celebration of the opening of the new Museum of Modern Art, designed by Yoshio Taniguchi. As such, this publication is more than just a second edition of a book; it is the continued documentation of the Museum's important—and growing—collection of contemporary art. Like the new Museum, with its dramatic galleries for contemporary art, *Modern Contemporary* embraces works of art from all of the Museum's curatorial departments: Film and Media, Architecture and Design, Photography, Painting and Sculpture, Prints and Illustrated Books, and Drawings.

Over the last decade, The Museum of Modern Art has initiated a number of efforts to both broaden and strengthen its commitment to contemporary art. These include merging in 1999 with P.S.1 Contemporary Art Center, in Long Island City; the creation of curatorial forums that bring together staff from MoMA and P.S.1 to discuss issues relating to contemporary art, as well as an interdisciplinary curatorial media committee and an acquisitions committee to expand our holdings of new media; the establishment of the Fund for the 21st Century, a special acquisitions fund for works of art made by emerging artists; and the construction of over twenty thousand square feet of gallery space dedicated to contemporary art, which will permit the Museum to display its contemporary holdings in new and varied ways. Taken together with MoMA's already existing programs in contemporary art, these initiatives will allow the Museum to move ahead in an area that is central to its long-term development.

Modern Contemporary, as its name implies, documents a portion of The Museum of Modern Art's evolving collection of contemporary work while underscoring the complex dialogue that exists between the immediate past and the present. No collection of contemporary art, by definition, can ever be complete or comprehensive. What is presented here is a sample of the different directions that have been pursued to date by the Museum's curatorial staff. Over time these directions will be amplified and strengthened, streamlined, and focused as the Museum continues to explore the richness and variety of contemporary art within the context of its unparalleled collection of modern art.

Glenn D. Lowry
Director
The Museum of Modern Art

Introduction | Kirk Varnedoe[1]

This volume presents a selection of artworks made after 1980, drawn from the collection of The Museum of Modern Art. The works, in diverse mediums, come from each of six curatorial departments in the Museum: Painting and Sculpture, Drawings, Prints and Illustrated Books, Architecture and Design, Photography, and Film and Media. Intended as a reexamination of the history of modern art and of the Museum's collection, this book seeks to integrate works from all curatorial departments and across traditional historical categories in ways that provide a testing-lab for fresh consideration of what the Museum has done in the past—and might do in the future—with its incomparable collection. It is impossible, in one book, to present comprehensively the richness of the Museum's acquisitions of recent art of the 1980s and 1990s; instead, this volume allows maximum exposure of a representative grouping of the least-known part of the Museum's collection, and underlines the institution's continuing engagement with contemporary art. While preliminary lists were solicited from the various curatorial departments, the final selections were ultimately the responsibility of the book's editors.

Modern and Contemporary Art at MoMA

The Museum of Modern Art was founded as, and has always been, an institution committed to contemporary art. From the inauguration in 1929, and for many years after, it was thought that the "permanent" collection would have relatively constant dimensions, but ever-changing elements. The founding director, Alfred H. Barr, Jr., proposed the notion of a torpedo through time, conjuring the image of a forward-moving collection that would always have its "nose" in the present and immediate past, and a "tail" in the receding past about fifty years distant. The metaphor implied that, as a balance to its ongoing acquisitions of new art, the Museum would steadily divest itself of the older art in its possession, as that older art became more "classic" than "modern." This practice was designed to keep the Museum forever fresh and free from the burdens of an extended history, and also indicated pragmatic concerns for limiting the size of the collection and for providing, by the occasional sale of the older artworks, a renewable source of funding for future purchases.[2]

Had the notion of the torpedo been followed literally, the earliest works in the Museum's collection would now be those of the early 1950s. Instead, the early 1950s were precisely the point at which the Museum began to accept—tentatively and piecemeal at first, then as a matter of general principle—that it would retain its collection of Post-Impressionist masterworks (such as Cézanne's *Bather* and van Gogh's *The Starry Night*) as the starting point of its painting and sculpture collection. (Other curatorial departments had different points of departure for their collecting: Photography and Film, for example, include the beginnings of their mediums, around 1840 and 1890, respectively.) This change meant that the tail of Barr's torpedo would become permanently pinned to around 1880, while the nose would continue to advance. The resultant tensions and stretches—between the ever-more-certified treasures of the historical collection and the seemingly ever-more-perilous adventures of collecting the art of the present—defined the character of The Museum of Modern Art in the last half of the twentieth century.

Those who have worked at the Museum in recent years, and those who have supported it, have felt that its built-in duality—the simultaneity of

its commitments to what might be called classic modern art and to the creativity of the immediate present—not only makes sense, but creates the special quality of the institution. There is an argument to be made that the revolutions that originally produced modern art, in the late nineteenth and early twentieth centuries, have not been concluded or superseded—and thus that contemporary art today can be understood as the ongoing extension and revision of those founding innovations and debates. The collection of The Museum of Modern Art is, in a very real sense, that argument. Contemporary art is collected and presented at this Museum as a part of modern art—as belonging within, responding to, and expanding upon the framework of initiatives and challenges established by the earlier history of progressive art since the dawn of the twentieth century.

The historical collection provides a special implicit framework, illuminating and demanding, within which to present the art of today. And, conversely, a continued engagement with today's art constantly challenges the curatorial staff to reexamine and reinterpret the history of innovations that preceded it. Without the dialogue between these twin aspects, The Museum of Modern Art would be a far less rewarding place for viewers to visit, for the staff to work, and for artists to show their work. The trick is, of course, to find the proper balance, in institutional time and resources, between the care and elucidation of the classic modern collection and the everyday-renewed need for growth and change. The works shown in this book are an important part of that process of growth—of the constant amendment, revision, and expansion of the collection that, in sum, constitutes an evolving definition of what the institution is.

Past Bedrocks and Present Risks

The German Expressionist painter Franz Marc once said, "Traditions are wonderful things—to create." The presence of a great historical collection at The Museum of Modern Art is a source of pride and incentive to those who acquire new art for the Museum. But, contrary to the suspicions of some critics of MoMA, the historical collection does not provide a monolithic canon against which potential new acquisitions can be universally measured, nor any sharply defined template for the institution's future. In this respect, Alfred Barr—the son of a preacher, and often described as a missionary—may have left his best legacy to subsequent curators, not in the form of a theological orthodoxy but in the form of an existential injunction to act and to take chances. He always insisted that if, two decades later, even a tenth of the works acquired in a given year were deemed worthy of showing on a long-term basis, it would be a positive accomplishment. And he insisted that, in the eyes of history, sins of omission look worse than sins of commission: that is, the curator is more often damned for what he or she failed to acquire, than for the things brought in that, over time, do not pan out.

A corollary of Barr's pragmatic outlook—humbling but encouraging at the same time—is that the quality of the collection is as much a matter of retrospective refinement as of on-the-spot discernment. It is easy to presume, given the many masterworks of early modern art in the collection, that the Museum had, early on, a "hot hand" for identifying and obtaining superior pieces of then-contemporary art. A closer look will show, however, that the institution began conservatively, and got more "progressive" as it aged. In the mid-1930s The Museum of Modern Art looked more like a museum of Kolbe, Maillol, and Pascin; it became the

Museum of Picasso, Matisse, Malevich, and Duchamp only gradually—often by key purchases made with the benefit of considerable hindsight. The purchase of Picasso's 1907 *Les Demoiselles d'Avignon* in 1937 is one example, the acquisition of key Abstract Expressionist works in the 1970s another; and several key works of the late 1950s and 1960s—by artists such as Rauschenberg, Warhol, and Judd—were only brought into the collection in the 1990s. In this respect as well as others, it would be mistaken to see the Museum's view of earlier modern art as frozen, in opposition to its changing assessments of the present. Instead, these two aspects—the revision and refinement of a view of history, and an openness to the lessons of contemporary creators—are often closely connected, and evolve in dialogue.

However, one premise of the "torpedo," involving the relationship between the older and newer parts of the collection, has become virtually inverted. It was originally thought that older modern art from the collection would be sold to buy more up-to-date works. In more recent years, while deaccessioning artworks has continued to be an important means of raising money for acquisitions, an unwritten policy has evolved with regard to works whose worth has been validated by history. The policy holds that such works should not be sold in order to fund the speculative field of contemporary art but only to acquire what are deemed better works of the same kind or, alternatively, to acquire works that have over the years become desirable additions to the historical collection.

A Changed Context

For many years after its founding, The Museum of Modern Art enjoyed a global preeminence owing at least in part to the uniqueness of its mission. But one measure of success is emulation, and, begin-ning in the 1960s, numerous institutions in the United States and abroad, either newly founded or reinvigorated, began to take up a parallel commit-ment to modern—and especially to contemporary—art. At the start of the twenty-first century, this competitive element has become ever more in-tense, as the status of contemporary art—among both private and state-supported institutions, and among the wealthiest private collectors—has ascended dramatically. The bar has been (and continues to be) raised, financially and in many other respects, for institutions like this one that aim for primacy on this hotly contested terrain. The depth and variety of the Museum's collection of early modern art, still unrivaled, only adds to its future challenges—to build its collection in a way that will both maintain the high levels of quality established by its past, and also redefine its singular character within a now crowded and intensely competitive field. One of the demands the altered situation places upon the Museum is that of carefully examining the mechanisms by which the institution has thus far acquired art, and of assessing their viability for the years to come. And in this regard, the impression this book presents—of a continuous, multimedia collection—actually belies the more complex and often fragmented procedures that brought these works to MoMA.

How Art Enters the Collection

While the works in this book are presented as a continuum of various mediums, they entered the collection by different routes, determined by the six different curatorial departments (divided according to medium) within the Museum. Each department has its own budget and its separate acquisition committee, made up of Trustees and other invited patrons of the Museum. The basic

mechanism of acquisition is everywhere the same: curators propose, and committees dispose. Works proposed for acquisition (including gifts offered) are presented at committee meetings by curators, who argue for the addition of the works to the collection. The committee (whose members contribute most of the funds that make up the acquisition budget) then votes to accept or reject the proposed work.

Beyond that, however, departmental philosophies of collection-building may differ widely. Some departments have specific exclusions built into the representation of their respective fields. While the Department of Film and Media might eagerly amass a collection of films related to war, for example, the Department of Architecture and Design has always refused to collect weapons. Yet while the design collection has been formed within a generally very broad, nonrestrictive consideration of functional and commercial objects, the collection of film (while it includes such diverse fields as feature films, animation, documentary, and experimental works) has specifically avoided collecting within the area of commissioned work, which constitutes one of the largest areas of film production—thereby specifically excluding industrial, religious, and pornographic films. The collecting of photography, film, and design objects at the Museum, meanwhile, proceeds in certain areas without regard for original artistic intention (acquiring, for example, items such as propellers, ball bearings, documentary photographs, family snapshots, instructional film, or home movies), while the departments of painting and sculpture, drawings, and prints only collect works defined and intended as art by their creators. No department aspires to anything like a reportorial or archival inclusiveness in dealing with its respective field, though the Department of Prints and Illustrated Books has made arrangements for

the acquisition of every work issued by certain publishers who have had particular significance for their area.

Perhaps most crucially, the collection is built by six separate staffs of curators, whose outlooks and strategies may vary widely. This produces a diverse range of approaches pursued simultaneously at any given moment in the Museum's history. It also means that each department's collection accumulates a particular set of idiosyncratic strengths and weaknesses—pockets of concentration and broad patterns of representation—that reflect different generations of leadership. Each new set of "builders" must in turn choose how to build further upon, or compensate for, the particular structures left by their predecessors. For example, when the photographer Edward Steichen was the head of the Department of Photography, his collecting reflected ideas of a universal language of photography (as embodied most evidently in his well-known 1955 exhibition *The Family of Man*); but his successor John Szarkowski focused his collecting and exhibitions program on the work of particular artists. From Barr's early exhibitions on Cubism and Surrealism to more recent shows devoted to Cy Twombly or Japanese textiles, curatorial programs of loan exhibitions have also opened special opportunities for acquisition, and left their mark on the permanent holdings of the Museum. Particular artists and schools have come in and out of favor, and the collection records these fluctuations. Barr did not share, for example, James Thrall Soby's early enthusiasm for Jackson Pollock, and it was not until William Rubin's efforts in the late 1960s and 1970s that the Museum's exceptional holdings of this artist were finally formed. Soby's affection for the work of Pavel Tchelitchew in the late 1930s and early 1940s, on the other hand, now seems a closed chapter in collecting, without any subsequent reinforcement.

Examples of similar shifts and stops and starts, corrections and revisions, mark every phase of the Museum's holdings in virtually every medium.

In sum, while the collection of the Museum may seem to many outside observers to represent a monolithic structure, built according to some uniform consensus, those inside the institution are most acutely aware of how its holdings are actually a rich patchwork, formed—from the beginning and still today—within a shifting constellation of contingencies, including the changing practices of separate departments, the divergent tastes of particular donors, and the shifting concerns of individual curators.

The Particular Challenges of Recent Art

The collecting of contemporary art has, in the past few decades, challenged the Museum's structures, both physical and organizational, in several ways. A number of impulses within new art since the 1960s—including Happenings or Performance Art, Conceptual Art, and Earthworks—have been explicitly opposed to the idea of the collectible object, and hence to a fundamental premise of the traditional museum. And even within the domains traditionally covered by the Museum's various departments, there has been an important upsurge of hybridization, intentionally and effectively transgressing the boundaries between, say, video and sculptural installation, or photography and painting. Many important artists since the 1960s have conceived of their art as one program expressed through diverse mediums, including not only painting, sculpture, drawing, and printmaking, but also often photography, film, and video. While it was Barr's genius to propose that all the diverse modern mediums—painting, film, photography, design, etc.—belonged together under one roof, the idea of separate languages of expression,

and separate historical traditions, still shaped the formation of the individual curatorial departments. Now, when artists frequently work simultaneously and interchangeably within several different mediums, and criss-cross the traditional lines between fine and applied arts as well, these curatorial divisions can frequently seem constraining and arbitrary.

This intellectual challenge is linked, paradoxically, with a shift in economic structures. Much of contemporary art has moved away from the basic model of the unique, handmade object, preferring instead mechanical means of production, and moving more comfortably in the zone of photography, prints, film, and video, where infinite replication is implied. But, at the same time, that art has, regardless of medium, often been pressed into conformity with models of marketing and sales associated with the traditional trade in paintings. Large-format, limited-edition works are now a staple of artists working in photography, film, and video, and the prices being asked are dramatically, by quantum leaps, larger than those observed within these mediums prior to the 1990s. In these circumstances, more collective planning and cooperation between the various departments of the institution seems a priority for any reasoned program of acquisitions. Accomplishing that coordination, while honoring and accommodating the pluralism and curatorial autonomy that has thus far enriched the Museum's holdings, will be a key goal of the present and future staff.

notes

1. Kirk Varnedoe's Introduction has been slightly modified from the original to suit this new edition.
2. Kirk Varnedoe, "The Evolving Torpedo: Changing Ideas of the Collection of Painting and Sculpture of The Museum of Modern Art," in *The Museum of Modern Art at Mid-Century: Continuity and Change.* Studies in Modern Art, No. 5 (New York: The Museum of Modern Art, 1995): 12–72.

Note to the Plates

The following plates are arranged chronologically, beginning in 1980. All are works of art in the collection of The Museum of Modern Art and represent acquisitions of contemporary work in the Museum's six curatorial departments: Painting and Sculpture, Drawings, Prints and Illustrated Books, Architecture and Design, Photography, and Film and Media.

• The year in which a work was made or completed is referenced at the bottom of the page next to the page number. The illustrations are accompanied by brief captions for purposes of identification; these give a plate number, the name of the artist, title and date of the work, and an abbreviated medium to indicate at a glance (and sometimes only in a general way) whether a work is a photograph or a film, a drawing or a painting, a print or a multiple, a sculpture or an installation, etc.

• The actual, complete medium of each work is given in the fuller caption in the Checklist of Illustrations on page 538, along with other information. The checklist is organized sequentially according to the disposition of the plates. There the reader will find for each illustrated work the plate number, the full title, series (if applicable), date, medium, and dimensions (in feet and inches, and in centimeters or meters, height before width before depth). For prints, dimensions are given both for plate or composition (comp.) size and sheet size, and the publisher, printer, and edition size are given where relevant. For architecture, inclusive dates represent the period from commission or design to completion; single dates may represent the point at which a drawing or model was made; and "project" indicates that a work is unbuilt. For film and media, a work is represented either by a still, or frame, from the work or a promotional image; and for these the country of origin, type of film, and running length are given. For design objects and multiples, the manufacturer may be given. For series in all mediums, a representative sample of the whole work may be shown; the size of the whole will be indicated in the checklist entry. The final part of most entries is the credit line, which indicates how the work entered the Museum's collection.

• To locate works by particular artists, the reader may consult the Index of Illustrations, on page 553, which lists the works alphabetically by artist and keys them by plate number.

ART SINCE 1980 AT MoMA

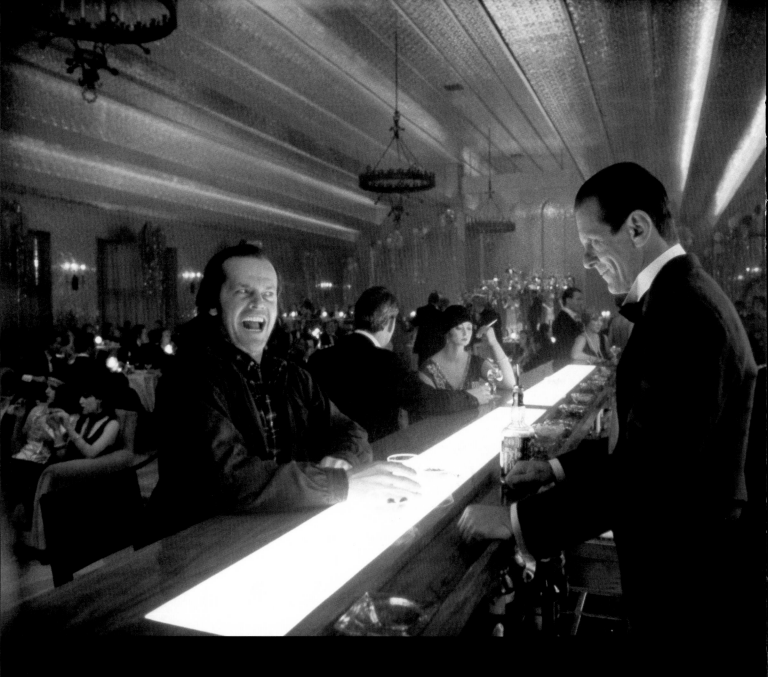

1. **Stanley Kubrick.** The Shining.
1980. Film

opposite:
2. **Cindy Sherman.** Untitled Film
Still #59. 1980. Photograph

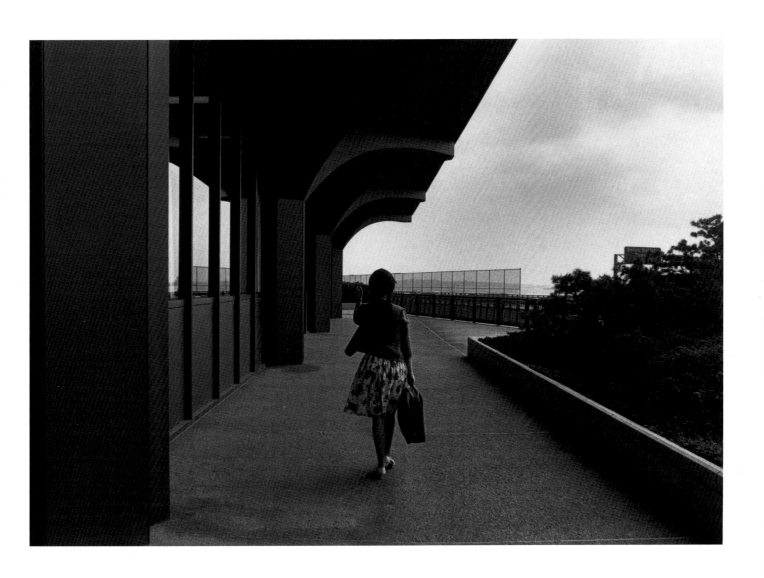

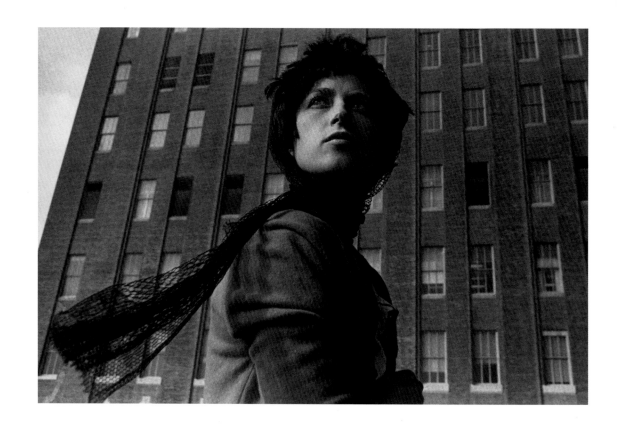

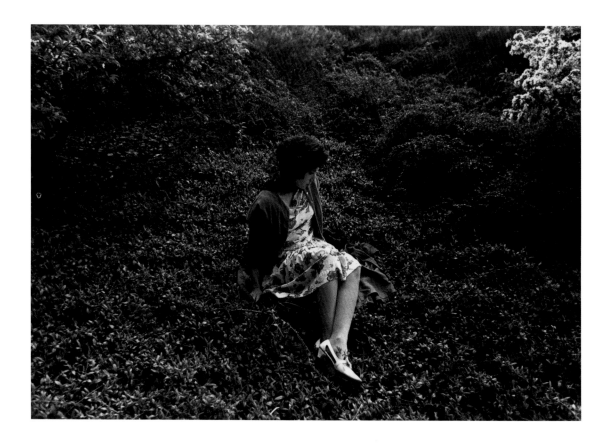

3. Cindy Sherman.
Untitled Film Still #58.
1980. Photograph

4. Cindy Sherman.
Untitled Film Still #57.
1980. Photograph

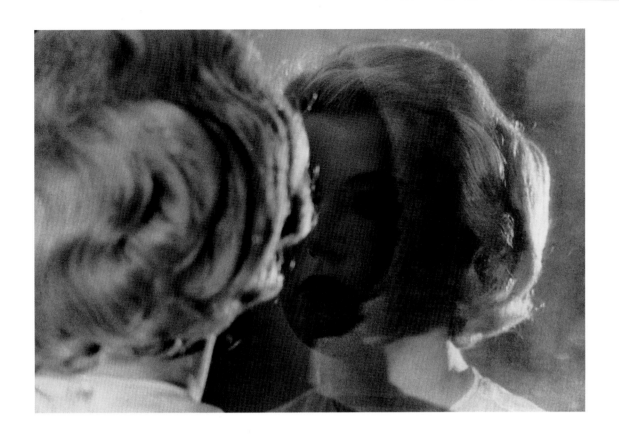

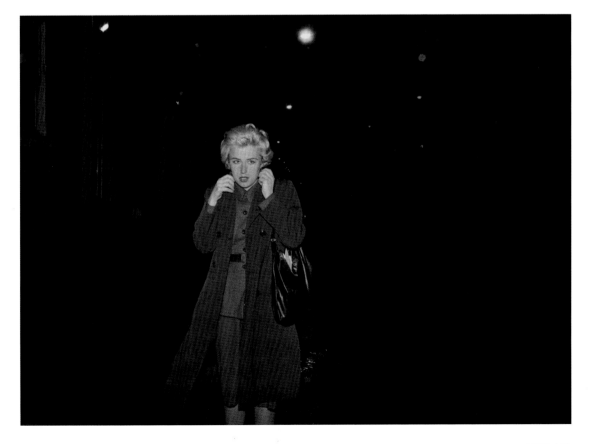

5. Cindy Sherman.
Untitled Film Still #56.
1980. Photograph

6. Cindy Sherman.
Untitled Film Still #54.
1980. Photograph

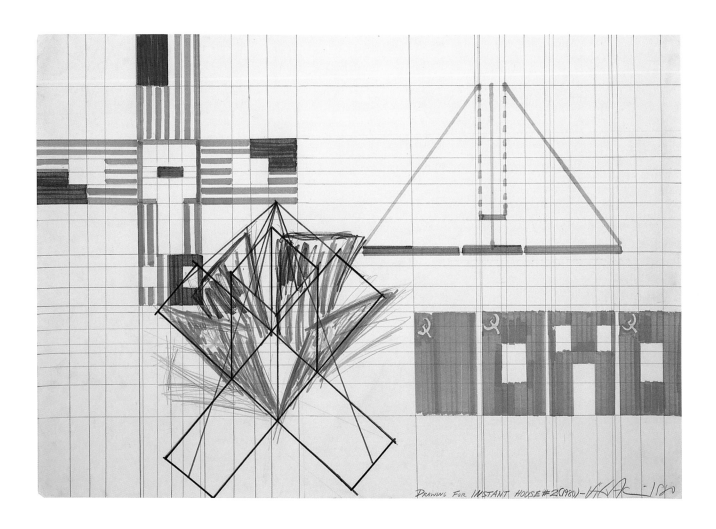

Drawing For INSTANT HOUSE #2(1980)—VITAC—1'80

7. Vito Acconci.
Instant House #2, Drawing.
1980. Drawing

opposite:
8. Vito Acconci.
20 Foot Ladder
for Any Size Wall.
1979–80. Print

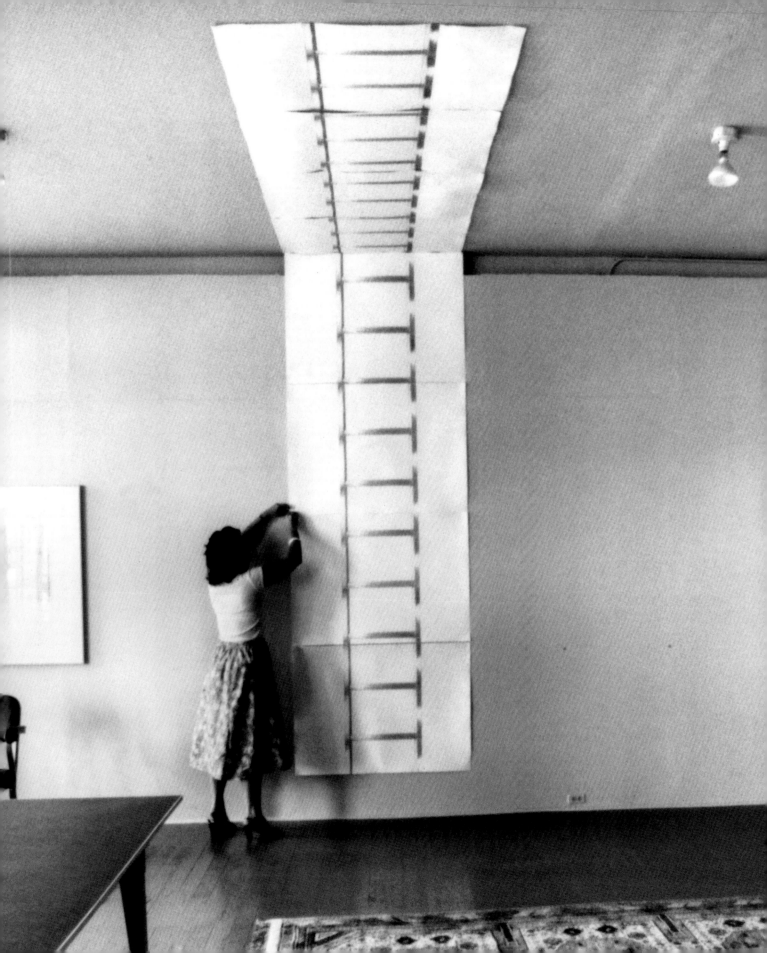

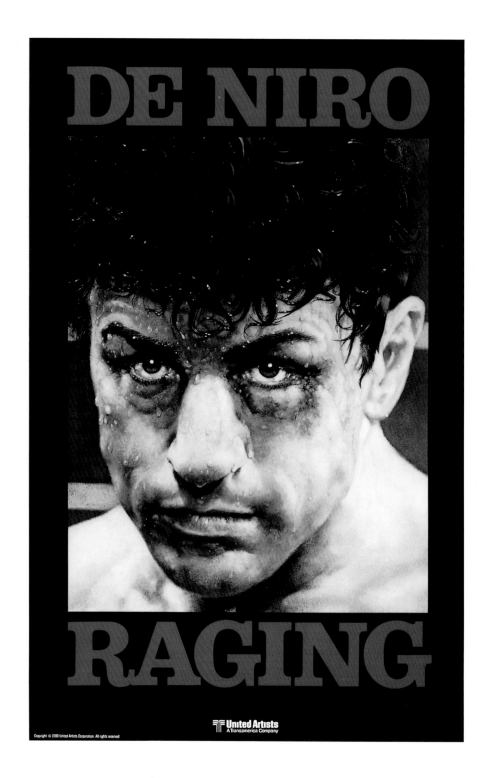

United Artists
A Transamerica Company

9. Martin Scorsese.
Raging Bull. 1980. Film

opposite:
10. Niklaus Troxler.
McCoy/Tyner/Sextet.
1980. Poster

11. Jean-Luc Godard.
Sauve qui peut (la vie).
1980. Film

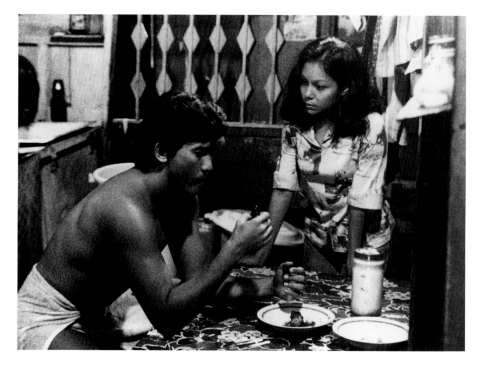

12. **Rainer Werner Fassbinder.** Berlin Alexanderplatz. 1980. Film

13. **Lino Brocka.** Bona. 1980. Film

opposite:
14. **John Hejduk.** A.E. Bye House, Ridgefield, Connecticut. Project, 1968–80. Architectural drawing

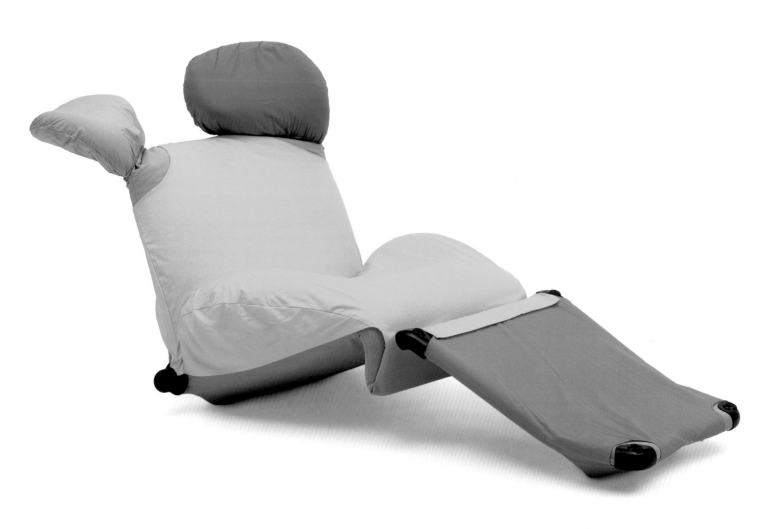

15. Toshiyuki Kita.
Wink Lounge Chair. 1980.
Design

16. Philip Guston.
Untitled. 1980. Drawing

17. Philip Guston.
Untitled. 1980. Drawing

18. Philip Guston.
Untitled. 1980. Drawing

19. Philip Guston.
Untitled. 1980. Drawing

20. Jörg Immendorff.
Cafe Deutschland (Style War).
1980. Painting

opposite:
21. Louis Malle. Atlantic City.
1980. Film

22. Shohei Imamura.
Vengeance Is Mine.
1980. Film

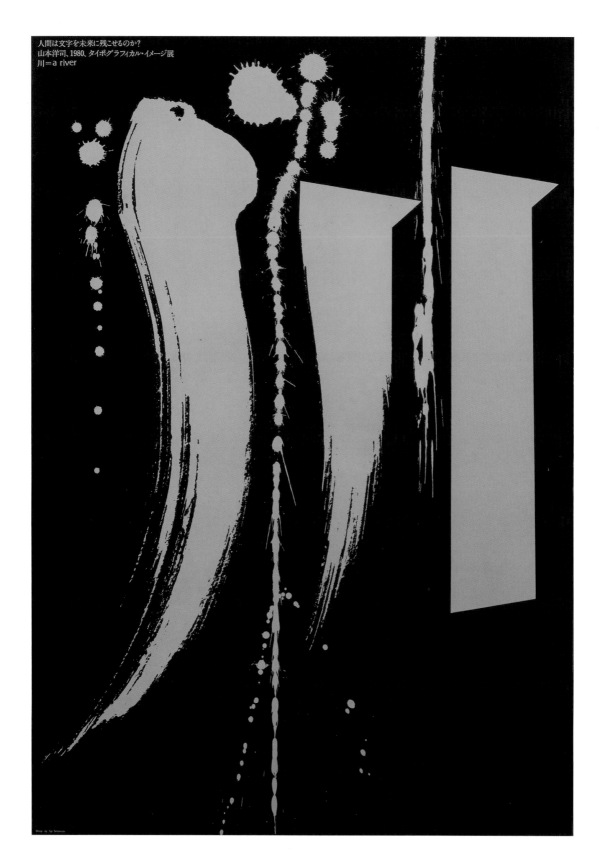

人間は文字を未来に残せるのか？
山本洋司、1980、タイポグラフィカル・イメージ展
川＝a river

23. Yoji Yamamoto.
A River. 1980. Poster

opposite:
24. Carlos Diegues.
Bye Bye Brazil. 1980. Film

25. Leon Hirszman.
They Don't Wear Black Tie.
1981. Film

26. Héctor Babenco.
Pixote. 1980. Film

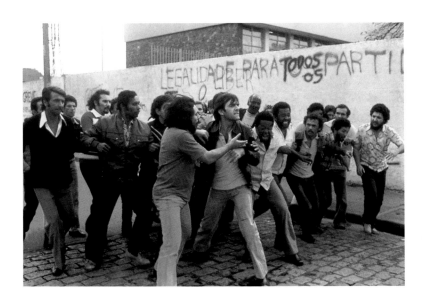

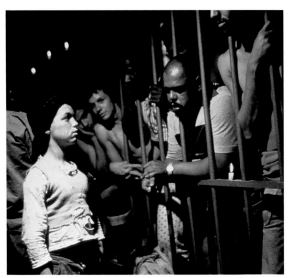

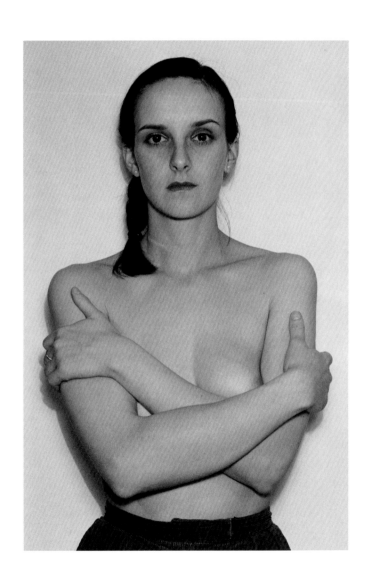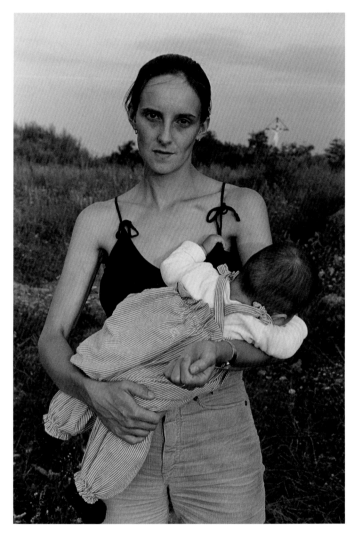

27. Seiichi Furuya.
Graz. 1980. Photograph

28. Seiichi Furuya.
Schattendorf. 1981.
Photograph

29. Peter Hujar.
Portrait of David
Wojnarowicz. 1981.
Photograph

30. Rainer Werner Fassbinder.
Lola. 1981. Film

31. Rainer Werner Fassbinder.
Lili Marleen. 1981. Film

opposite:
32. James Welling. Untitled #46
May 20, 1981. Photograph

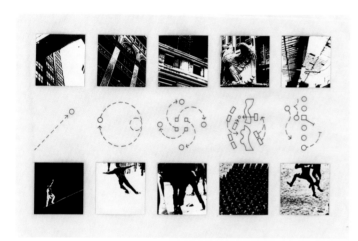

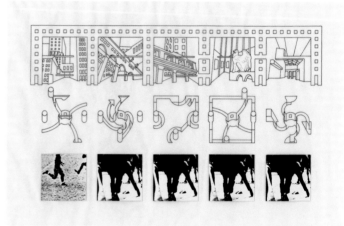

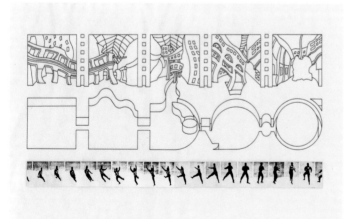

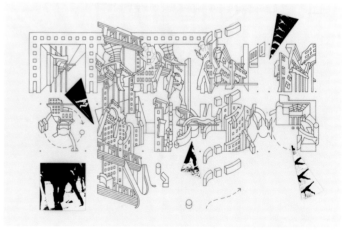

33. Bernard Tschumi.
The Manhattan Transcripts.
Episode 4: The Block.
Project, 1976–81.
Architectural drawings

34. Frank Gohlke.
Aerial View, Downed
Forest near Elk Rock,
Approximately Ten
Miles Northwest of
Mount St. Helens,
Washington. 1981.
Photograph

35. Georg Baselitz.
Woman on the Beach.
1981. Print

36. Georg Baselitz.
Drinker. 1981. Print

37. Scott Burton.
Pair of Rock Chairs.
1980–81. Sculpture

38. Lee Friedlander.
Untitled. 1980. Photograph

39. Lee Friedlander.
Untitled. 1980. Photograph

40. Lee Friedlander.
Untitled. 1981. Photograph

41. Cindy Sherman.
Untitled #96. 1981.
Photograph

opposite:
42. Willem de Kooning.
Pirate (Untitled II). 1981.
Painting

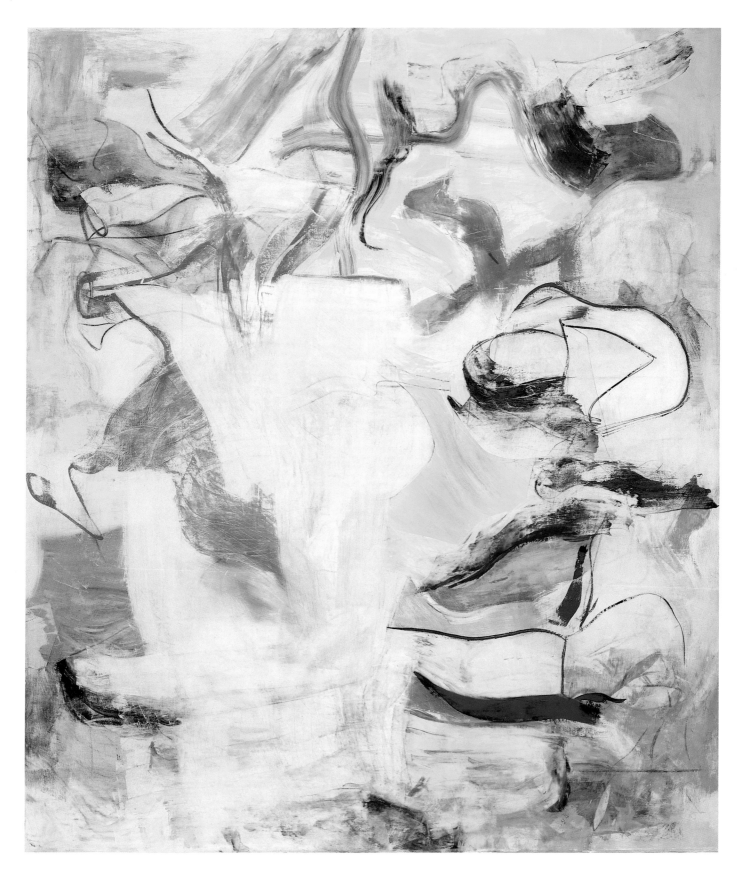

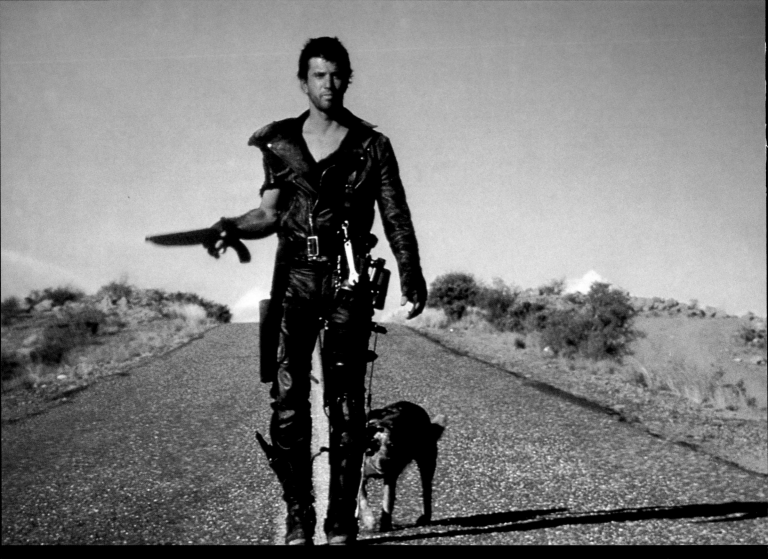

43. George Miller.
Mad Max 2 (The Road
Warrior). 1981. Film

opposite:
**44. A. R. Penck
(Ralf Winkler).**
Nightvision. 1982.
Print

45. Andrzej Pagowski.
Wolf's Smile (Usmiech Wilka).
1982. Poster

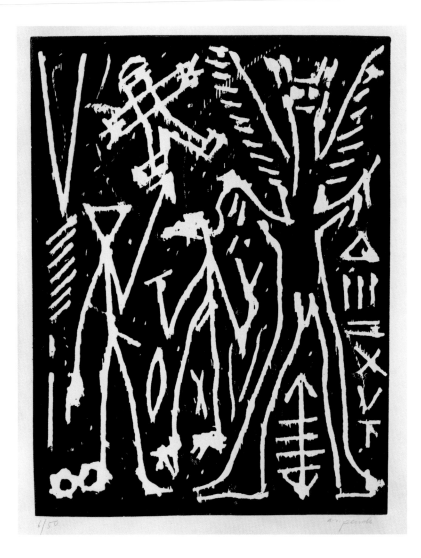

6/50

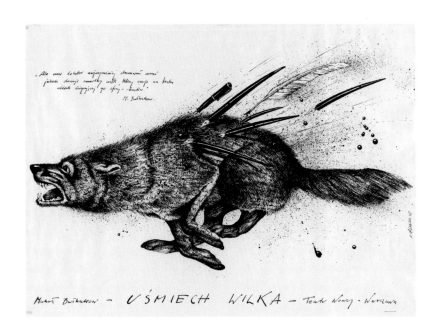

Michaił Bułhakow — UŚMIECH WILKA — Teatr Nowy - Warszawa

22/48 V. Celmins

46. Vija Celmins.
Alliance. 1982. Print

opposite:
47. Werner Herzog.
Fitzcarraldo. 1982. Film

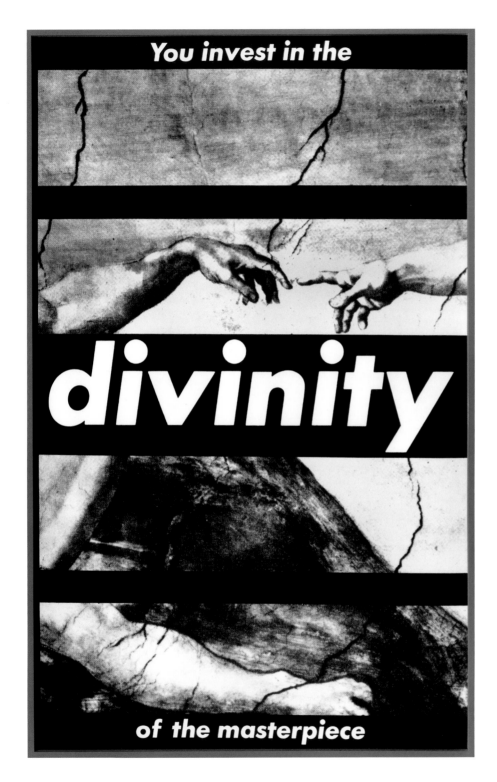

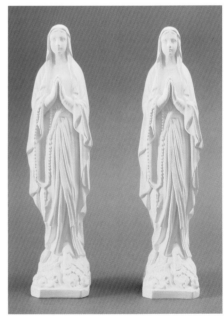

48. Barbara Kruger.
Untitled (You Invest in the
Divinity of the Masterpiece).
1982. Painting

49. Katharina Fritsch.
Madonna. 1982. Multiples

50. Krzysztof Kieslowski.
Blind Chance. 1982. Film

51. Ingmar Bergman.
Fanny and Alexander.
1982. Film

52. Tina Barney.
Sunday New York Times.
1982. Photograph

53. Nicholas Nixon.
Chestnut Street, Louisville,
Kentucky. 1982. Photograph

opposite:
54. Judith Joy Ross.
Untitled from Eurana Park,
Weatherly, Pennsylvania.
1982. Photograph

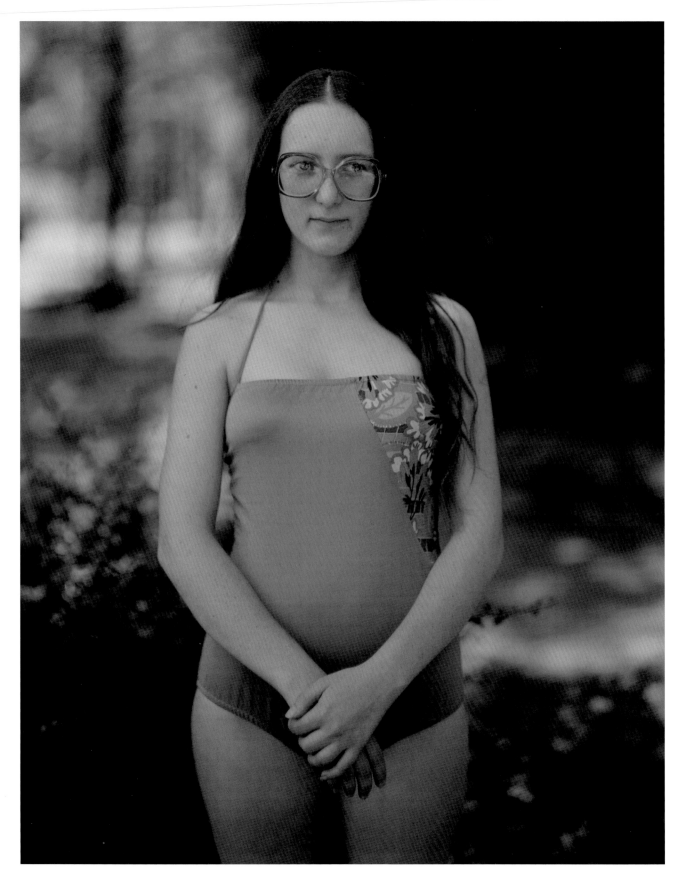

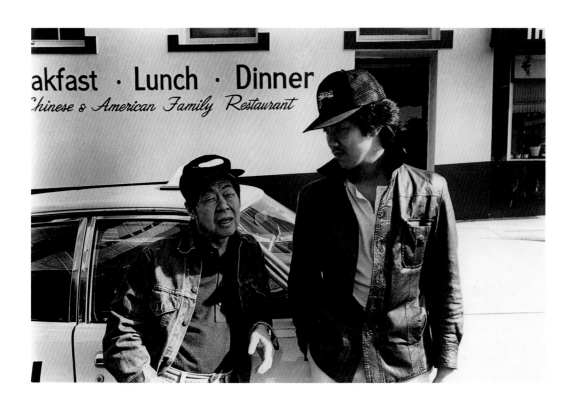

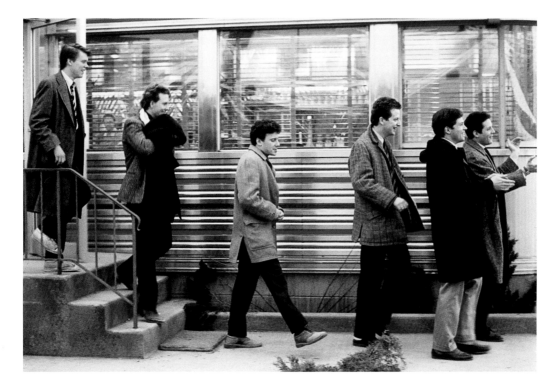

55. Wayne Wang.
Chan Is Missing.
1982. Film

56. Barry Levinson.
Diner. 1982. Film

opposite:
57. Uwe Loesch.
Point (Punktum).
1982. Poster

Punktum.

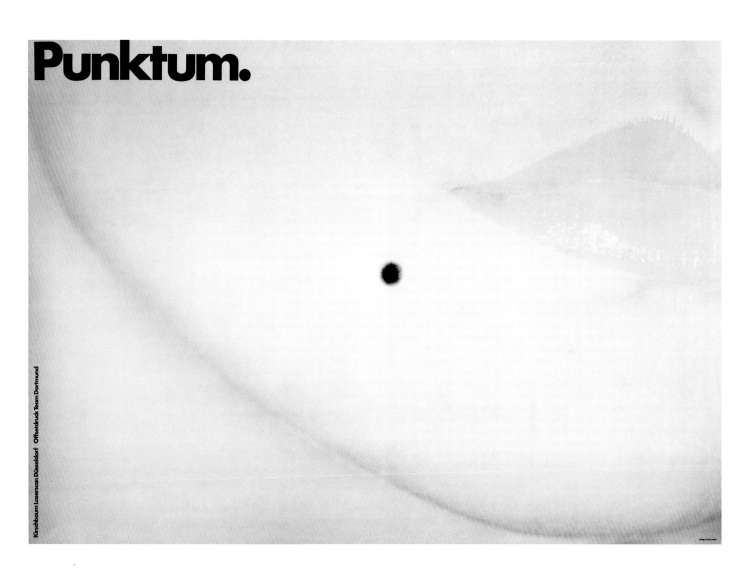

Kirschbaum Laserscan Düsseldorf Offsetdruck Team Dortmund

58. William Wegman.
Blue Head. 1982.
Photographs

opposite:
59. Paul Rand.
IBM. 1982. Poster

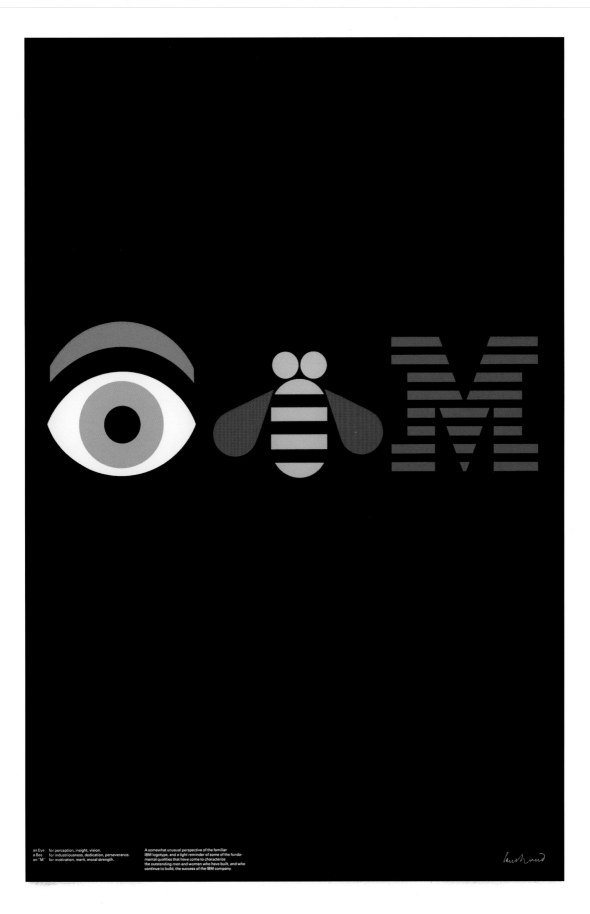

an Eye for perception, insight, vision.
a Bee for industriousness, dedication, perseverance.
an "M" for motivation, merit, moral strength.

A somewhat unusual perspective of the familiar
IBM logotype, and a light reminder of some of the funda-
mental qualities that have come to characterize
the outstanding men and women who have built, and who
continue to build, the success of the IBM company.

60. Ridley Scott.
Blade Runner. 1982. Film

opposite:
61. Joan Fontcuberta.
Guillumeta Polymorpha.
1982. Photograph

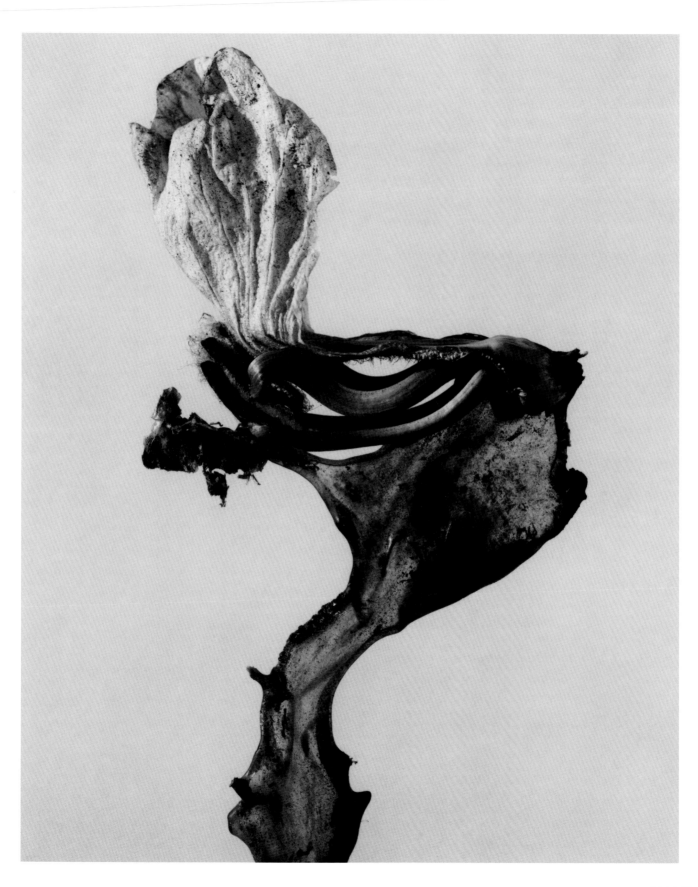

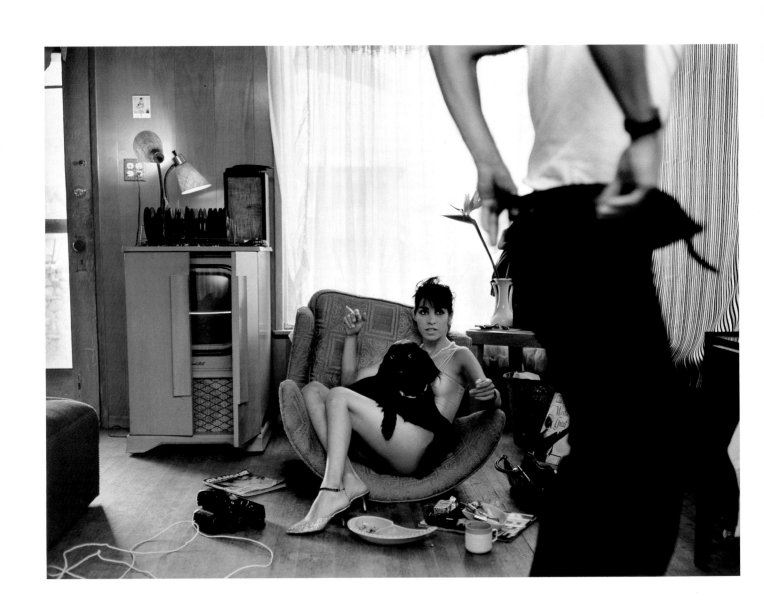

62. Philip-Lorca diCorcia.
Mary and Babe. 1982. Photograph

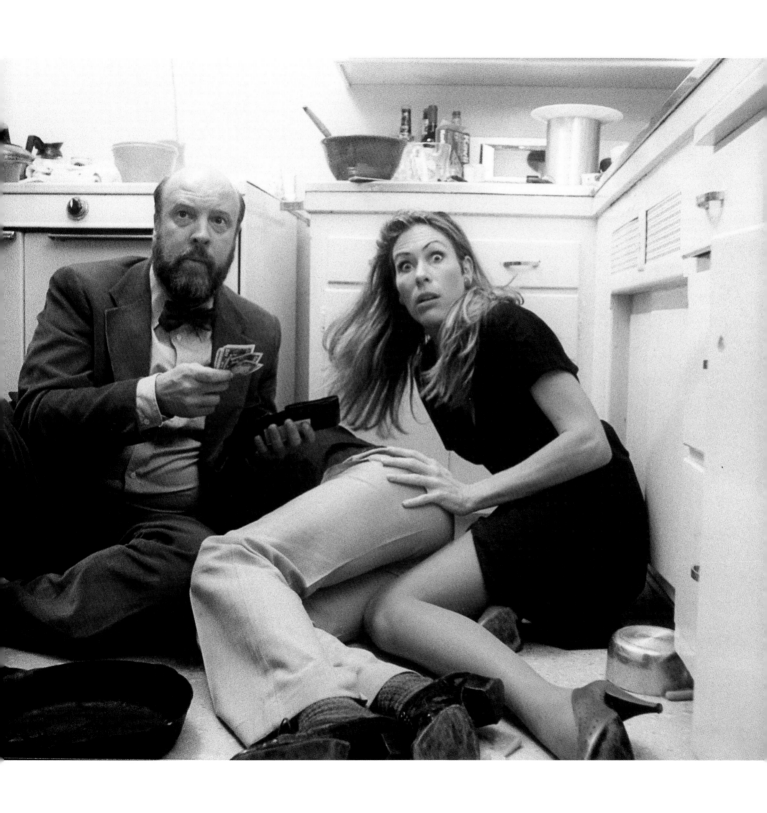

63. Paul Bartel.
Eating Raoul. 1982. Film

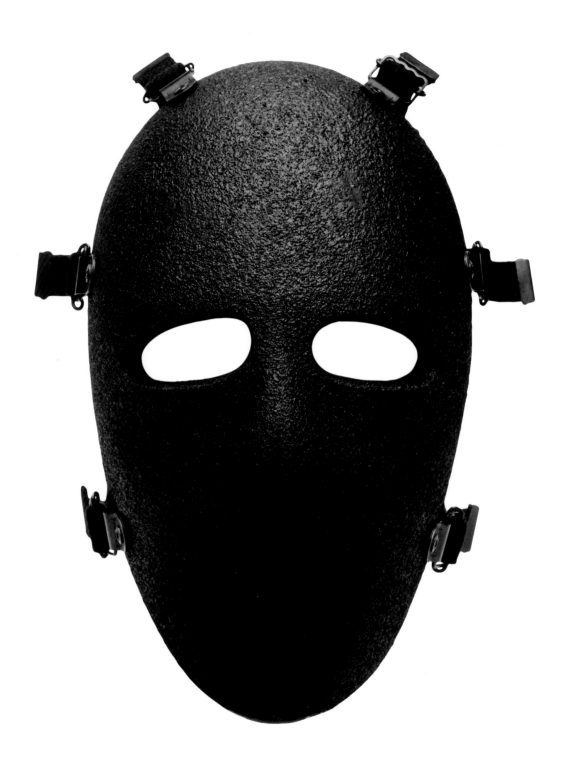

64. Stephen Armellino.
Bullet-Resistant Mask.
1983. Design

65. John Canemaker.
Bottom's Dream. 1983.
Animated film

66. John Divola.
Untitled. 1983.
Photograph

opposite:
67. Jannis Kounellis.
Untitled. 1983.
Sculpture

70. Terry Jones and Terry Gilliam.
Monty Python's The Meaning of Life.
1983. Film

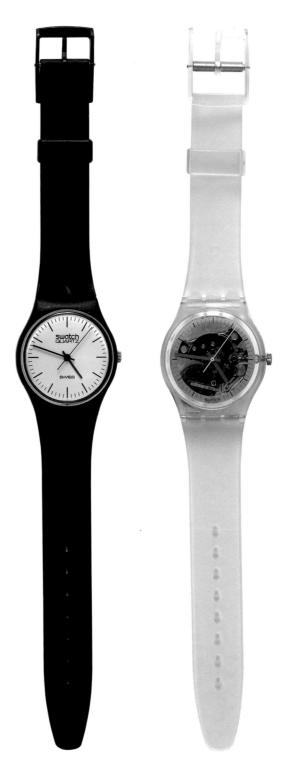

71. Swatch.
GB 001 Watch.
1983. Design

72. Swatch.
GK 100 Jellyfish Watch.
1983. Design

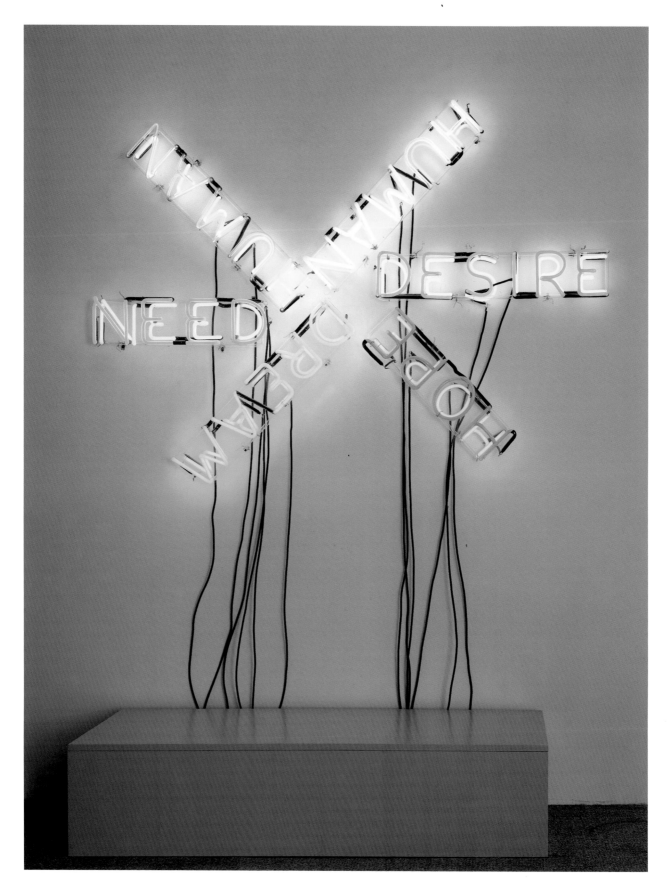

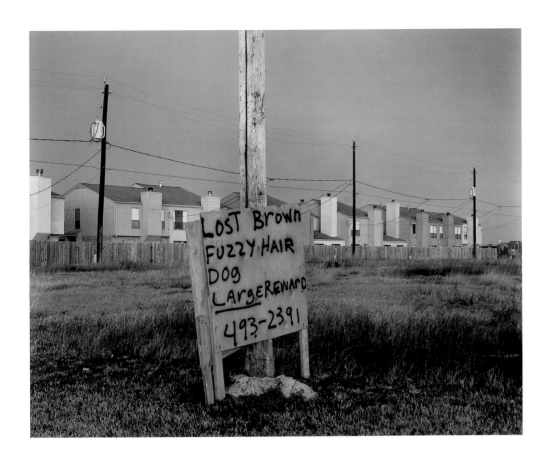

74. Joel Sternfeld.
Houston, Texas. 1983.
Photograph

75. Joel Sternfeld.
Canyon Country, California.
1983. Photograph

opposite:
73. Bruce Nauman.
Human/Need/Desire.
1983. Sculpture

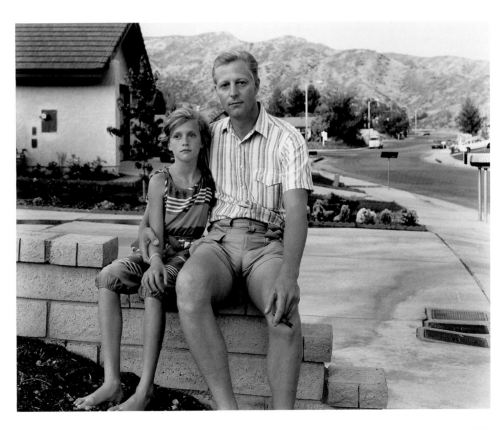

**76. Kathryn Bigelow and
Monty Montgomery.**
Breakdown (The Loveless).
1983. Film

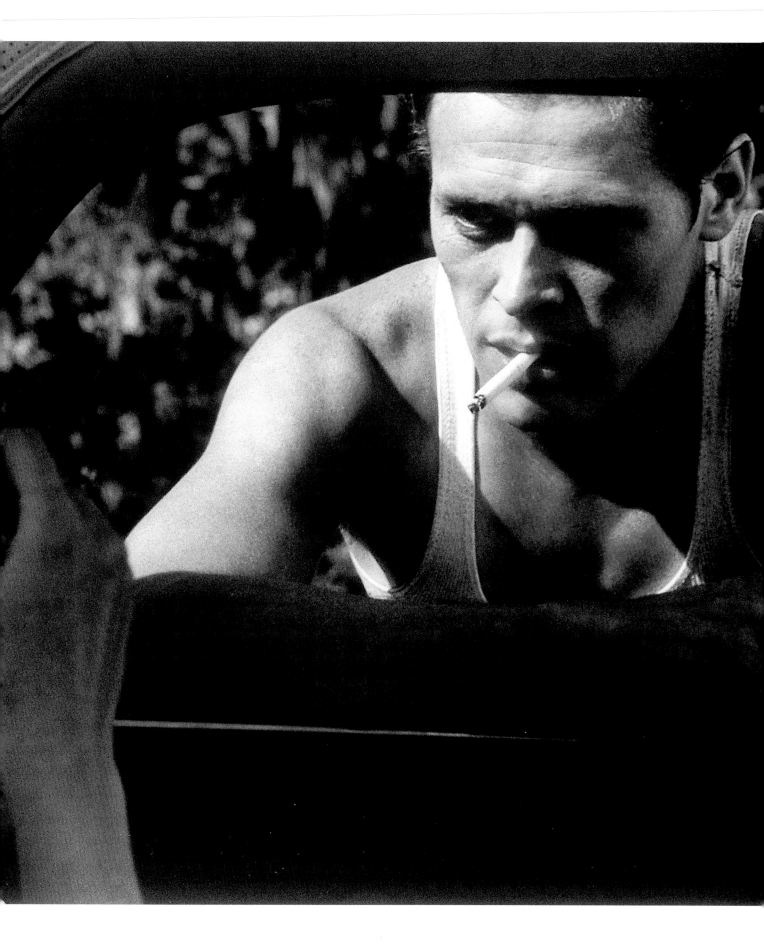

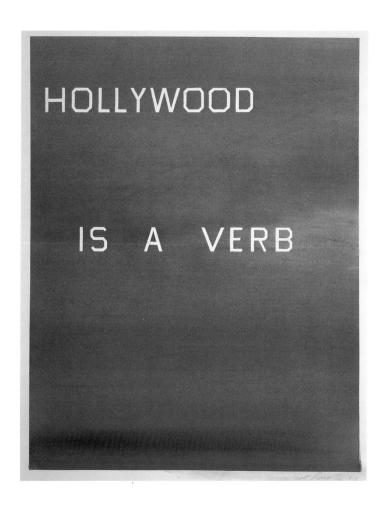

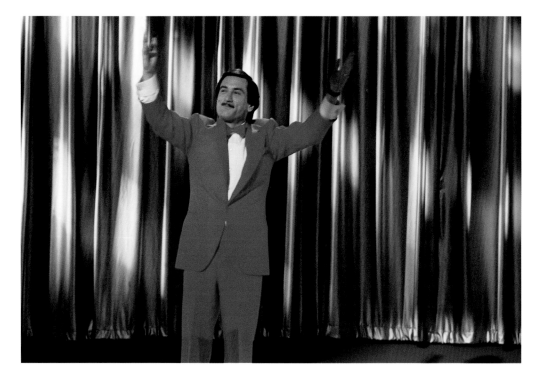

77. Edward Ruscha.
Hollywood Is a Verb.
1983. Drawing

78. Martin Scorsese.
The King of Comedy.
1983. Film

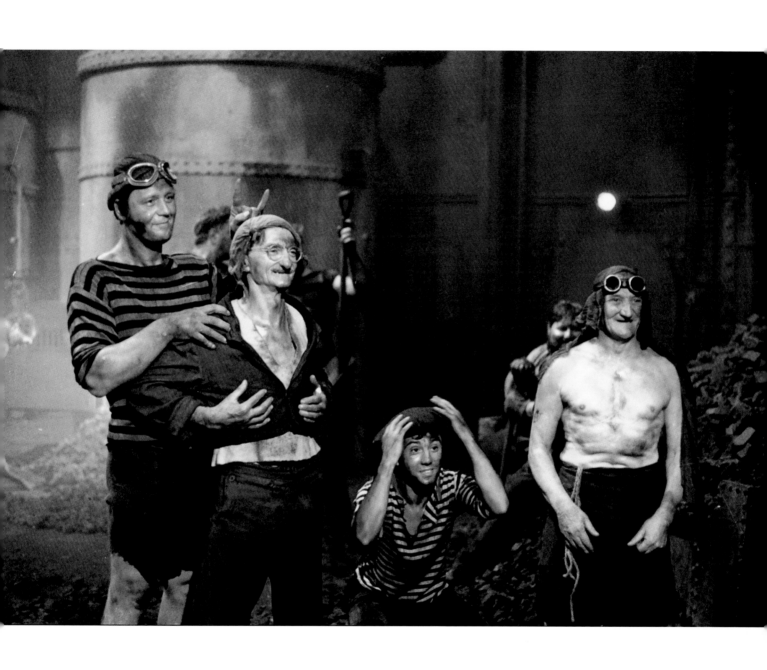

79. Federico Fellini.
And the Ship Sails On.
1983. Film

80. Nicholas Nixon.
C.C., Boston. 1983.
Photograph

opposite:
81. Anselm Kiefer.
Der Rhein. 1983.
Illustrated book

82. Jan Groover.
Untitled. 1983.
Photograph

opposite:
83. Francesco Clemente.
Conversion to Her. 1983.
Painting

84. Mike Leigh.
Meantime. 1983. Film

85. Lizzie Borden.
Born in Flames. 1983. Film

86. Jörg Immendorff.
Futurology. 1983. Print

87. Mazda Motor Corporation.
MX5 Miata Automobile Taillights.
1983. Design

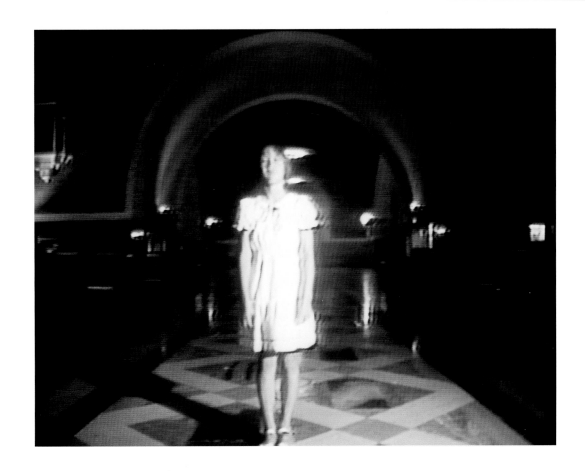

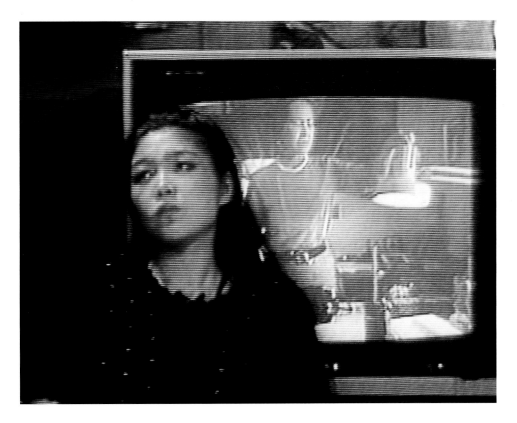

88. Bill Viola.
Anthem. 1983. Video

89. Mako Idemitsu.
Great Mother Part II: Yumiko.
1983. Video

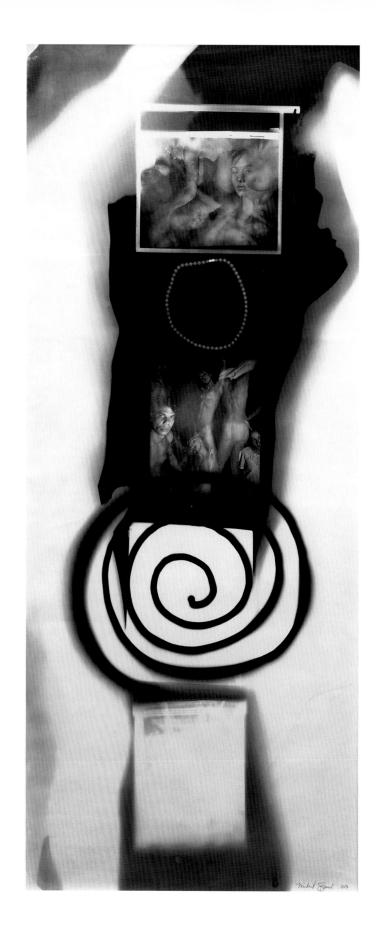

90. Michael Spano.
Photogram—Michael Spano.
1983. Photograph

opposite:
91. Jonathan Borofsky.
Stick Man. 1983. Print

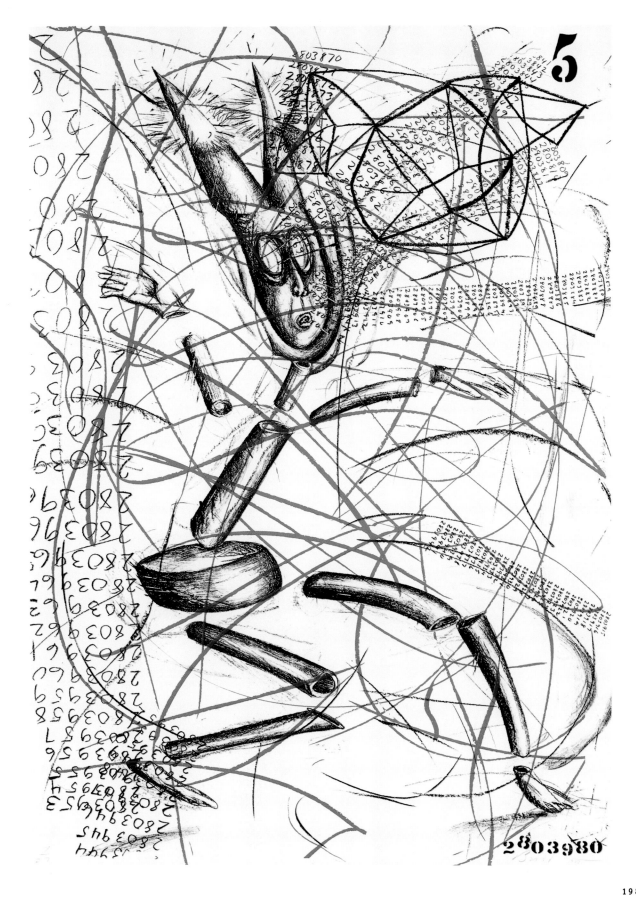

2803980

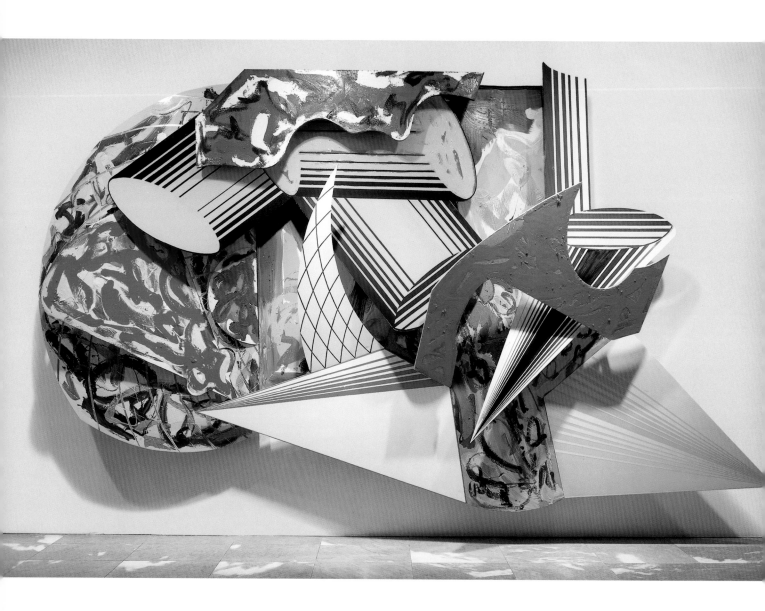

92. Frank Stella.
Giufà, la luna, i ladri e le guardie.
1984. Painting

opposite:
93. Sigmar Polke.
Watchtower. 1984. Painting

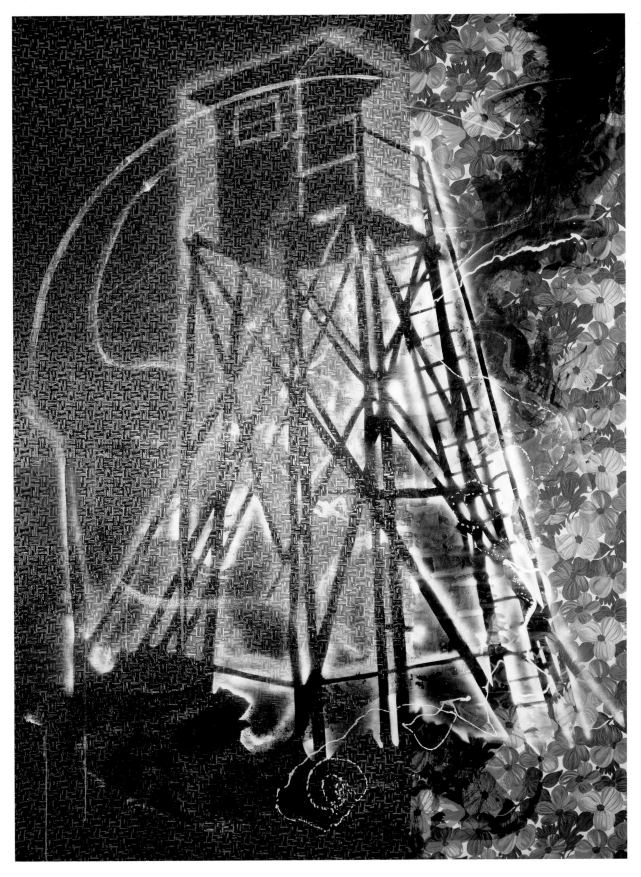

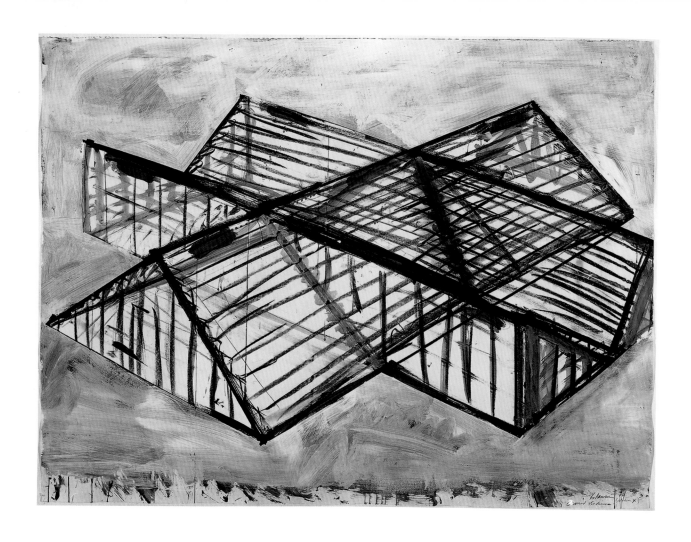

94. Bruce Nauman.
Crossed Stadiums. 1984.
Drawing

95. Claes Oldenburg.
Proposal for a Monument to
the Survival of the University
of El Salvador: Blasted Pencil
(That Still Writes). 1984. Print

opposite:
96. Sergio Leone.
Once upon a Time in America.
1984. Film

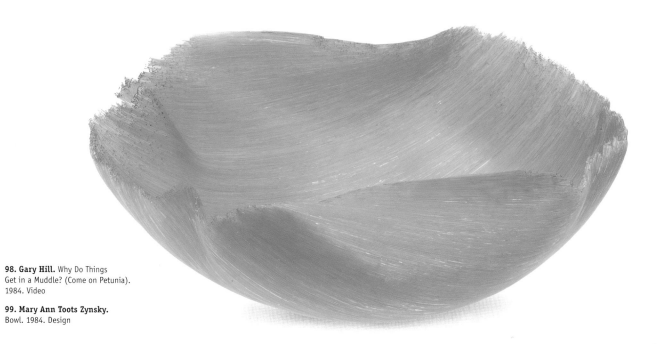

98. Gary Hill. Why Do Things
Get in a Muddle? (Come on Petunia).
1984. Video

99. Mary Ann Toots Zynsky.
Bowl. 1984. Design

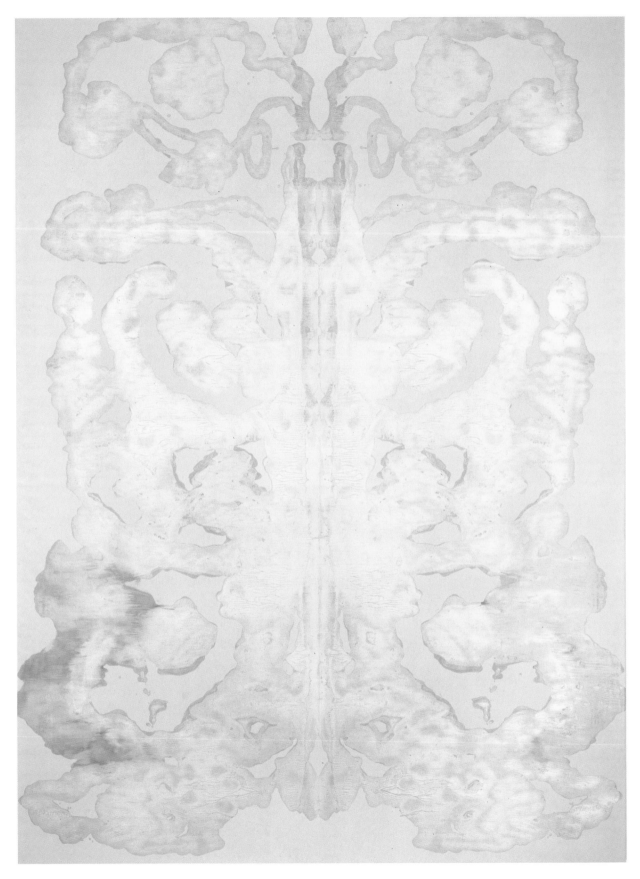

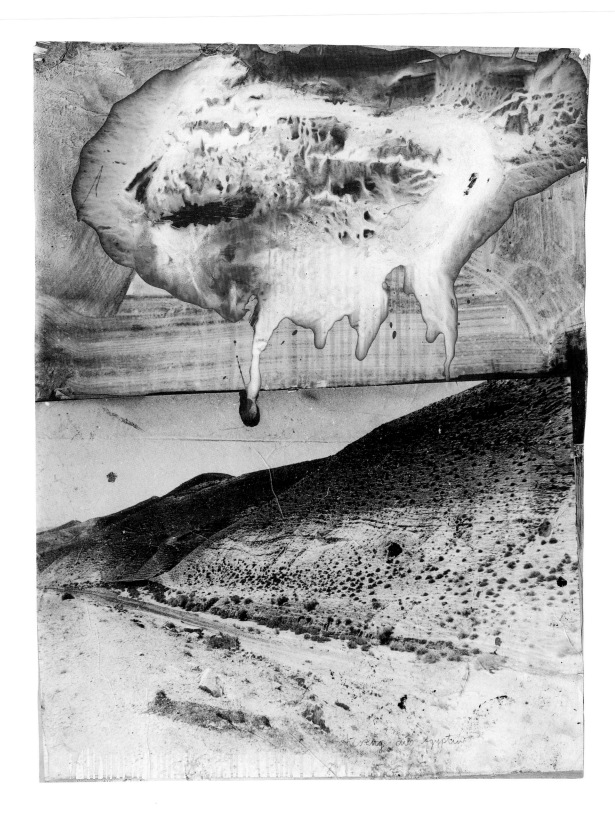

opposite:
100. Andy Warhol.
Rorschach. 1984.
Painting

101. Anselm Kiefer.
Departure from Egypt.
1984. Drawing

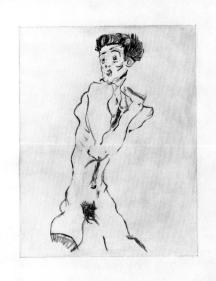

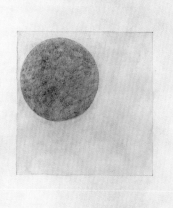

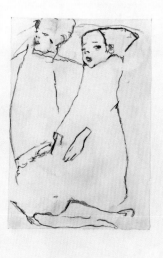

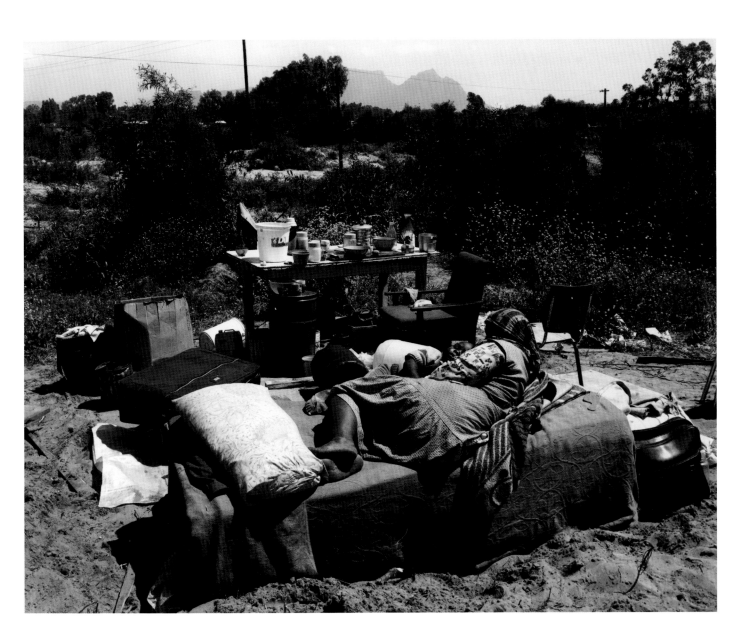

opposite:
102. Sherrie Levine.
Untitled (After Kasimir
Malevich and Egon Schiele)
from The 1917 Exhibition at
Nature Morte Gallery, 1984.
1984. Drawings

103. David Goldblatt. Mother and child in their home after the destruction of its shelter by officials of the Western Cape Development Board, Crossroads, Cape Town, 11 October 1984. 1984. Photograph

The shelter was a framework of Port Jackson brushwood staked into loose sand of the Cape Flats and covered by plastic sheets—black plastic near the base for privacy, translucent plastic over the roof for light. Neatly, without touching the contents of the home or its occupants, a team of five overalled Black men, supervised by an armed White, lifted the entire structure of frame and plastic skin off the ground and placed it nearby. Then they pulled off the plastic, smashed the framework, and threw the pieces onto a waiting truck. Hardly a word was spoken. While they could legally destroy the wooden framework, they were forbidden, by the quirk of a court decision brought against the State seeking to prevent these demolitions, from confiscating or destroying the plastic. So it was left where it fell.

Then the convoy—a police Landrover, the truck with the demolition squad and broken wood, and a Casspir with policemen in camouflage lolling in its armoured back—moved towards the next group of shelters.

For a while the woman lay with the child. Then she got up and began to cut and strip branches of Port Jackson bush to make a new framework for her house.

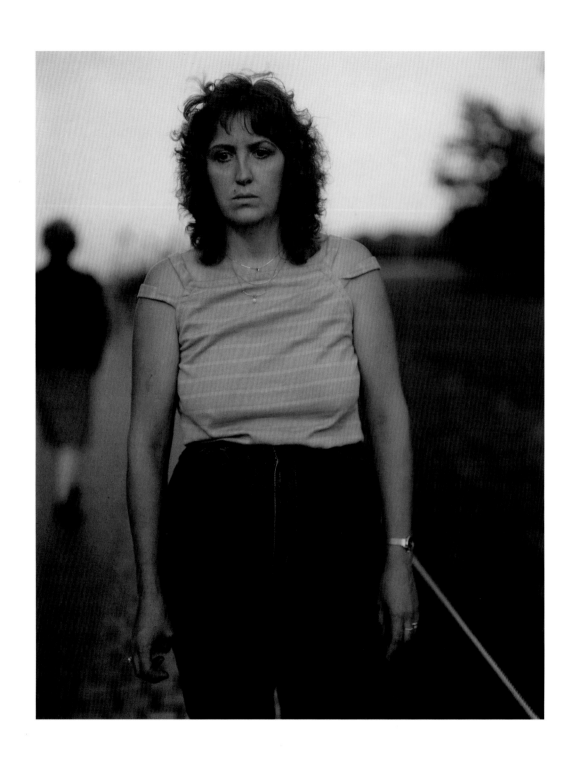

104. Judith Joy Ross.
Untitled from Portraits at the
Vietnam Veterans Memorial,
Washington, D.C. 1984.
Photograph

105. Aldo Rossi.
Cemetery of San Cataldo,
Modena, Italy. 1971–84.
Architectural drawing

106. Aldo Rossi.
Cemetery of San Cataldo,
Modena, Italy. 1971–84.
Architectural drawing

107. Su Friedrich.
The Ties That Bind.
1984. Film

108. Hou Hsiao-hsien.
Summer at Grandpa's.
1984. Film

109. frogdesign.
Macintosh SE Home
Computer. 1984. Design

110. Allan McCollum.
40 Plaster Surrogates.
1982–84. Installation

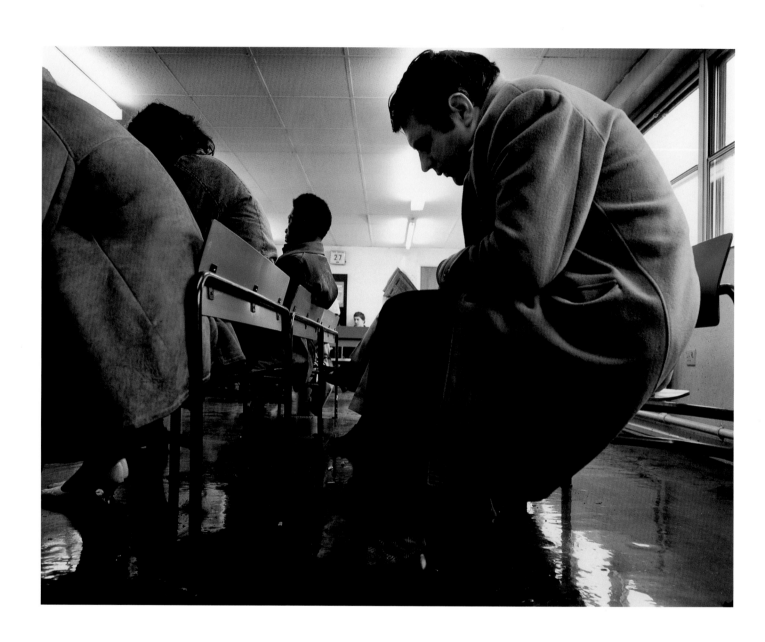

111. Paul Graham.
Crouched Man, DHSS
Waiting Room, Bristol.
1984. Photograph

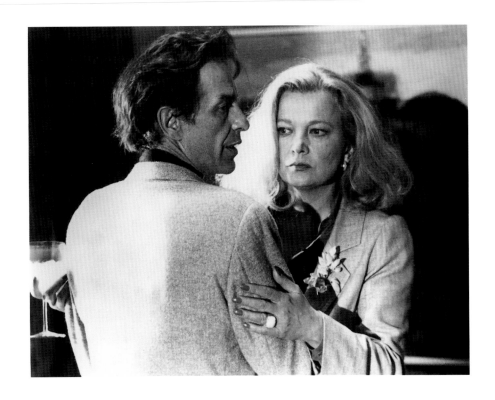

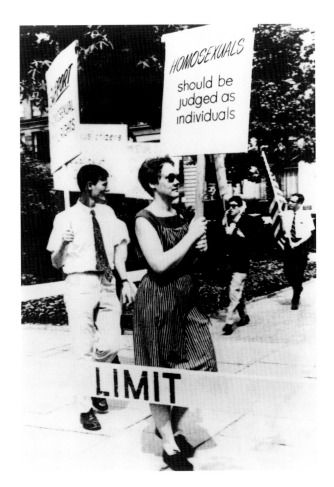

112. John Cassavetes.
Love Streams. 1984. Film

**113. Greta Schiller and
Robert Rosenberg.** Before
Stonewall. 1984. Film

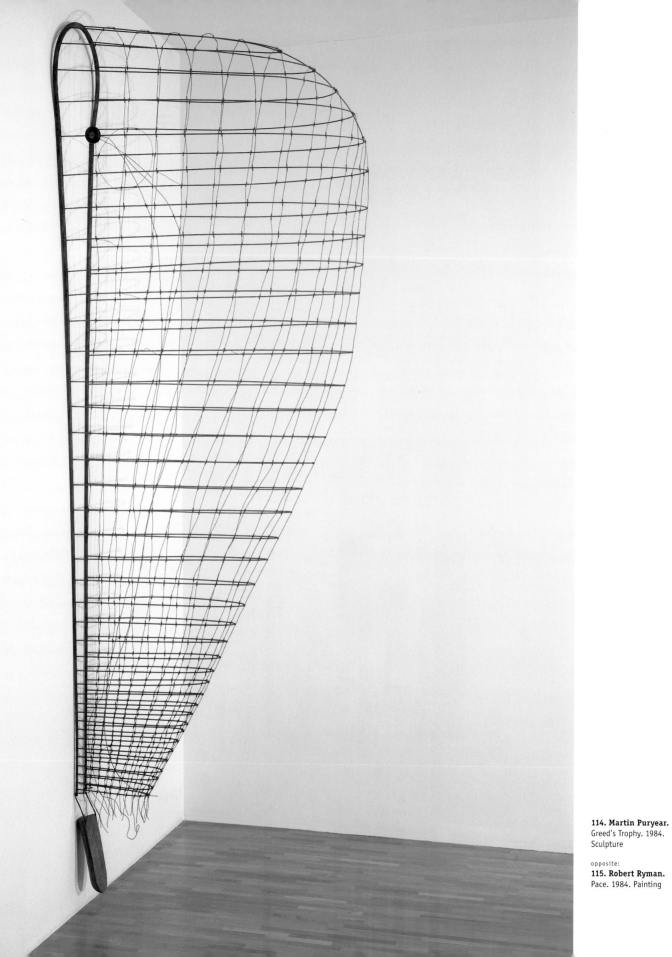

114. Martin Puryear.
Greed's Trophy. 1984.
Sculpture

opposite:
115. Robert Ryman.
Pace. 1984. Painting

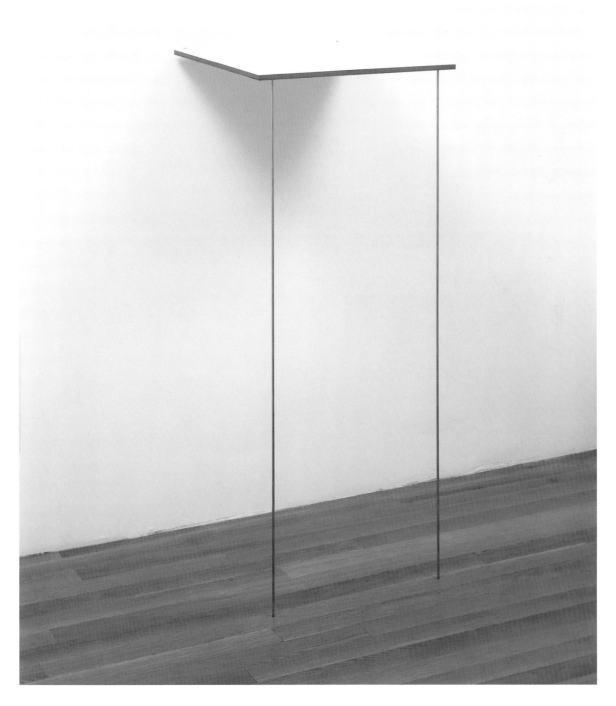

116. Jim Jarmusch.
Stranger Than Paradise.
1984. Film

117. Woody Allen.
Broadway Danny Rose.
1984. Film

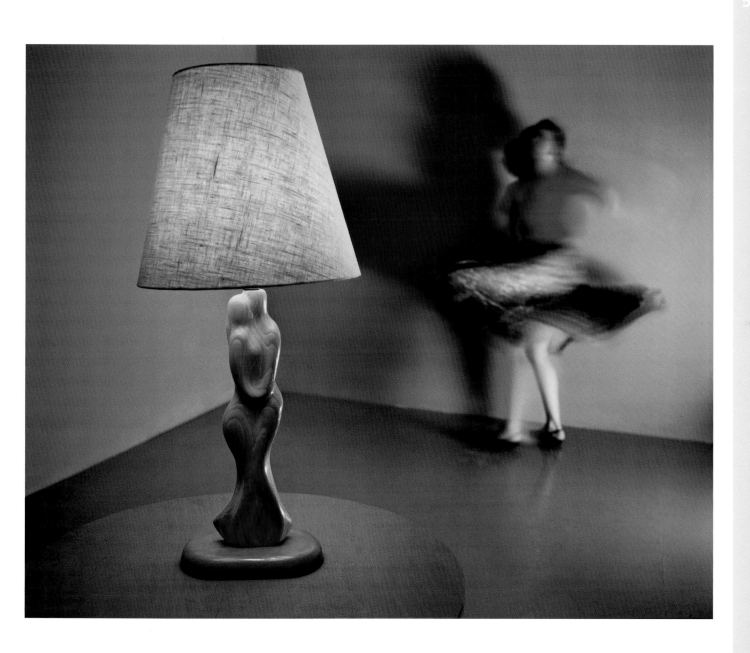

118. Jo Ann Callis.
Woman Twirling. 1985.
Photograph

119. Robert Frank.
Boston, March 20, 1985.
1985. Photographs

120. Bernard Tschumi.
Parc de la Villette, Paris, France.
1985. Architectural model

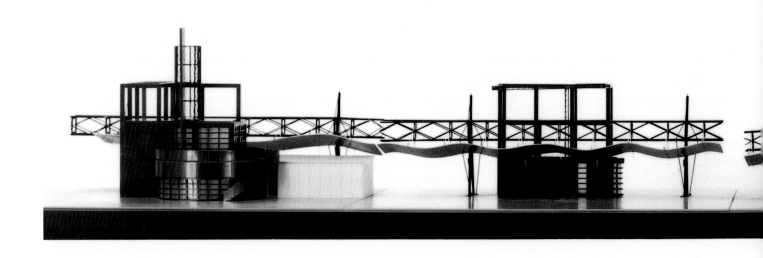

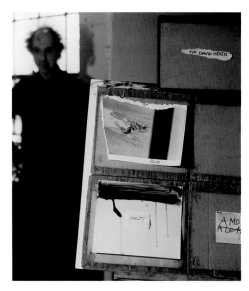

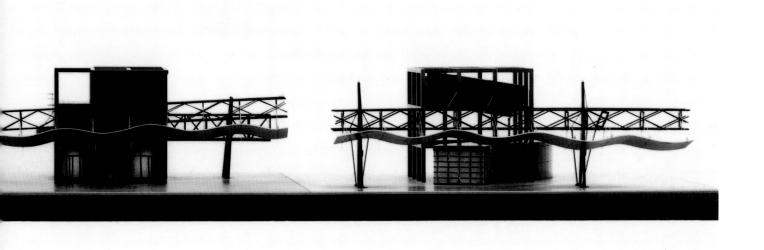

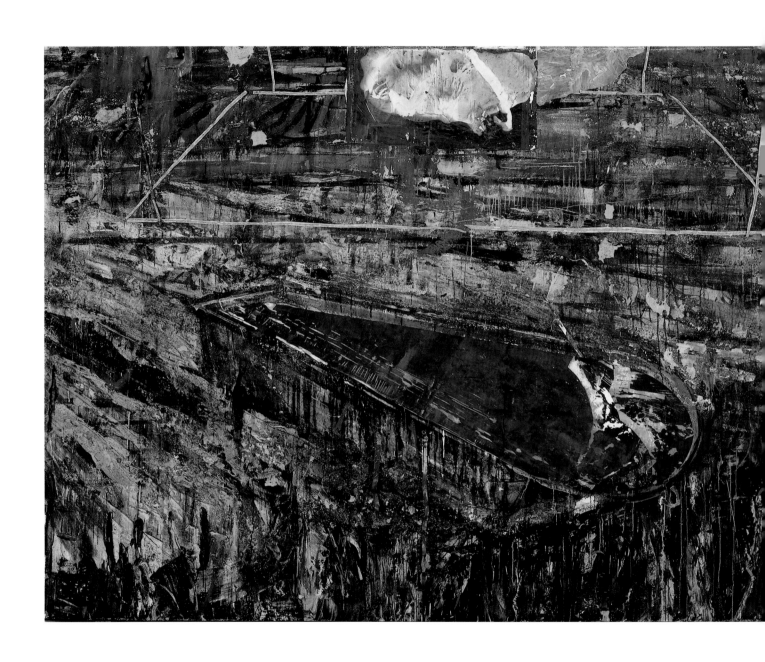

121. Anselm Kiefer.
The Red Sea. 1984–85.
Painting

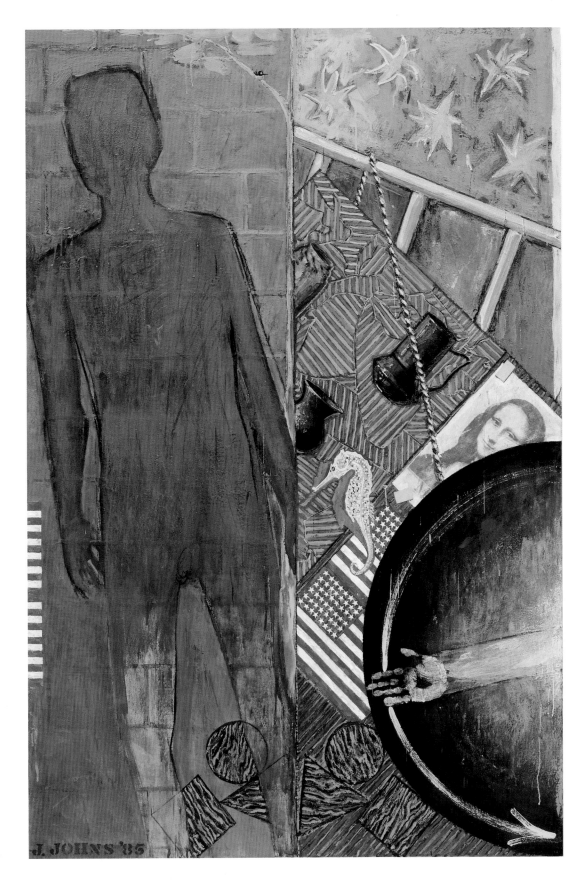

122. Jasper Johns.
Summer. 1985. Painting

123. Jean-Michel Basquiat.
Untitled. 1985. Drawing

124. David Salle.
Muscular Paper. 1985.
Painting

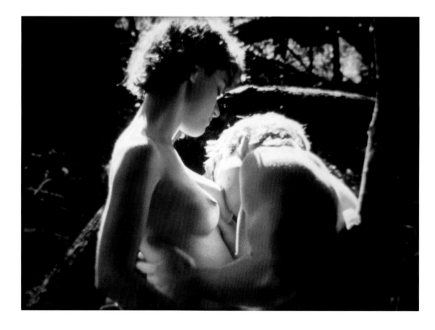

125. Sir Norman Foster.
Hong Kong and Shanghai Bank,
Hong Kong. 1979–85.
Architectural drawing

126. James Herbert.
River. 1985. Film

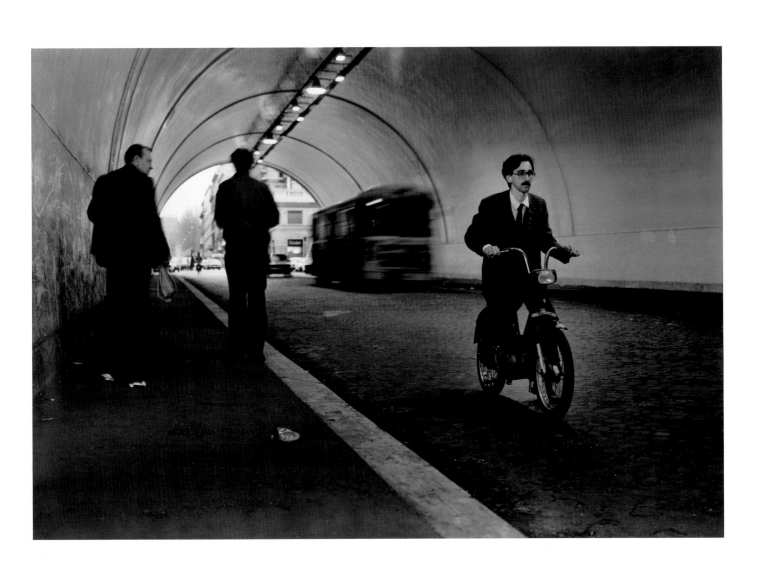

127. Philip-Lorca diCorcia.
Francesco. 1985. Photograph

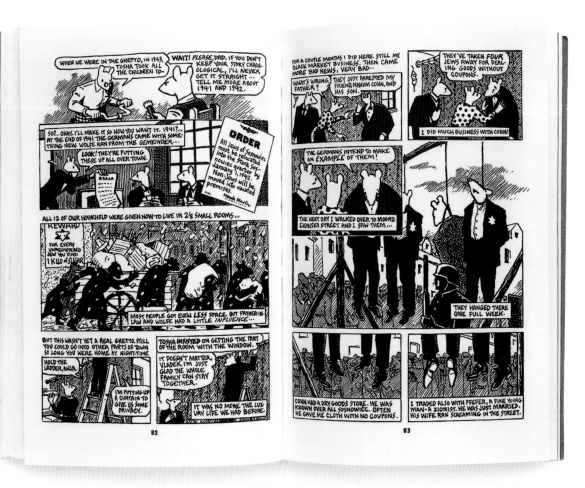

128. Art Spiegelman.
Maus: A Survivor's Tale.
1980–85. Illustrated book

la fin du voyage.

129. Claude Lanzmann.
Shoah. 1985. Film

130. John Schlesinger.
Untitled. 1985. Photograph

opposite:
131. Mike Kelley.
Exploring (from "Plato's
Cave, Rothko's Chapel, Lincoln's
Profile"). 1985. Drawing

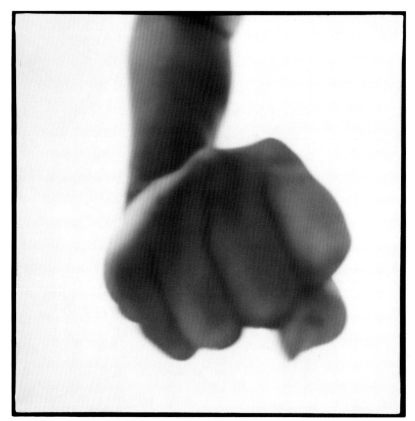

132. Thomas Florschuetz.
In Self-Defense. 1985.
Photographs

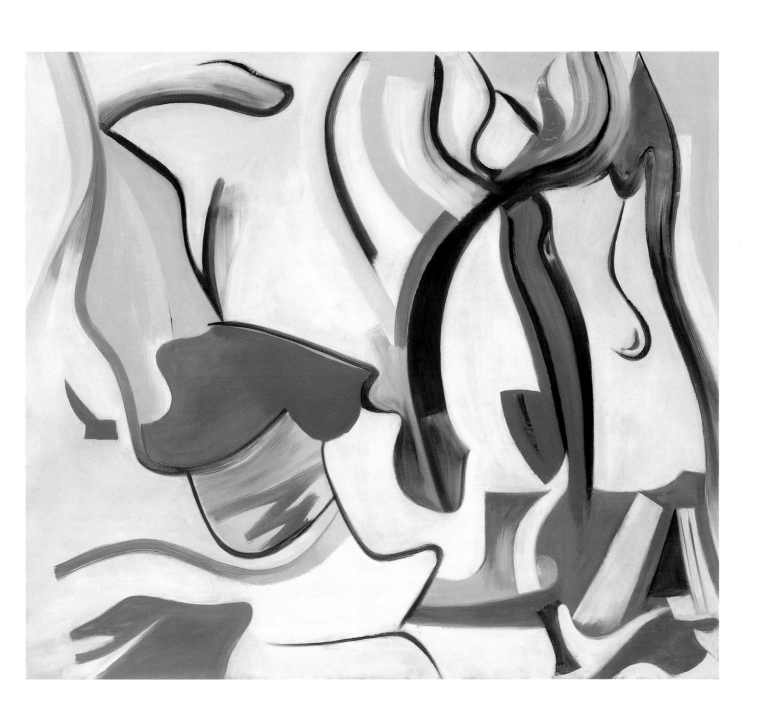

133. Willem de Kooning.
Untitled VII. 1985. Painting

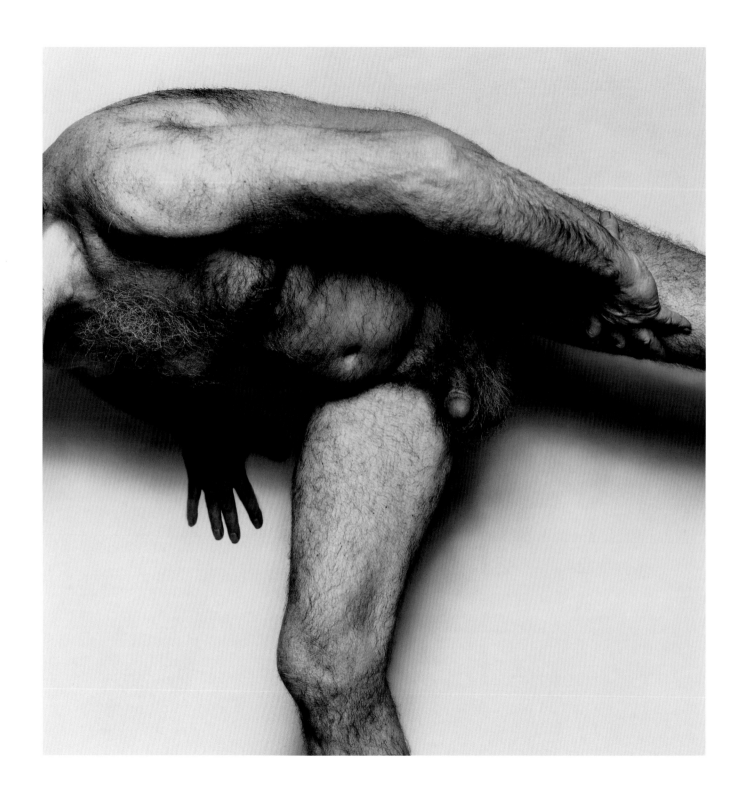

134. John Coplans.
Self-Portrait. 1985. Photograph

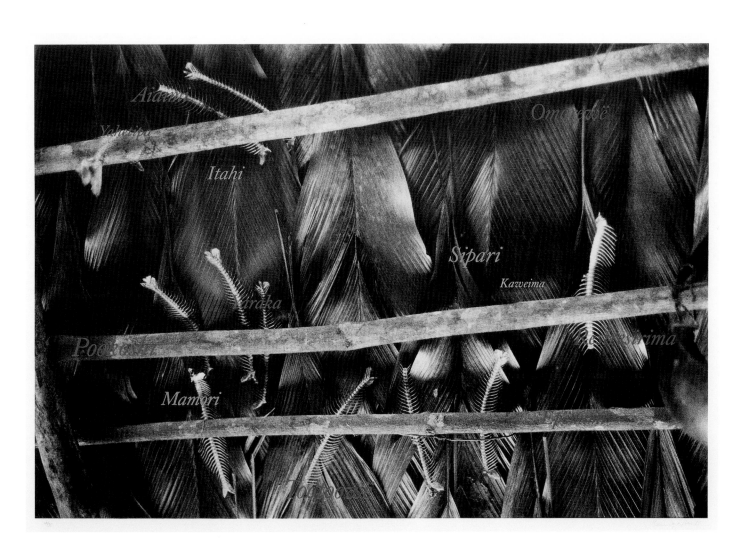

135. Lothar Baumgarten.
Untitled (Fish). 1985. Print

136. Terry Gilliam.
Brazil. 1985. Film

opposite:
137. Jeff Koons.
Three Ball 50/50 Tank.
1985. Sculpture

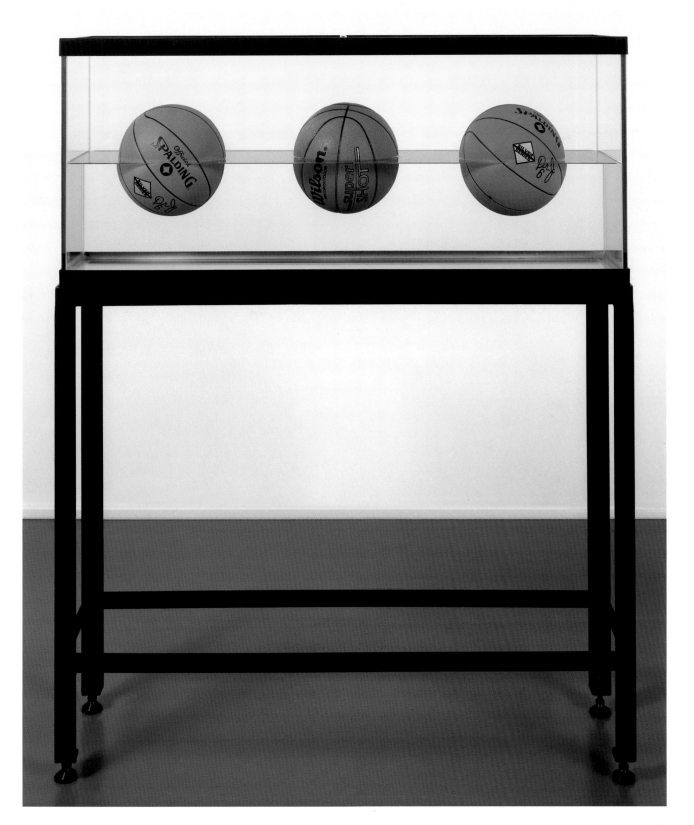

138. James Casebere.
Covered Wagons. 1985.
Photograph

139. Trinh T. Minh-ha.
Naked Spaces: Living Is Round.
1985. Film

140. Susan Rothenberg.
Biker. 1985. Painting

141. Susan Rothenberg.
Boneman. 1986. Print

142. Bill Viola.
I Do Not Know What
It Is I Am Like.
1986. Video

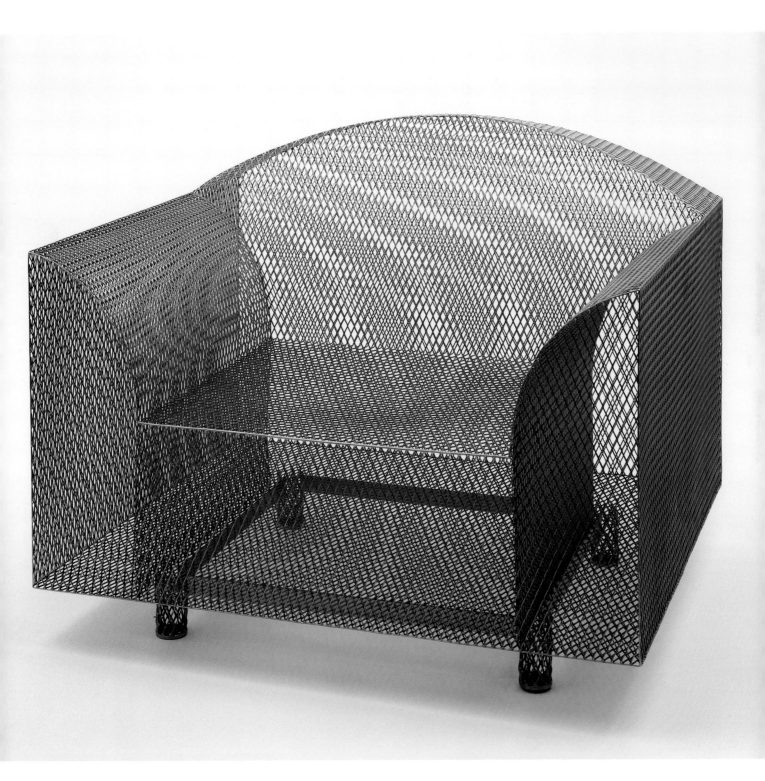

143. Shiro Kuramata.
How High the Moon Armchair.
1986. Design

144. Bernhard and Anna Blume.
Kitchen Frenzy. 1986. Photographs

145. Robert Gober.
Untitled. 1986.
Sculpture

146. Ellsworth Kelly.
Three Panels: Orange, Dark
Gray, Green. 1986. Painting

147. Larry Fink.
Pearls, New York City.
1986. Photograph

148. Patrick Faigenbaum.
Massimo Family, Rome. 1986.
Photograph

149. Eugenio Dittborn.
8 Survivors. 1986. Print

150. Bertrand Tavernier.
Round Midnight. 1986. Film

opposite:
151. Niklaus Troxler.
A Tribute to the Music of
Thelonious Monk. 1986. Poster

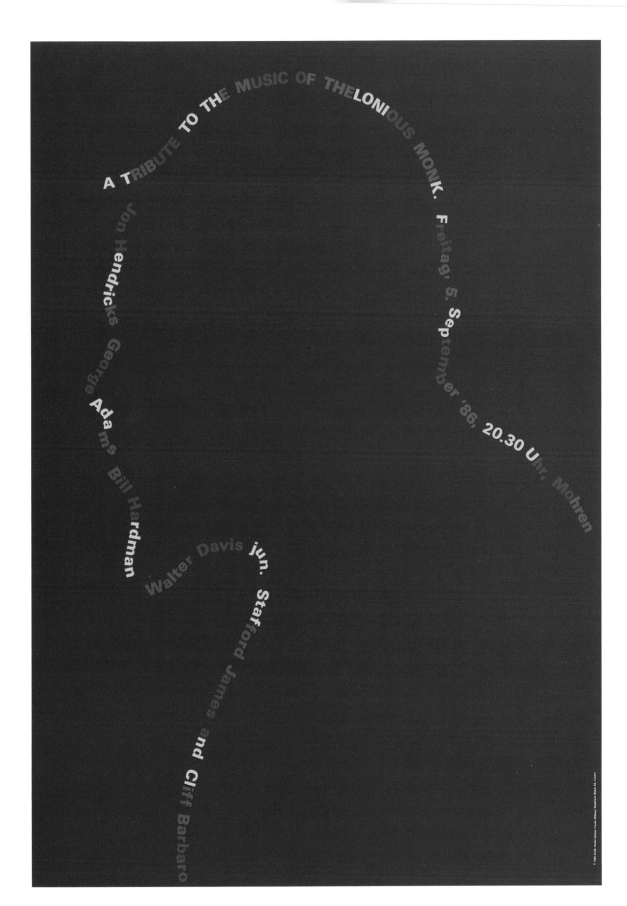

A TRIBUTE TO THE MUSIC OF THELONIOUS MONK. Freitag, 5. September '86, 20.30 Uhr, Mohren

Jon Hendricks George Adams Bill Hardman Walter Davis jun. Stafford James and Cliff Barbaro

wounded English soldiers traveling with us) and shoes on feet — by order of the captain. Our captain is a fat lobster from the south of Italy, who, when in Taranto, dressed in the uniform of an ensign but who, while steering the ship now, wears a pair of white trousers and a dark blue jacket and cap with shiny visor, the border of which is trimmed with chevroned silk. Our captain's duties are exactly as follows: to be present at the distribution of rations and to give the order to put on our life jackets. Each time we leave port, at the first shock of the propellers, the captain bounces like a spring up to the bridge, armed with a cyclopean megaphone under which, it seems to me, he could quite conveniently hide in case of danger. The captain blows a rolling toot on his nickel whistle, which has the effect of drawing to his modest person the one thousand two hundred eyes of the six hundred soldiers on board, after which he noses the megaphone about like a brigantine trombone, first in the direction of the stem, then in the direction of the stern, and fires this command twice: "Present life jackets!" But the captain lacks the temper of a commander: it's obvious to me and — I believe — obvious to him as well; this explains the diligence with which he tries to make up for this lack, having recourse to bonhomie even. Before drawing anchor at Taranto, he informed us: "I'm your father and you're my sons," but there as well, he lacked that authority which distinguishes a respectable parent. The captain is a good man; it would be better to say: he does good; better still, lacking the more sterling qualities, he has diligently set himself to the task of professing an intense affability. Beyond the boundaries of this putative family of six hundred chance sons, among them blackguards and rogues from every part of Italy, I imagine him with his true, carnal family and see him in the double role of pet-husband (being dragged on a leash by an autocratic Amazon of a wife) and pet-father, overpowered, washed out and resigned to the tyranny of a swarm of rosy-cheeked, chubby, spoiled brats. Next I wonder what sort of control he can

possibly expect to hold over these six hundred "sons," unlike him in every way – babies who will have to leave the trenches, not the cradle, broken in for the human hunt by three years of war!... After the voice of the homunculus has exhausted itself in the giant funnel, there follows a bit of commotion on deck and one sees the raised arms and bent torsos of his "sons" in the sham gestures of putting on their life jackets. But once the captain's little round body slips into the hatchway, all arms fall, backs straighten up and the life jackets return to their primary function as seats, pillows and card tables. I find this swindle so exasperating that I decide to have an eye to eye talk with the captain just to make perfectly clear the psychological line to be followed in the performance of his duties: "It bears upon the matter, sir, of the life jackets issued to the six hundred soldiers committed to your care, the effectiveness of which is guaranteed, I'm sure. It could have been shown just how well they work by putting them to the test back at Taranto: If I were you, I'd have asked for a show of hands from all those men who can't swim. From their number I'd have picked two trustworthy lads and ordered them to tie on their life jackets and jump into the sea. They'd have floated like pumpkins. But nothing will alter the fact that this example wouldn't be nearly persuasive enough when applied to these boys, the ones assembled for the demonstration, these Italians, I might further add. Better alter the phrasing of your command in this manner: "Thro w awa y life jackets!" and you'll get the opposite result, I might even venture to say, the desired one." But while preparing my discourse, I realize that I'd better do a little psychological housecleaning first. Why disturb the captain's serene spirits? He's the one who has to order us to put on our life jackets and in so doing absolves himself of all obligations plain and simple. He hasn't any other duties to take care of, and, pronouncing the words for which the government pays him his salary, he's freed of every further responsibility, and with peace of mind he can go down to the officer's

152. Francesco Clemente.
The Departure of the
Argonaut by Alberto Savinio.
1986. Illustrated book

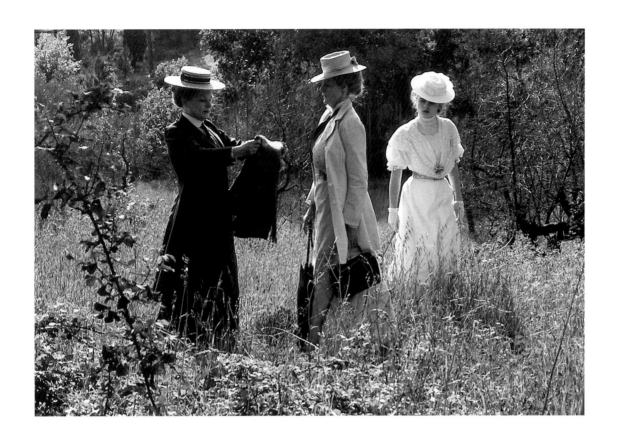

153. James Ivory.
A Room with a View.
1986. Film

154. John Frankenheimer.
52 Pick-Up. 1986. Film

155. **John Baldessari.**
Untitled. 1986. Drawing

156. **Bill Sherwood.**
Parting Glances. 1986. Film

157. Louise Bourgeois.
Articulated Lair. 1986. Sculpture

158. Jeff Koons.
Baccarat Crystal Set.
1986. Sculpture

159. Edward Ruscha.
Jumbo. 1986. Painting

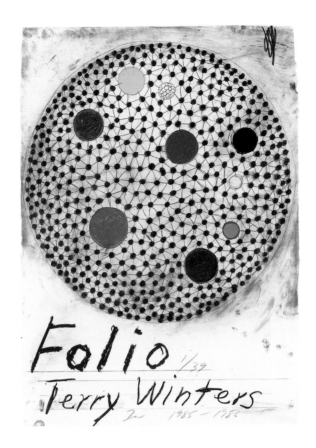

160. Terry Winters.
Folio. 1985–86. Prints

161. Robert Breer.
Bang! 1986. Animated film

162. Frank Gehry.
Fishdance Restaurant,
Kobe, Japan. c. 1986.
Architectural drawing

163. Frank Gehry.
Winton Guest House,
Wayzata, Michigan.
1983–86.
Architectural model

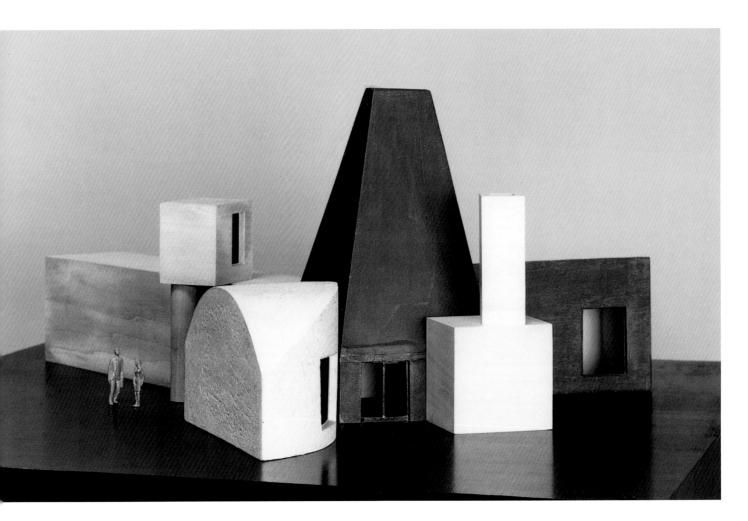

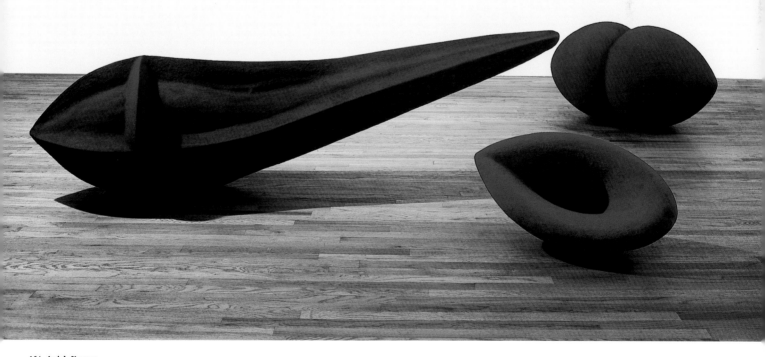

164. Anish Kapoor.
A Flower, A Drama Like Death.
1986. Sculpture

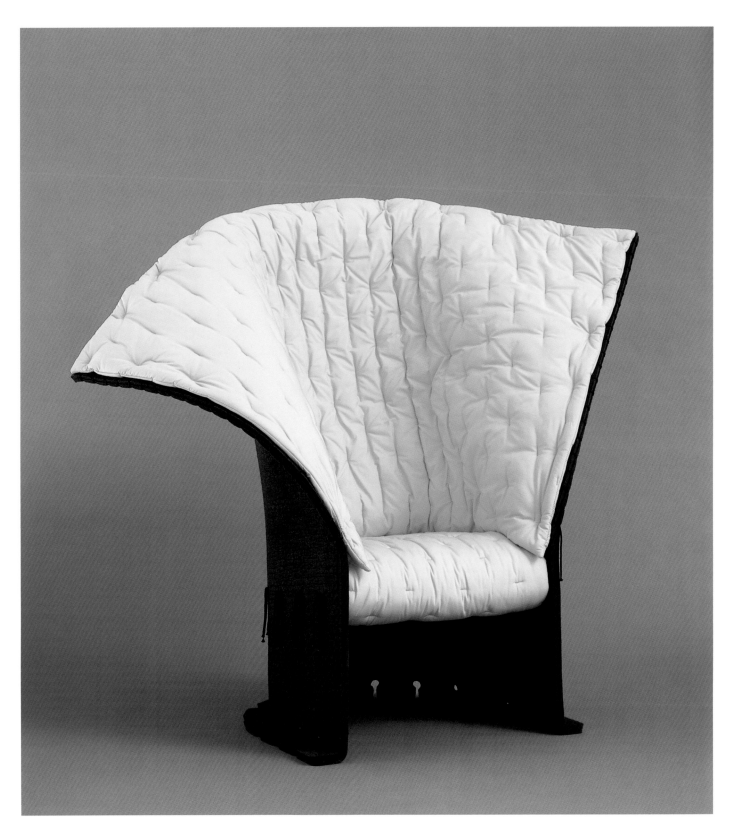

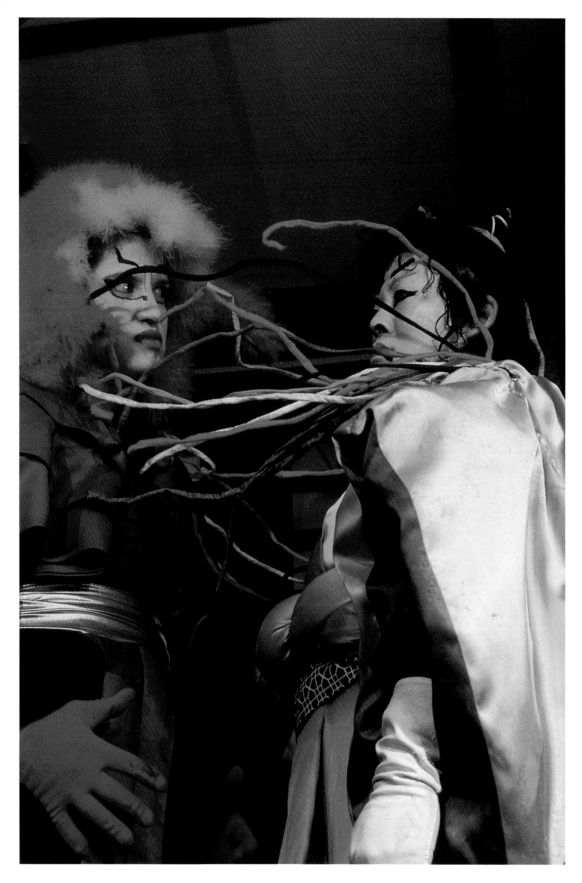

opposite:
165. Gaetano Pesce.
Feltri Chair. 1986. Design

right:
166. Janice Findley.
Beyond Kabuki. 1986. Film

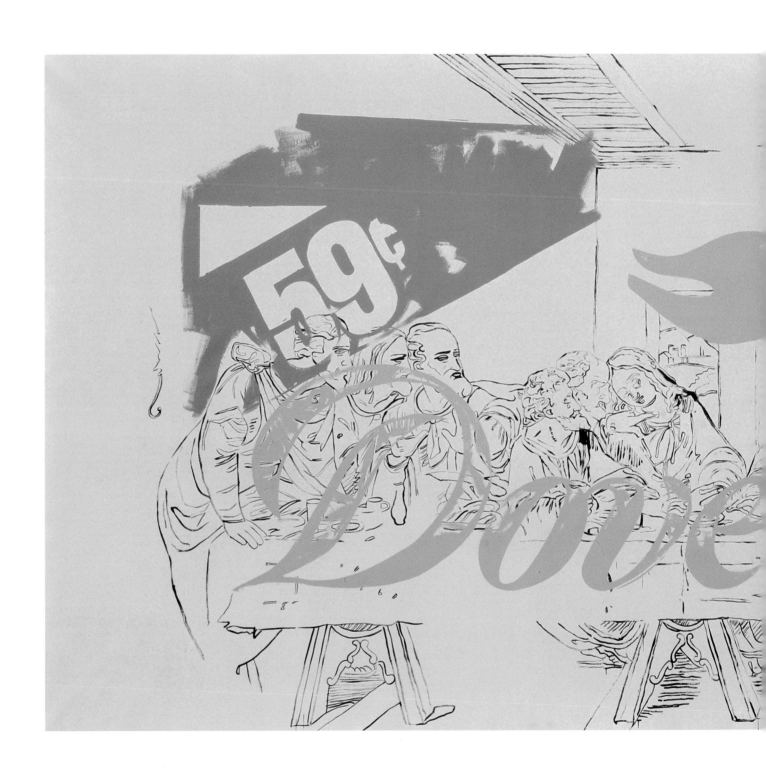

167. Andy Warhol.
The Last Supper. 1986. Painting

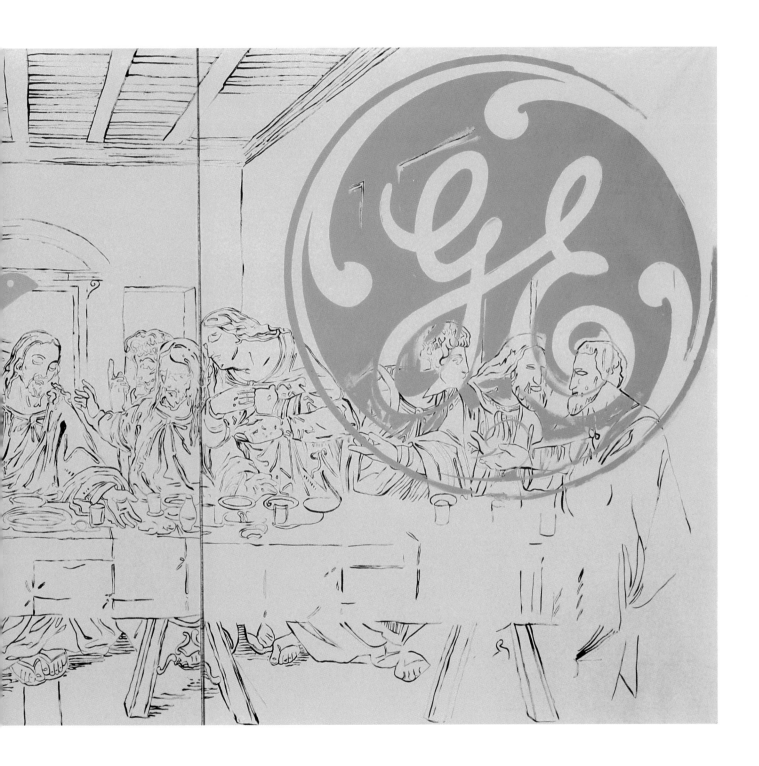

168. Clint Eastwood.
Heartbreak Ridge.
1986. Film

169. Oliver Stone.
Platoon. 1986. Film

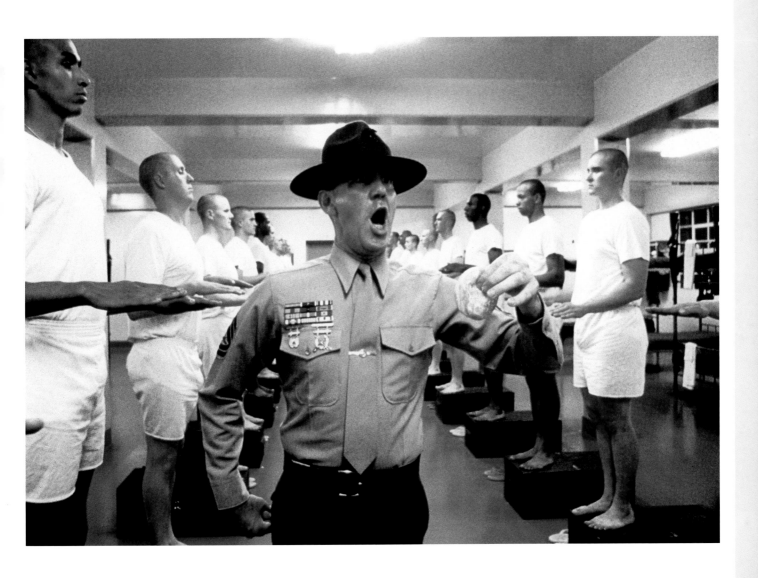

170. Stanley Kubrick.
Full Metal Jacket. 1987. Film

171. David Wojnarowicz.
Fire. 1987. Painting

172. Bruce Nauman.
Dirty Story. 1987.
Video installation

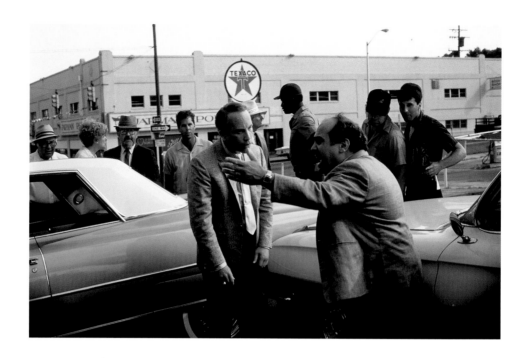

173. Barry Levinson.
Tin Men. 1987. Film

174. Jeffrey Scales.
12:54, A. Philip Randolph
Square. 1987. Photograph

175. Abigail Child.
Mayhem. 1987. Film

176. George Kuchar.
Creeping Crimson. 1987. Video

177. Nikita Mikhalkov.
Dark Eyes. 1987. Film

**178. Paolo Taviani and
Vittorio Taviani.**
Good Morning Babylon.
1987. Film

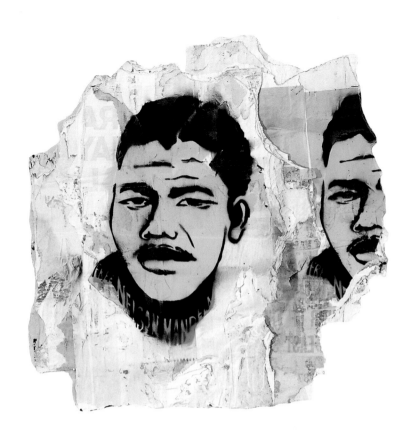

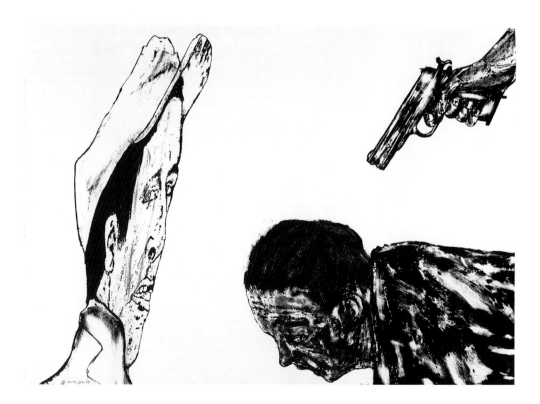

179. David Hammons.
Free Nelson Mandela.
1987. Print

180. Leon Golub.
White Squad. 1987. Print

opposite:
181. Christopher Wilmarth.
Self-Portrait with Sliding Light.
1987. Sculpture

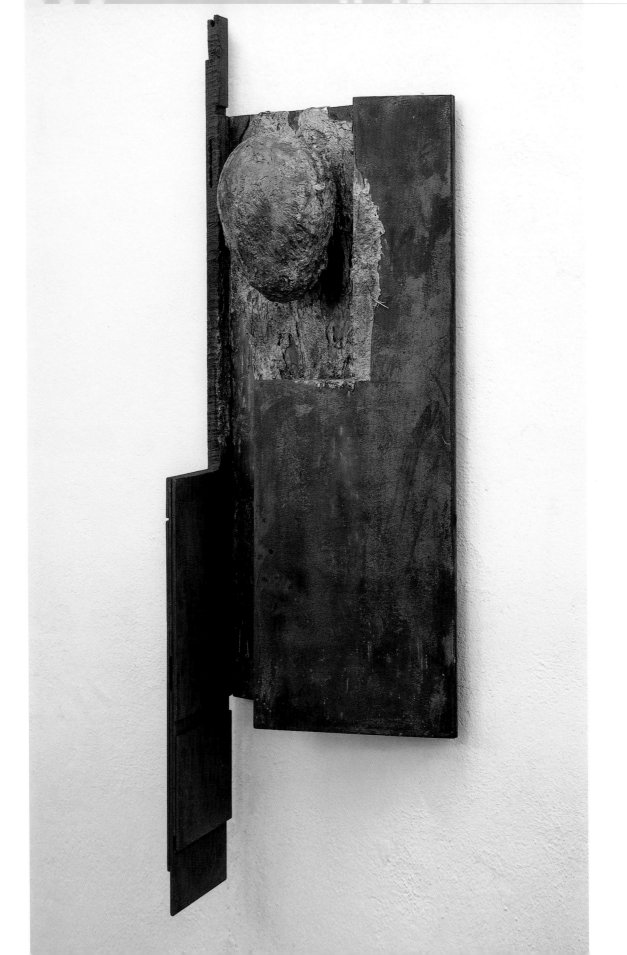

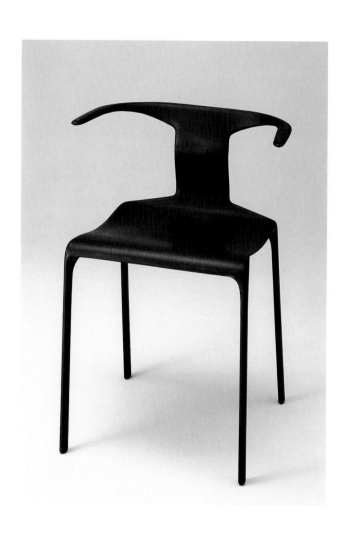

182. Alberto Meda.
Light Light Armchair.
1987. Design

183. Eric Fischl.
Portrait of a Dog.
1987. Painting

184. Tina Barney.
Sheila and Moya. 1987.
Photograph

185. Jac Leirner.
Lung. 1987. Sculpture

186. Tony Cragg.
Oersted Sapphire.
1987. Sculpture

187. Frank Gehry.
Bubbles Lounge Chair.
1987. Design

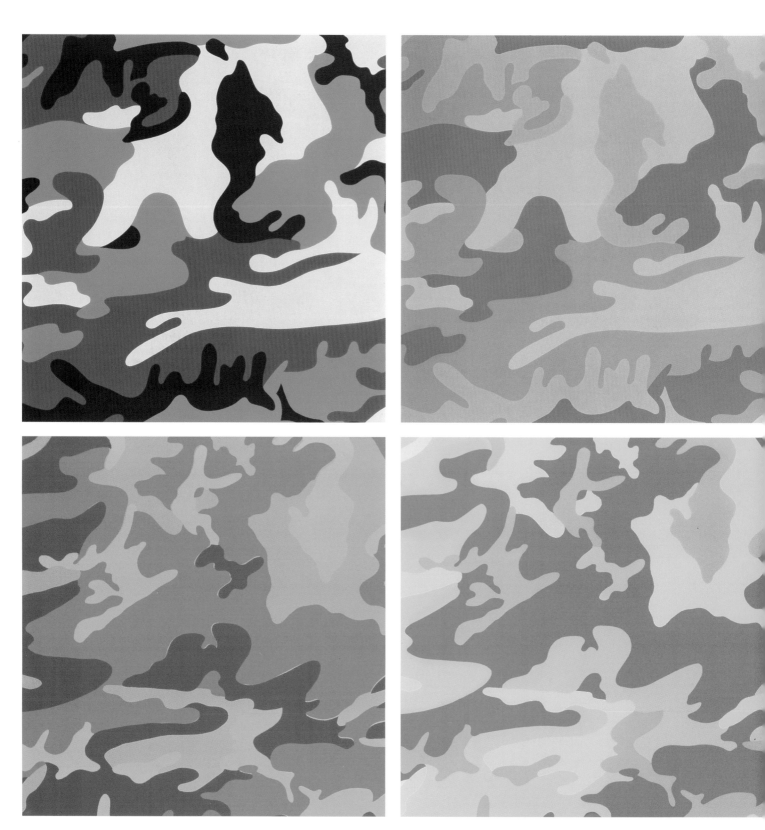

188. Andy Warhol.
Camouflage. 1987. Prints

189. Nathaniel Dorsky.
Alaya. 1976–87. Film

190. Mary Lucier.
Ohio at Giverny: Memory
of Light. 1987. Video

191. Anish Kapoor.
Untitled (Red Leaf).
1987. Drawing

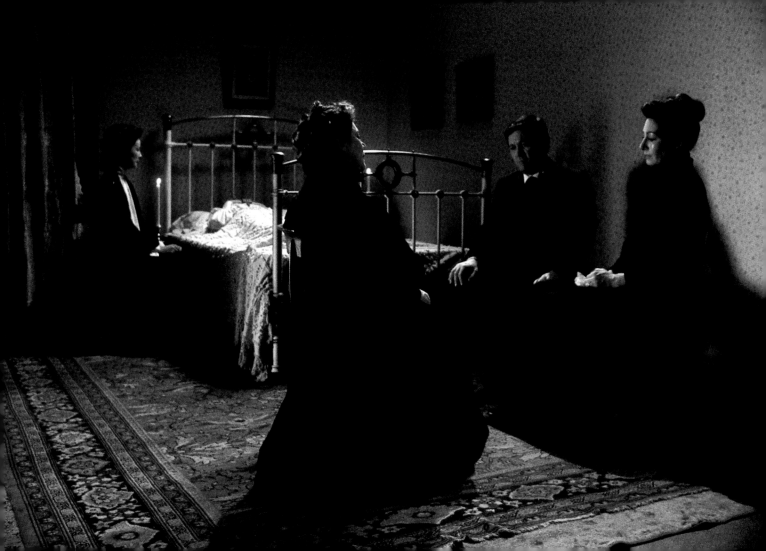

193. John Boorman.
Hope and Glory. 1987. Film

194. Aleksandr Askoldov.
The Commissar. 1967–87. Film

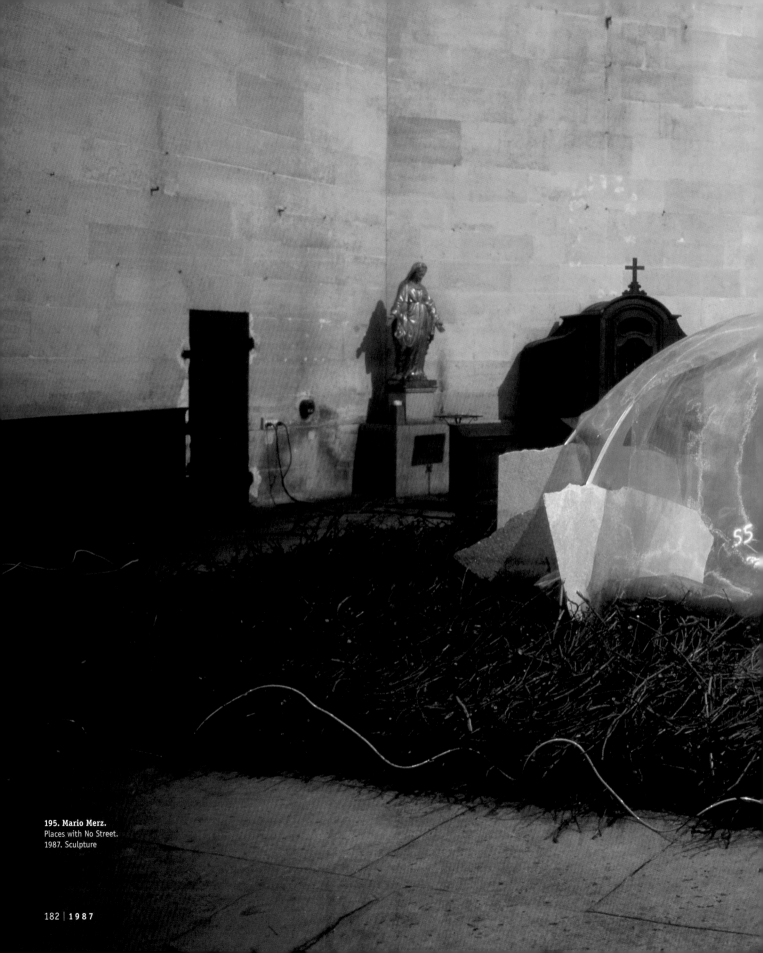

195. Mario Merz.
Places with No Street.
1987. Sculpture

196. Office for Metropolitan Architecture. City Hall Competition, the Hague, the Netherlands. 1987. Architectural drawing

opposite:
197. Wolfgang Laib. The Passageway. 1988. Sculpture

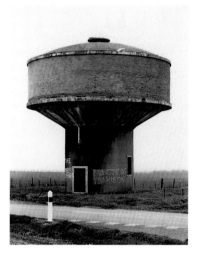

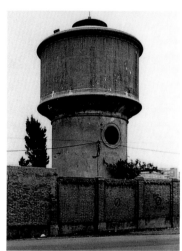
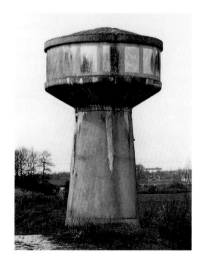
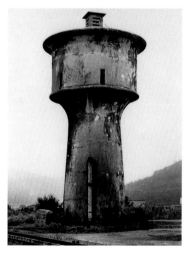
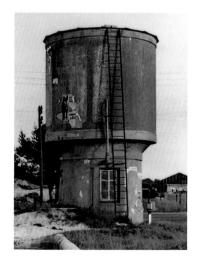

198. Bernd and Hilla Becher.
Water Towers. 1988.
Photographs

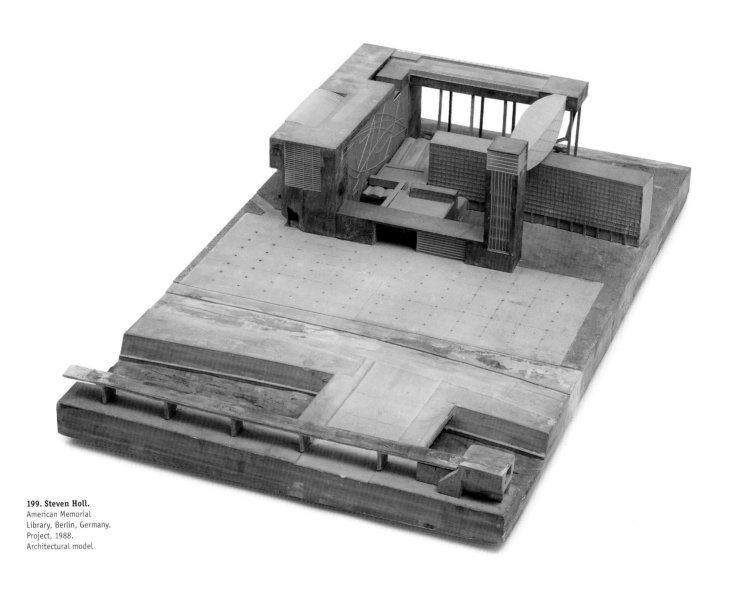

199. Steven Holl.
American Memorial
Library, Berlin, Germany.
Project, 1988.
Architectural model

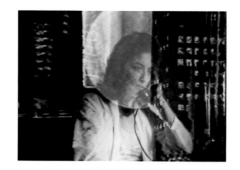

200. Jean-Luc Godard.
Puissance de la parole.
1988. Film

opposite:
201. Christian Boltanski.
The Storehouse (La Grande Reserve).
1988. Sculpture

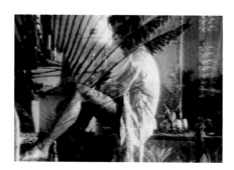

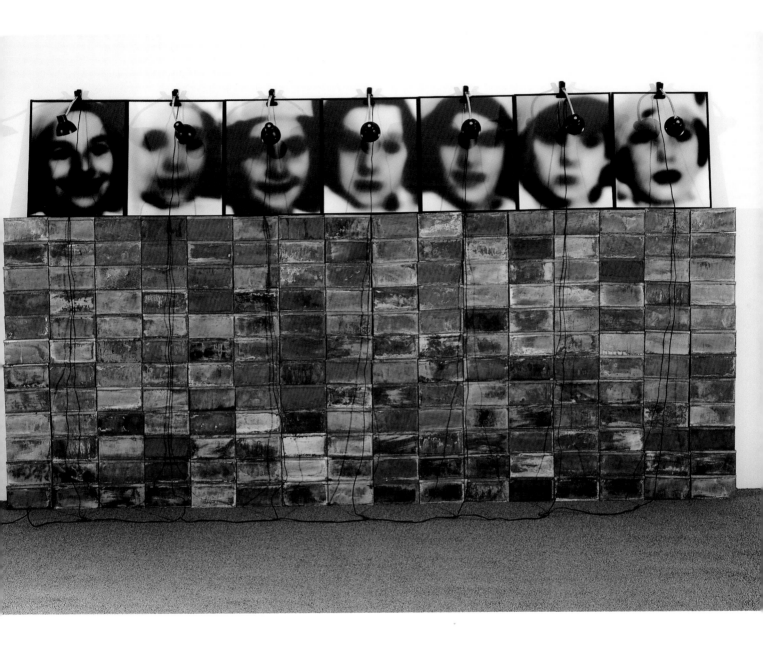

IT'S NOT ART (THAT COUNTS NOW)

ARE YOU CRYING?

WHAT SHOULD I DO?

NOSTALGIA 24 HOURS A DAY

GOOD LUCK!

NOTHING ★ NOBODY

EVERYTHING IS OVER

ADULTS O·N·L·Y PLEASE

NO I'VE GOT SOMETHING IN MY EYE

Who's afraid of the New Now?

202. Allen Ruppersberg.
Preview. 1988. Prints

opposite:
203. Tadanori Yokoo.
Japanese Society for the
Rights of Authors, Composers,
and Publishers. 1988. Poster

204. David Wojnarowicz.
The Weight of the Earth, Part I.
1988. Photographs

opposite:
205. Ashley Bickerton.
Tormented Self-Portrait (Susie
at Arles). 1987–88. Painting

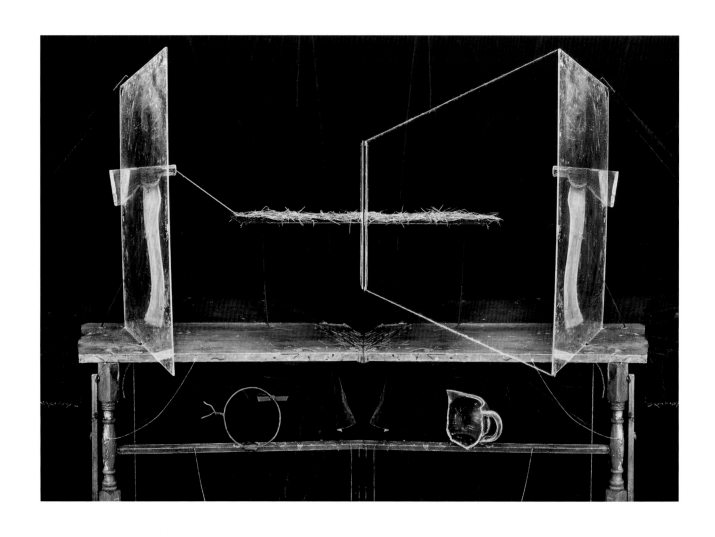

206. Zeke Berman.
Untitled. 1988. Photograph

opposite:
207. Morphosis.
6th Street House Project.
Santa Monica, California.
1987–88. Architectural print

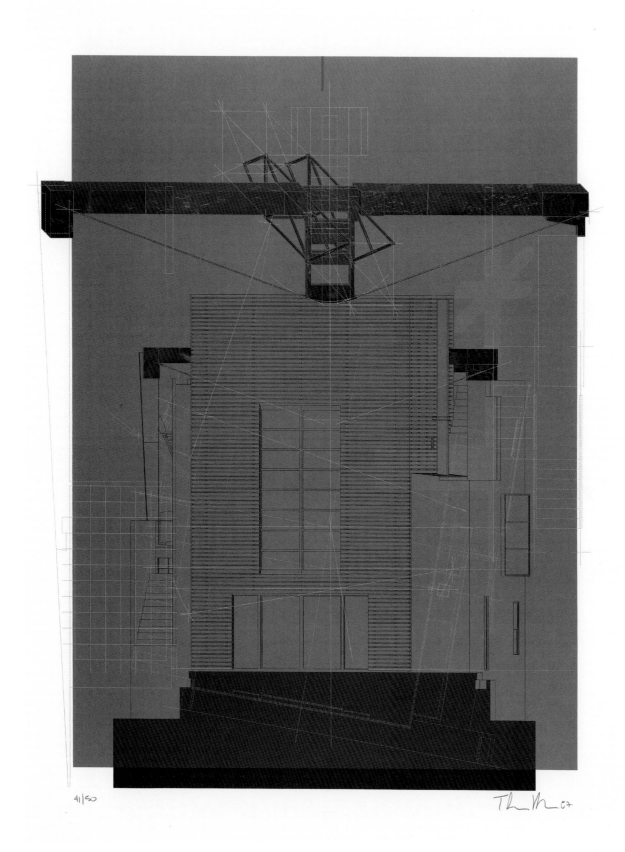

41/50

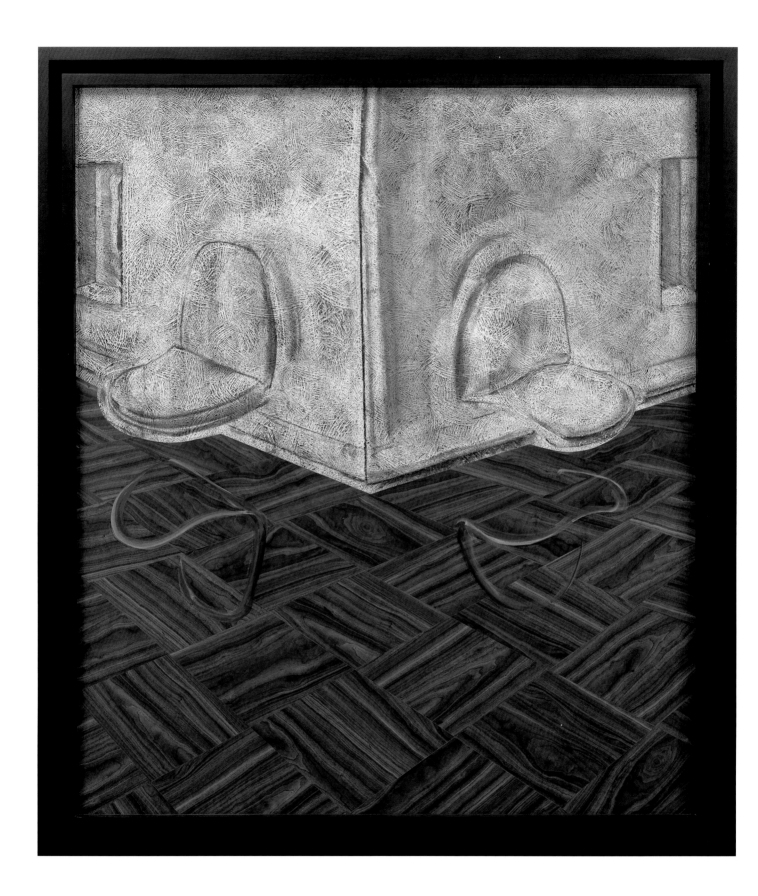

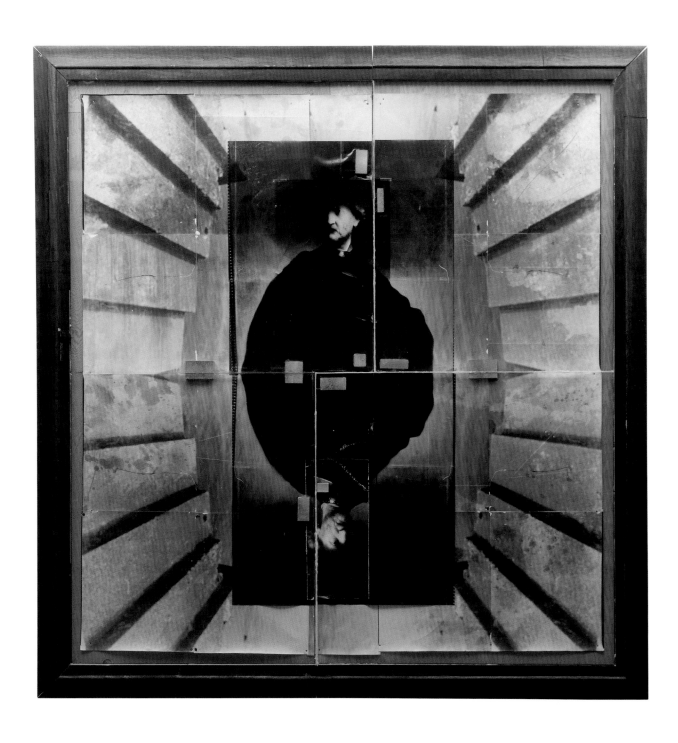

opposite:
208. Richard Artschwager.
Double Sitting. 1988. Painting

209. Mike and Doug Starn.
Double Rembrandt with Steps. 1987–88.
Photographic collage

210. Gerhard Richter.
October 18, 1977. 1988.
Five of fifteen paintings:
Funeral (Beerdigung)

overleaf:
Cell (Zelle); Hanged (Erhängte);
Youth Portrait (Jugendbildnis);
Record Player (Plattenspieler)

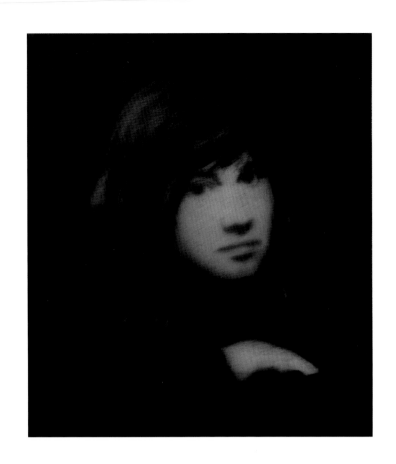

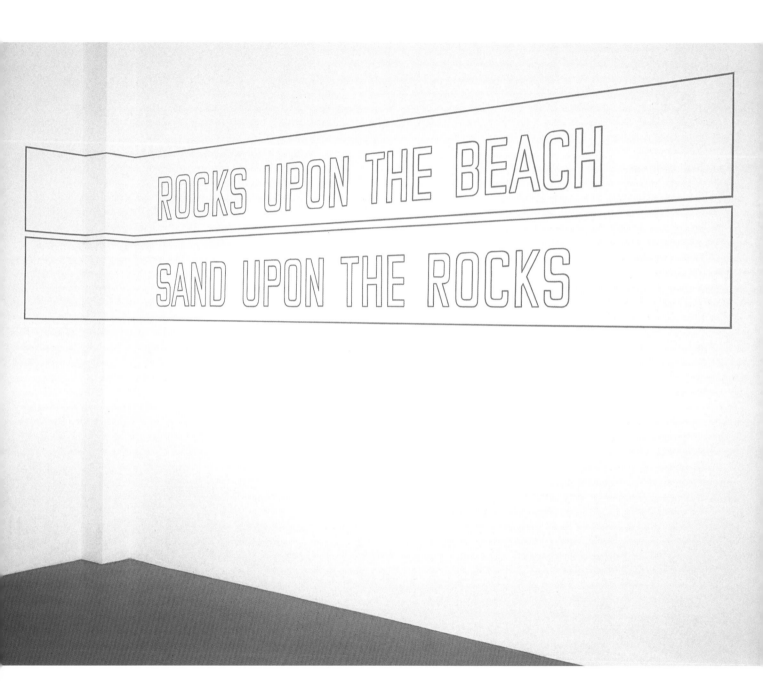

211. **Lawrence Charles Weiner.**
Rocks upon the Beach/Sand upon
the Rocks. 1988. Installation

opposite:
212. **Clint Eastwood.** Bird.
1988. Film

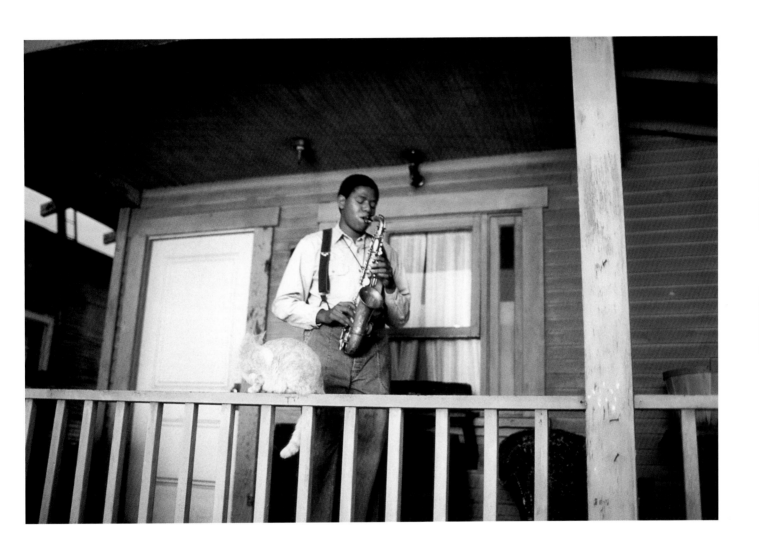

opposite:

213. Bruce Nauman.
Learned Helplessness in
Rats (Rock and Roll Drummer).
1988. Video installation

214. Ilya Kabakov. The Man
Who Flew Into His Picture.
1981–88. Installation

215. **Stephen Peart and Bradford Bissell.** "Animal" Wet Suit. 1988. Design

opposite:
216. **Jeff Koons.** Pink Panther. 1988. Sculpture

217. Günter Förg.
Stairway. 1988.
Photograph

opposite:
**218. Tony Oursler and
Constance DeJong.**
Joyride. 1988. Video

219. Julie Zando.
Let's Play Prisoners.
1988. Video

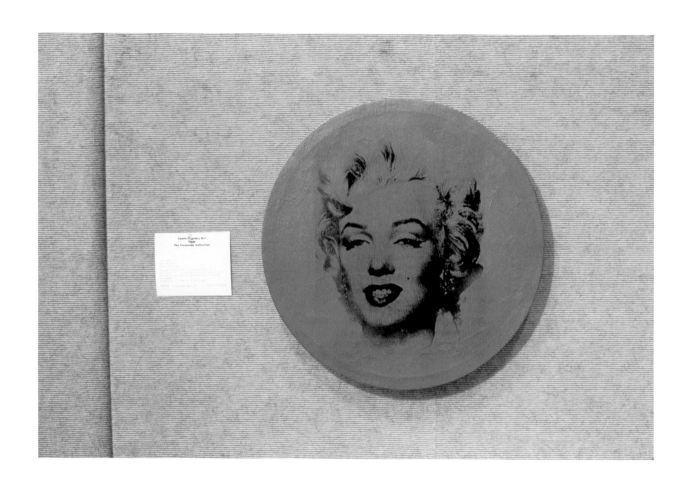

220. Louise Lawler.
Does Andy Warhol Make
You Cry? 1988. Photograph

221. Roy Lichtenstein.
Bauhaus Stairway. 1988.
Painting

222. Matt Mullican.
Untitled. 1988. Prints

223. Martin Kippenberger.
The World of the Canary. 1988.
Drawings

opposite:
224. Marc Newson.
Wood Chair. 1988. Design

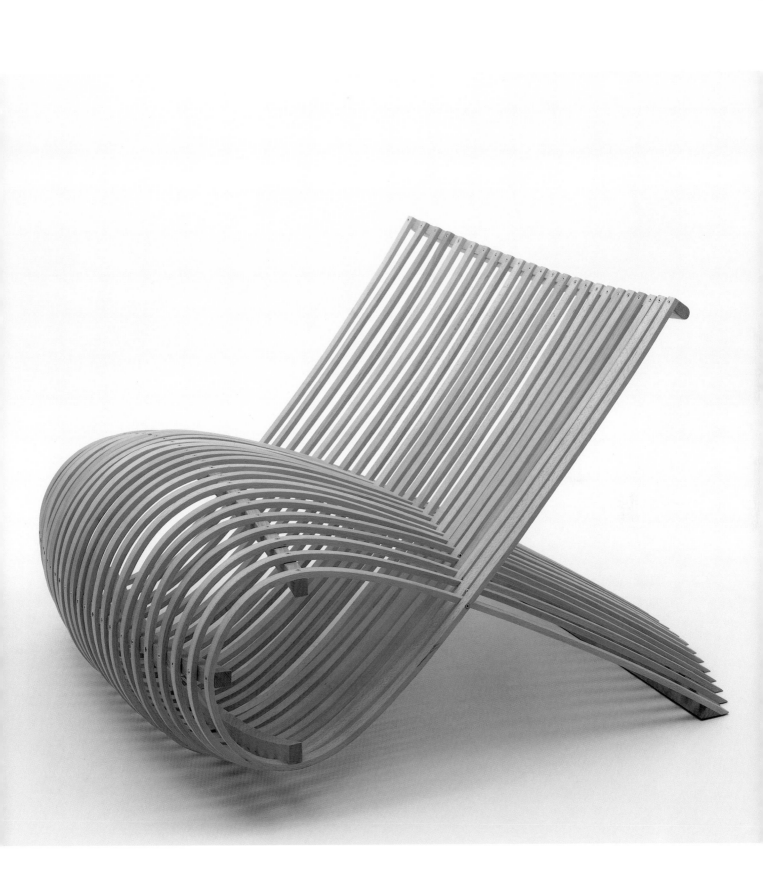

225. Gregory Crewdson.
Untitled from the series Natural
Wonder. 1988. Photograph

226. Adam Fuss.
Untitled. 1988. Photograph

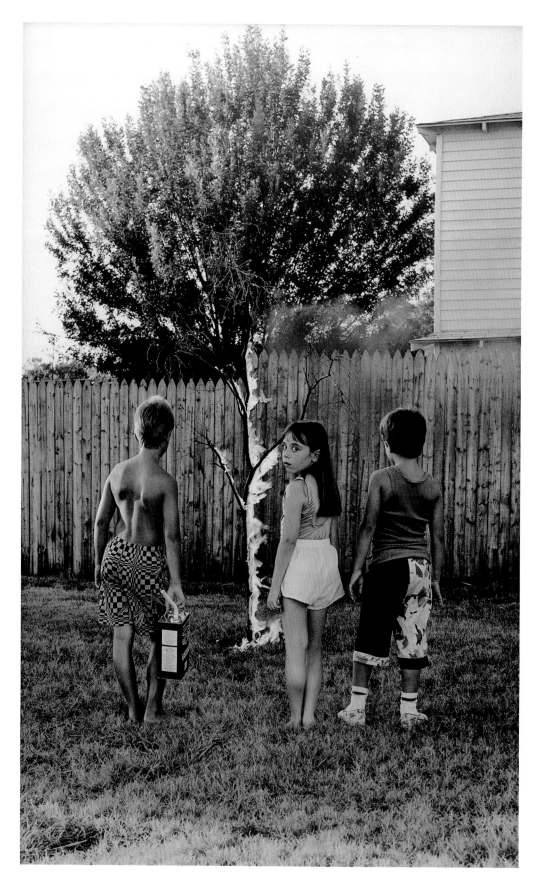

227. **Nic Nicosia.**
Real Pictures #11.
1988. Photograph

opposite:
228. **Paul Thek.**
The Soul Is the Need
for the Spirit. 1988.
Drawing

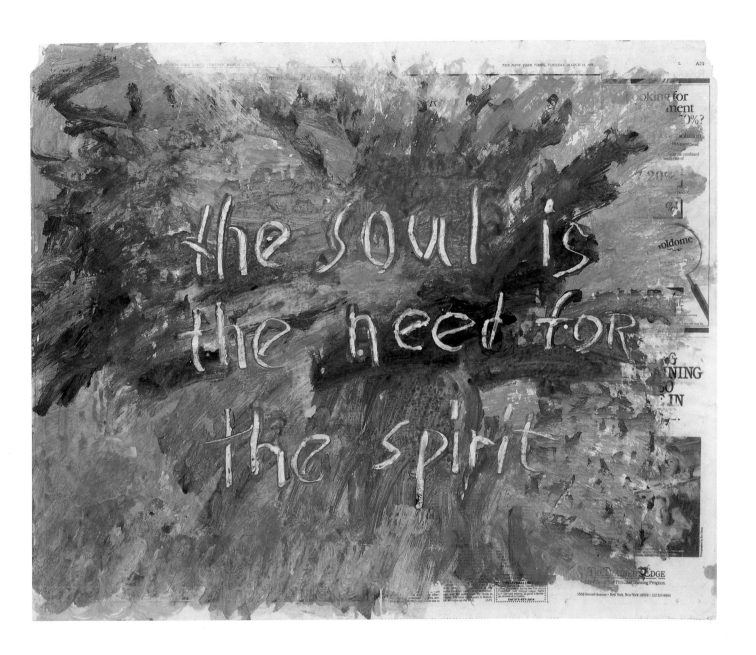

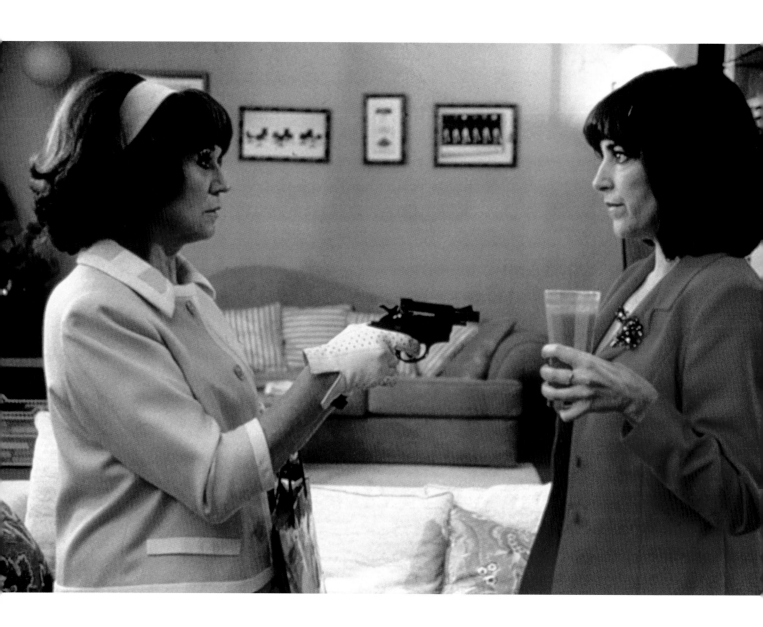

229. Pedro Almodóvar.
Women on the Verge of a
Nervous Breakdown.
1988. Film

opposite:
230. Cindy Sherman.
Untitled #197. 1989.
Photograph

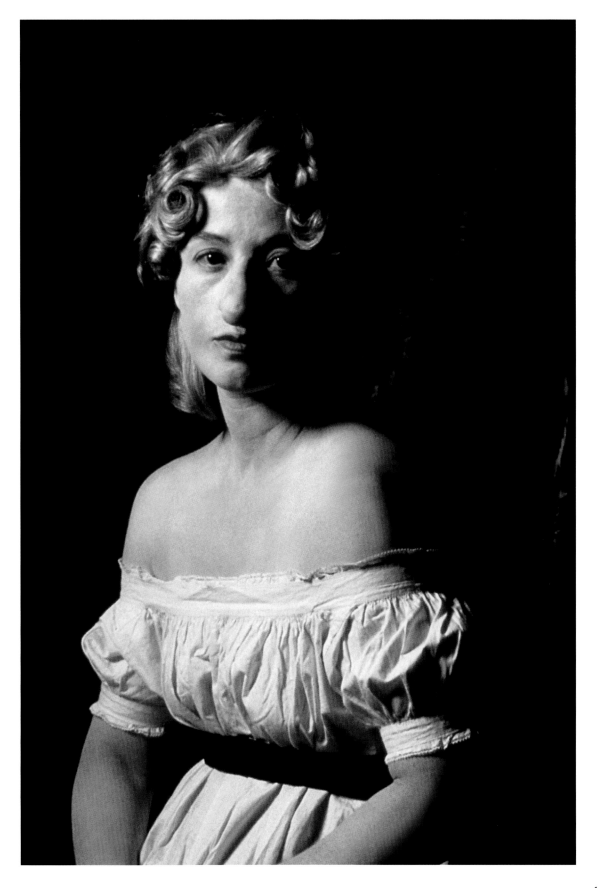

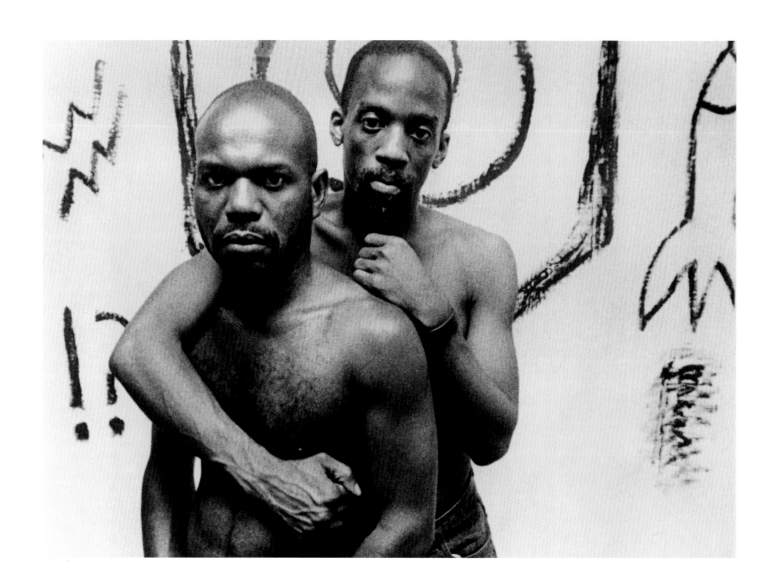

231. Marlon Riggs.
Tongues Untied. 1989. Video

opposite:
232. Martin Scorsese.
The Last Temptation of Christ.
1989. Film

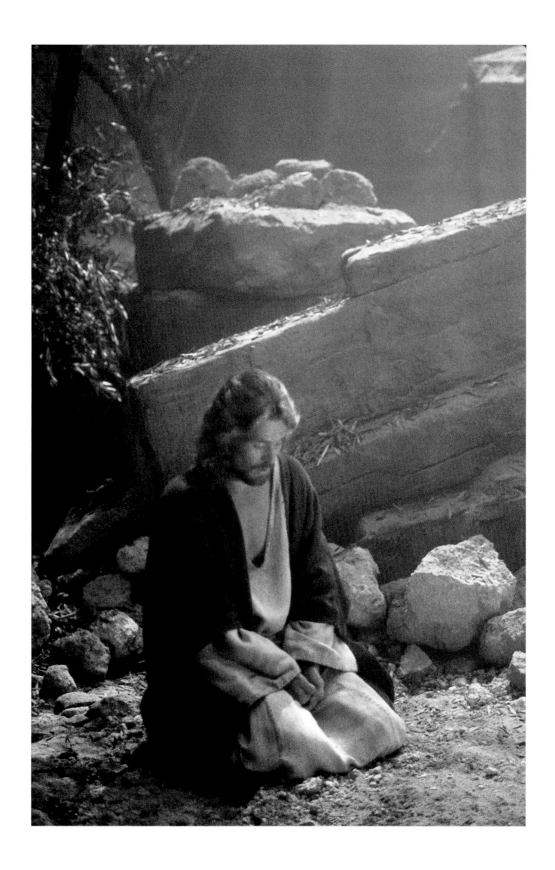

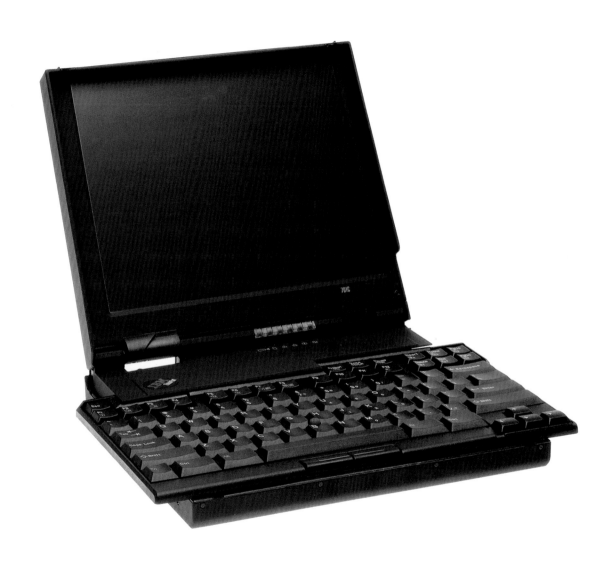

233. **Richard Sapper and
Sam Lucente.** Leapfrog Computer.
1989. Design

opposite:
234. **Thomas Ruff.** Portrait.
1989. Photograph

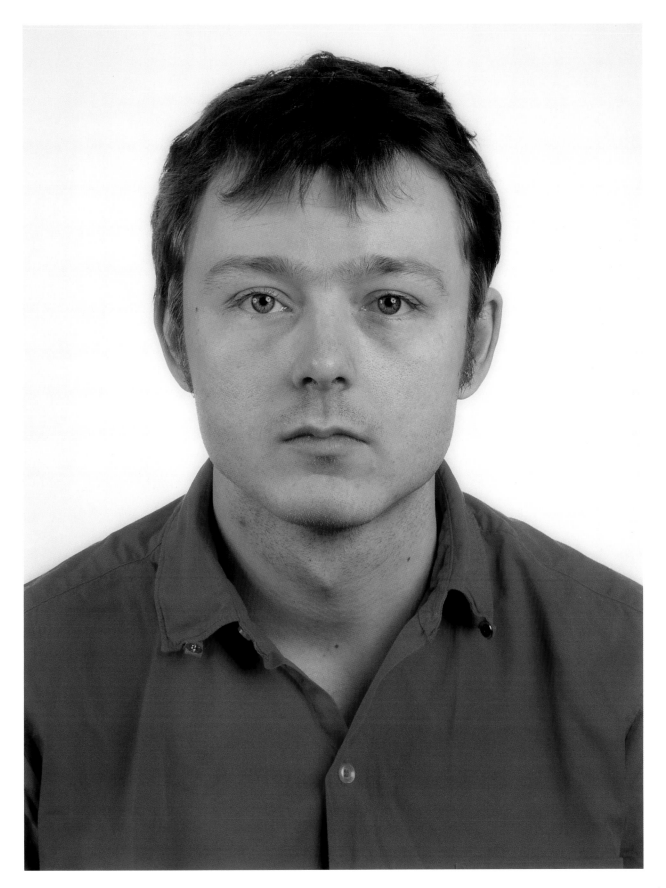

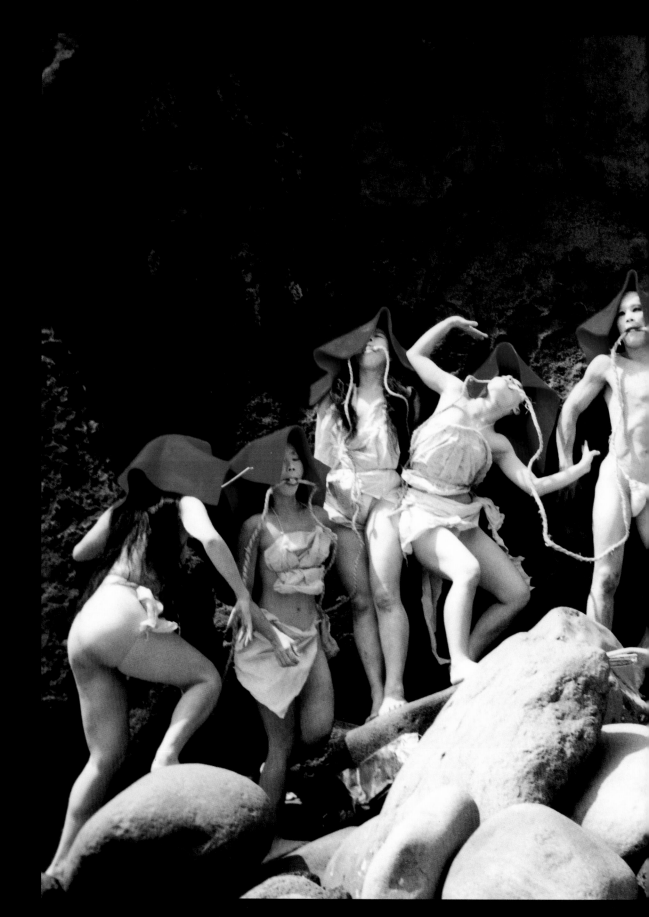

235. Edin Velez.
Dance of Darkness.
1989. Video

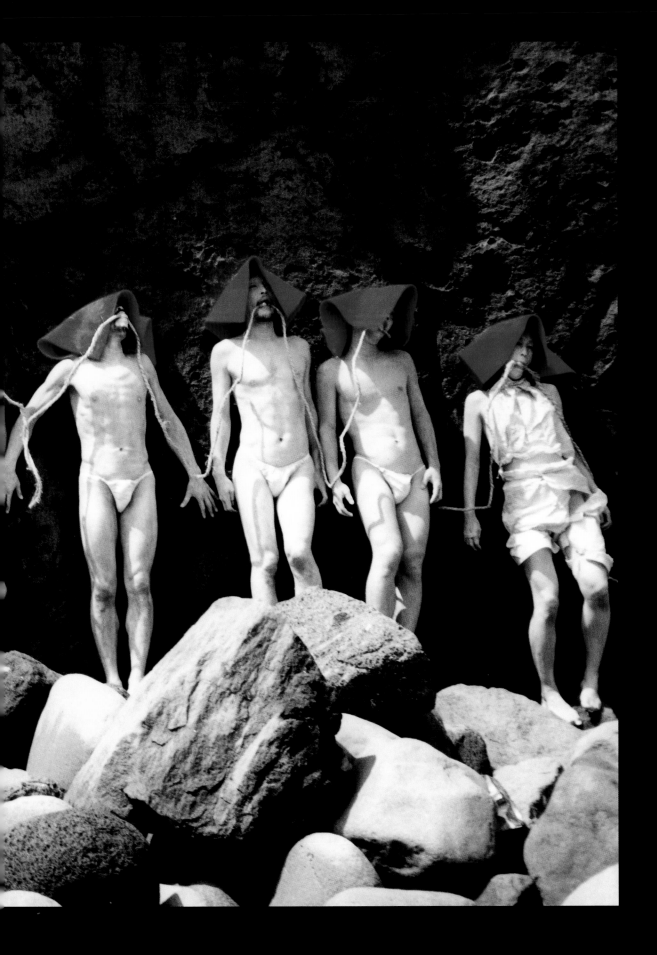

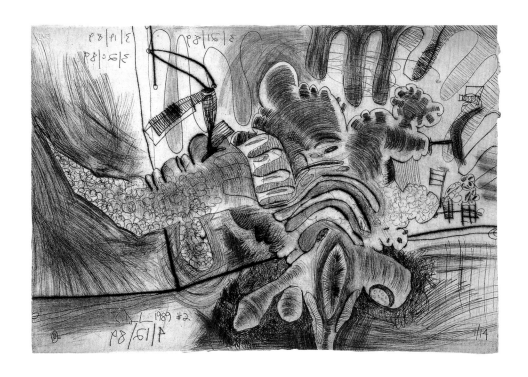

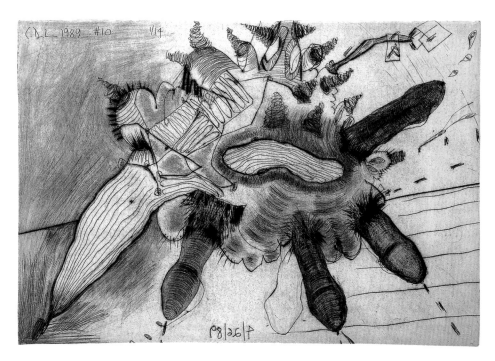

236. Carroll Dunham.
Shadows. 1989. Prints

opposite:
237. Tadanori Yokoo.
Fancydance. 1989. Poster

**238. Elizabeth Diller and
Ricardo Scofidio.** Slow House,
Long Island, New York. 1989.
Architectural model

239. Rafael Viñoly. Tokyo
International Forum, Tokyo, Japan.
1989. Architectural drawing

240. Bruce Nauman.
Model for Animal Pyramid II.
1989. Photographic collage

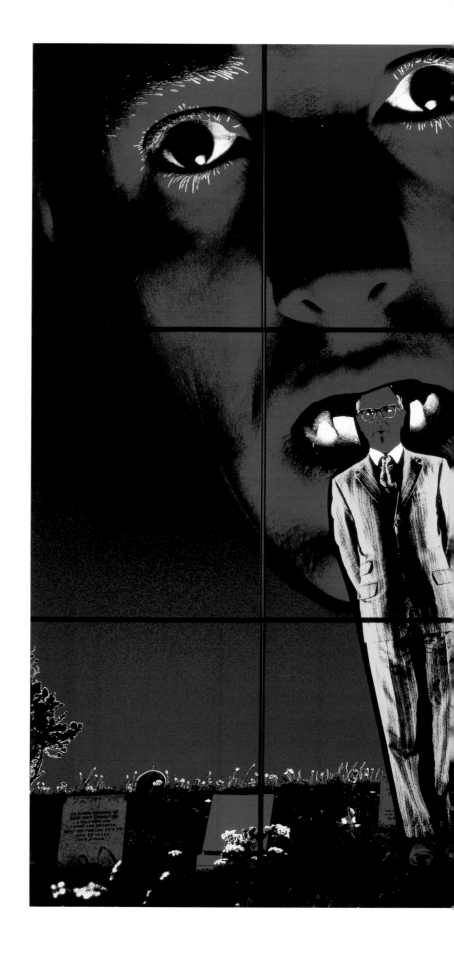

241. Gilbert and George.
Down to Earth. 1989. Painting

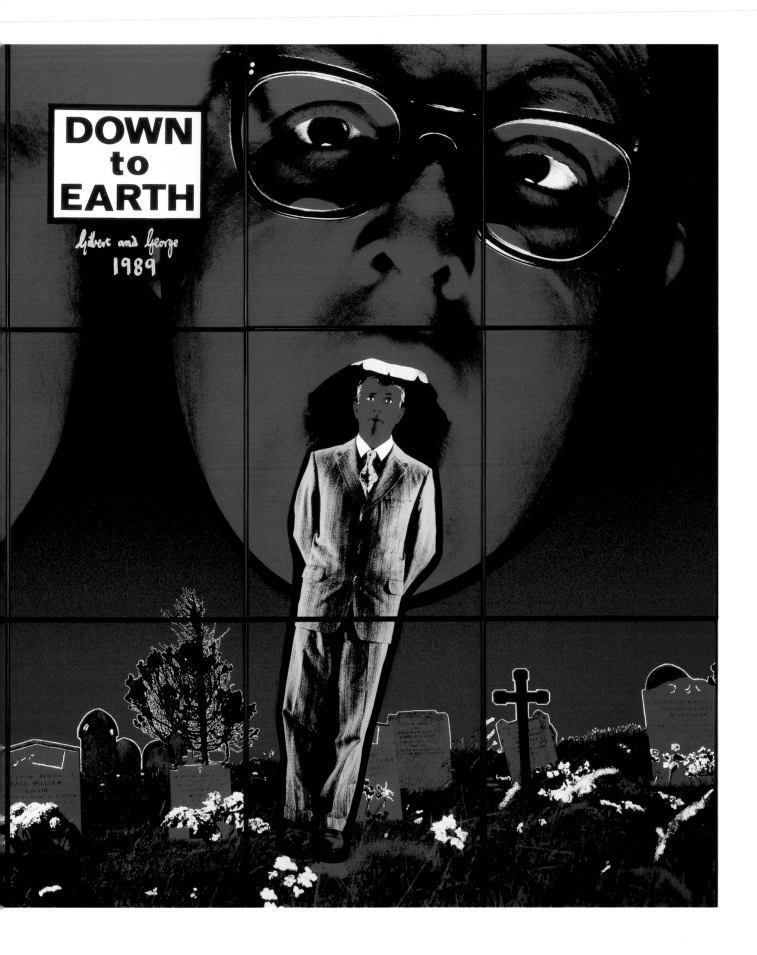

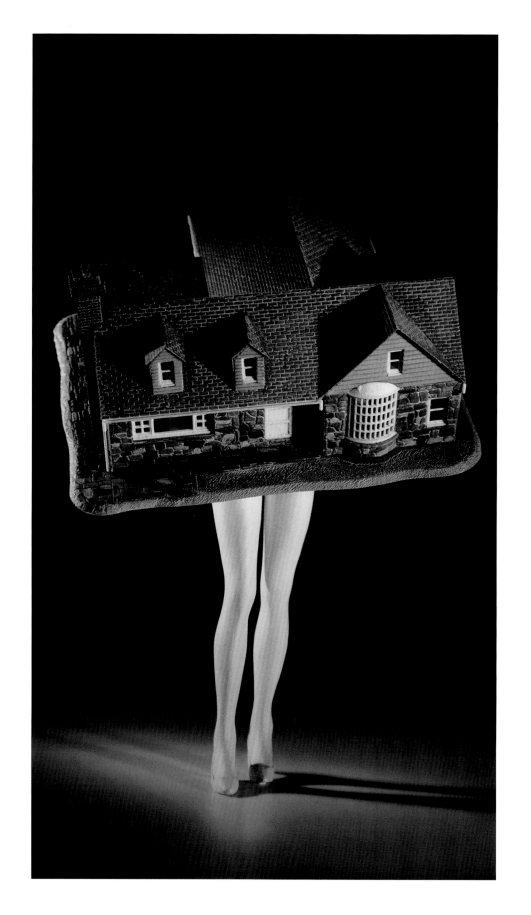

242. **Laurie Simmons.**
Walking House. 1989.
Photograph

opposite:
243. **David Levinthal.**
Untitled from the series
Cowboys. 1989.
Photograph

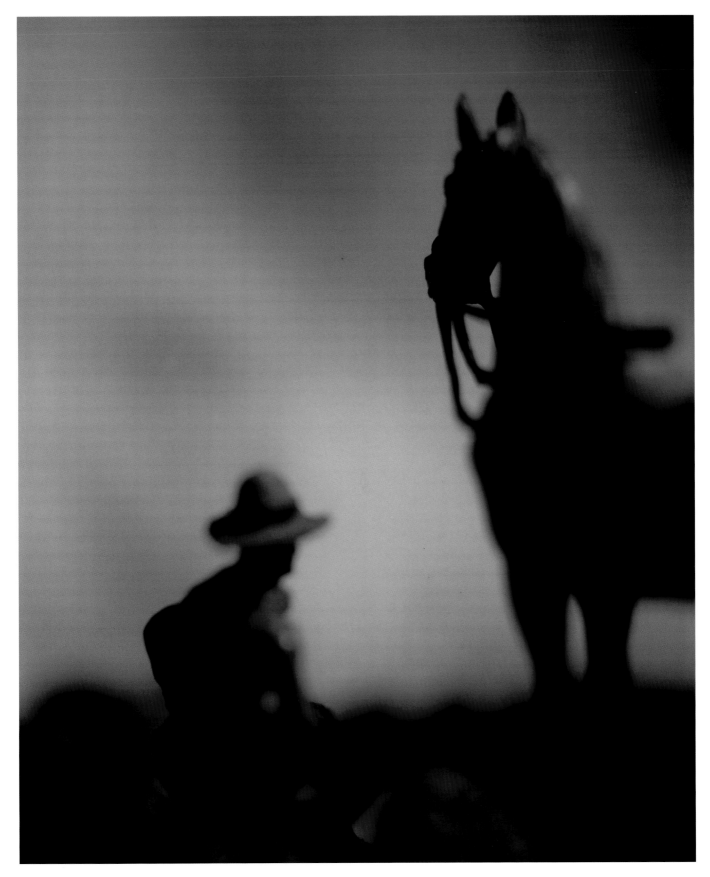

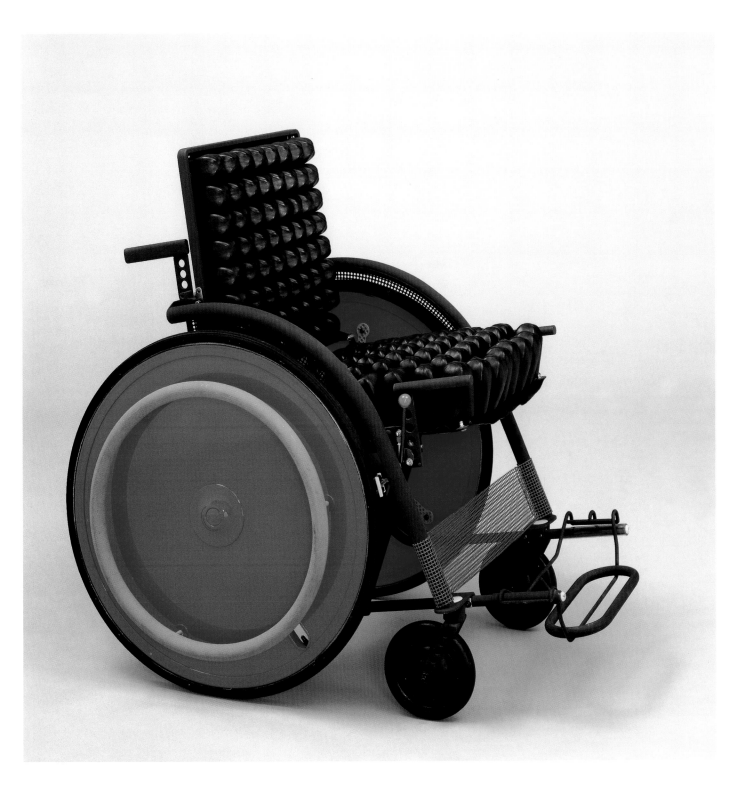

247. Office for Metropolitan Architecture. National Library of France (Très Grande Bibliothèque), Paris. Project, 1989. Architectural model

248. Kazuo Kawasaki. Carna Wheelchair. 1989. Design

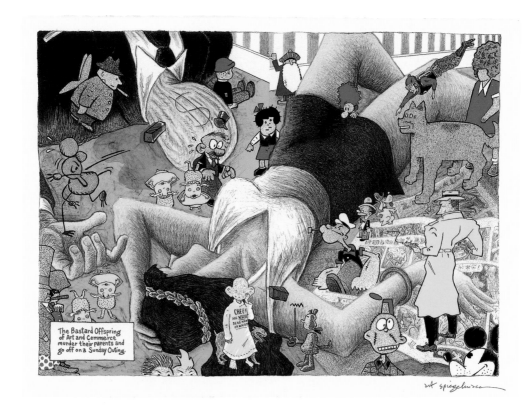

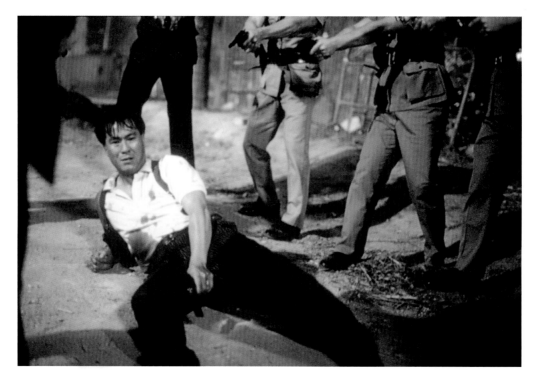

249. Art Spiegelman.
Lead Pipe Sunday. 1989.
Print

250. John Woo.
The Killer. 1989. Film

251. Ida Applebroog.
Chronic Hollow. 1989.
Painting

252. Peggy Ahwesh.
Martina's Playhouse.
1989. Film

opposite:
253. Shiro Kuramata.
Miss Blanche Chair. 1989.
Design

overleaf:
254. Edward Ruscha.
That Is Right and Other
Similarities. 1989. Prints

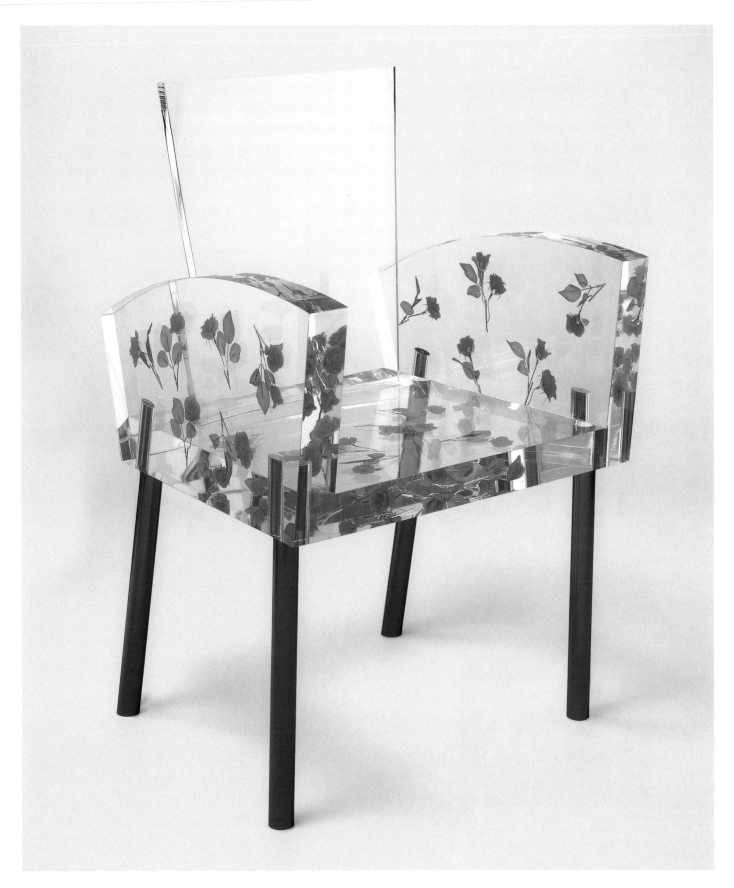

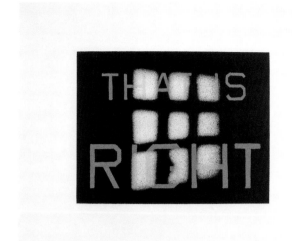

28

28/30 ＥR'89 28/30 ＥR'89

28/30 ＥR'89 28/30 ＥR'89

28/30 ＥR'89 28/30 ＥR'89

28/30 ER'89

28/30 ER'89

28/30 ER'89

28/30 ER'89

28/30 ER'89

28/30 ER'89

255. José Leonilson.
To Make Your Soul Close to Me.
1989. Drawing

256. Sadie Benning.
Me and Rubyfruit. 1989.
Video

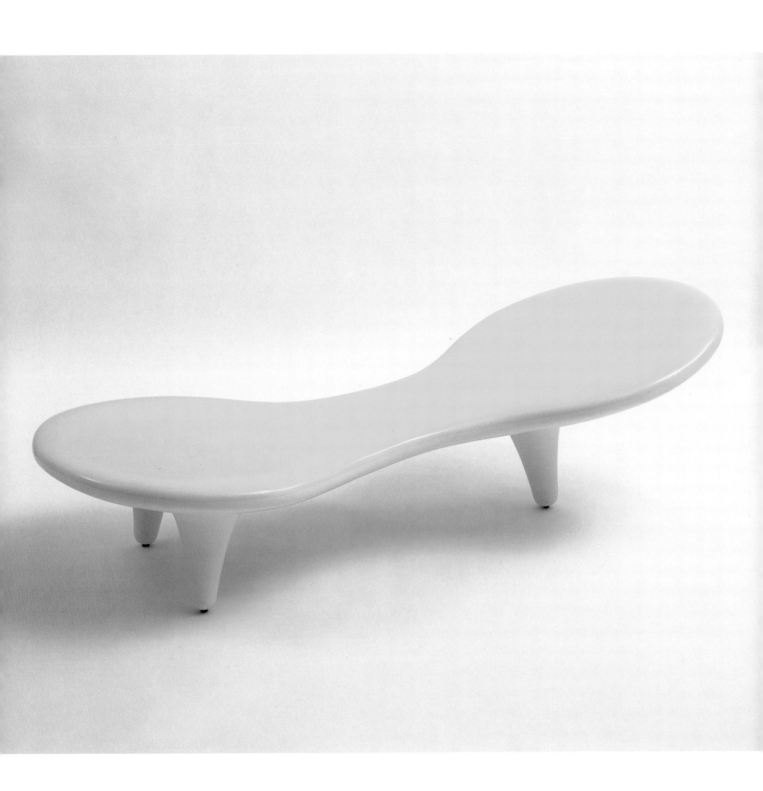

257. Marc Newson.
Orgone Chaise Longue.
1989. Design

258. Joan Jonas.
Volcano Saga. 1989. Video

opposite:
259. Giuseppe Penone.
Thirty-Three Herbs. 1989.
Prints

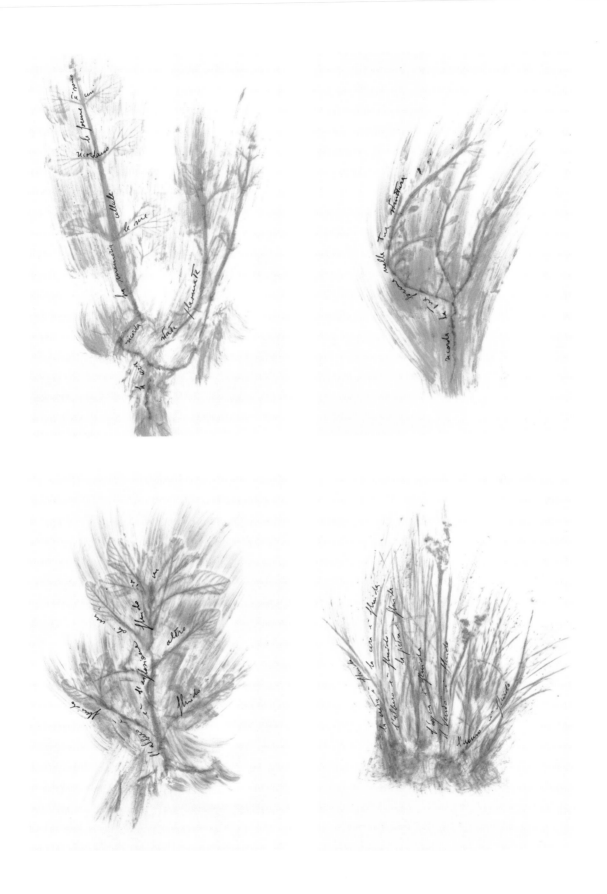

260. Gundula Schulze.
Dresden. 1989. Photograph

261. Martin Parr.
Midsummer Madness,
Conservative Party Social
Event. 1986–89.
Photograph

262. Steina Vasulka.
In the Land of the Elevator Girls.
1989. Video

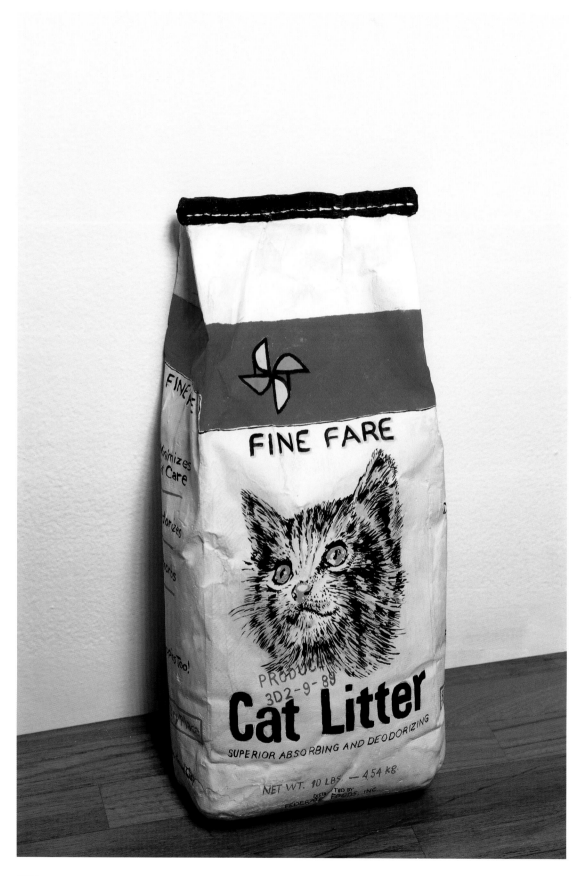

263. Robert Gober.
Cat Litter. 1989. Sculpture

opposite:
264. Thomas Schütte.
Untitled. 1989. Drawings

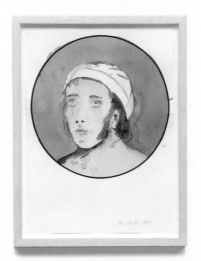

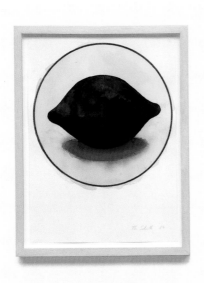

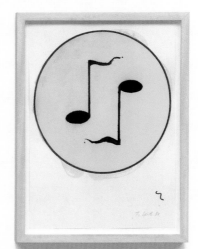

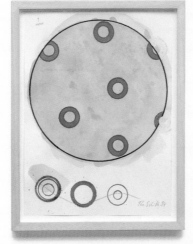

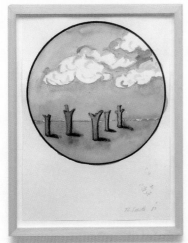

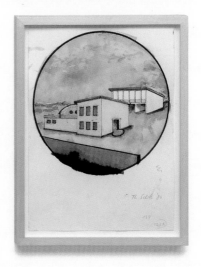

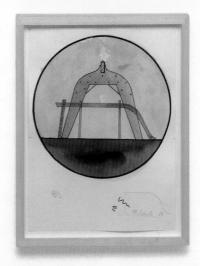

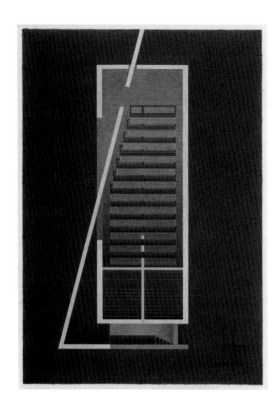

Tadao Ando

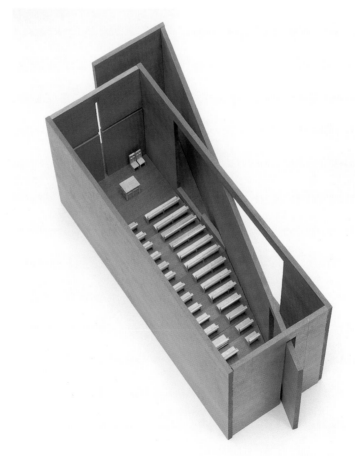

265. Tadao Ando.
Church of the Light,
Ibaraki, Osaka, Japan.
1984–89. Architectural print

266. Tadao Ando.
Church of the Light,
Ibaraki, Osaka, Japan.
1984–89. Architectural drawing

267. Tadao Ando.
Church of the Light,
Ibaraki, Osaka, Japan.
1984–89. Architectural model

opposite:
268. James Lee Byars.
The Table of Perfect. 1989.
Sculpture

269. Steven Holl.
Nexus World Kashii,
Fukuoka, Japan. 1989.
Architectural drawing

opposite:
270. James Turrell.
First Light, Series C.
1989–90. Prints

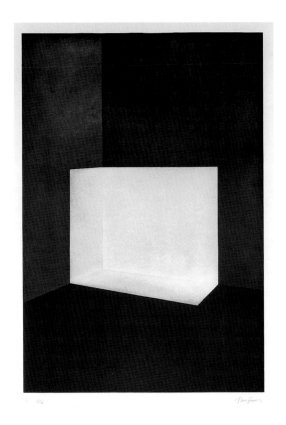
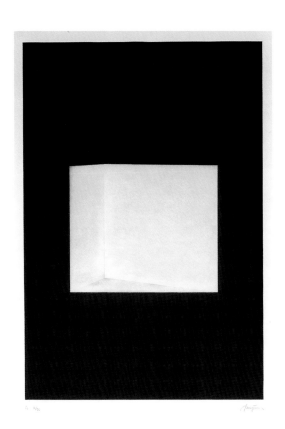
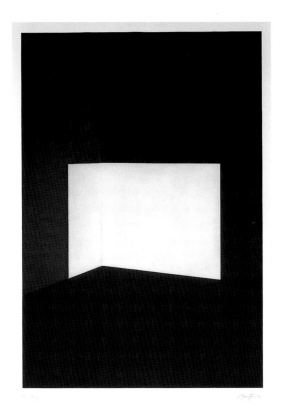
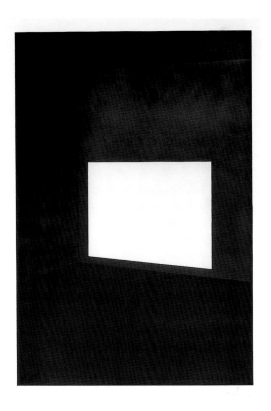

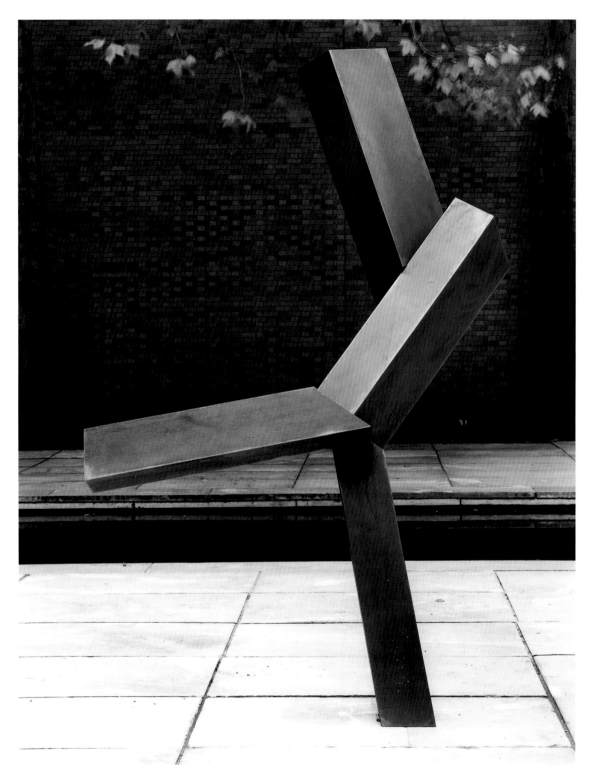

271. Joel Shapiro.
Untitled. 1989–90.
Sculpture

opposite:
272. Steven Holl.
"Edge of a City"
Parallax Towers,
New York. Project,
1990. Architectural
model

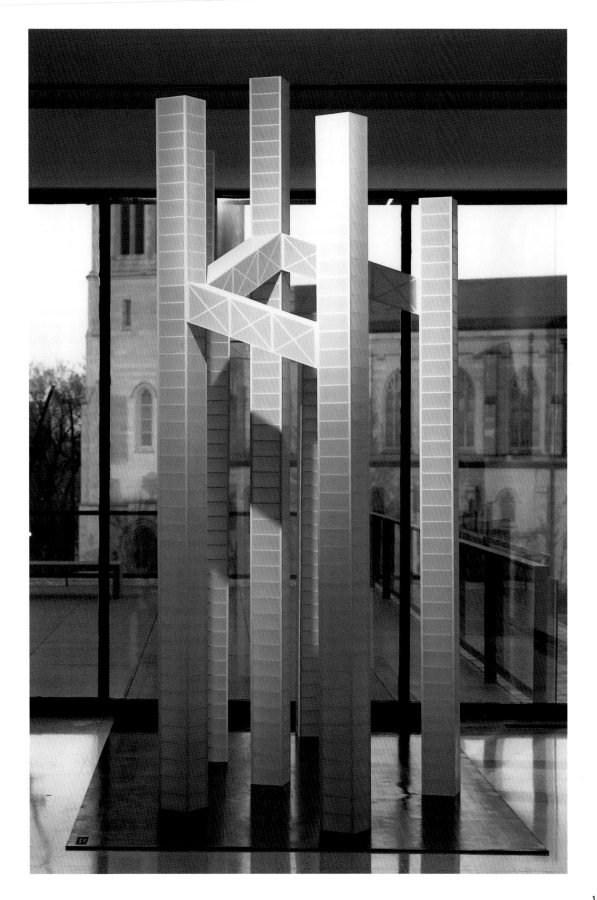

CATS INBAG BAGS IN RIVER

273. Christopher Wool.
Untitled. 1990. Painting

opposite:
274. Martin Kippenberger.
Martin, Stand in the Corner
and Be Ashamed of Yourself.
1990. Sculpture

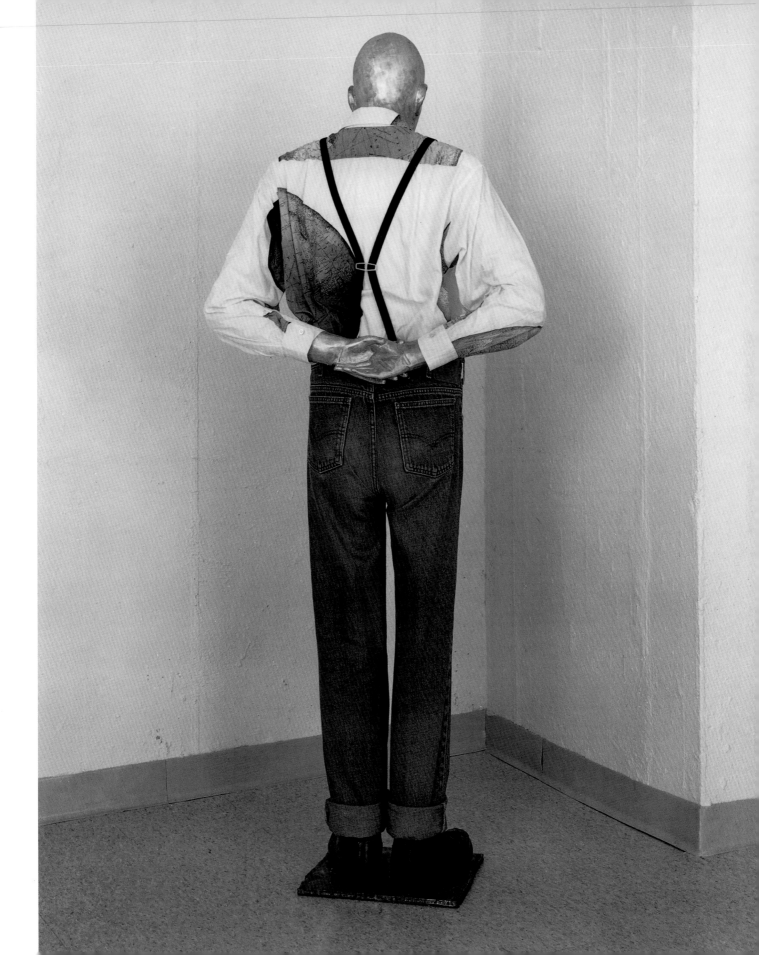

275. John Barnard.
Formula 1 Racing Car 641/2.
1990. Design

276. Gary Hill.
Inasmuch As It Is
Always Already Taking
Place. 1990. Video
installation

277. General Idea.
AIDS projects. 1988–90.
Prints

opposite:
278. Lari Pittman.
Counting to Welcome
One's Defrosting. 1990.
Drawing

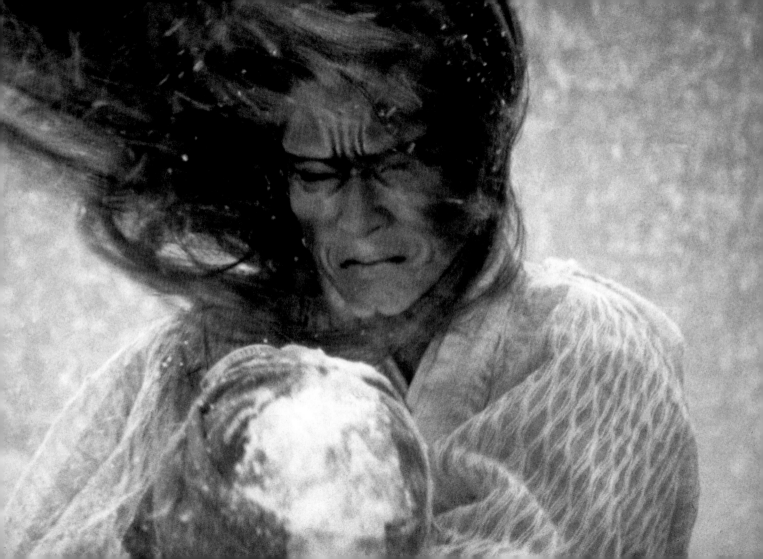

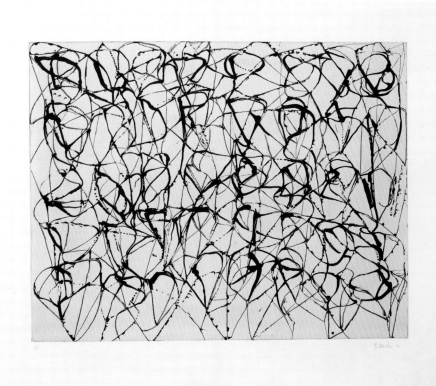

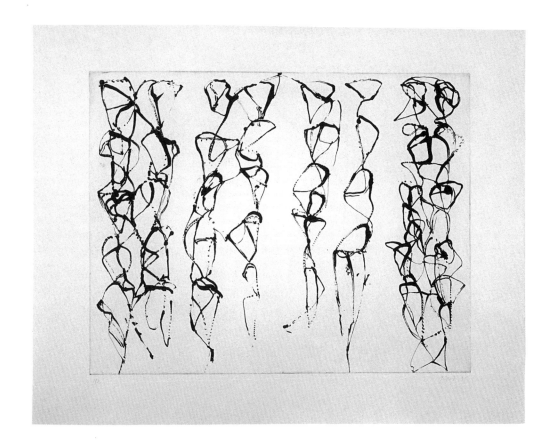

282. Thomas Struth.
Pantheon, Rome. 1990.
Photograph

283. Thomas Struth.
South Lake Apartments 3,
Chicago. 1990. Photograph

284. Thomas Struth.
South Lake Apartments 4,
Chicago. 1990. Photograph

285. Arata Isozaki.
City in the Air: "Ruin of
Hiroshima." Project, 1990.
Architectural print

286. Arata Isozaki.
City in the Air: "Incubation
Process." Project, 1990.
Architectural print

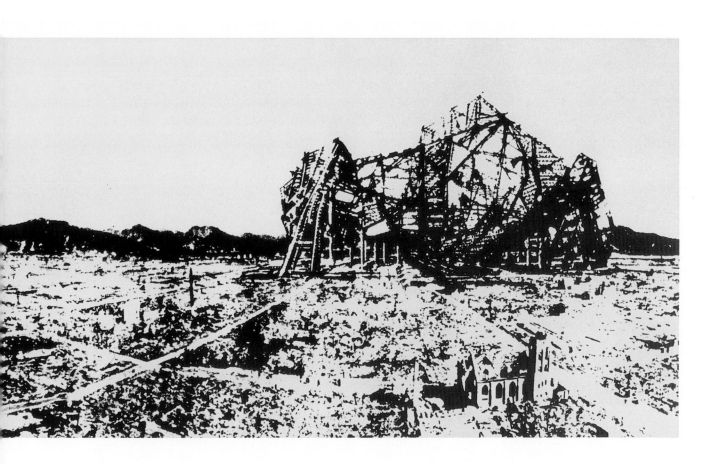

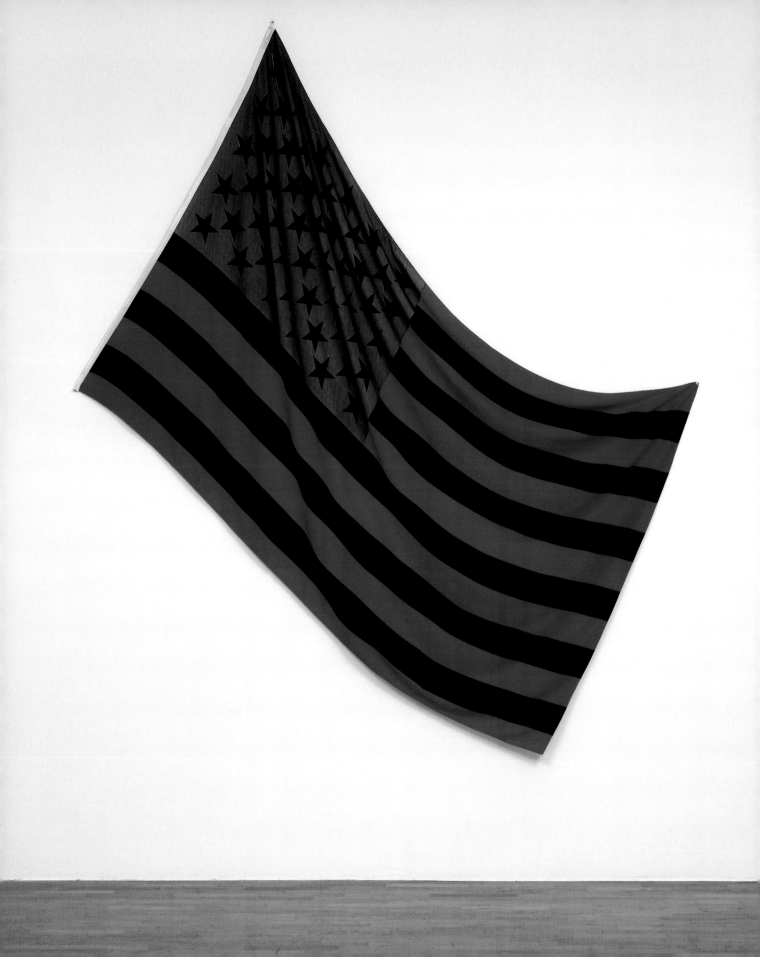

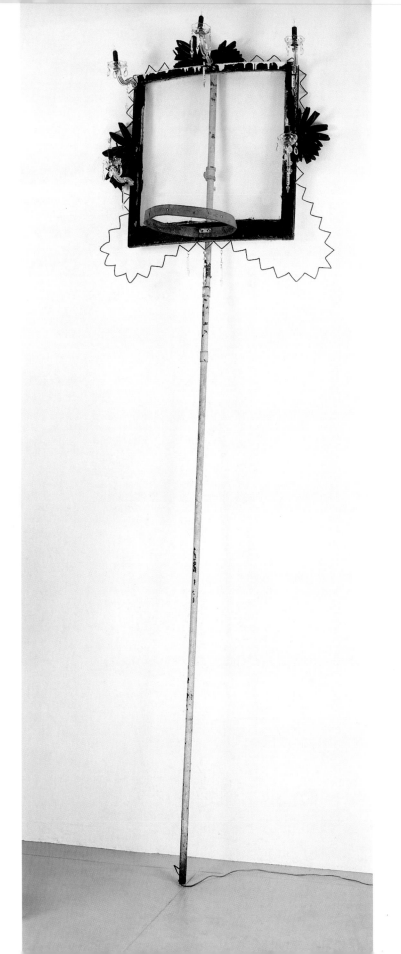

opposite:
287. David Hammons.
African-American Flag.
1990. Fabric object

right:
288. David Hammons.
High Falutin'. 1990. Sculpture

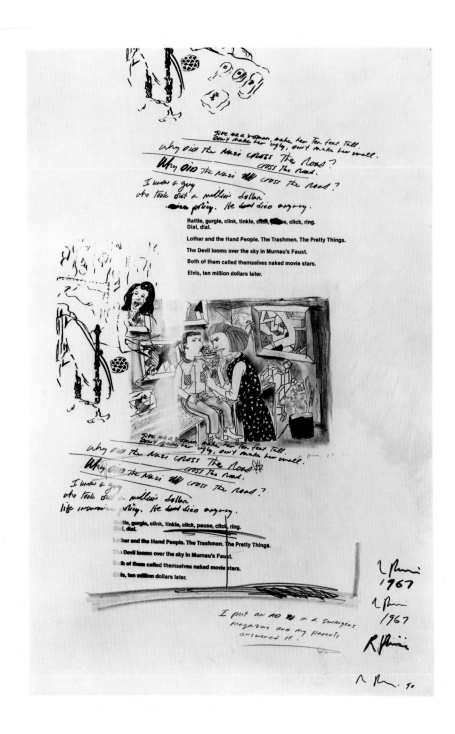

289. Richard Prince.
Untitled. 1984 and 1990.
Drawing

290. Joel Sternfeld.
An Attorney with Laundry,
Bank and Fourth, New York,
New York. 1990. Photograph

291. Yvonne Rainer.
Privilege. 1990. Film

292. **Kiki Smith.**
A Man. 1990. Drawing

293. **Kiki Smith.**
Untitled. 1987–90.
Sculpture

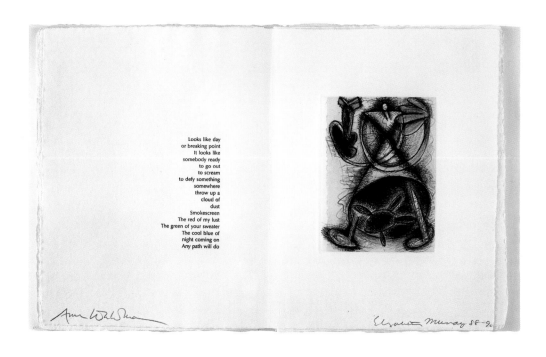

Looks like day
or breaking point
It looks like
somebody ready
to go out
to scream
to defy something
somewhere
throw up a
cloud of
dust
Smokescreen
The red of my lust
The green of your sweater
The cool blue of
night coming on
Any path will do

Cluster in tongue
drives me mad
after all
I say "upstreperous"
I say "Avenue du Clichy"
I want to say Concorde
Stop Here Now

294. Elizabeth Murray.
Her Story by Anne Waldman.
1990. Illustrated book

opposite:
295. Elizabeth Murray.
Dis Pair. 1989–90. Painting

296. Mike Kelley.
Untitled. 1990.
Sculpture

297. John Cage.
Wild Edible Drawing No. 8.
1990. Drawing

298. Bruce Conner.
INKBLOT DRAWING. 1990.
Drawing

299. Office for Metropolitan Architecture. Palm Bay Seafront Hotel and Convention Center, Florida. Project, 1990. Architectural model

300. Felix Gonzalez-Torres.
"Untitled" (Death by Gun). 1990.
Prints

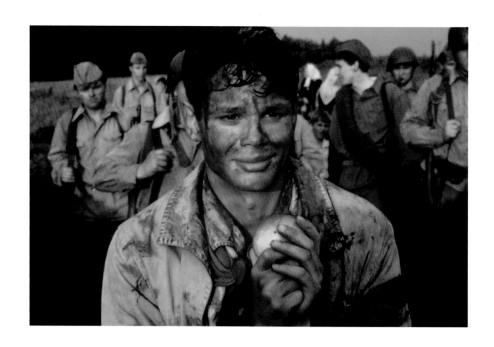

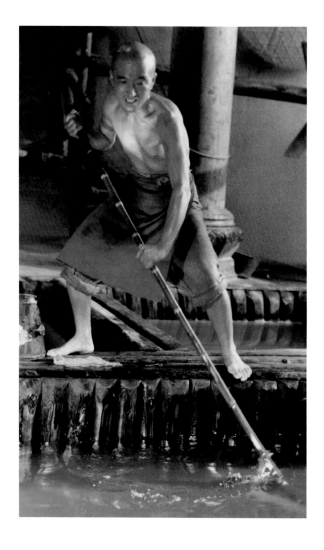

301. Agnieszka Holland.
Europa Europa. 1990. Film

302. Zhang Yimou and Yang Fengliang. Ju Dou. 1990. Film

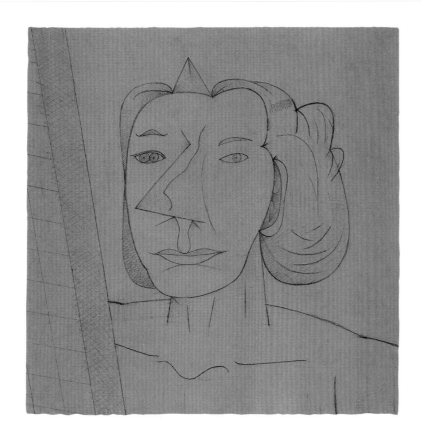

303. Jim Nutt.
Drawing for Fret.
1990. Drawing

304. Stephen Frears.
The Grifters. 1990. Film

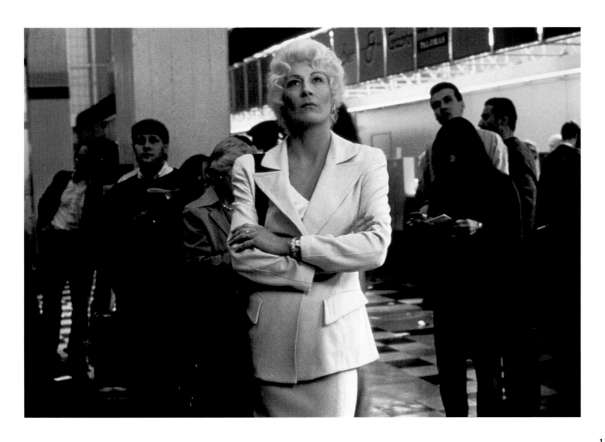

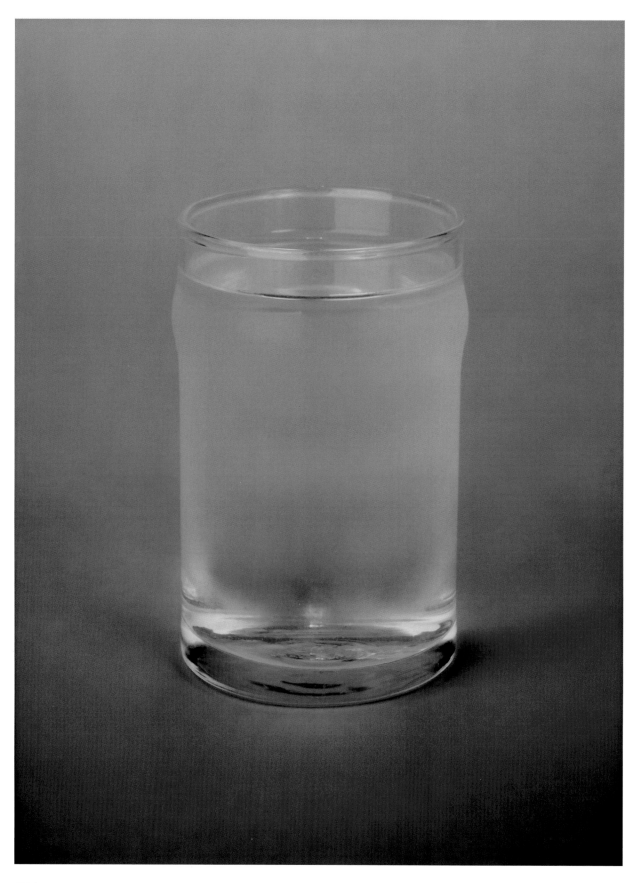

305. **Neil Winokur.**
Glass of Water. 1990.
Photograph

opposite:
306. **Chris Killip.**
Untitled. 1990.
Photograph

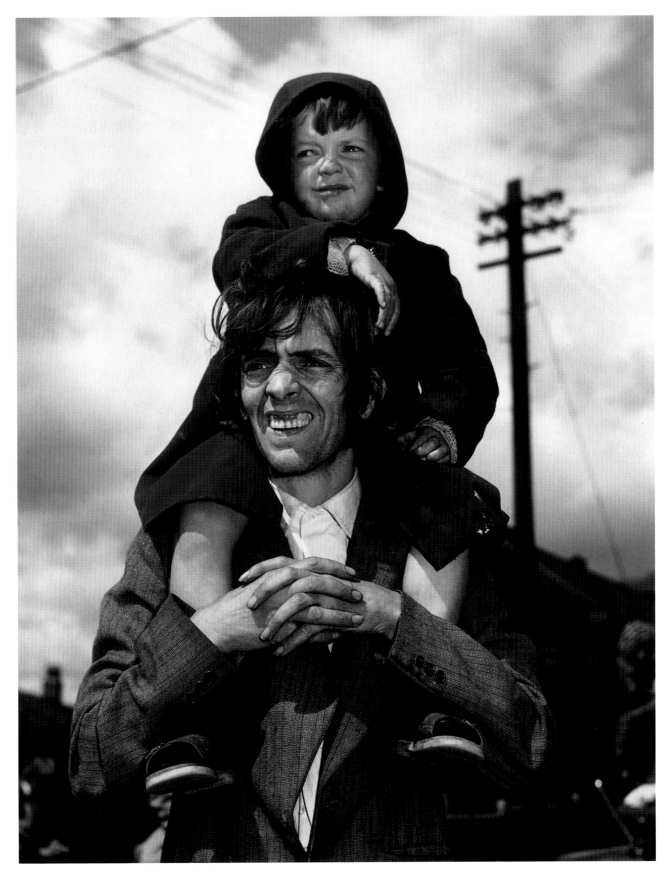

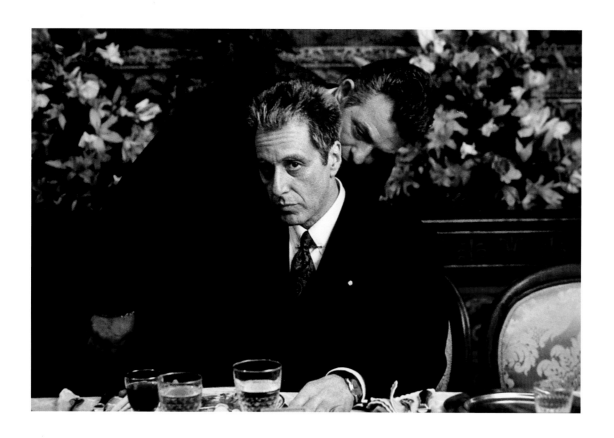

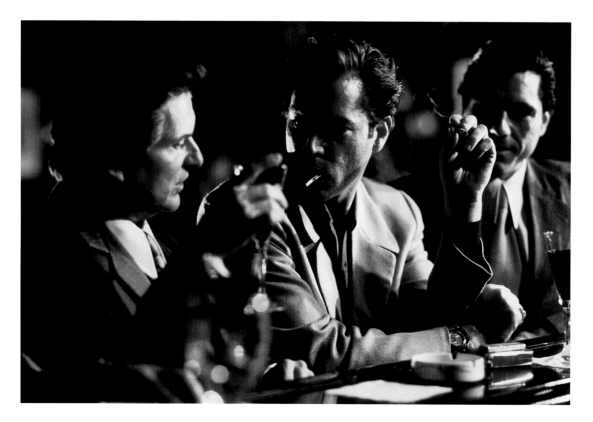

307. Francis Ford Coppola.
The Godfather, Part III. 1990.
Film

308. Martin Scorsese.
GoodFellas. 1990. Film

opposite:
309. Toshiyuki Kita.
The Multilingual Chair.
1991. Design

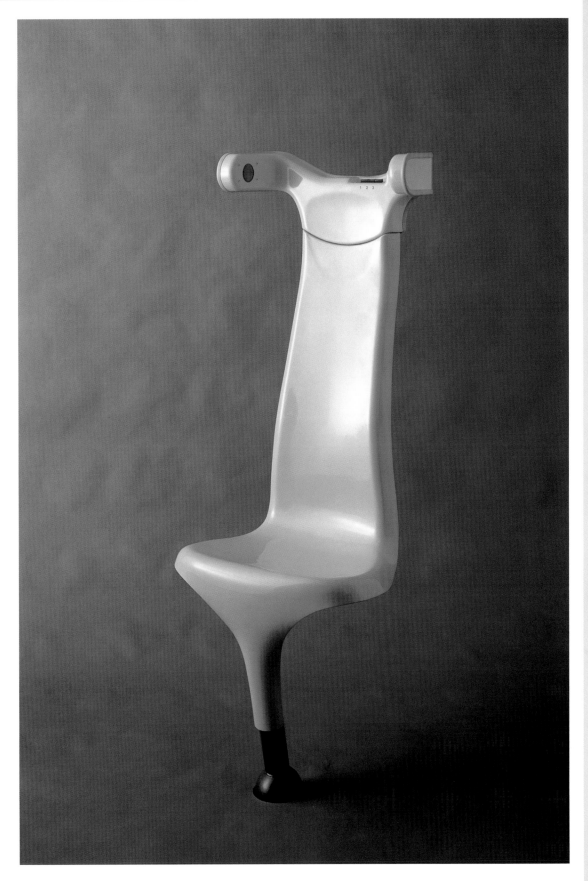

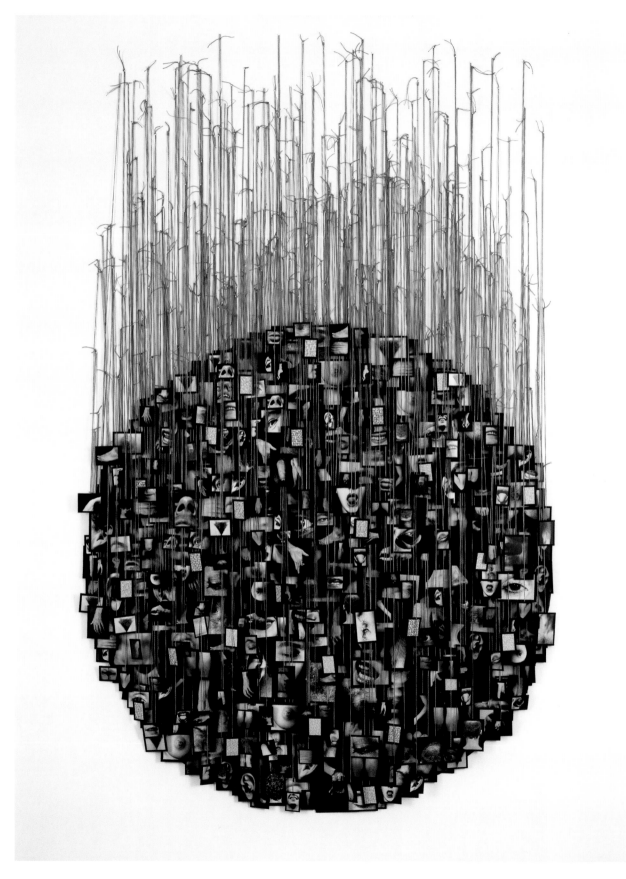

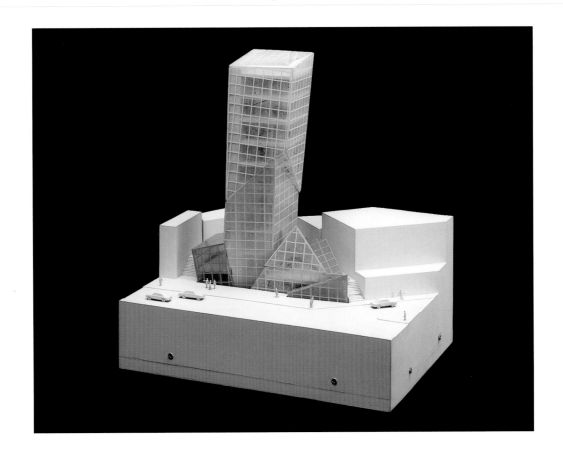

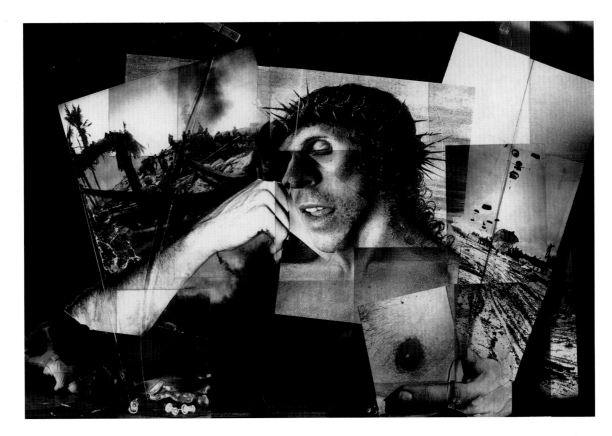

opposite:
310. Annette Messager.
My Vows. 1988–91.
Installation

right:
311. Peter Eisenman.
Alteka Tower Project, Tokyo,
1991. Architectural model

312. John O'Reilly.
War Series #34: PFC USMC
Killed in Action, Gilbert
Islands, 1943, Age 23.
1991. Photographic collage

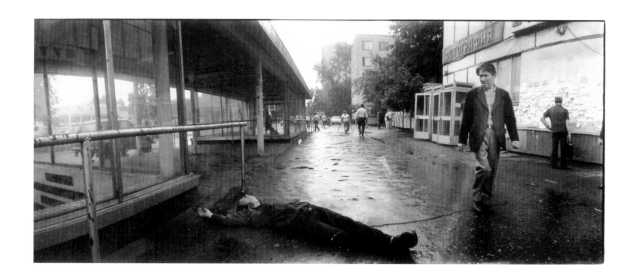

313. Boris Mikhailov.
Untitled from the series
U Zemli (On the Ground).
1991. Photograph

314. Boris Mikhailov.
Untitled from the series
U Zemli (On the Ground).
1991. Photograph

315. Boris Mikhailov.
Untitled from the series
U Zemli (On the Ground).
1991. Photograph

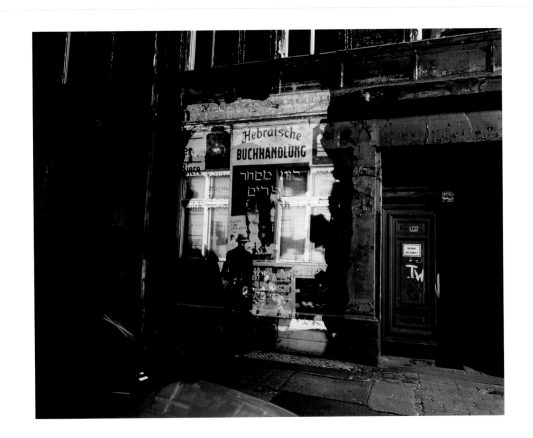

316. Shimon Attie.
Almstadtstrasse 43,
Berlin, 1991 (1930).
1991. Photograph

317. Julie Dash.
Daughters of the Dust.
1991. Film

318. Toyo Ito.
Shimosuma Municipal
Museum, Shomosuma-machi,
Nagano Prefecture, Japan.
1991. Architectural model

319. Warren Sonbert.
Short Fuse. 1991. Film

320. Ernie Gehr.
Side/Walk/Shuttle.
1991. Film

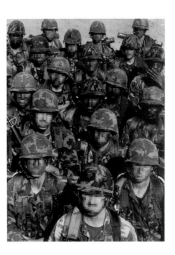

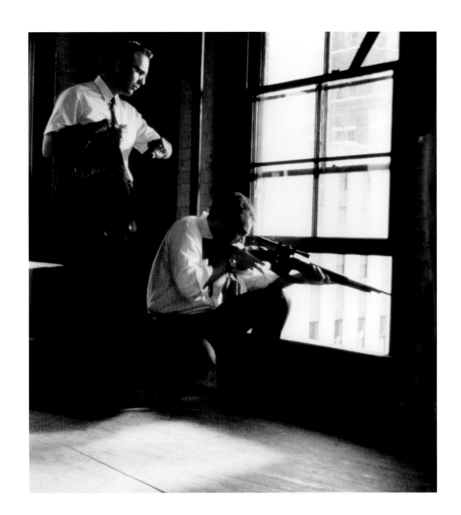

321. Annette Lemieux.
Stolen Faces. 1991. Print

322. Oliver Stone.
JFK. 1991. Film

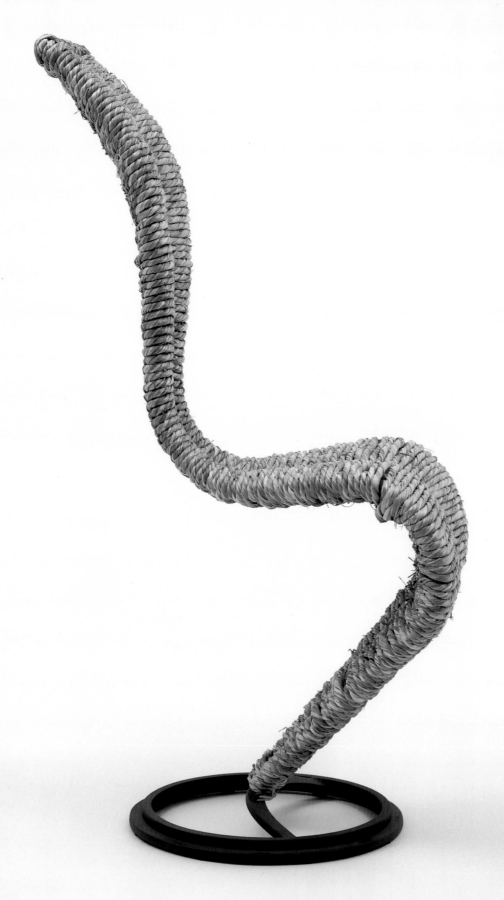

323. Tom Dixon.
S-Chair. 1991. Design

opposite:
324. Dieter Appelt.
The Field. 1991.
Photographs

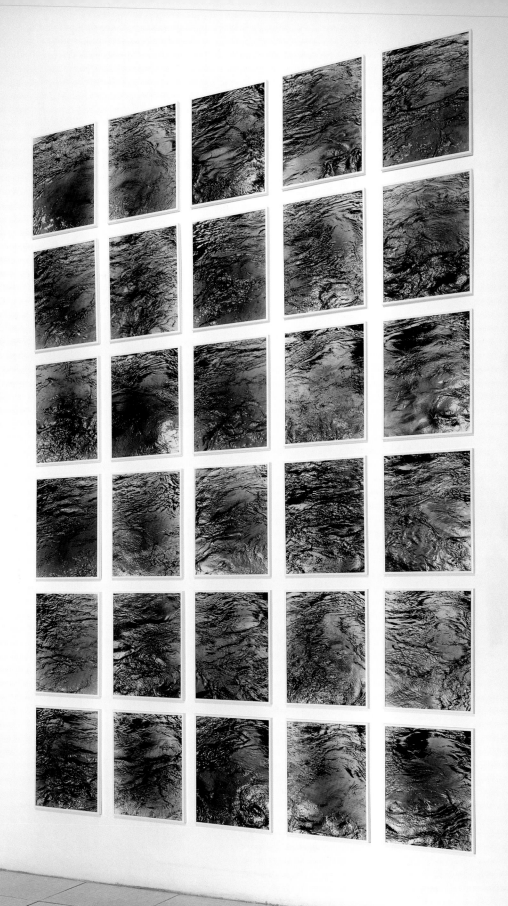

opposite:
325. Jean-Michel Othoniel.
The Forbidden. 1991. Print

above:
326. Vito Acconci.
Adjustable Wall Bra.
1990–91. Sculpture

327. Felix Gonzalez-Torres.
"Untitled" (Perfect Lovers). 1991.
Sculpture

328. Felix Gonzalez-Torres.
"Untitled" (Supreme Majority).
1991. Sculpture

opposite:
329. Felix Gonzalez-Torres.
"Untitled" (Placebo). 1991.
Installation

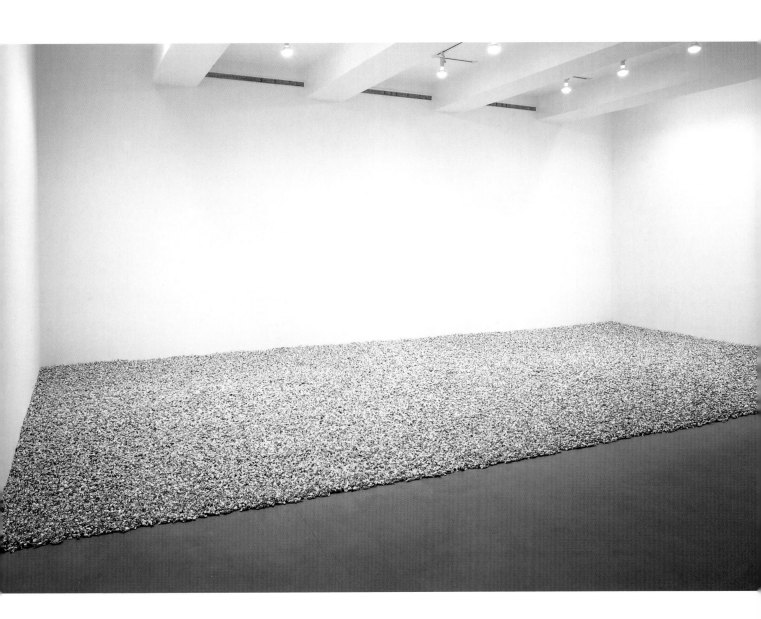

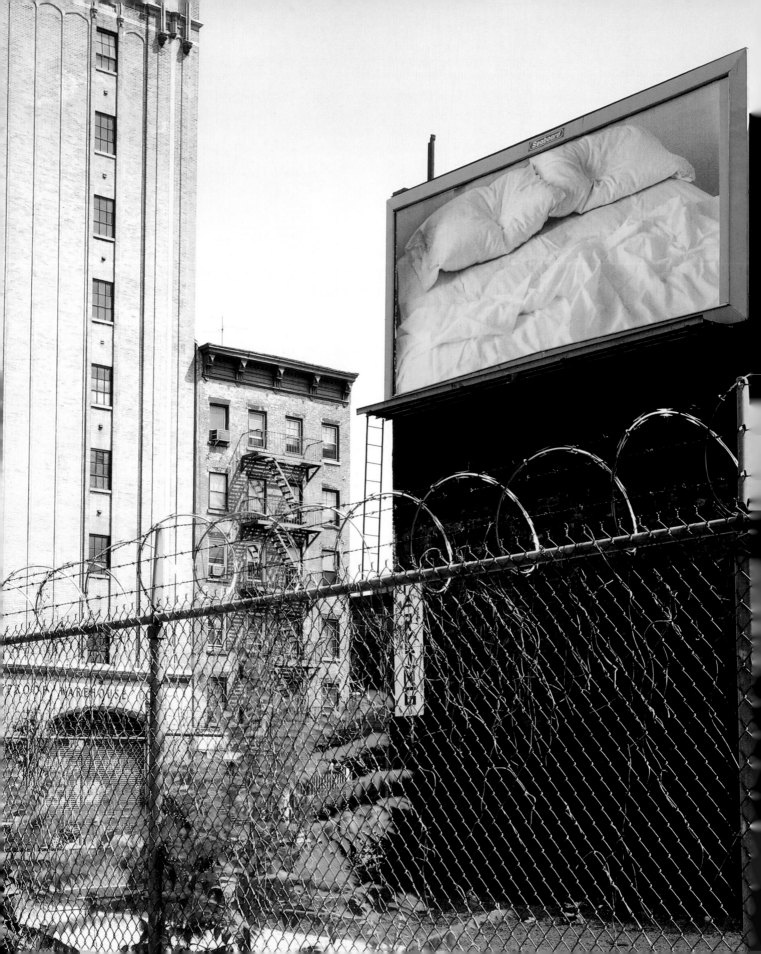

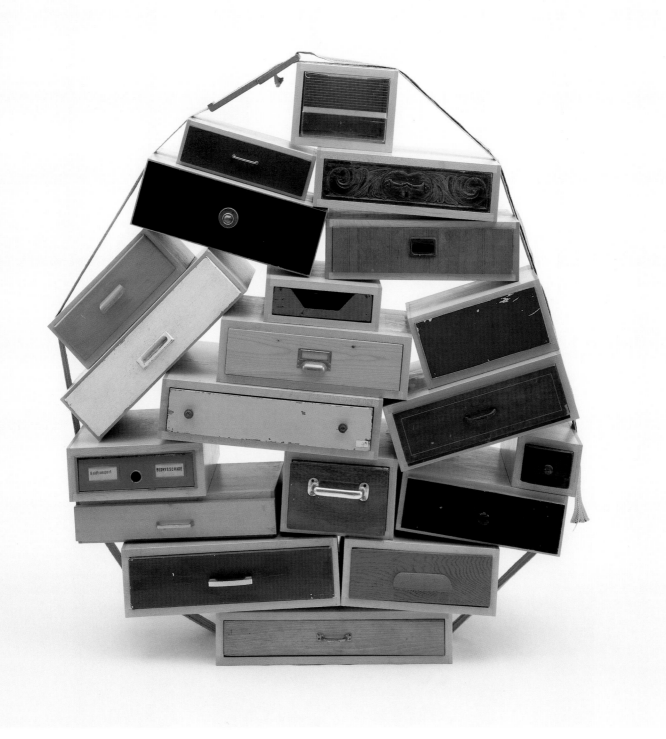

opposite:
330. Felix Gonzalez-Torres.
"Untitled." 1991. Installation

above:
331. Tejo Remy. "You Can't
Lay Down Your Memory" Chest
of Drawers. 1991. Design

332. Enzo Mari.
Flores Box. 1991.
Design

333. Abelardo Morell.
Light Bulb. 1991.
Photograph

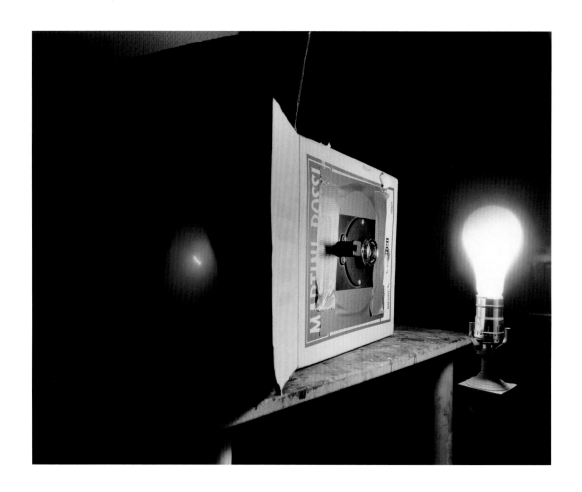

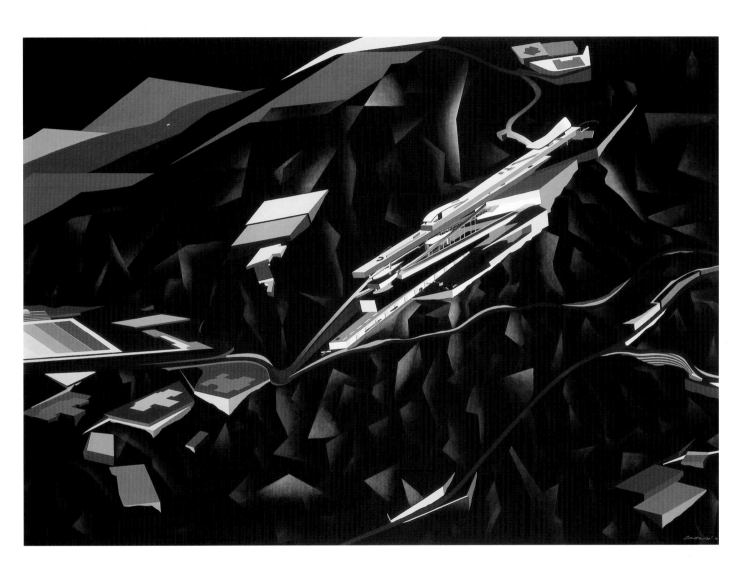

334. Zaha M. Hadid.
Hong Kong Peak Competition,
Hong Kong. 1991.
Architectural drawing

335. Glenn Ligon.
Untitled (How it feels to
be colored me. . . Doubled).
1991. Drawing

One day this kid will get larger. One day this kid will come to know something that causes a sensation equivalent to the separation of the earth from its axis. One day this kid will reach a point where he senses a division that isn't mathematical. One day this kid will feel something stir in his heart and throat and mouth. One day this kid will find something in his mind and body and soul that makes him hungry. One day this kid will do something that causes men who wear the uniforms of priests and rabbis, men who inhabit certain stone buildings, to call for his death. One day politicians will enact legislation against this kid. One day families will give false information to their children and each child will pass that information down generationally to their families and that information will be designed to make existence intolerable for this kid. One day this kid will begin to experience all this activity in his environment and that activity and information will compel him to commit suicide or submit to danger in hopes of being murdered or submit to silence and invisibility. Or one day this kid will talk. When he begins to talk, men who develop a fear of this kid will attempt to silence him with strangling, fists, prison, suffocation, rape, intimidation, drugging, ropes, guns, laws, menace, roving gangs, bottles, knives, religion, decapitation, and immolation by fire. Doctors will pronounce this kid curable as if his brain were a virus. This kid will lose his constitutional rights against the government's invasion of his privacy. This kid will be faced with electro-shock, drugs, and conditioning therapies in laboratories tended by psychologists and research scientists. He will be subject to loss of home, civil rights, jobs, and all conceivable freedoms. All this will begin to happen in one or two years when he discovers he desires to place his naked body on the naked body of another boy.

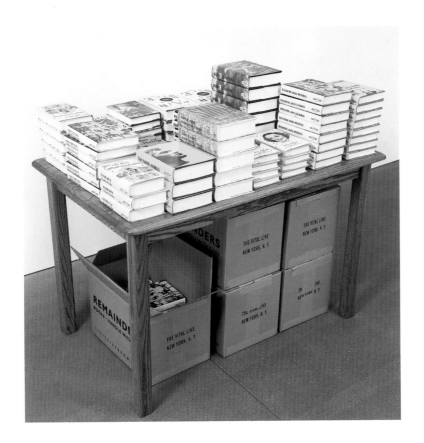

336. David Wojnarowicz.
Untitled. 1990–91. Print

337. Allen Ruppersberg.
Remainders: Novel, Sculpture, Film. 1991. Installation

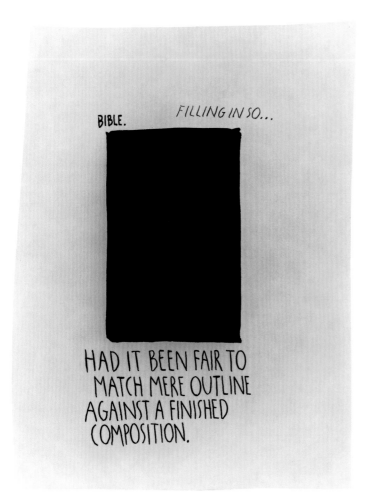

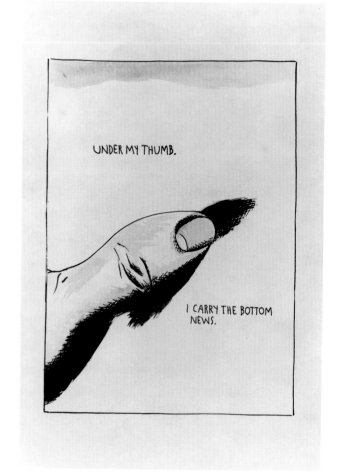

338. Raymond Pettibon.
No Title (Filling In So . . .).
1991. Drawing

339. Raymond Pettibon.
No Title (Under My Thumb).
1991. Drawing

opposite:
340. Christopher Wool.
Untitled. 1991. Drawing

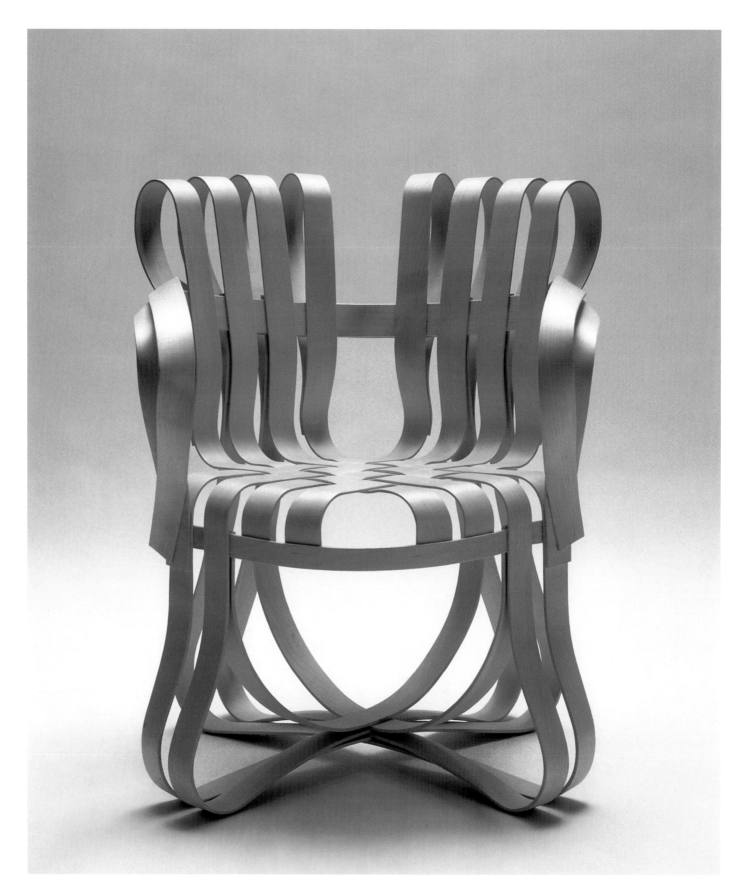

341. Frank Gehry.
Cross Check Armchair.
1991. Design

above:
342. Brice Marden.
Rain. 1991. Drawing

343. Robert Gober.
Untitled. 1992. Sculpture

344. Robert Gober.
Untitled. 1991. Sculpture

345. Robert Gober.
Untitled. 1992. Photograph

346. Robert Gober.
Newspaper. 1992. Multiple

347. Cindy Sherman.
Untitled #263. 1992.
Photograph

348. Janine Antoni.
Gnaw. 1992. Installation

349. Paul McCarthy.
Sketchbook "Heidi."
1992. Illustrated book

350. Paul McCarthy and Mike Kelley.
Heidi. 1992. Video

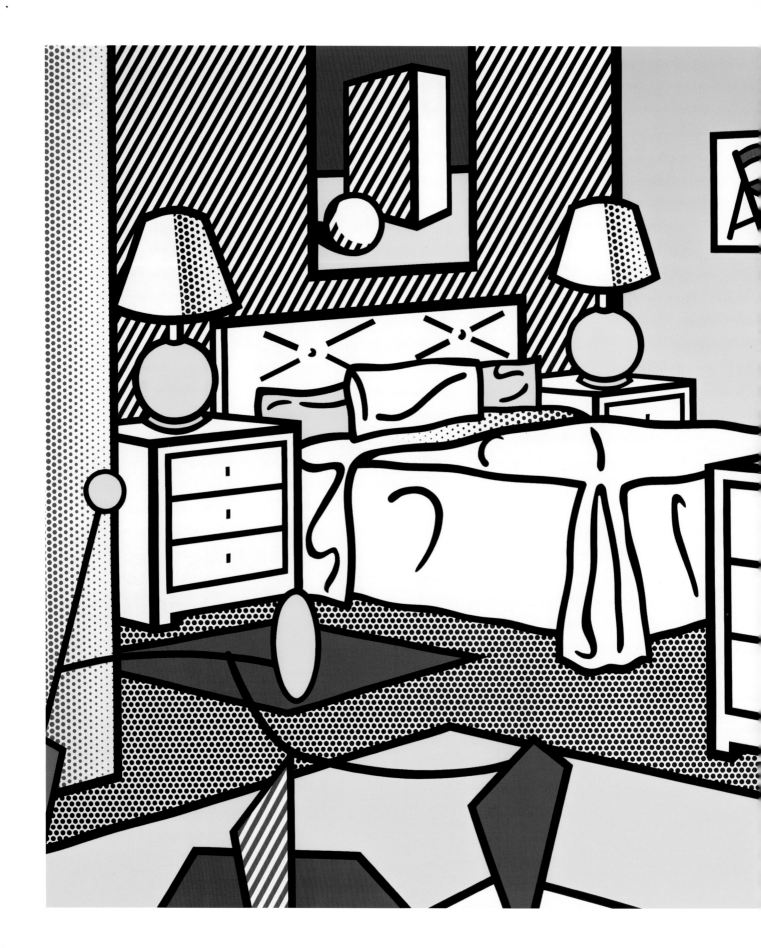

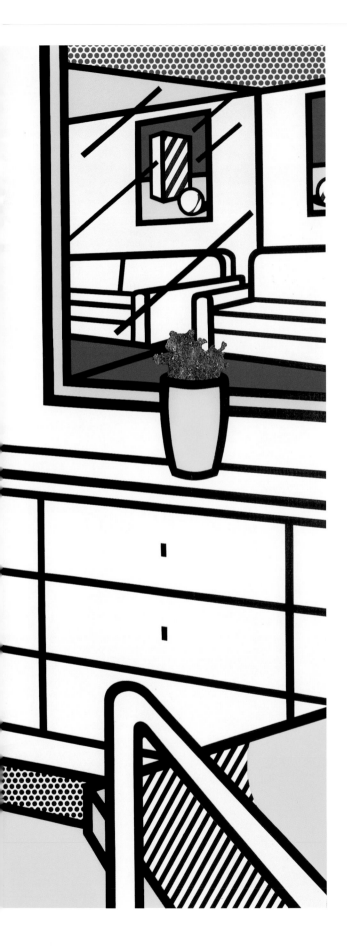

351. Roy Lichtenstein.
Interior with Mobile. 1992.
Painting

352. Christopher Connell.
Pepe Chair. 1992. Design

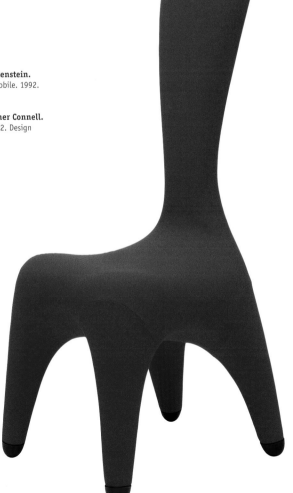

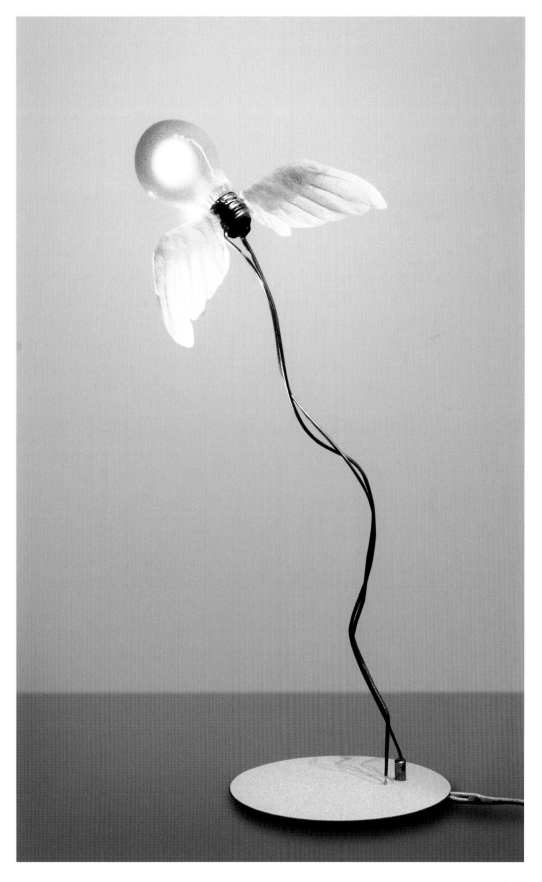

opposite:
353. Ben Faydherbe.
Festival in the Hague
(Wout de Vringer).
1992. Poster

right:
354. Ingo Maurer.
Lucellino Wall Lamp.
1992. Design

355. Guillermo Kuitca.
Untitled. 1992. Painting

opposite:
356. Willie Cole.
Domestic I.D., IV.
1992. Print

GENERAL ELECTRIC　　　　SUNBEAM　　　　SUNBEAM　　　　HAMILTON BEACH

NORELCO　　　　GENERAL ELECTRIC　　　　PROCTOR SILEX　　　　SUNBEAM

PROCTOR SILEX　　　　STEAM-O-MATIC　　　　SILEX　　　　GENERAL ELECTRIC

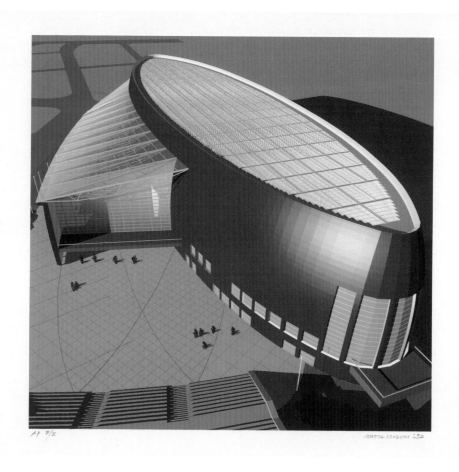

357. Arata Isozaki.
Convention Hall, Nara, Japan.
1992. Architectural drawing

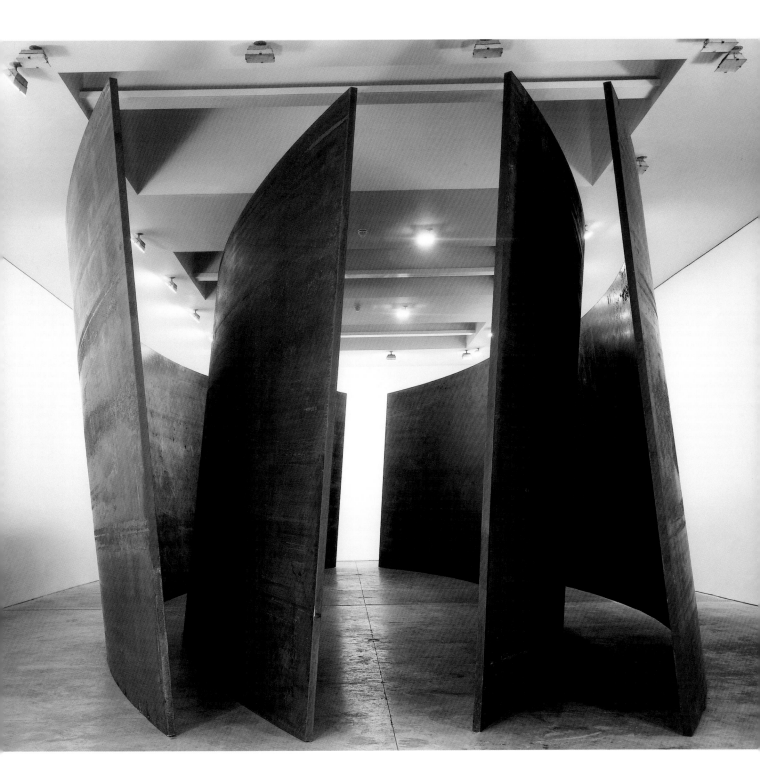

358. Richard Serra.
Intersection II. 1992.
Sculpture

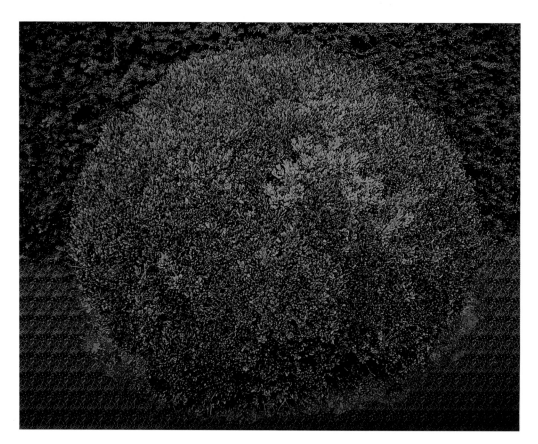

359. Peter Campus.
Burning. 1992.
Photograph

360. Rudolf Bonvie.
Imaginary Picture I.
1992. Photograph

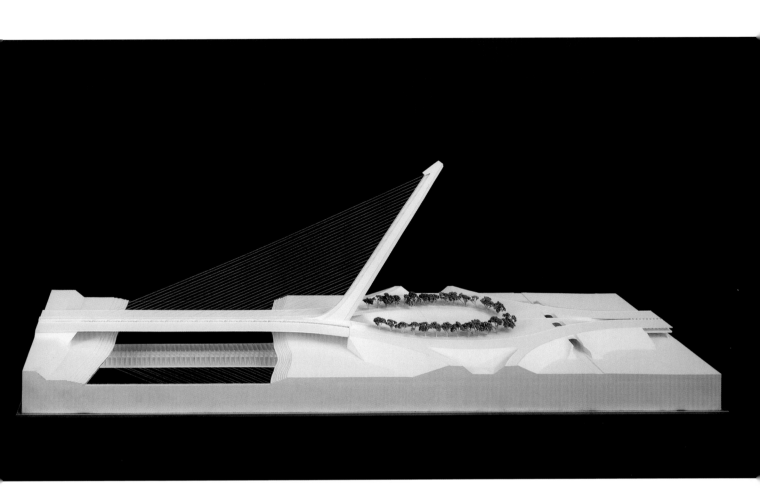

361. Santiago Calatrava. Alamillo Bridge
and Cartuga Viaduct, Seville, Spain.
1987–92. Architectural model

362. Santiago Calatrava. Alamillo Bridge
and Cartuga Viaduct, Seville, Spain.
1987–92. Architectural drawing

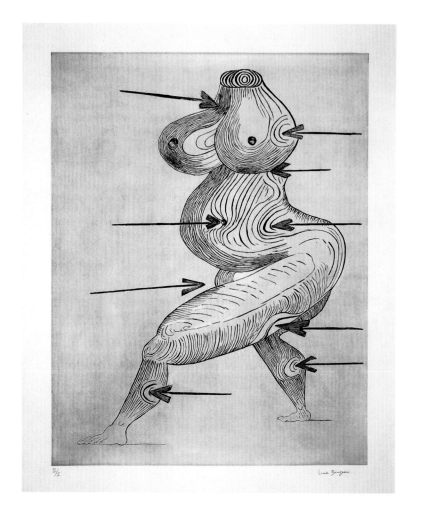

363. José Leonilson.
I Am Your Man. 1992.
Drawing

364. Louise Bourgeois.
Ste Sebastienne. 1992. Print

opposite:
365. Rody Graumans.
85 Lamps Lighting Fixture.
1992. Design

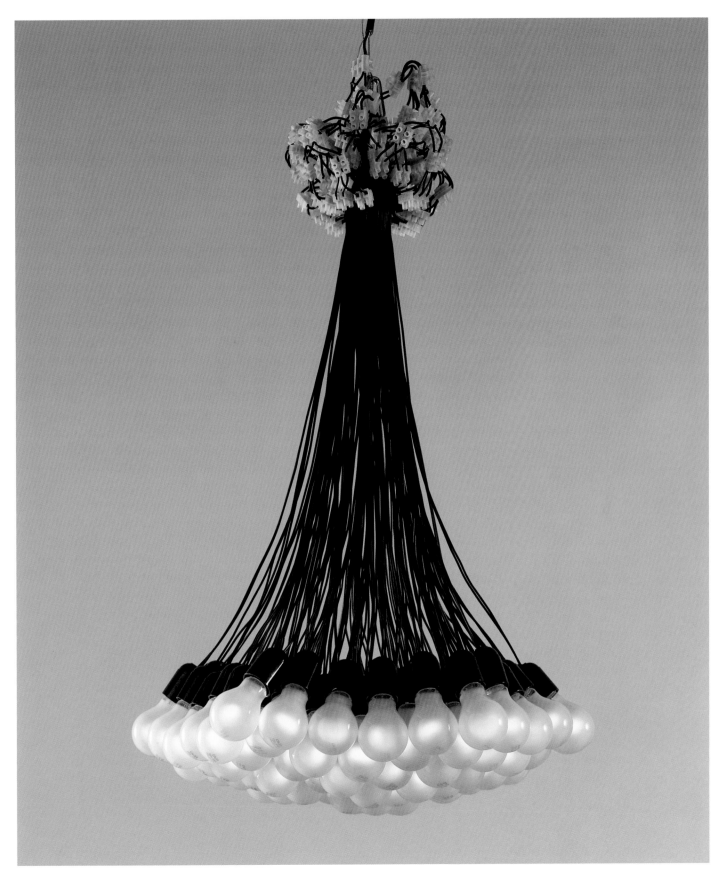

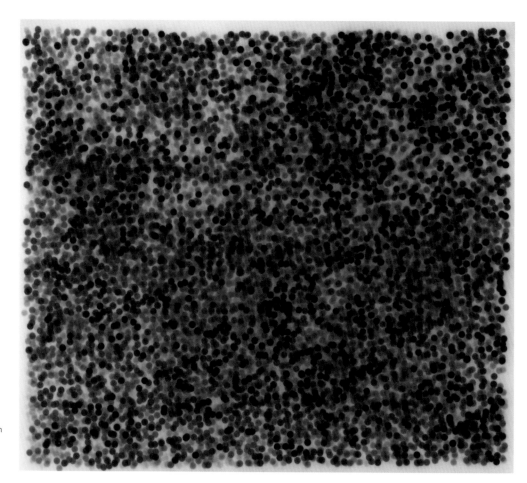

366. Christopher Bucklow.
14,000 Solar Images; 1:23 P.M.,
13th June 1992. 1992. Photograph

367. Terence Davies.
The Long Day Closes. 1992.
Film

368. Sigmar Polke.
The Goat Wagon. 1992.
Painting

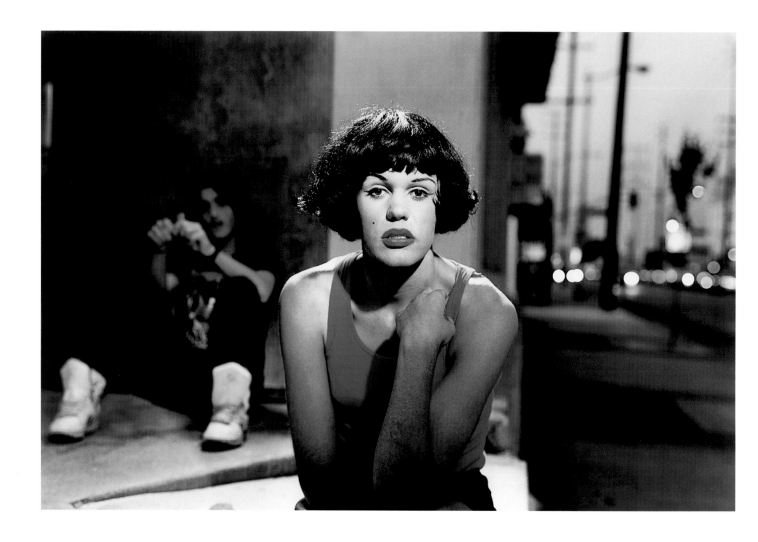

369. Philip-Lorca diCorcia.
Marilyn; 28 years old. Las Vegas,
Nevada; $30. 1990–92.
Photograph

opposite:
370. Juan Sánchez.
For don Pedro. 1992. Print

371. Raymond Pettibon.
No Title (The Sketch Is).
1992. Drawing

372. Rosemarie Trockel.
Untitled. 1992. Drawing

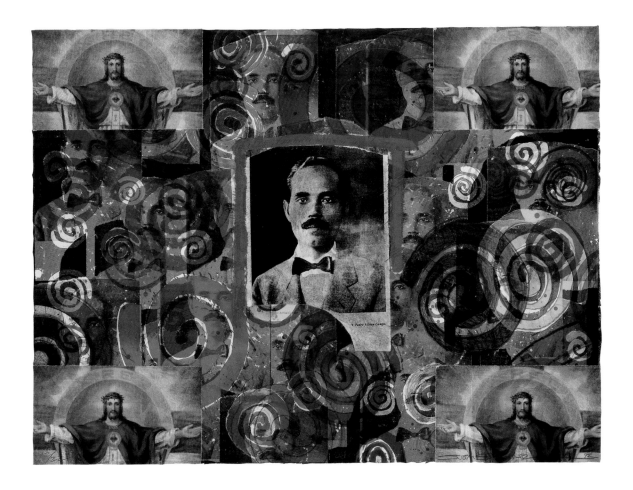

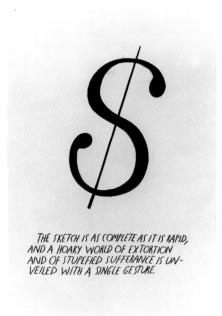

THE SKETCH IS AS COMPLETE AS IT IS RAPID,
AND A HOARY WORLD OF EXTORTION
AND OF STUPEFIED SUFFERANCE IS UN-
VEILED WITH A SINGLE GESTURE.

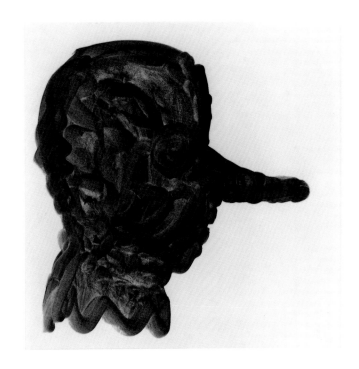

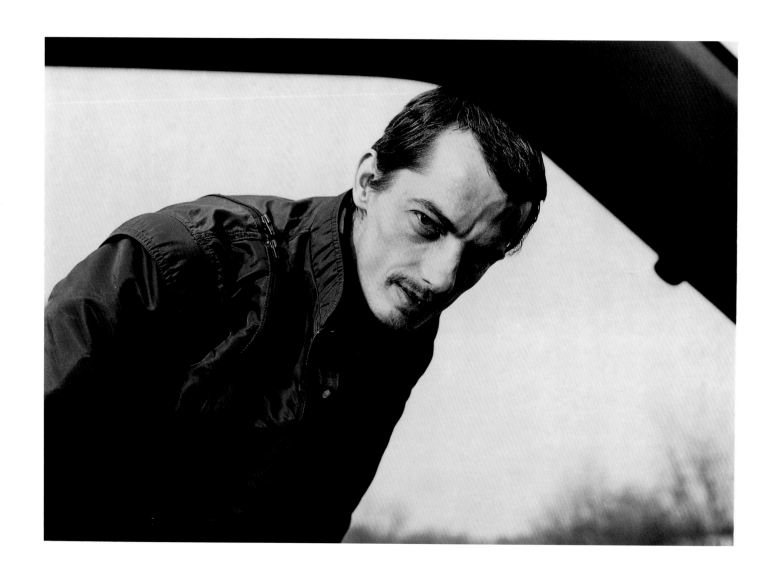

373. Mark Steinmetz.
Knoxville. 1992. Photograph

374. Gabriel Orozco.
Maria, Maria, Maria. 1992.
Drawing

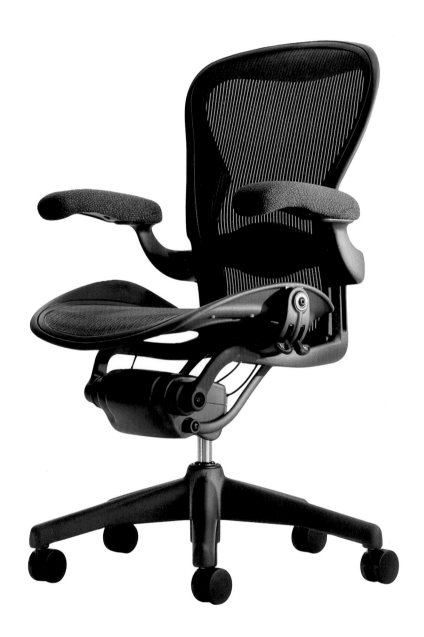

**375. Donald T. Chadwick
and William Stumpf.**
Aeron Office Chair. 1992.
Design

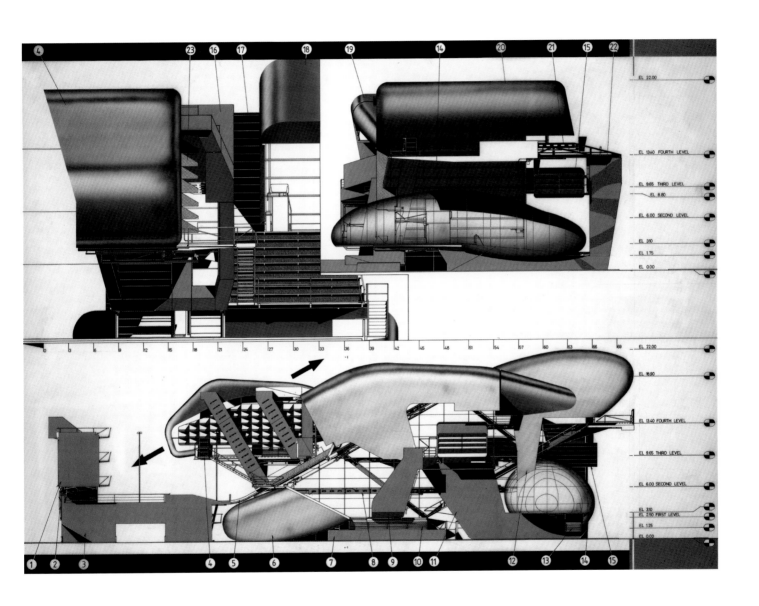

376. Neil M. Denari.
Prototype Architecture School,
Wilshire Boulevard, Los Angeles,
California. Project, 1992.
Architectural drawing

377. Simon Patterson.
The Great Bear. 1992.
Print

opposite:
378. Chris Burden.
Medusa's Head. 1989–92.
Sculpture

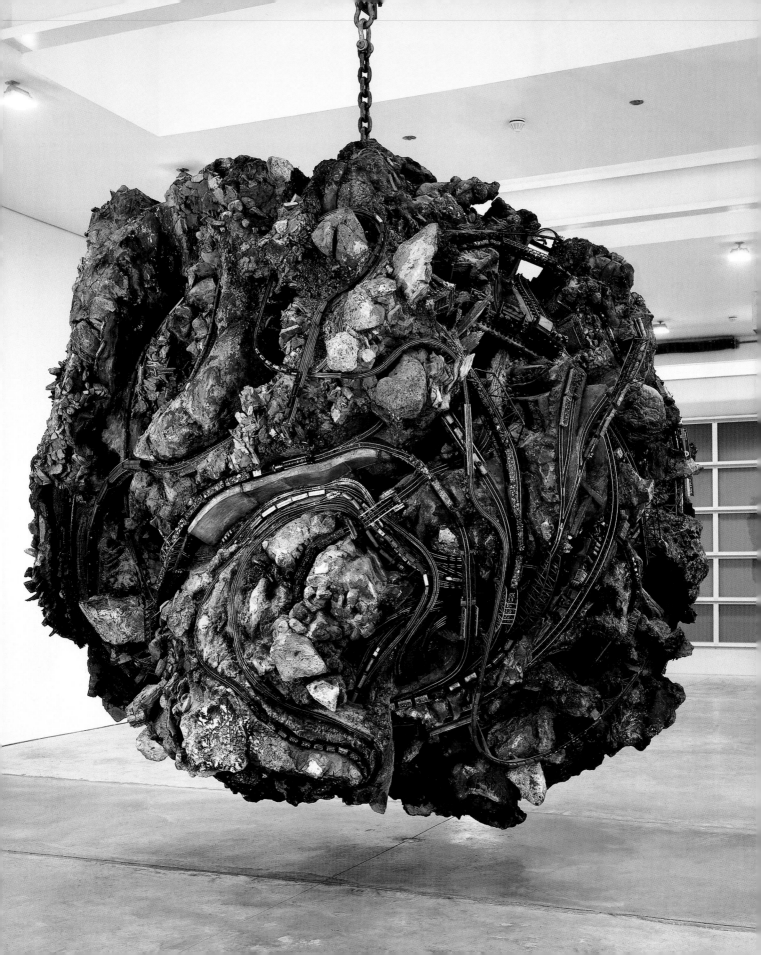

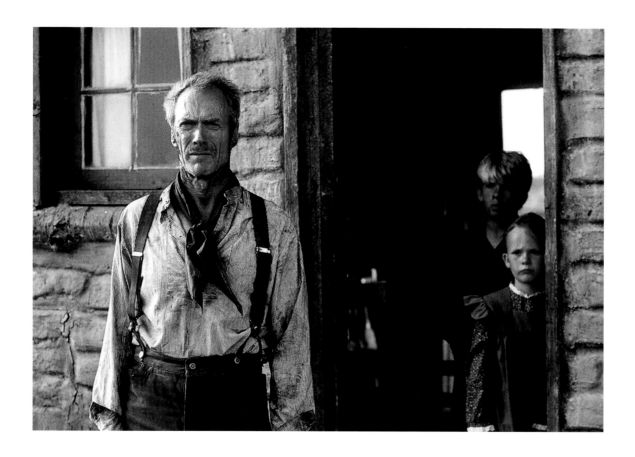

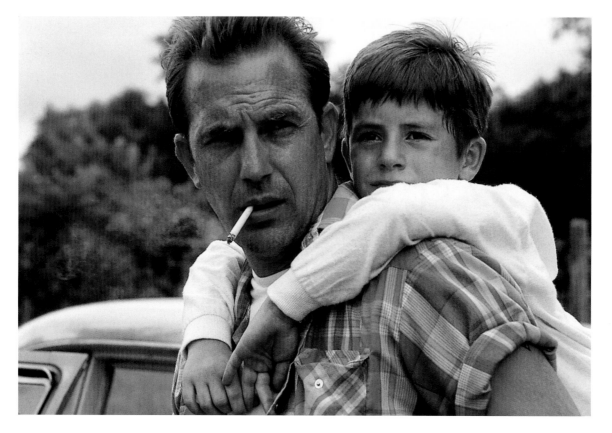

379. Clint Eastwood.
Unforgiven. 1992. Film

380. Clint Eastwood.
A Perfect World. 1993. Film

opposite:
381. Reiko Sudo.
Jellyfish Fabric. 1993.
Design

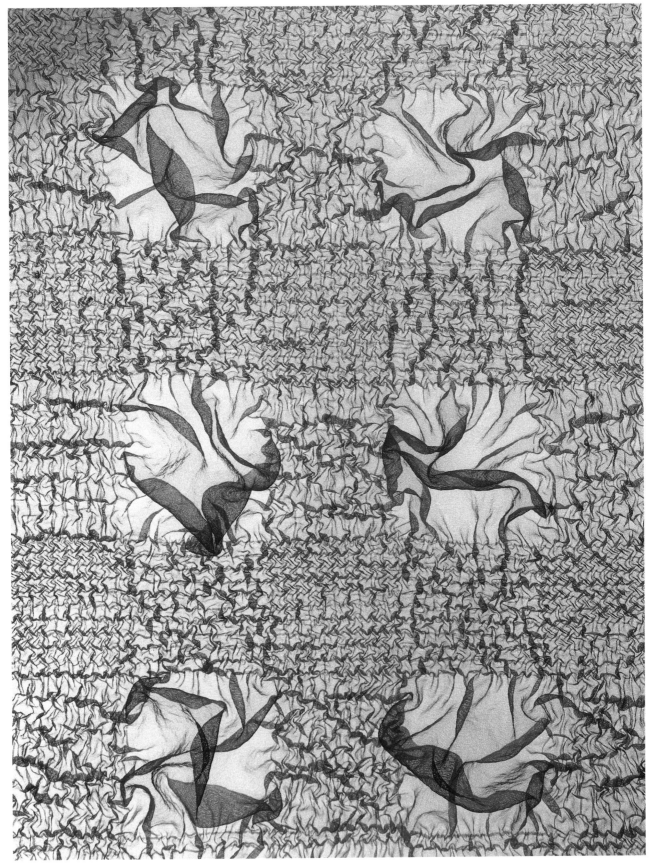

382. Helen Chadwick.
Number 11 from the series
Bad Blooms. 1992–93.
Photograph

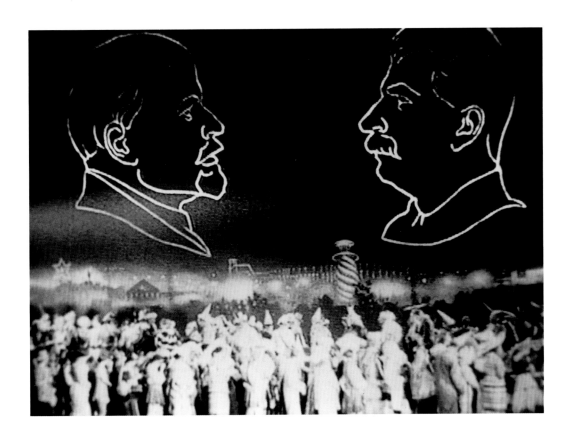

383. Chris Marker.
The Last Bolshevik
(Le Tombeau d'Alexandre).
1993. Video

384. Zacharias Kunuk.
Saputi. 1993. Video

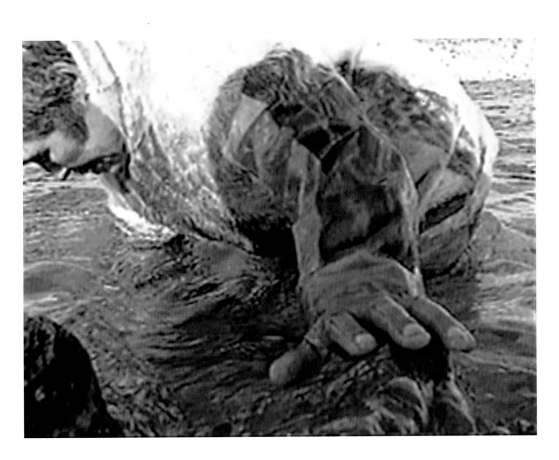

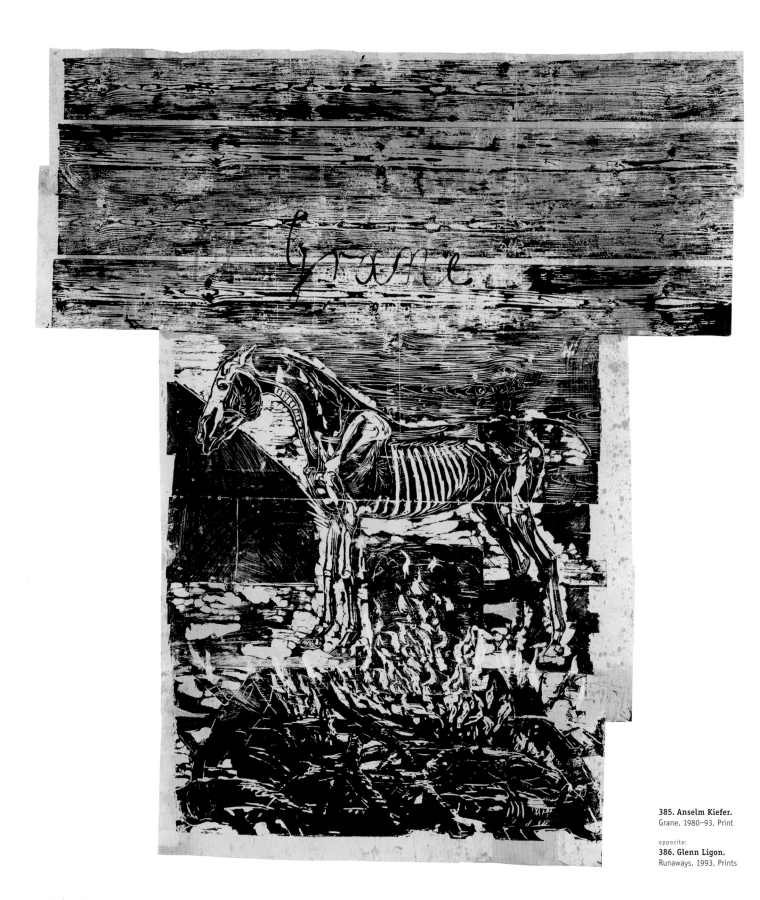

385. Anselm Kiefer.
Grane. 1980–93. Print

opposite:
386. Glenn Ligon.
Runaways. 1993. Prints

R AN AWAY, Glenn, a black male, 5'8", very short hair cut, nearly completely shaved, stocky build, 155-165 lbs., medium complexion (not "light skinned," not "dark skinned," slightly orange). Wearing faded blue jeans, short sleeve button-down 50's style shirt, nice glasses (small, oval shaped), no socks. Very articulate, seemingly well-educated, does not look at you straight in the eye when talking to you. He's socially very adept, yet, paradoxically, he's somewhat of a loner.

R AN AWAY, Glenn. Medium height, 5'8", male. Closely-cut hair, almost shaved. Mild looking, with oval shaped, black-rimmed glasses that are somewhat conservative. Thinly-striped black-and-white short-sleeved T-shirt, blue jeans. Silver watch and African-looking bracelet on arm. His face is somewhat wider on bottom near the jaw. Full-lipped. He's black. Very warm and sincere, mild-mannered and laughs often.

R AN AWAY, a man named Glenn. He has almost no hair. He has cat-eye glasses, medium-dark skin, cute eyebrows. He's wearing black shorts, black shoes and a short sleeve plaid shirt. He has a really cool Timex silver watch with a silver band. He's sort of short, a little hunky, though you might not notice it with his shirt untucked. He talks sort of out of the side of his mouth and looks at you sideways. Sometimes he has a loud laugh, and lately I've noticed he refers to himself as "mother."

Ran away, Glenn Ligon. He's a shortish broad-shouldered black man, pretty dark-skinned, with glasses. Kind of stocky, tends to look down and turn in when he walks. Real short hair, almost none. Clothes non-descript, something button-down and plaid, maybe, and shorts and sandals. Wide lower face and narrow upper face. Nice teeth.

387. Rosemarie Trockel.
What It Is Like to Be What
You Are Not. 1993. Prints

388. Brice Marden.
Vine. 1992–93. Painting

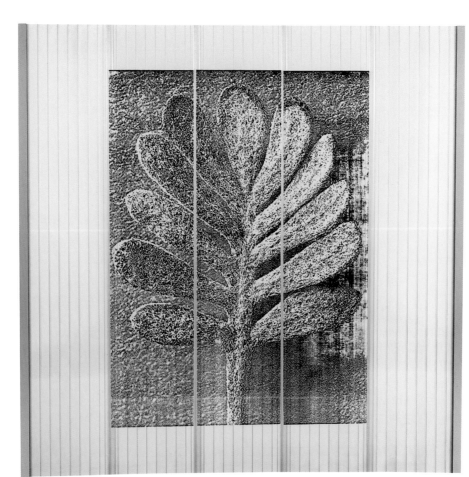

389. Herzog & de Meuron Architects. Facade panel from the Ricola Europe Factory and Storage Building. 1993. Architectural fragment

390. Herzog & de Meuron Architects. Ricola Europe Factory and Storage Building. 1993. Architectural model

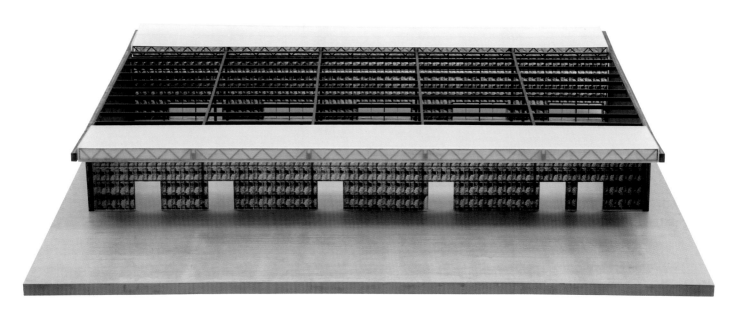

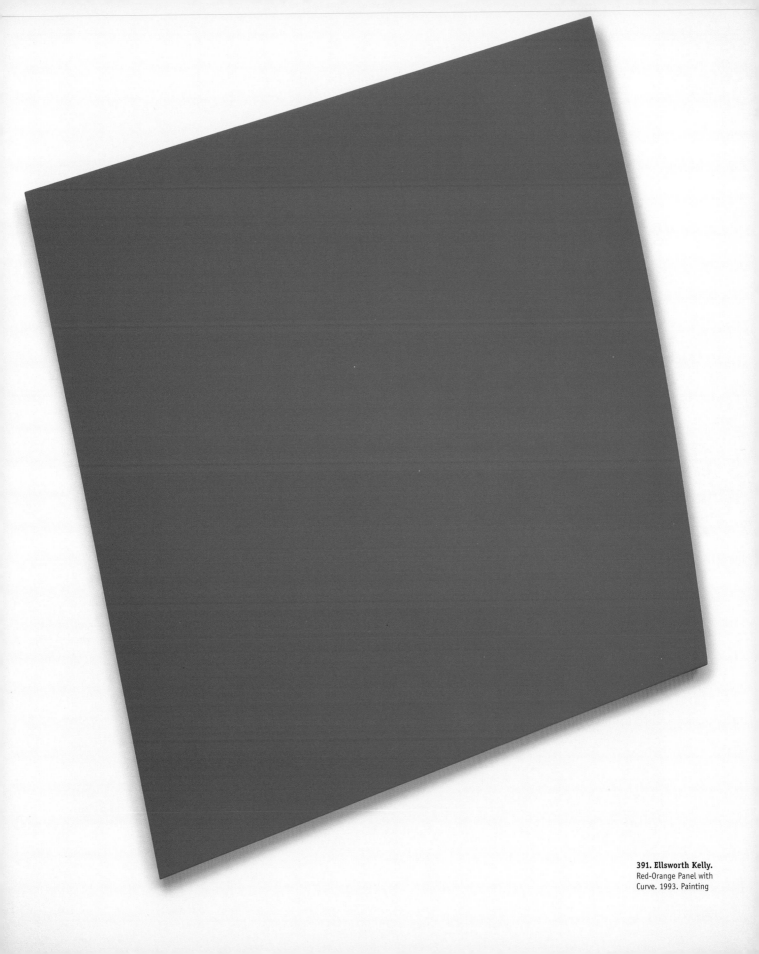

391. Ellsworth Kelly.
Red-Orange Panel with
Curve. 1993. Painting

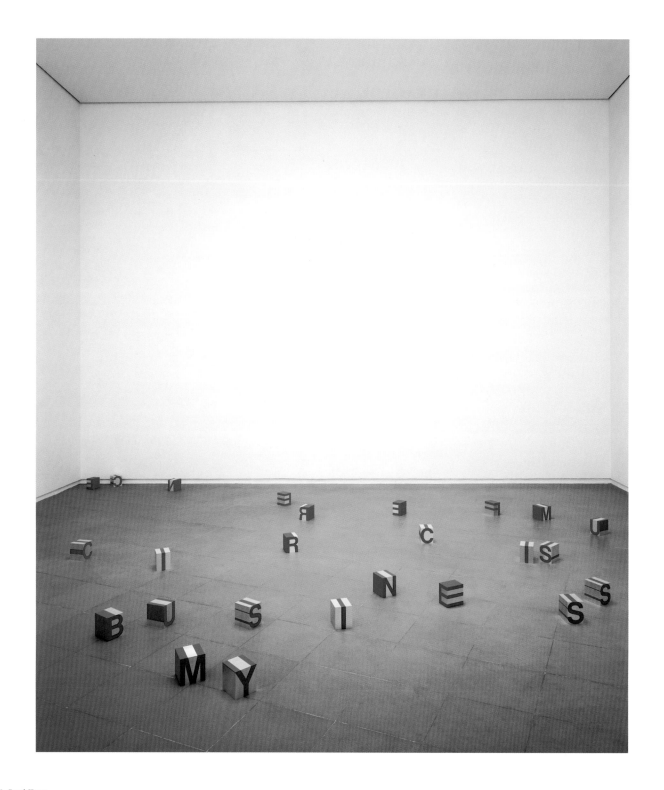

392. Roni Horn.
How Dickinson Stayed
Home. 1993. Installation

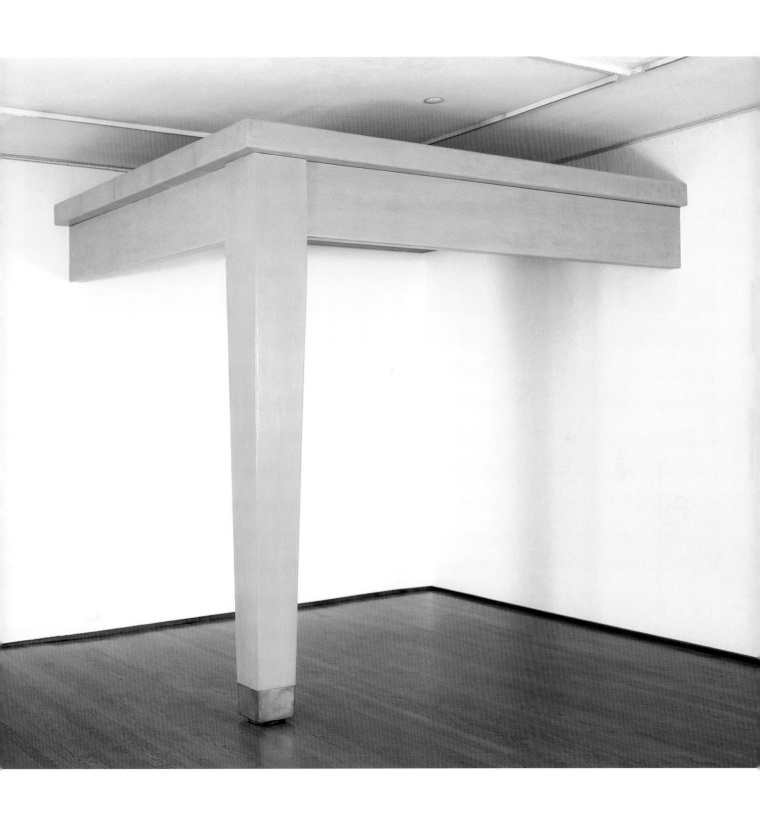

393. Robert Therrien.
No Title. 1993. Sculpture

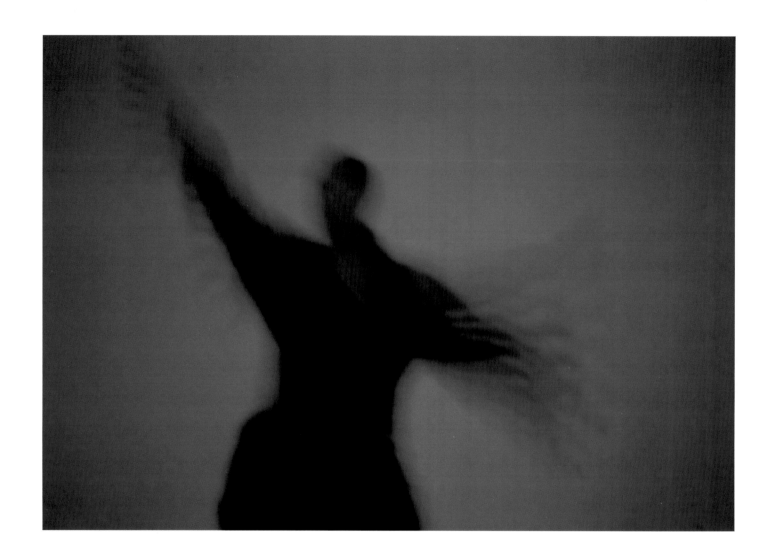

394. Derek Jarman.
Blue. 1993. Film

opposite:
**395. Fernando Campana
and Humberto Campana.**
Vermelha Chair. 1993. Design

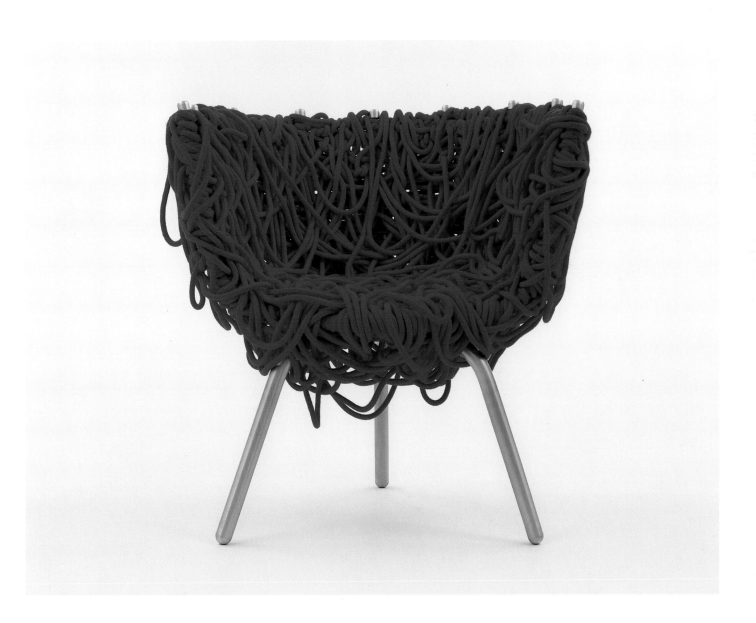

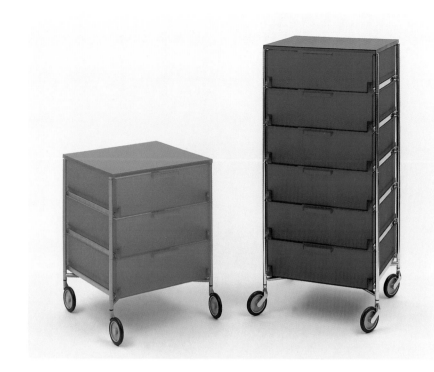

**396. Antonio Citterio
and Glen Oliver Löw.**
Mobil Container System.
1993. Design

397. Jean Nouvel.
Cartier Foundation for
Contemporary Art. 1992–93.
Architectural drawing

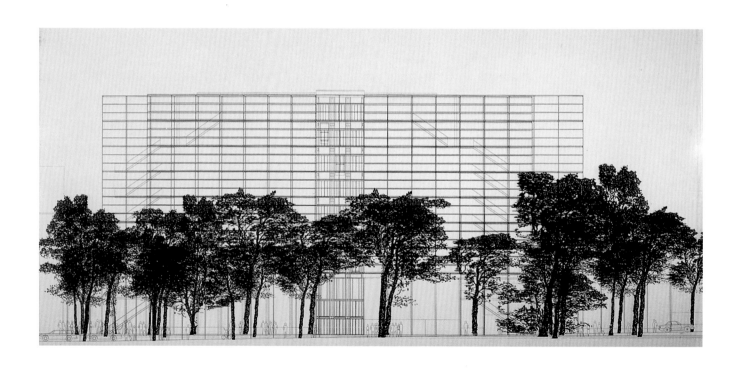

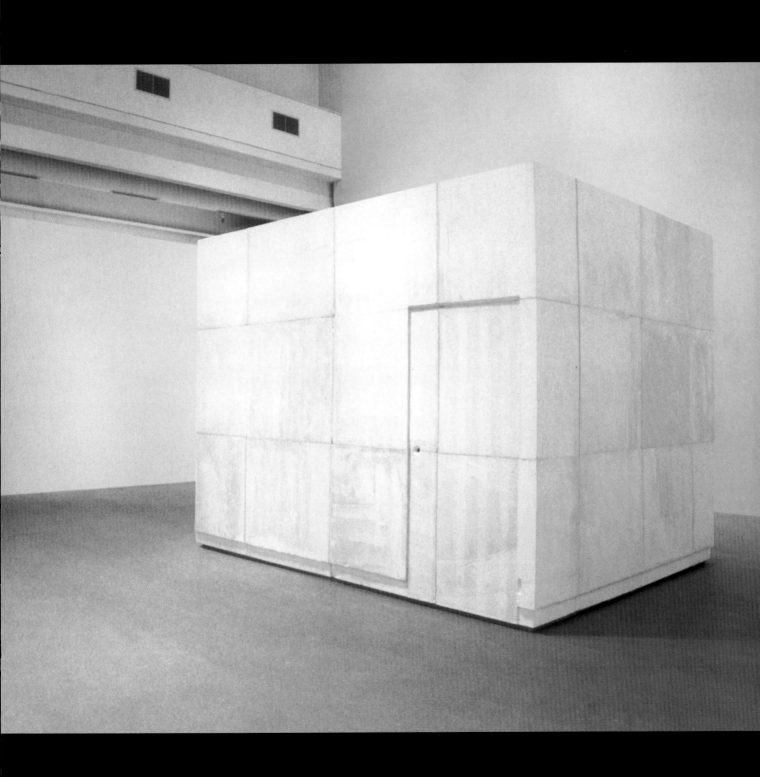

398. Rachel Whiteread.
Untitled (Room). 1993.
Sculpture

AN 18th CENTURY LINE ON A WATERING-CAN

The mute dispenser of the vernal shower

A grove of gean or wild cherry trees. On a small fluted column among the trees is a bronze or stone basket of cherries with the words *l'idylle des cerises.*

'I climbed into a cherry tree, and threw bunches of cherries down to the girls, who then returned the cherry-stones through the branches. Seeing one of the girls holding out her apron and tilting her head, I took such good aim that I dropped a bunch into her bosom. "Why are my lips not cherries?" I thought. "How gladly would I throw them there too!"'

Jean-Jacques Rousseau, *Confessions.* For a sympathetic account of the famous 'idyll of the cherries' see Renato Poggioli, *The Oaten Flute.*

"I have seen that Death is a Reaper, who cuts down with his scythe not only the lowly clover, but also the grass that grows tall; I have seen that Death is a Gardener, who does away with the climbing larkspur as well as the violets that creep along the earth; I have seen that Death is a Player, and indeed a naughty one, for he knocks down the skittles and does not set them up again, and he takes the king as well as the pawns; I have seen that Death is a thunderbolt that strikes not only the tumble-down straw huts, but also the splendid houses of monarchs..."

Abraham a Santa Clara

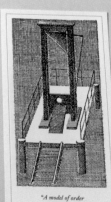

"A model of order even if set in a space filled with doubt"

399. Ian Hamilton Finlay.
Artist's book and cards. 1986–93.
Prints

400. Martin Scorsese.
The Age of Innocence.
1993. Film

401. Ximena Cuevas.
Bleeding Heart. 1993.
Video

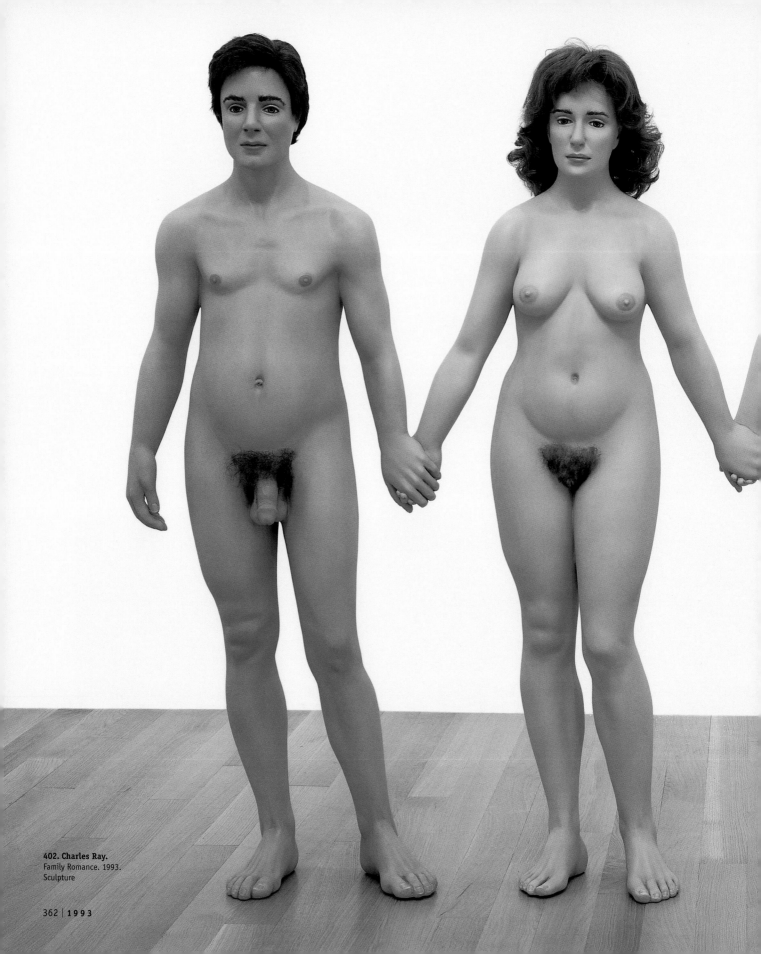

402. Charles Ray.
Family Romance. 1993.
Sculpture

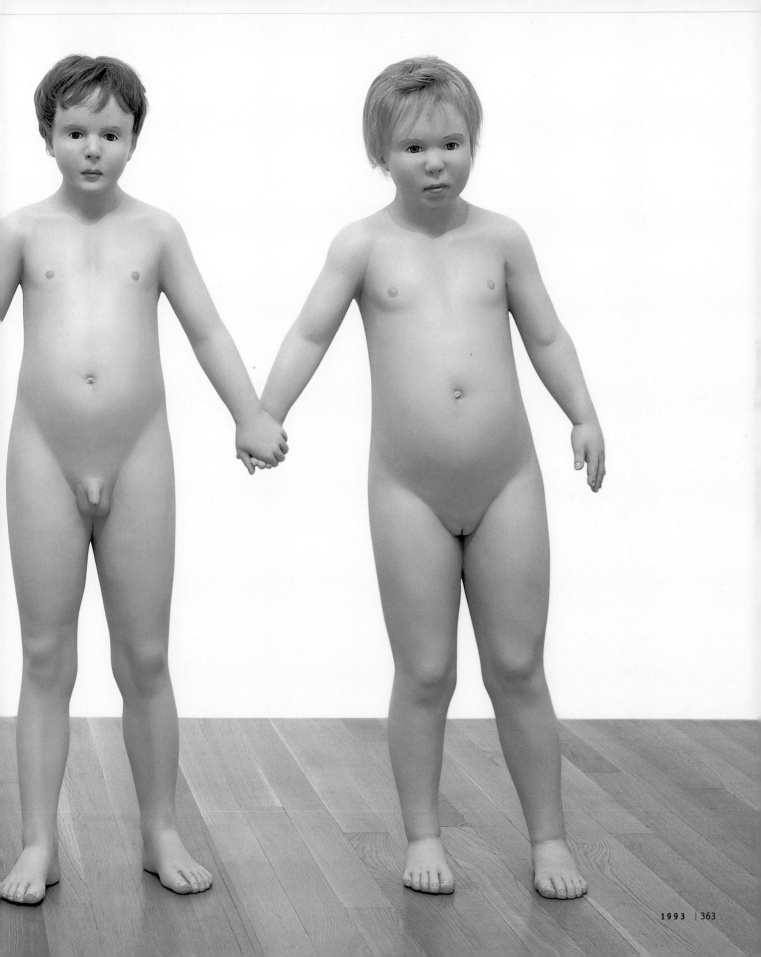

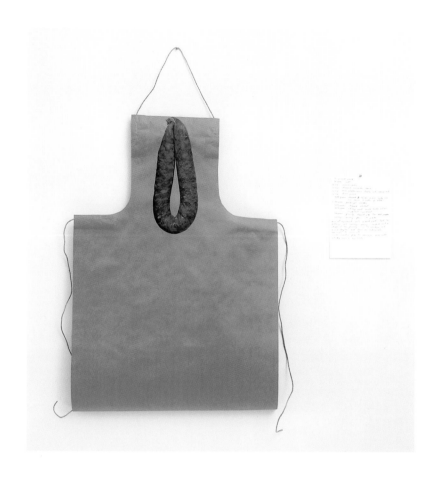

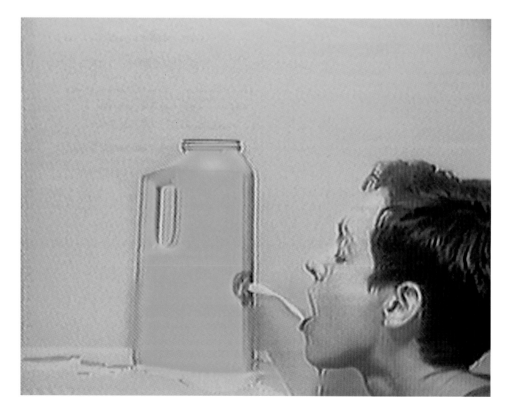

403. Rirkrit Tiravanija. Untitled (apron and Thai pork sausage). 1993. Multiple

404. Cheryl Donegan. Head. 1993. Video

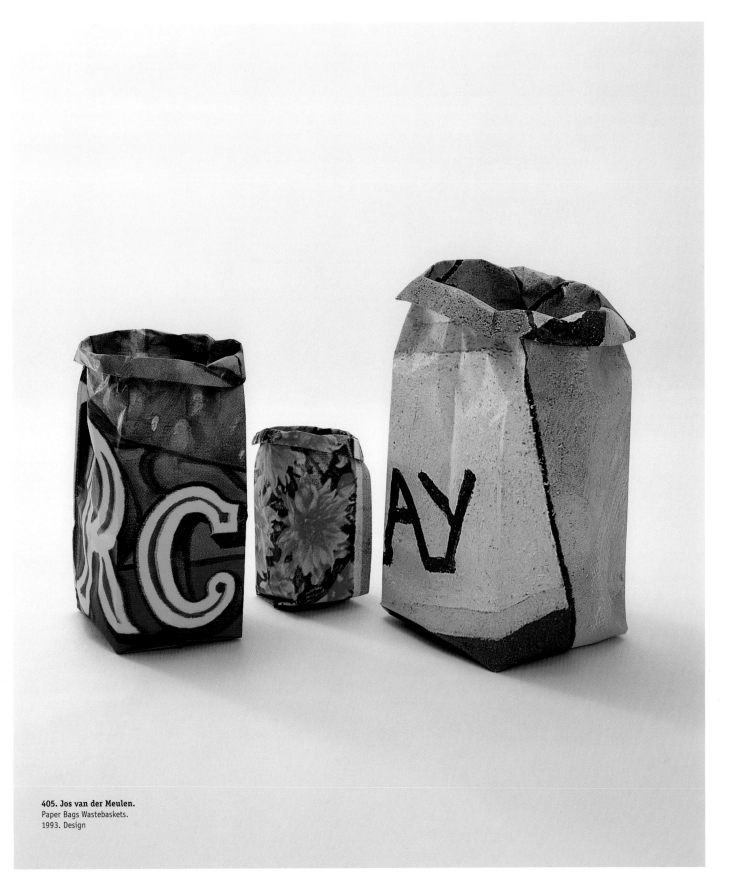

405. Jos van der Meulen.
Paper Bags Wastebaskets.
1993. Design

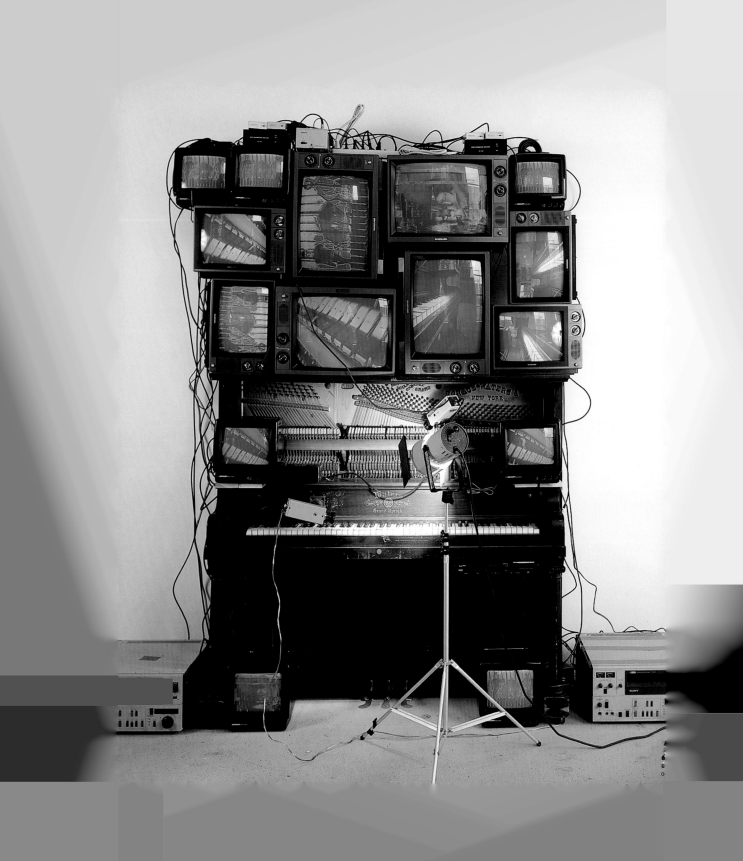

407. Hal Hartley.
Amateur. 1994. Film

408. Quentin Tarantino.
Pulp Fiction. 1994. Film

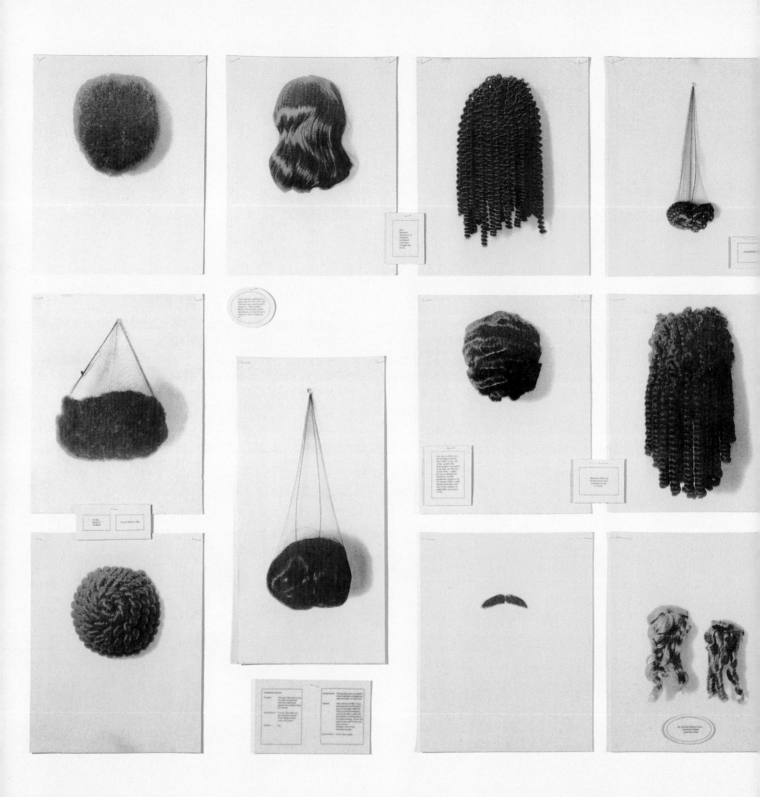

409. Lorna Simpson.
Wigs (Portfolio). 1994.
Prints

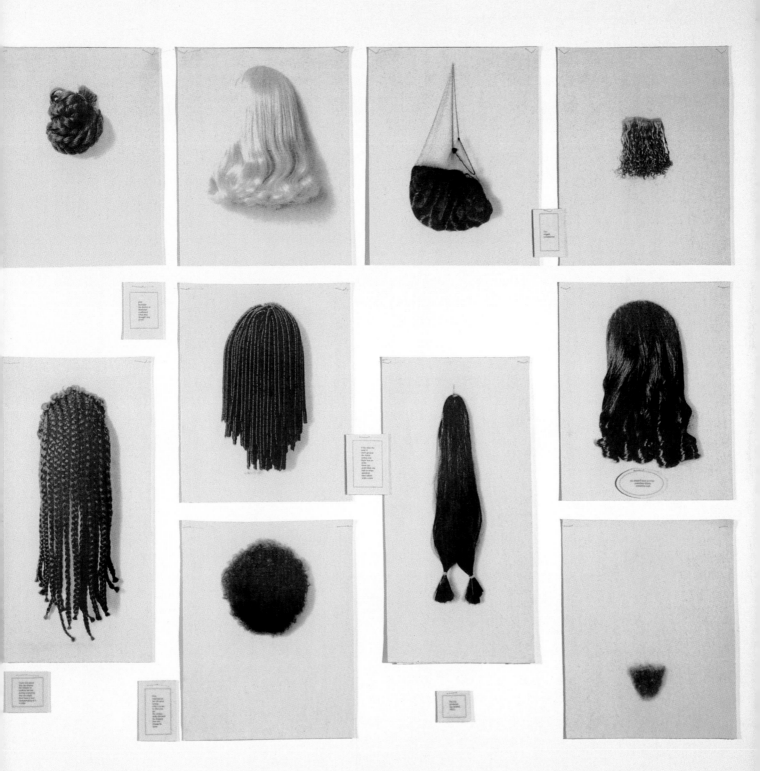

410. Renzo Piano.
Kansai International
Airport, Osaka, Japan.
1988–94.
Architectural model

411. Takeshi Ishiguro.
Rice Salt-and-Pepper Shakers.
1994. Design

412. Kim Jones.
Untitled. 1991–94.
Drawing

413. Andreas Gursky.
Shatin. 1994. Photograph

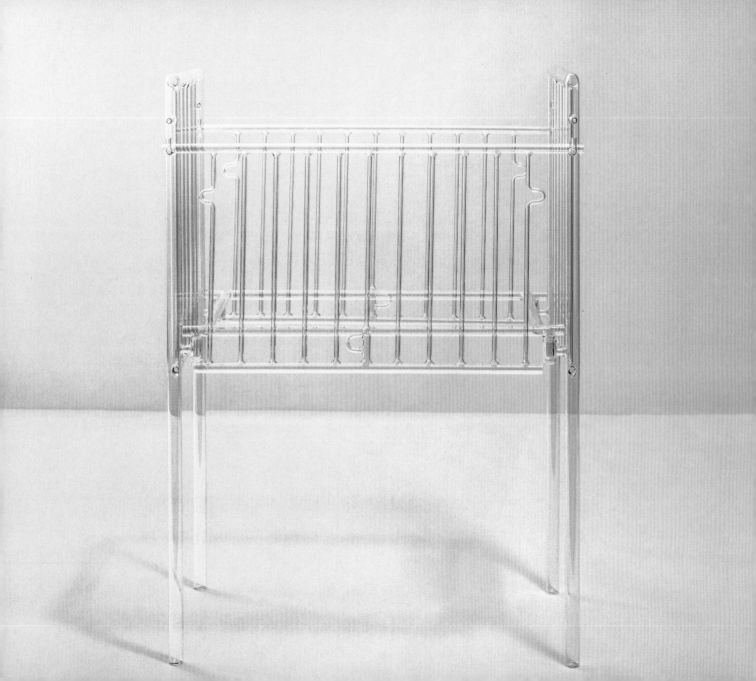

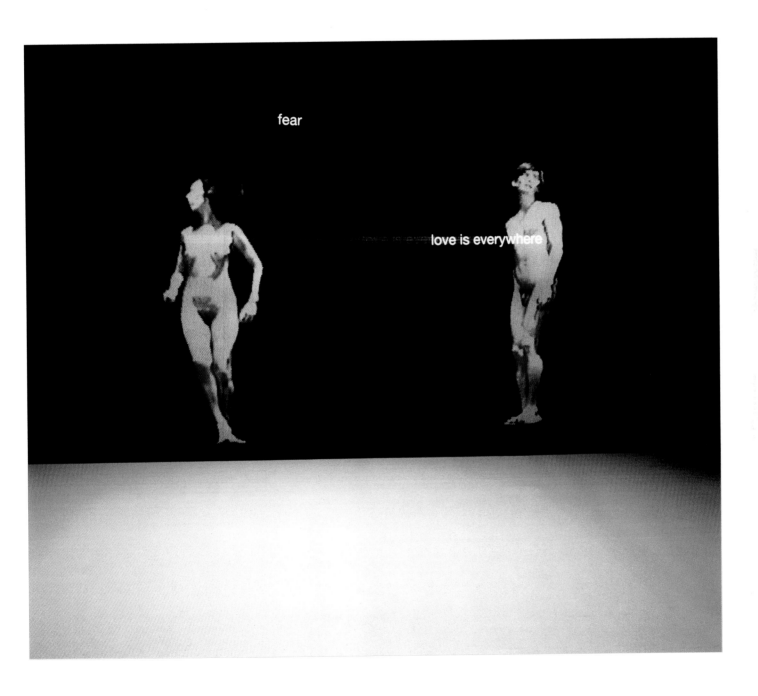

opposite:
414. Mona Hatoum.
Silence. 1994. Sculpture

above:
415. Teiji Furuhashi.
Lovers. 1994.
Video installation

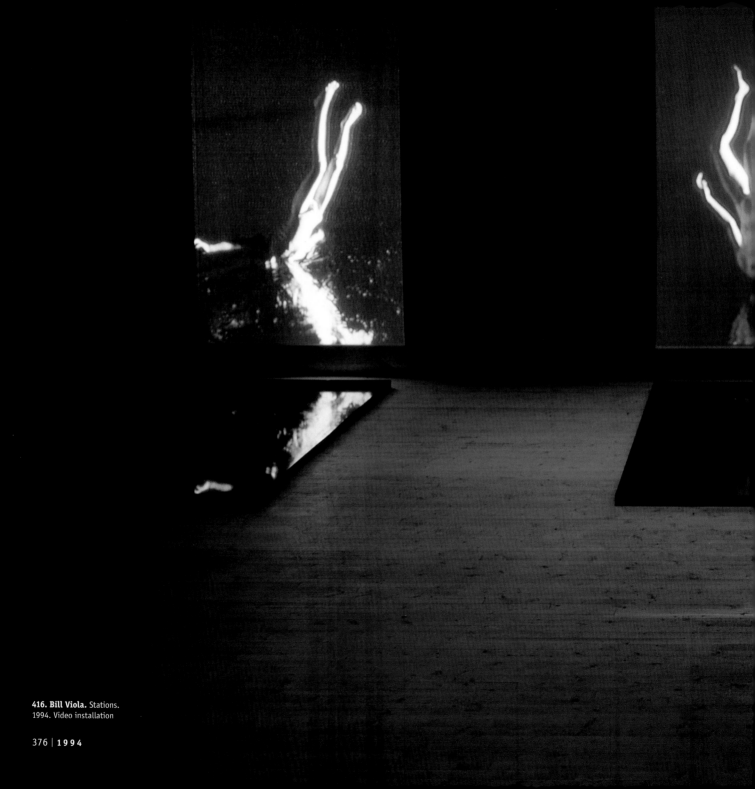

416. Bill Viola. Stations.
1994. Video installation

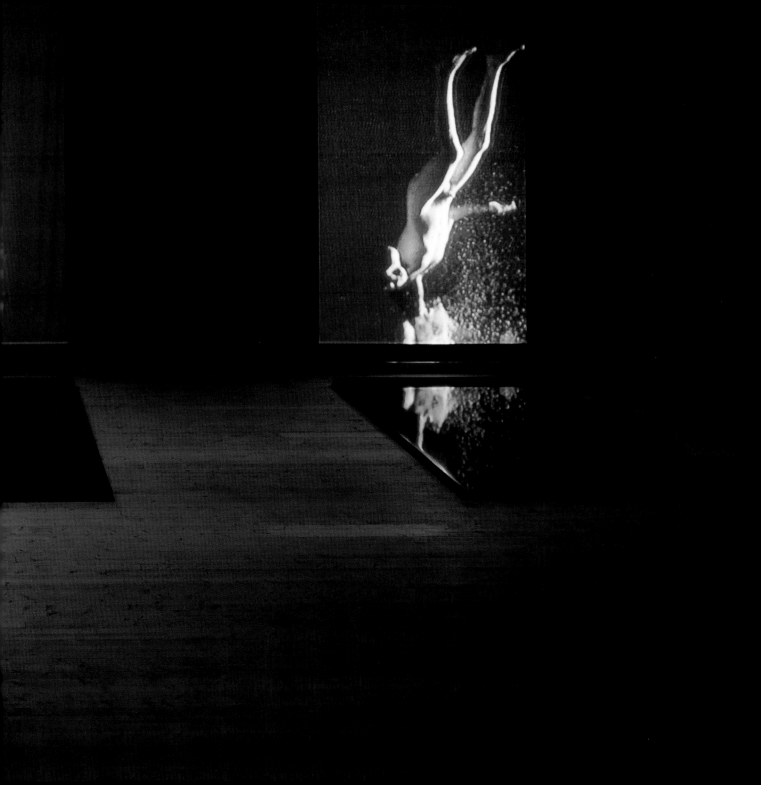

417. Jenny Holzer.
Truisms projects. 1980–94.
Multiples

418. Robert Gober.
Untitled. 1993–94.
Sculpture

419. Ann Hamilton.
Seam. 1994. Video
installation

420. Ross Bleckner.
Memorial II. 1994. Painting

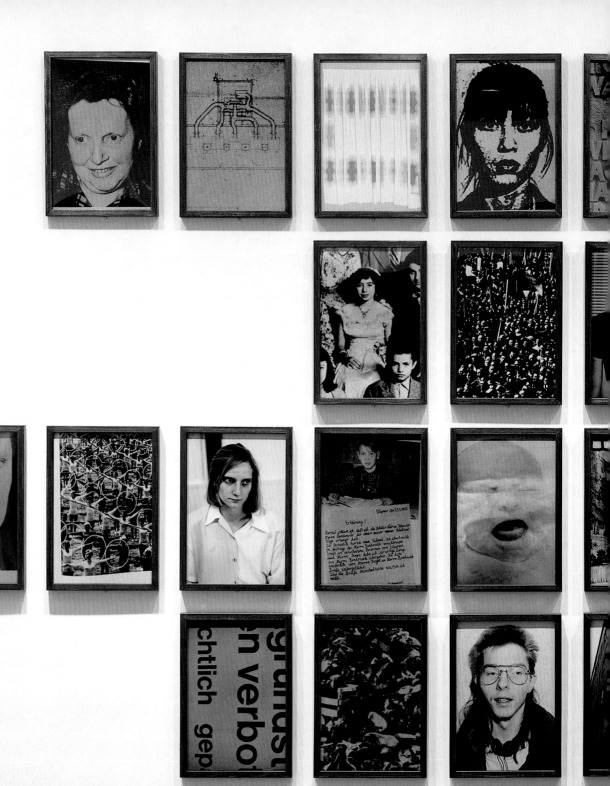

421. Michael Schmidt.
U-ni-ty (Ein-heit).
1991–94. Photographs

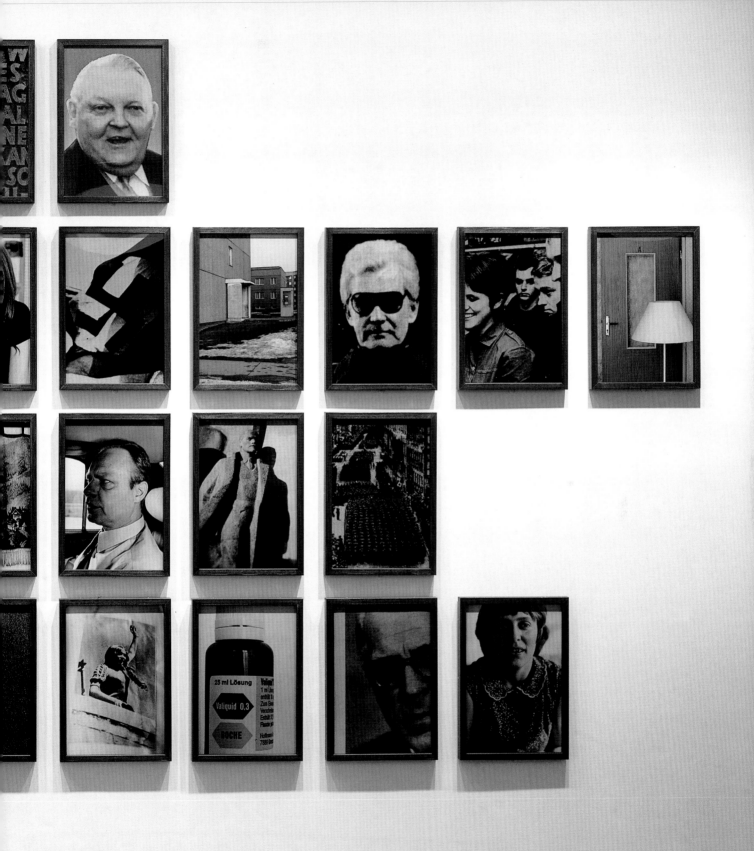

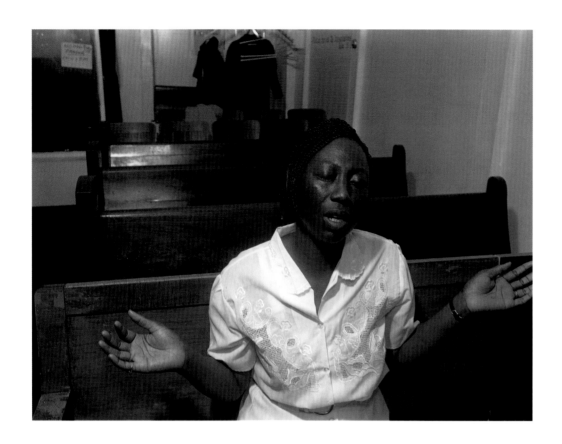

422. Thomas Roma.
Untitled from the series
Come Sunday. 1991–94.
Photograph

423. Richard Artschwager.
Five untitled works. 1994.
Sculptures

424. Uta Barth.
Ground #35. 1994.
Photograph

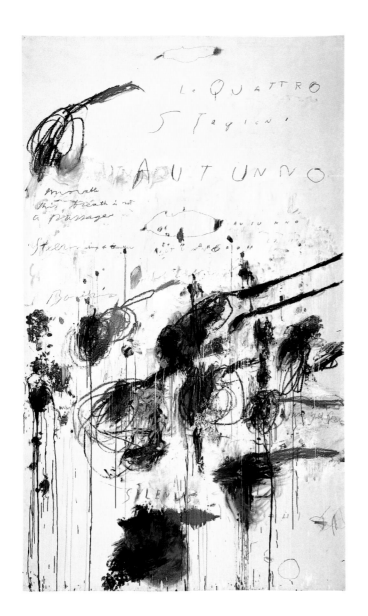
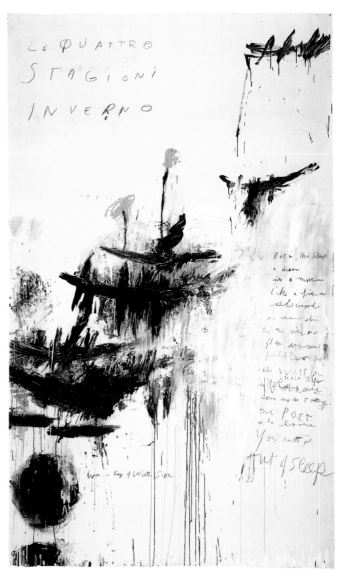

425. Cy Twombly.
The Four Seasons: Autumn,
Winter, Spring, and Summer.
1993–94. Paintings

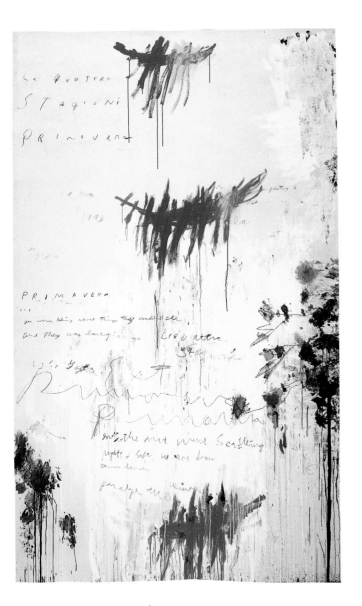

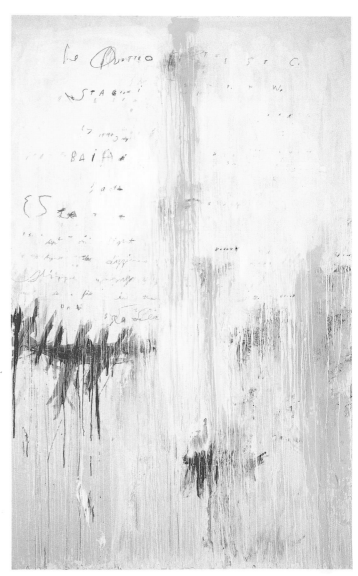

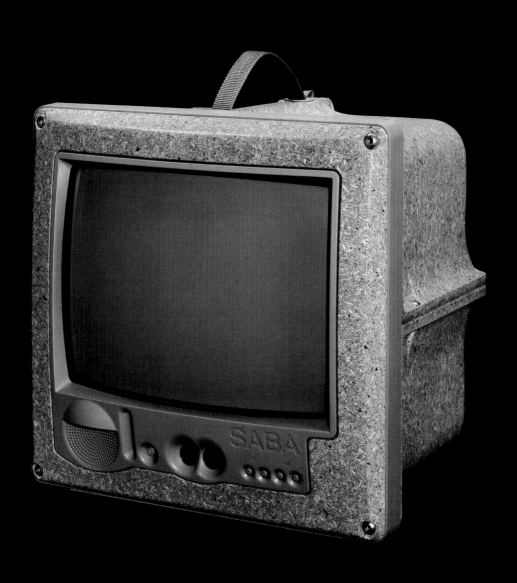

426. Philippe Starck.
Jim Nature Portable Television.
1994. Design

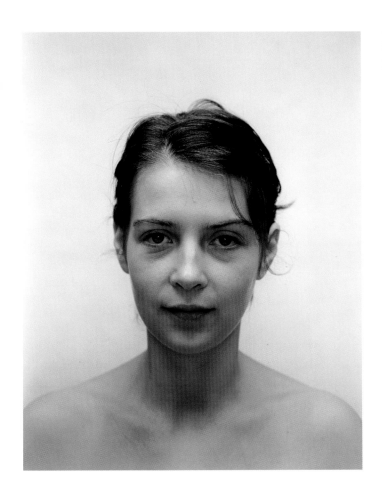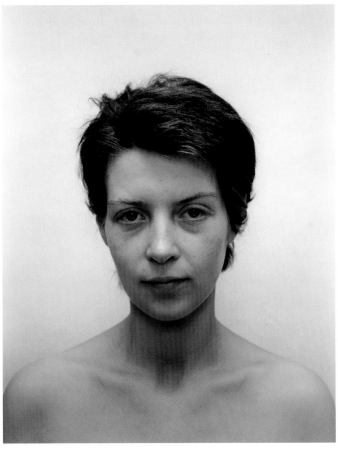

427. Rineke Dijkstra.
Tia, Amsterdam, the Netherlands,
14 November 1994. Tia, Amsterdam,
the Netherlands, 23 June 1994.
1994. Photographs

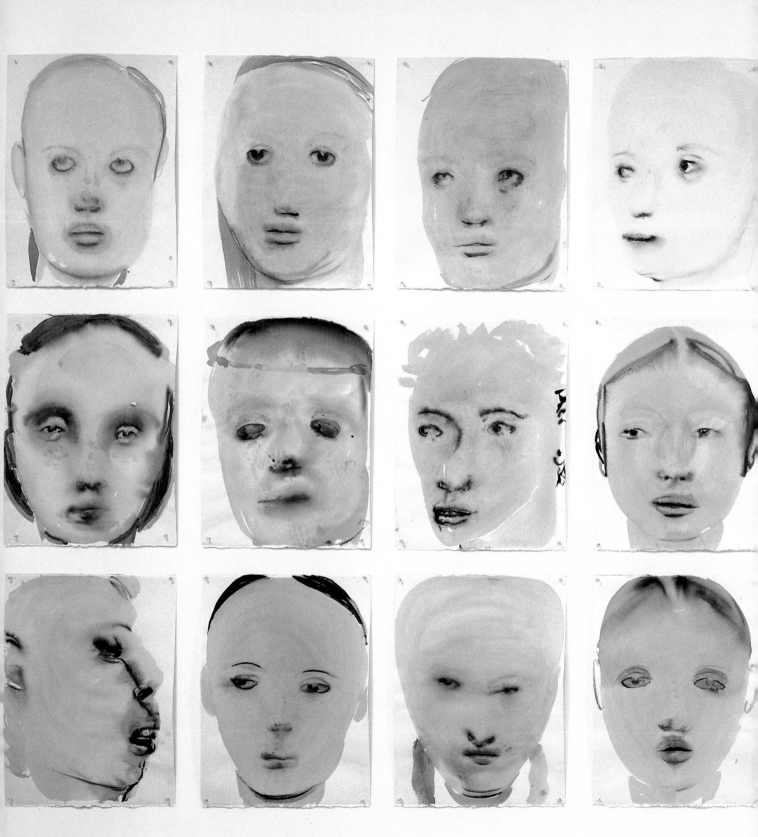

428. Marlene Dumas.
Chlorosis. 1994. Drawings

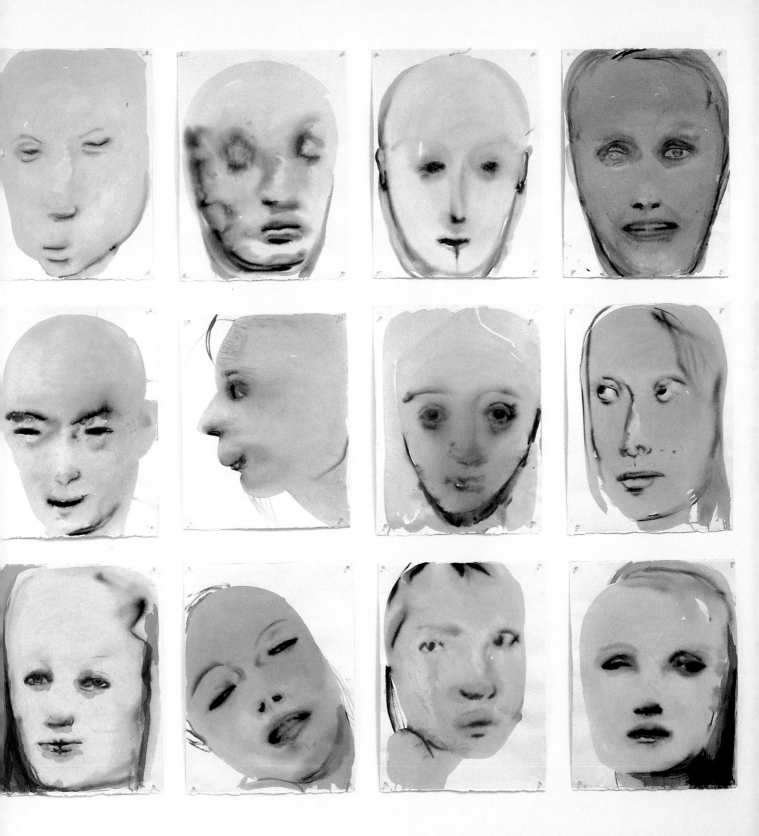

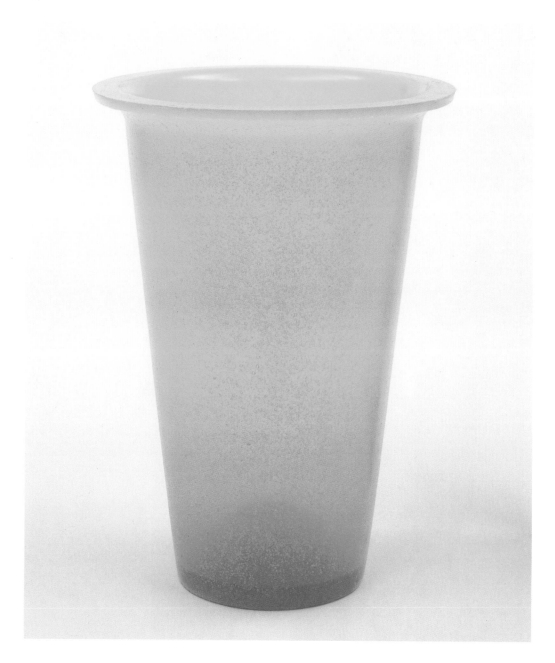

429. Hella Jongerius.
Soft Vase. 1994. Design

opposite:
430. James Turrell.
A Frontal Passage. 1994.
Installation

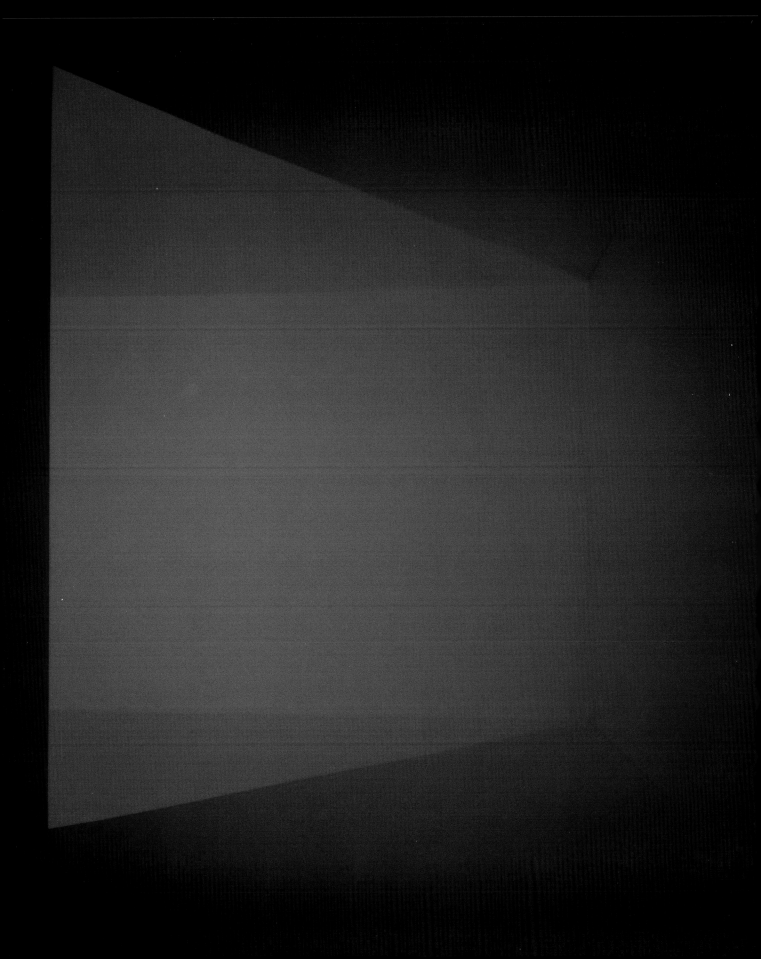

433. Louise Bourgeois.
Fenelon. 1994. Drawing

434. Bob Evans.
Tan Delta Force Fin.
1994. Design

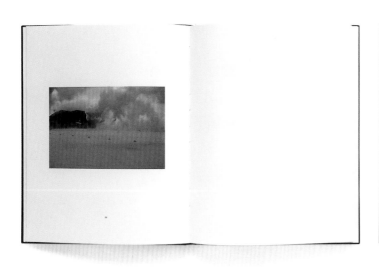

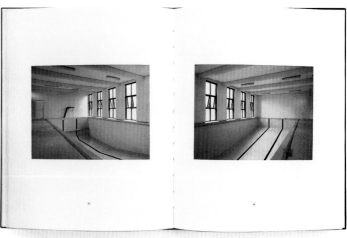

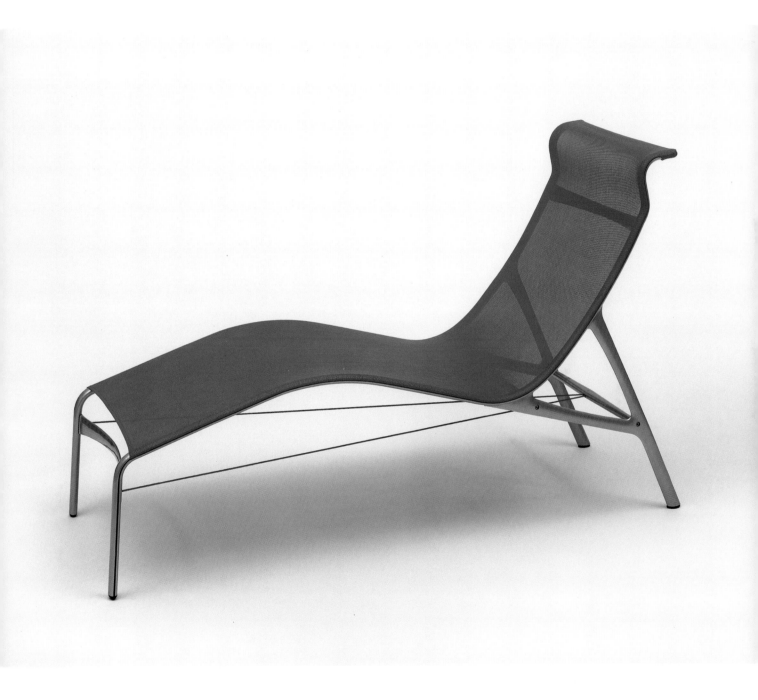

438. Glenn Ligon.
White #19. 1994. Painting

opposite:
439. Carrie Mae Weems.
You Became a Scientific
Profile; A Negroid Type;
An Anthropological Debate;
A Photographic Subject.
From the series From Here I
Saw What Happened and I
Cried. 1995. Photographs

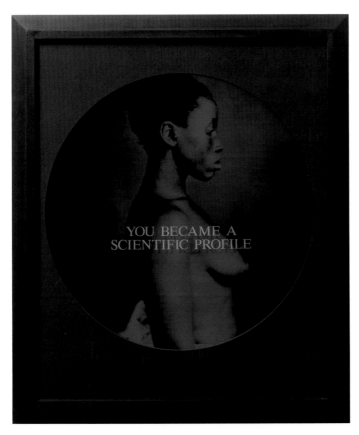

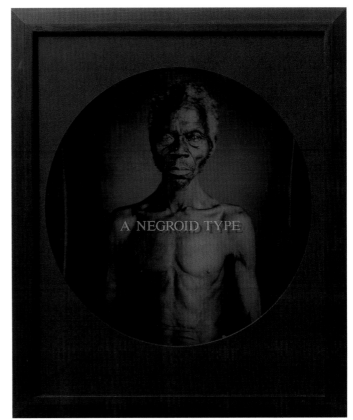

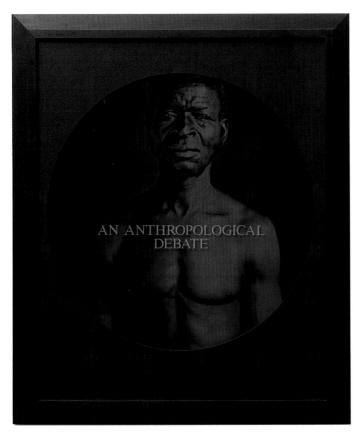

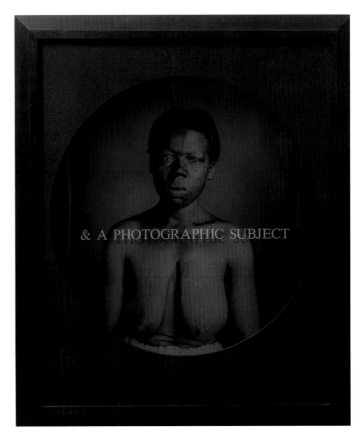

440. Louise Bourgeois.
Ode à ma mère. 1995.
Illustrated book

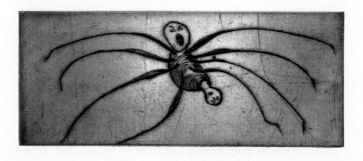

441. Marcel Wanders.
Knotted Chair. 1995. Design

442. Tom Friedman.
Untitled. 1995. Sculpture

opposite:
443. Peter Halley.
Exploding Cell Wallpaper.
1995. Prints

overleaf:
444. Toba Khedoori.
Untitled (Doors). 1995.
Drawing

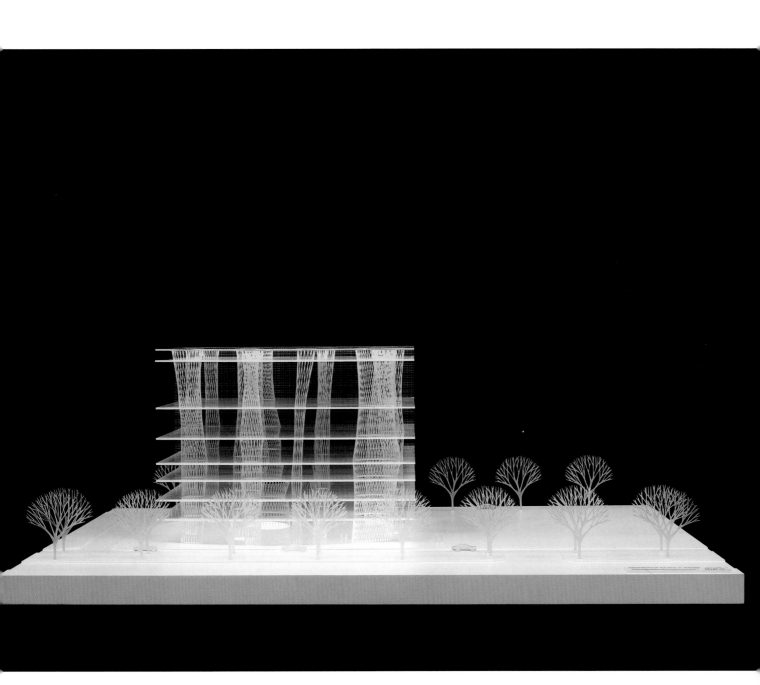

opposite:
445. Ellen Gallagher.
Oh! Susanna. 1995. Painting

above:
446. Toyo Ito.
Mediathèque Project,
Sendai, Japan. 1995.
Architectural model

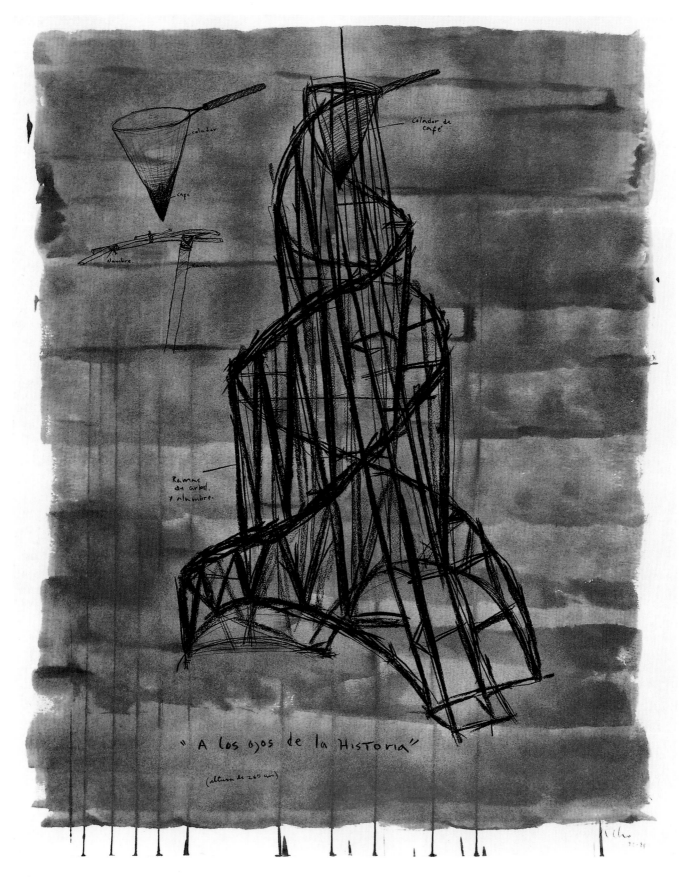

colador

café

colador de café

alambre

Ramas de arbol, y alambre.

" A los ojos de la Historia "

(altura de 2.65 mts)

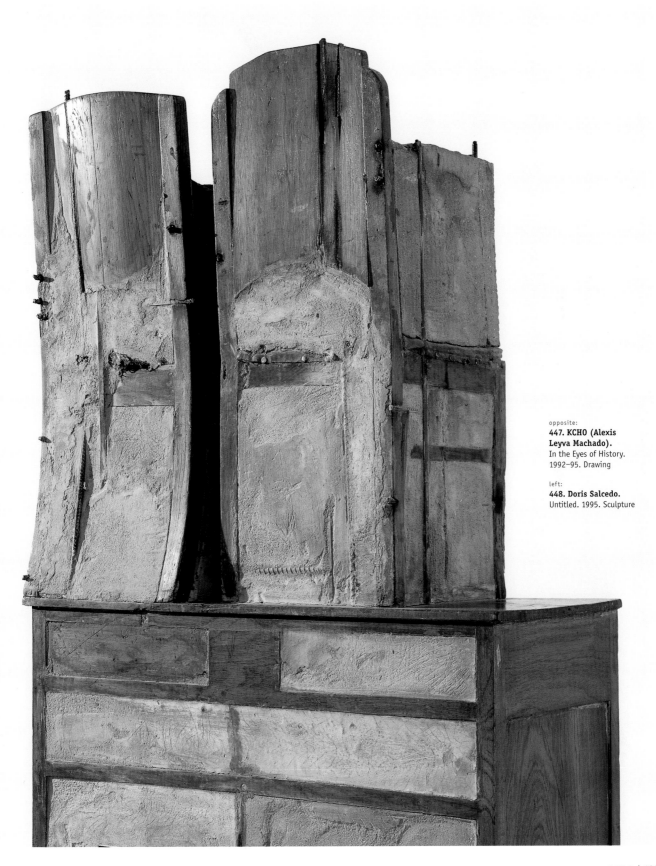

opposite:
**447. KCHO (Alexis
Leyva Machado).**
In the Eyes of History.
1992–95. Drawing

left:
448. Doris Salcedo.
Untitled. 1995. Sculpture

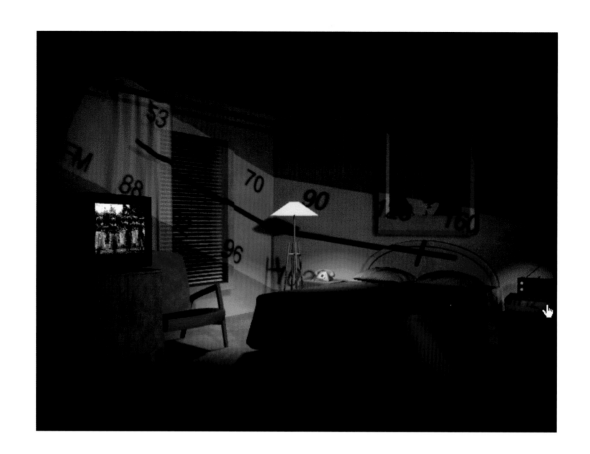

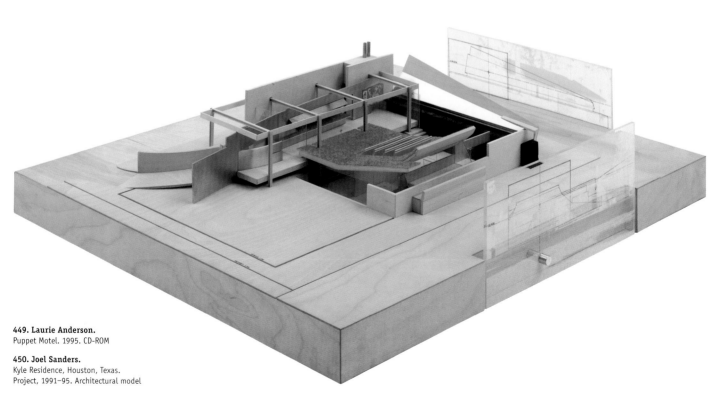

449. Laurie Anderson.
Puppet Motel. 1995. CD-ROM

450. Joel Sanders.
Kyle Residence, Houston, Texas.
Project, 1991–95. Architectural model

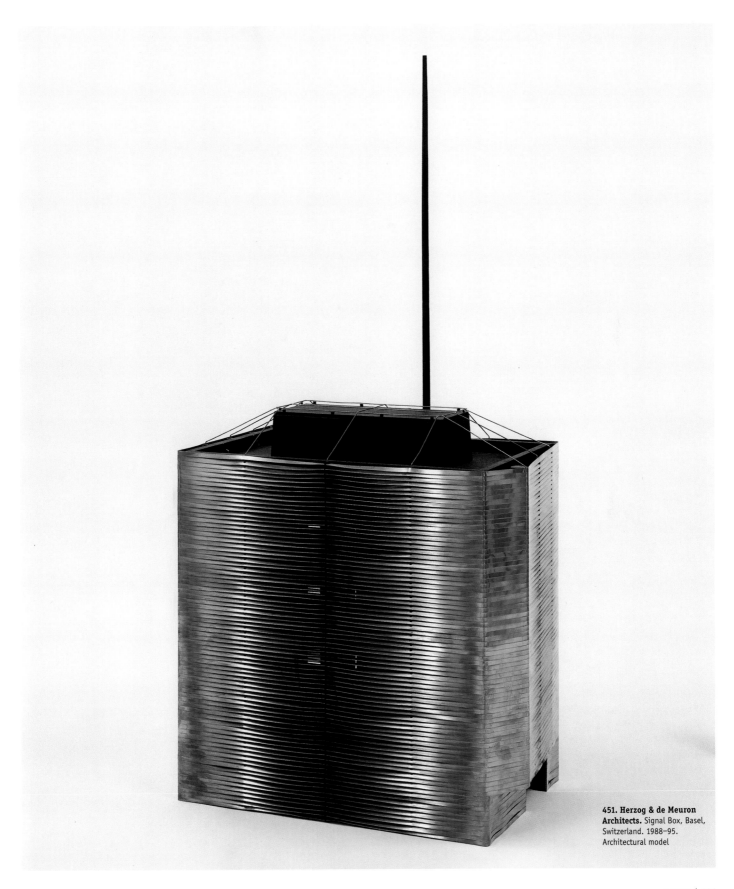

451. Herzog & de Meuron Architects. Signal Box, Basel, Switzerland. 1988–95. Architectural model

452. Sigmar Polke.
Bulletproof Vacation
magazine. 1995. Prints

opposite:
453. Chuck Close.
Dorothea. 1995.
Painting

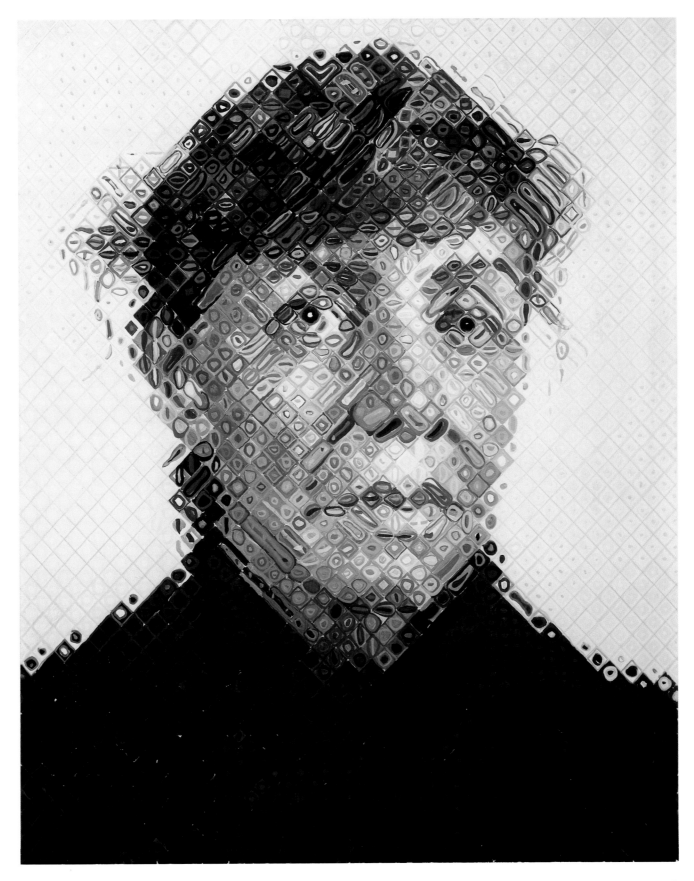

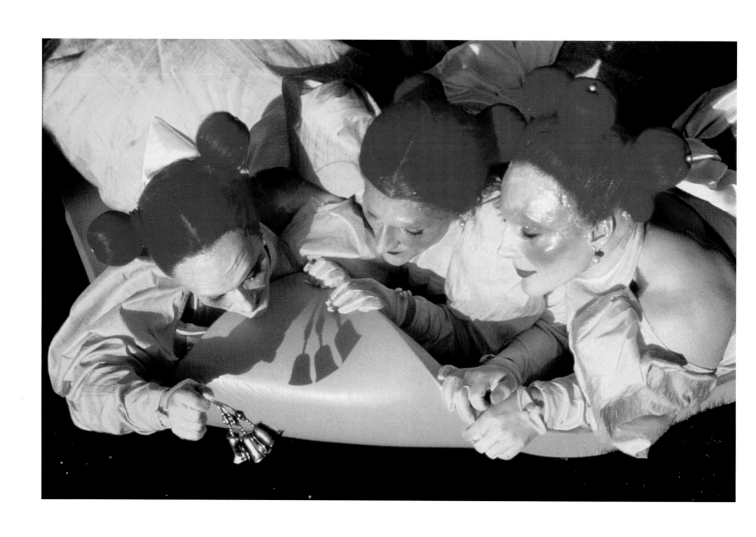

454. Matthew Barney.
Cremaster 4. 1994–95. Video

455. cyan.
Foundation Bauhaus
Dessau, Events,
July–August 1995
(Event Stiftung Bauhaus
Dessau, Jul–Aug 1995).
1995. Poster

456. Sheron Rupp.
Untitled (Bayside,
Ontario, Canada).
1995. Photograph

457. Stan Douglas.
Historic set for "Der Sandman"
at DOKFILM Studios, Potsdam,
Babelsburg, December 1994.
1995. Photograph

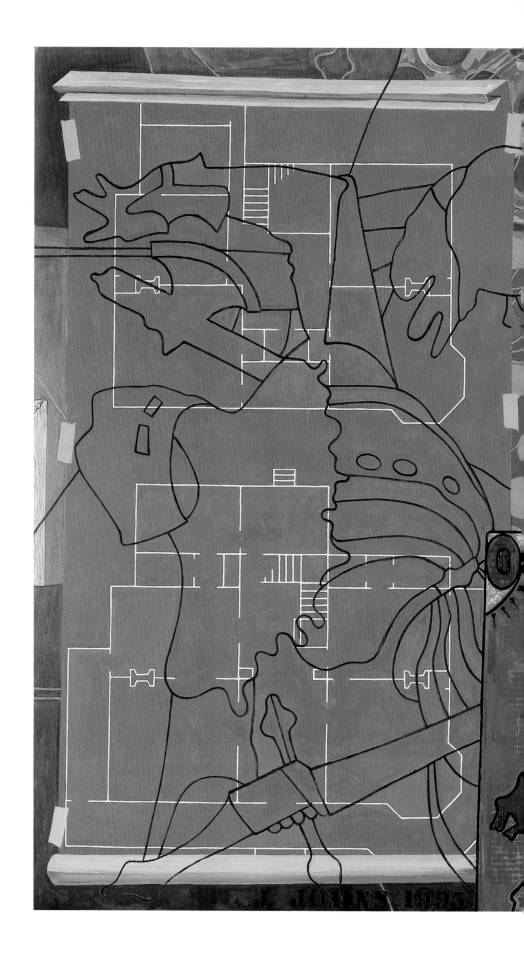

458. Jasper Johns.
Untitled. 1992–95. Painting

459. Inoue Pleats Co., Ltd.
Wrinkle P. 1995. Design

460. Luc Tuymans.
A Flemish Intellectual. 1995.
Drawing

461. Luc Tuymans.
The Heritage IV. 1996.
Painting

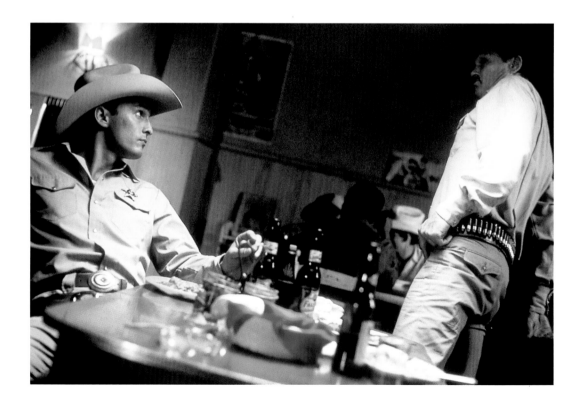

462. Joel and Ethan Coen.
Fargo. 1996. Film

463. John Sayles.
Lone Star. 1996. Film

464. José María Sicilia.
Two volumes of Le Livre
des mille nuits et une nuit.
1996. Illustrated books

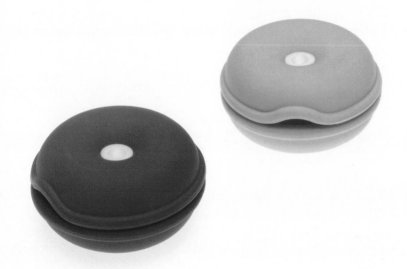

465. Flex Development B.V.
Cable Turtle. 1996. Design

466. Mona Hatoum.
Rubber Mat. 1996. Multiple

467. John Armleder.
Gog. 1996. Prints

468. David Hammons.
Out of Bounds. 1995–96.
Drawing

opposite:
469. KCHO (Alexis Leyva Machado). The Infinite Column I. 1996. Sculpture

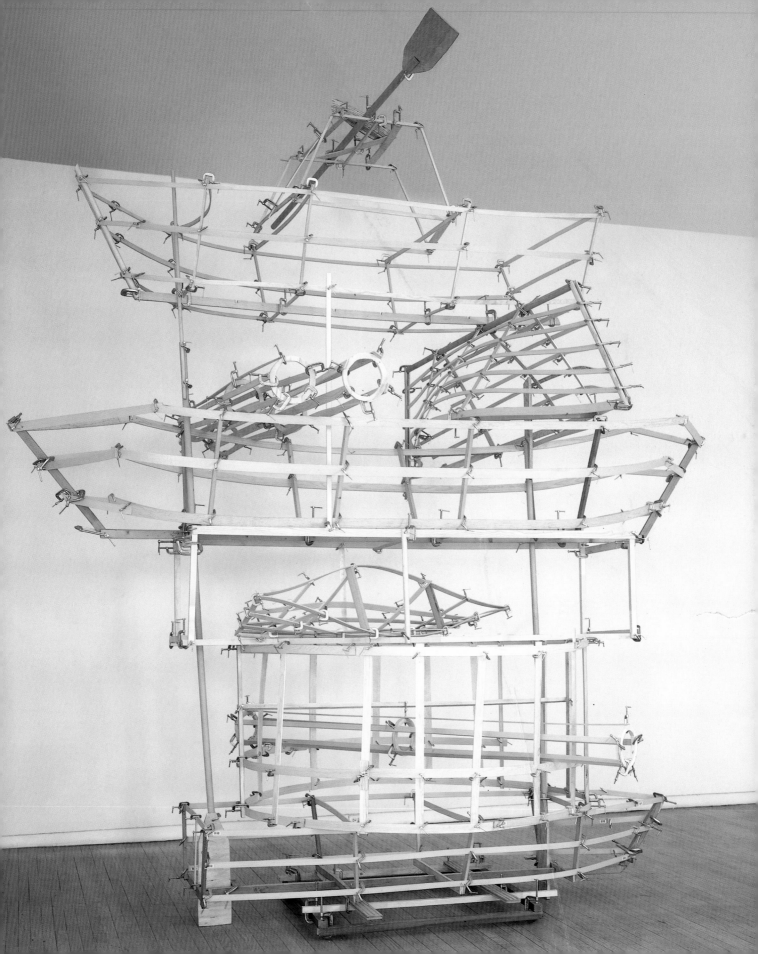

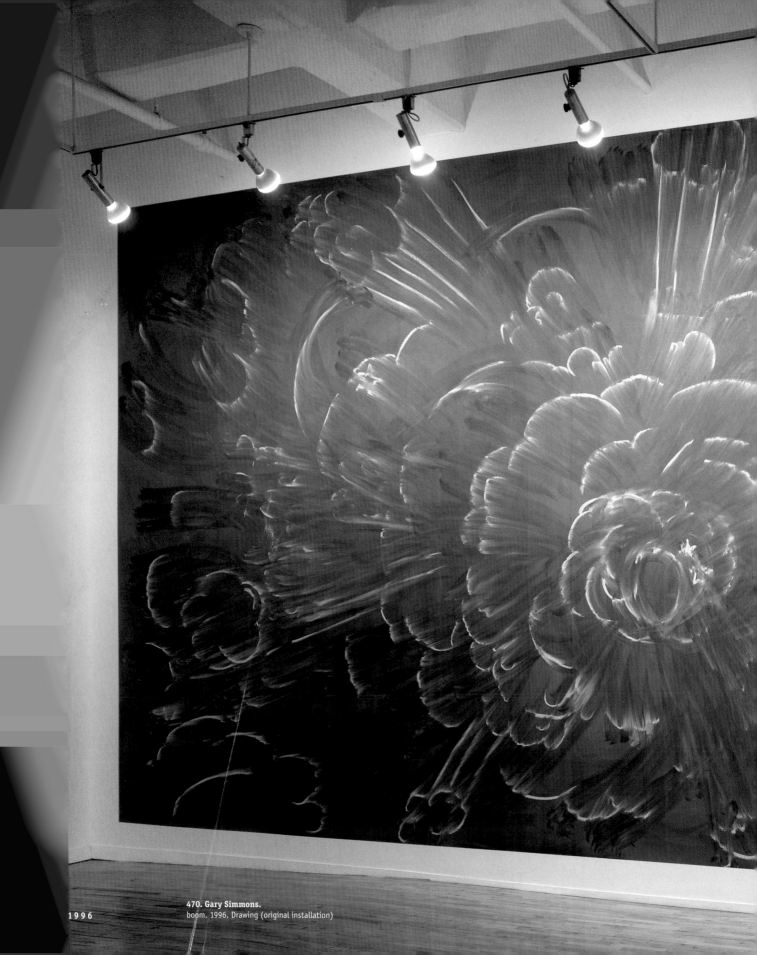

470. Gary Simmons.
boom. 1996. Drawing (original installation)

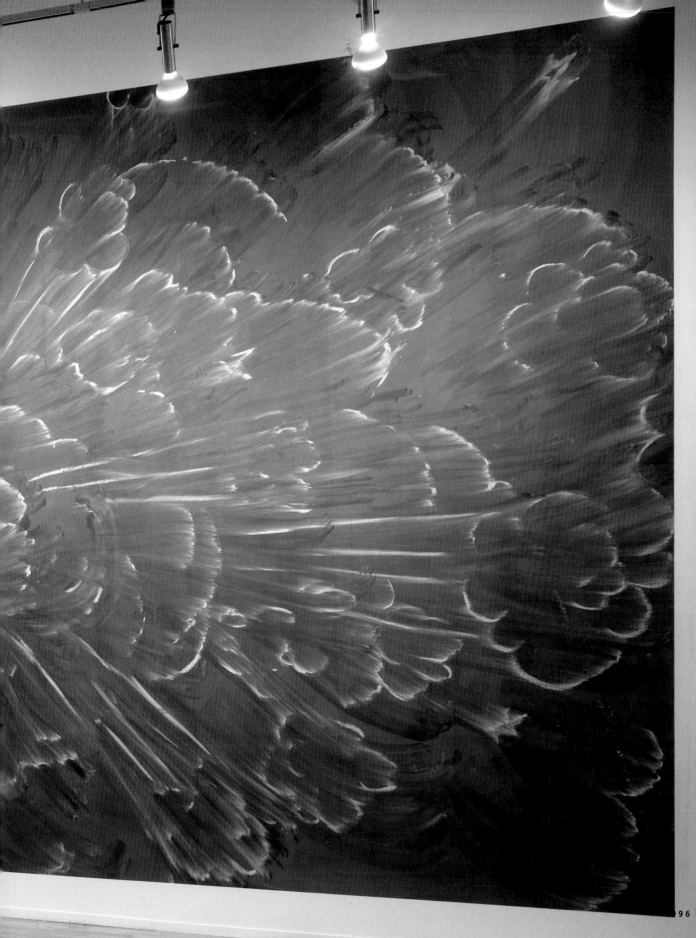

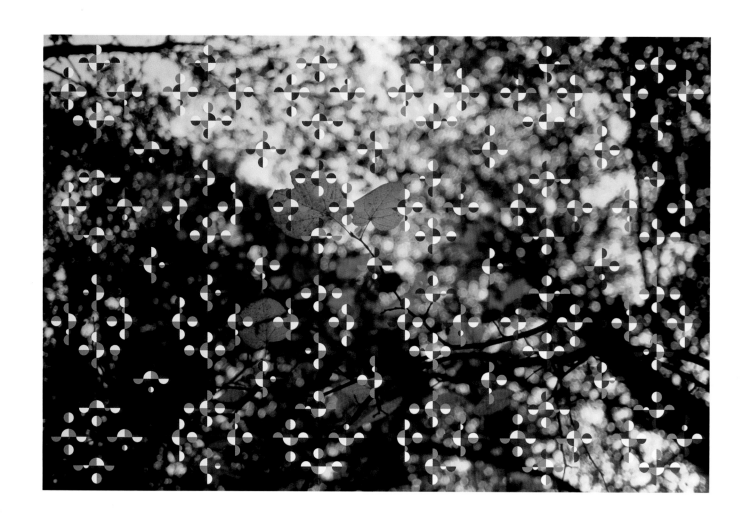

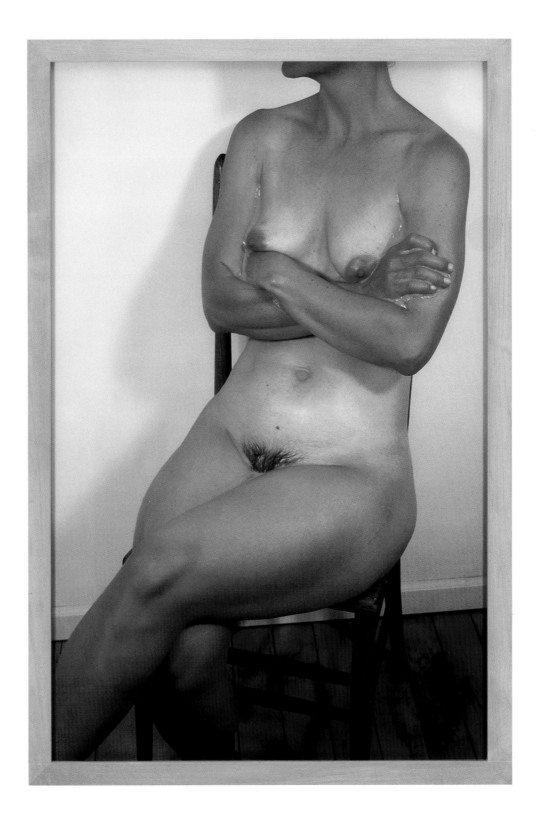

opposite:
471. Gabriel Orozco.
Light Through Leaves.
1996. Print

472. Chris Ofili.
North Wales. 1996.
Prints

473. Jeanne Dunning.
Untitled. 1996. Photograph

474. Thomas Demand.
Room. 1996. Photograph

475. Andrea Zittel.
A-Z Escape Vehicle: Customized
by Andrea Zittel. 1996.
Sculpture

476. Werner Aisslinger.
Juli Armchair. 1996. Design

477. Franz West.
Spoonerism. 1996.
Installation

478. Al Pacino.
Looking for Richard.
1996. Film

479. Toray Industries, Inc.
Encircling Fishing Net. 1996.
Design

480. Ken Jacobs.
Disorient Express.
1996. Film

481. Igor Moukhin.
Moscow, May 9, 1996.
1996. Photograph

482. Kiki Smith.
Constellations. 1996.
Print

483. Raymond Pettibon.
Untitled (Justly Felt and Brilliantly Said). 1996. Illustrated book

484. Kara Walker.
Freedom: A Fable or A Curious Interpretation of the Wit of a Negress in Troubled Times. 1997. Illustrated book

opposite:
485. Arthur Omar.
The Last Mermaid. 1997. Video

486. Kristin Lucas.
Host. 1997. Video

overleaf:
487. Vik Muniz.
Mass from the series Pictures of Chocolate. 1997. Photographs

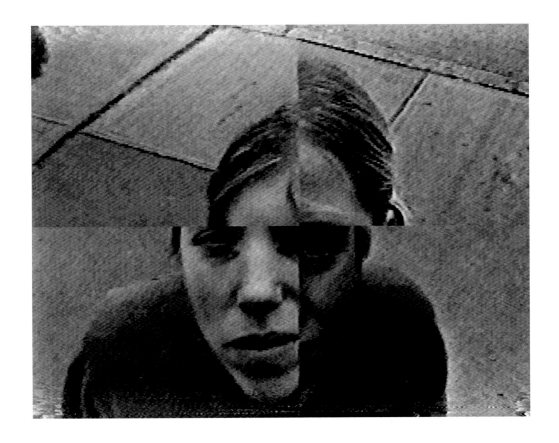

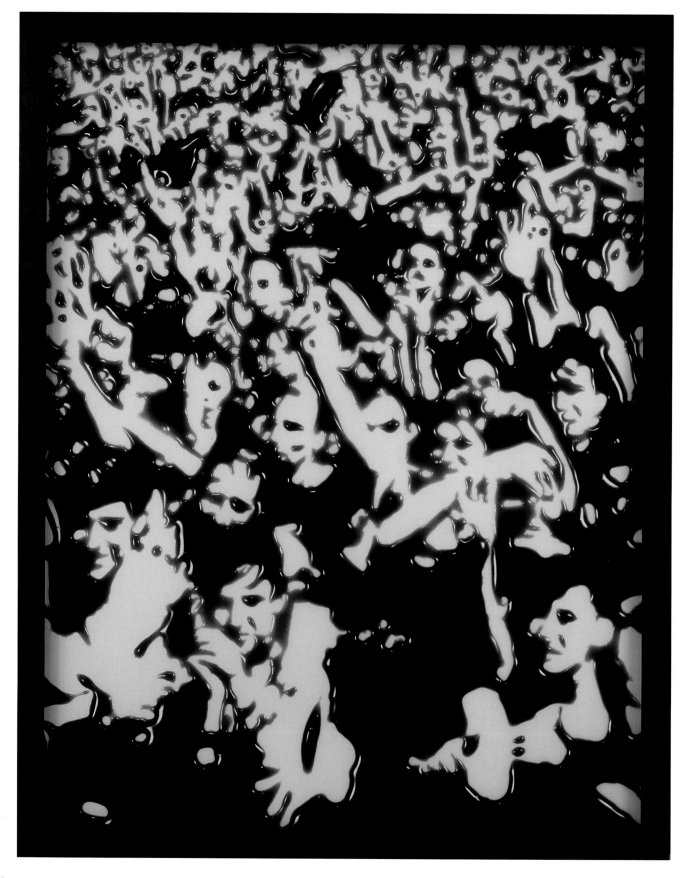

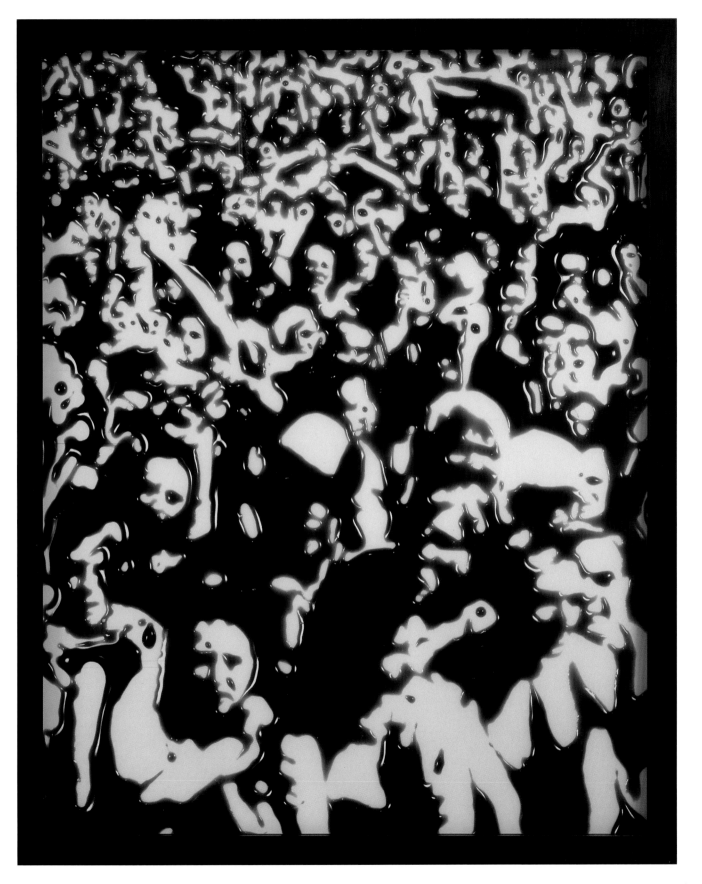

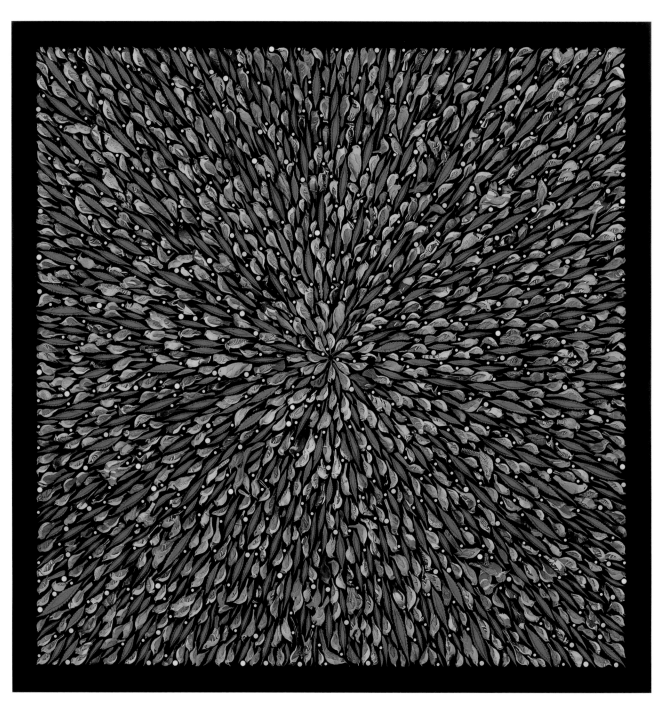

488. Fred Tomaselli.
Bird Blast. 1997. Painting

opposite:
489. Chuck Close.
Self-Portrait. 1997. Painting

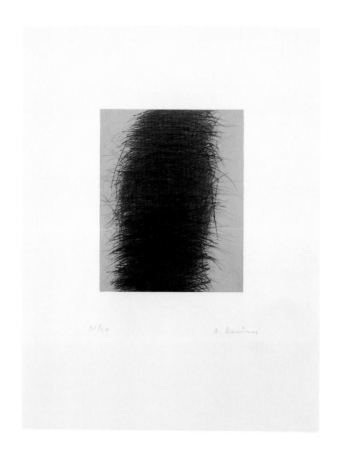

31/35 A kanim

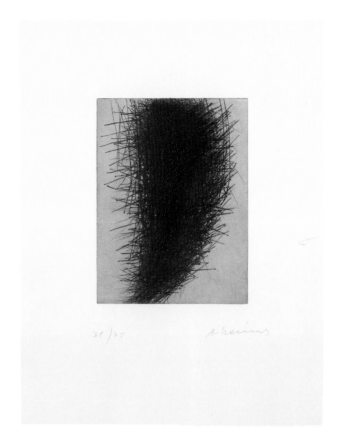

31/35 A kanim

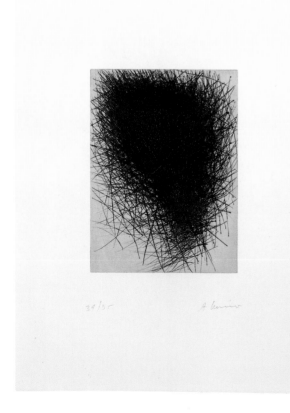

34/35 A kanim

31/35 A kanim

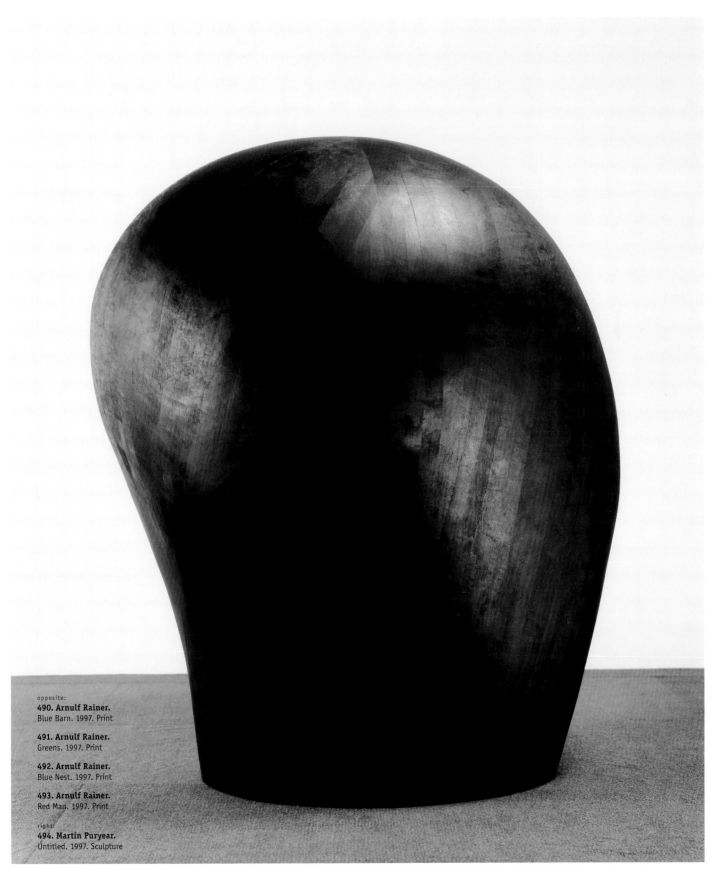

opposite:
490. Arnulf Rainer.
Blue Barn. 1997. Print

491. Arnulf Rainer.
Greens. 1997. Print

492. Arnulf Rainer.
Blue Nest. 1997. Print

493. Arnulf Rainer.
Red Man. 1997. Print

right:
494. Martin Puryear.
Untitled. 1997. Sculpture

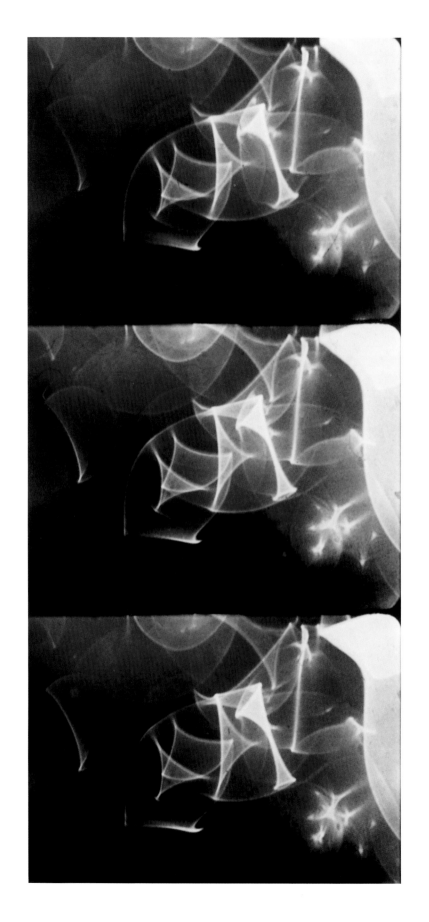

495. Stan Brakhage.
Commingled Containers.
1997. Film

opposite:
496. Reiko Sudo.
Origami Pleat Scarf.
1997. Design

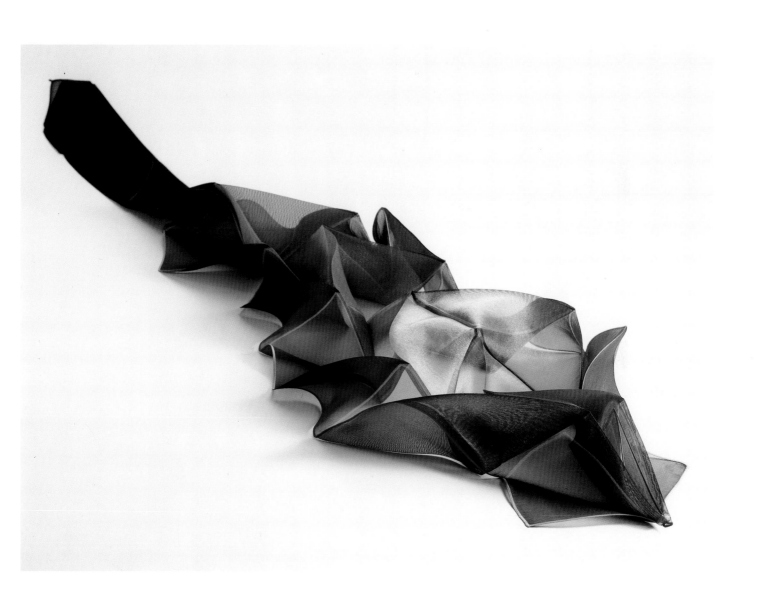

497. Reiko Sudo.
Shutter. 1997. Design

opposite:
498. Daniel Libeskind.
Berlin Museum with Jewish
Museum, Berlin, 1989–97.
Architectural model

4/16

St

499. Willie Cole.
Stowage. 1997. Print

500. Kiki Smith.
Endocrinology. 1997.
Illustrated book

501. William Kentridge.
Ubu Tells the Truth. 1996–97.
Prints

AND

502. John Baldessari.
Goya Series: And. 1997.
Painting

opposite:
503. Rachel Whiteread.
Untitled (Paperbacks).
1997. Installation

504. Franz West.
Hangarounds. 1997.
Drawing (two-sided)

505. Lewis Klahr.
Pony Glass. 1997. Animated film

506. Sue Williams.
Mom's Foot Blue and
Orange. 1997. Painting

opposite:
507. Yukinori Yanagi.
Wandering Position. 1997.
Prints

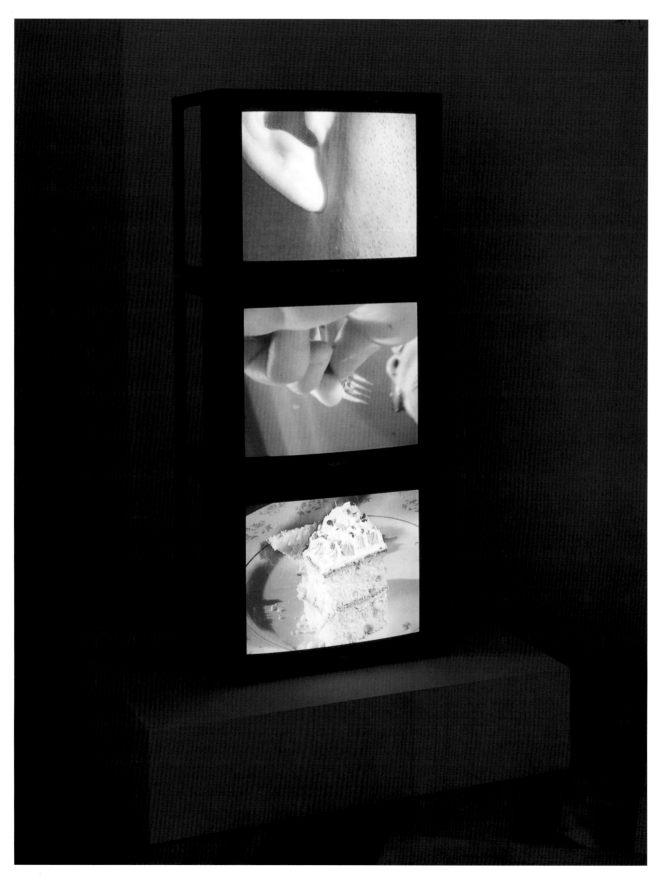

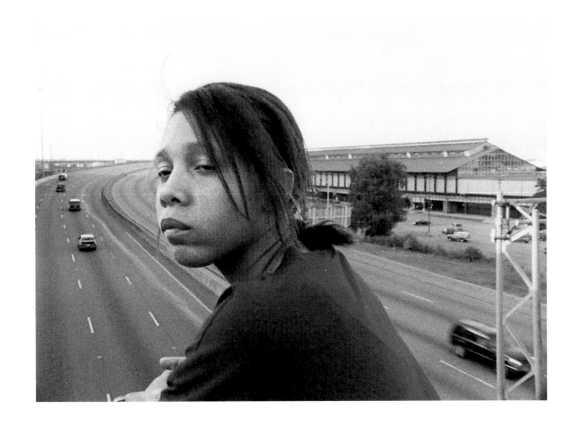

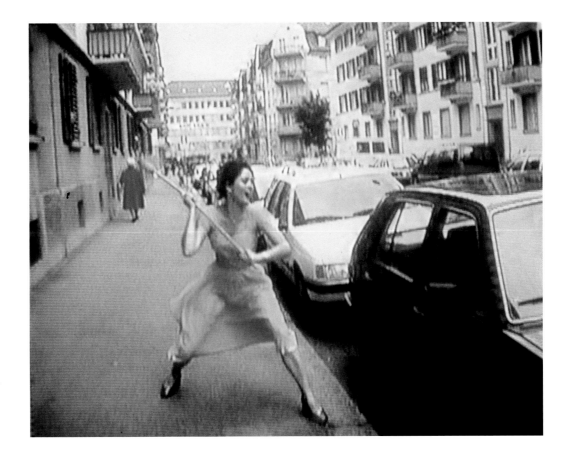

508. Zhang Peili.
Eating. 1997.
Video installation

509. David Williams.
Thirteen. 1997. Film

510. Pipilotti Rist.
Ever Is Over All. 1997.
Video installation

IT'S TIME FOR LUNCH." "IT'S TEN THIRTY!" YOU SEE THEM THROUGH

APER. THE GUY NEAREST PUTS THE PAPER DOWN AND POINTS, "RIGHT

HOP. THEY SELL MEATBALL SANDWICHES - THE BEST IN THE WORLD."

EANING ON THE SIDE OF THE CAR, "GO ON, WOULD YOU GO AND GET ME TW

ACK AT HIM,"CUMON PARTNER, TWO." THE GUY GETS OUT OF THE CAR, YOU

OOR SLAMS. HE STARTS READING THE PAPER AGAIN AND SAYS, "THANK YO

EADING THE PAPER, THEN HE PULLS HIMSELF UP OUT OF THE WINDOW AND YELL

ITH HIS FINGERS. HE GETS OUT OF THE CAR AND IS IN THE PLACE SAYING,

ND ONE TUNA ON WHEAT, THANK YOU." SHE'S SERVING HIM. THROUGH THE WIND

MALL AND THE GLASS MAKES IT QUIET. THREE, MAYBE FOUR GUYS PILE OUT, A

OOKS LIKE A ROAD KILL." "ROAD KILL?" "SEE THAT CAR PULL UP?" "THAN

OWWOWW!" RUSTLES AROUND THE PAPERS LIKE HE CAN'T WAIT TO GET IN AND G

OULD EAT THE WINNETS OUT OF A DEAD RHINO'S ARSE... I SHOULD OF GOT YOU

NTO THE HUGE SANDWICH AND SQUINTS ACROSS, "WHAT CAR?" THE GUY POINTS

HE STRAW AT THE SAME TIME. ACROSS THE WAY THREE, MAYBE FOUR PEOPLE PILE OUT

NTO THE CAR, THE CAR ACROSS THE ROAD - JUST AS FAST. HE'S PULLING SOME

THER GUY, BUT HE SHOUTS, "GODDAMN IT!" HE'S UP, NOT IN THE CAR ANYMORE. HOLDI

NG REALLY FAST, "GODDAMNIT!" HE SWERVES ROUND,"FREEZE... FREEZE!" RUNNING FO

OMES BACK FROM THE CAR, "I GOT HIM... I GOT HIM!" THEN YOU SEE ONE OF THE

OT A WEIRD PLASTICY FACE, LIKE A MASK. HE HOLDS SOMETHING OUT IN FRONT OF HIM,

HE OTHERS, JUST BEFORE HE GETS INTO THE CAR, SLAMS HIS FIST DOWN ON THE GUN

FRIEEEZE..." AGAIN AND THE CAR SQUEALS OFF. HE'S THERE HOLDING THE GUN DEAD STRAI

HEN THREE OR FOUR MORE, BUT ALL YOU SEE IS THEM GOING INTO THE BOOT OF THE CAR AS

NE OF THEM SHATTERS THE BACK WINDSCREEN. IT ALL FALLS OUT THEN ALL YOU CAN SEE IS THE B

Y UNEVEN. SUDDENLY HIS CAR IS RIGHT BEHIND. HE FIRES OUT THE LITTLE JAGS OF FIRE, HOLDI

ELLS, "COME ON... GET IN! GET IN!" FROM INSIDE. "JESUS CHRIST..." THE OTHER GUY INTERRUPT

HERE, CAN'T SEE EITHER OF THEM BECAUSE OF THE LIGHT ON THE WINDSCREEN, THE CAR SCREECHES

ROM THE GLARE, BUT YOU SEE HIM BEND FORWARDS AND REALLY TUG ON THE GEAR, THE ENGINE REVS, YOU SE

IVE BACK OF THE WING MIRROR AND THE SHAKY HORIZON. THEN IT'S GONE. YOU SEE THE RED CAR FROM TH

AR'S BLARING RED FROM THE BRAKE LIGHTS. IT'S AS IF THE CAR'S GOING TO TURN AND FOR A MOMENT YOU C

KIDS, SQUEALS ROUND THE CORNER, THE RIGHT HAND CORNER, HARD, AND YOU SEE THE WHOLE SIDE OF IT. IT'S SLI

OUDER. FOR A MOMENT THE OTHER CAR FLASHES IN FRONT THEN YOU SEE IT FROM THE FRONT, NOT ALL OF IT AND

HE METAL CRASHING AND THE SOUND OF THE ENGINES REVVING. IT'S AS IF THE CARS ARE STUCK TOGETHER. THEY'R

ONNET OF THE RED CAR AND THE GLARE ON THE WINDSCREEN'S BLINDING. THEY'RE CAREERING ROUND THE CORNER - STUCK

HE FRONT NOW. THE RED CAR KEEPS BASHING INTO THE WHITE ONE, BUT IT DOESN'T REALLY MAKE ANY IMPACT - THEY BO

T'S AS IF THEY'RE NOT EVEN MOVING, OTHER THAN FOR THE INCREDIBLE SOUND. THE RED ONE NOSES AHEAD A BIT. THEN YOU SEE

HE RED ONE BASHES IN AND I THINK IT GETS LIFTED OFF THE ROAD. THEN SUDDENLY THE ROADS RIGHT THERE IN BETWEEN THEM.

AME FROM. FOR AN INSTANT IT'S THE ONLY THING, JUST SPINNING THROUGH THE SUNLIGHT. THEN ALL YOU SEE'S HIS FACE THRO

NSIDE HIS MOUTH, "GO!" THEN YOU SEE THE DRIVER, FROM THROUGH THE OPEN WINDOW AT THE SIDE TAKING THE WHEEL, REALLY LEA

ME A FUCKIN BRAKE... I AM GOING!" THE ROAD STREAKS PAST BEHIND HIS PROFILE THEN EVERYTHING SWERVES ROUND IN FRONT, KI

IDDLE OF THE ROAD. THE BACK TIRES SLING ACROSS THE TARMAC FIRST AND A HUGE CLOUD OF EXHAUST SMOKE'S BELCHING OUT BEH

T, THEN IT'S NOWHERE NEAR. THE DARK REAR VIEW MIRROR'S DEAD IN THE MIDDLE OF THE WINDSCREEN. SOMEONE FROM THE BACK

EE THE OTHER GUY IN THE BACK SEAT TURNED TO THE ROAD BEHIND, THEN HE SWINGS ROUND AND YELLS, "I DON'T FUCKING BELIEVE T

EE THE TWO OF THEM IN THE FRONT, FROM THROUGH THE PASSENGER WINDOW, SWAYING WITH THE CAR. THEIR FACES ARE SO BIG. THE

ENGER SHOUTS, "I THINK WERE LOOSING THEM!" SOUNDS BREATHLESS AND MUTED. THEIR EXPRESSIONS ARE STRANGE, SO TOTALLY FIXED, THE

OAD FOR A SPLIT SECOND. THEN THEY COME STRAIGHT INTO A JUNCTION. HE YANKS THE WHEEL HARD, THE CAR SKIDS ONTO THE OTHER

ARMAC. YOU CAN SEE A FULL ROW OF HEADLIGHTS BEHIND THEM, ALL THE CARS QUEUED UP WAITING TO GO, THEY'RE RIGHT OVER ON

HEY'RE SQUEALING LIKE MAD. THEN JUST BEFORE THEY HIT THE CENTRAL RESERVATION THE CAR STOPS GLIDING AND SPURTS FORWARDS.

IDDLE, AND THE ROAD IN FRONT DARK FROM THE SHADOW OF THE TREES ON THE CENTRAL RESERVATION. THEN THEY'RE ON TOP OF THE

AR BECAUSE OF HIS WHITE GLOVES. YOU CAN SEE THE STEERING WHEEL AND THE HUNCHED SHOULDERS, AND THE DRIVERS GLOVES THE BACK'

LED WAY. THEN RIGHT IN FRONT OF THEM IS THE STRIPY BARRIER, THE CAR SWERVES AGAIN. THE BRAKES SQUEAL, THEN THE SAME GUY YELLS

LET IT GO." THE STRIPES GET CLOSER AND CLOSER, THEN THEY BANG RIGHT THROUGH. THEN YOU JUST SEE ANOTHER CAR COMING AT THEM. IT'

T THE RED CAR. THEN YOU SEE THE PASSENGERS SCREAMING FACE, "OHHH SHHHIT." AND HIS HAND CLENCHED ON THE DASHBOARD. THE DRIVER

RIGHT ANGLE AND LEAVING LONG ARCHING TIRE MARKS BEHIND. THE WHEELS LOOK LIKE THEY'RE GOING THE OTHER WAY, LIKE THEY'RE GOING TO COM

FACE AGAIN, BLURRING ACROSS THE WINDSCREEN - HE'S SAYING SOMETHING, CAN'T HEAR ANYTHING BUT THE ROAR OF THE ENGINES. THEN YOU JUST CA

NG SO HIGH. THEN RIGHT IN FRONT IT'S JUST THE SHINY RED CAR, THE BACK OF IT, THE LIGHT ON AND THE BLARING ENGINE. THE PILLARS STROBE IN FR

HE CAR, WEAVING THROUGH ALL THE OTHERS, IT MUST BE A CAR PARK OR SOMETHING. ITS GOING LEFT THEN IT CHANGES AND PULLS OFF TO THE RIGHT. THE SOUND OF THE ENGIN

RABBING THE WHEEL HE'S SUCKING IN HIS LIPS, REALLY CONCENTRATING. THEN ALL THE CARS BLUR IN FRONT. THERE'S JUST ONE BIG WHITE ONE RIGHT IN FRONT

OU SEE THEY'RE SHINING EVEN MORE. IT'S GONE, STROBING BEHIND THE OTHERS, YOU SEE IT AGAIN IN GLIMPSES. THE OTHER CAR'S EVEN CLOSER AND THE DRIVEN

RESCENDOS THEN REVS EVEN HIGHER. YOU SEE ALL THE OTHER CARS, ALL DIFFERENT COLOURS BLINKING PAST, THEN THE RED CAR'S VISIBLE AGAIN - JUST THE SHINY SI

LOSE AND SO BRIGHT IT'S THE ONLY THING YOU CAN SEE. THE DRIVERS FACE IS REALLY CLOSE, LOOKING STRAIGHT OUT ONTO THE ROAD. HIS FACE IS REALLY CLOSE. TH

ALONG THE TARMAC, LOW ON ONE SIDE, BUT IT HASN'T EVEN SLOWED DOWN. THE SCRAPING SOUND ON THE TARMAC'S DEEPER AND DEEPER - THEN IT TURNS ACROSS THE RO

ASKED FOR A MOMENT BY THE BIG TREE IN THE FOREGROUND, DRAGGING THE FIRE UNDERNEATH. THEN IT PULLS STILL, AND THE WHOLE BODY JERKS ON THE CHAS

UDDY..." THEN HE'S GRABBING THE PETROL PUMP POINTING IT AT THE GUY, SAYING COAXING "TRY IT MAN... JUST TRY IT...." ALL THREE OF THEM ARE OUT PUSHING AROUN

A GUY LEANING OVER HIS CAR, IT'S BRIGHT YELLOW, HE'S SPONGING DOWN THE WINDSCREEN, SOMEONE YELLS, "I'VE GOT IT MAN... I'VE GOT IT." THE GUY LOOKS UP BEMUSED

S HIM ONTO THE BONNET. SLAM. HE YELLS, "GET AWAY FROM THE CAR... MOVE IT... GET IN..." ITS ALL SHAKING AROUND - A LOT. THEY CLIMB INTO THE CAR, STILL HOLDING TH

HE DOOR SLAMS SHUT. IN A FLASH YOU SEE THE GUY LEAN FORWARDS FROM THE BACK SEAT. THE OTHERS ARE SHOUTING "LETS GO... LETS GET MOVING..." HE HOLDS UP HIS HAND AN

GUN OUT OF THE WINDOW. YOU HEAR THE INCREDIBLE FORCE OF THE PETROL SQUIRTING OUT OF THE END OF THE PUMP... THEN YOU SEE IT, CATCHING THE LIGHT, THEN YOU SEE IT SQUIRTIN

T, TRYING TO GET TO THE GUY BUT THE SPRAY KEEPS COMING AT HIM. THEN YOU SEE THE BLOKE HOLDING THE PUMP PALE FROM ALL THE SPRAY AND LIGHT IN FRONT OF HIM. HE LOOKS ROUN

BACKWARDS, EYES FIXED ON THE FLAME. THE GUY SAYS, YELLING, MUFFLED, FROM BEHIND THE MASK, "DON'T DO IT MAN, DON'T DO IT MAN, DON'T BE STUPID... RUN!" YOU SEE THE FLAME

HAND HOVERS NEAR THE END OF THE PUMP, IT FLICKS THE LIGHTER AGAIN. THEN THE WHOLE THING STARTS SPURTING FIRE, IT'S ROARING. HE POINTS IT AT THE RED CAR AND THE FL

TO BE ON FIRE. YOU CAN SEE THEM THROUGH THE FRONT WINDSCREEN, YOU CAN'T SEE THE GUY HOLDING THE TORCH ANYMORE, YOU SEE HIM IN THE CAR LOOKING OUT AT THE FLAMES, AND THEY LOOK ALL WARPED

THE BLOKE WITH THE FLAMING PUMP FROM THE SIDE, HE'S PALE IN THE ORANGE GLARE. SOMEONE FROM THE CAR YELLS, "COME ON... WAIT A MINUTE..." BUT HE DOESN'T HEAR. HE LOOKS DOWN AT THE GUSHING FIRE. HE'S

FIRE. THEN YOU CAN'T SEE HIM EITHER, HE'S HIDDEN BY IT, THE ROAR IS EVEN LOUDER AND BLACK SMOKE'S COLLECTING ROUND THE EDGES. IN THE CAR EVERYBODY'S YELLING AT THE SAME TIME, IT'S HARD TO MAKE OUT W

AND TURNS AWAY FROM THE BURNING CAR... THE FLAMES RIP ACROSS THE GROUND AND COVER THE BODYWORK. THEN FROM THE SMOKE BEHIND YOU THERE'S A HOLLOW BASHING SOUND, IT'S GETTING CLOSER. THEN YOU

THEY'RE DOWN IN THE FLAMES, DOWN ON THE GROUND, "OHHH AHHH OOOOOO..." THEY ROLL OVER A FEW TIMES, STILL CLINGING ON TO EACH OTHER. ONE'S ON TOP THEN IT'S THE OTHER. THEY'RE ROLLING IN THE FLAMES, TH

REVVING LIKE CRAZY, BUT STILL. THEN YOU SEE THEM PACKED INTO THE BACK SEAT, STILL SHOUTING OVER EACH OTHER. THEN FROM OUTSIDE THE OTHER GUY FROM THE WHITE CAR'S RUSHING ACROSS, HE'S CLUTCHING A GUN

FALLS OUT COMPLETELY AND YOU SEE HIM THERE HUNCHED OVER THE GUN, FIRING THEM OUT. ALL OF THEM IN THE CAR SCREAM, "OHHH SHIT' BUT THEIR SAYING IT AT DIFFERENT TIMES, AT THE SAME TIME. THEN FOR A SPLIT

REVS UP. ONE OF THE GUNS IS STICKING OUT OF THE SIDE WINDOW. THE CAR REVS MORE THEN SQUEALS OFF. THE GUYS LEFT THERE, CLUTCHING THE GUN, HE UNLOADS ANOTHER THREE OR FOUR, PAMM, PAMMM, PAMMM. THE OTHE

SOMEHOW HE'S GOT THE OTHER GUYS HEAD UNDER THE BONNET, HE SLAMS IT DOWN, THREE OR FOUR TIMES, REALLY WEDGES IT IN. THE TINNY BONNET BASHES DOWN ONTO HIM. THEN HE BELTS IT ACROSS THE GARAGE, TRAILING TH

BEHIND. THEN YOU SEE THE OTHER GUY THE ONE IN JEANS RUNNING AFTER HIM. HE'S ALL PALE RUNNING THROUGH THE SMOKE, HE COMES OUT THE OTHER SIDE, TUGGING HIS GUN OUT OF HIS BACK POCKET. HE DASHES PAST THE COKE MACHIN

BUT NOT SLOWING DOWN. IT'S SMOKY, HE'S RUNNING DRAGGING THE CLOUD BEHIND HIM. THEN THE OTHER GUYS RIGHT THERE, YOU CAN SEE HIM OVER HIS SHOULDER. THEY'RE RUNNING ACROSS A ROAD, YOU SEE THE GUY IN FRONT FIRST, THE

AT HIS SIDE. HE'S RUNNING DOWN THE LONG BREEZE BLOCK CORRIDOR RIGHT UP TO THE WALL. THERE'S SOME THUNDER FROM BEHIND AND THE SKY'S FILLING UP WITH AN ENORMOUS FIREBALL, RIGHT BEHIND THE TELEPHONE WIRES AND CO

RIDOR, EVERYTHING'S BLURRY HE GETS TO THE END AND IS GONE. THEN YOU SEE THE GUY CHASING, IT'S JUMPY. THE GUY INFRONT'S BELTING IT UP SOME KIND OF RAMP. HE BASHES THROUGH A FLOCK OF BUSHES THEN IS AT THE TOP IN THE LIGHT

LEFT AND RIGHT, CAN'T DECIDE WHICH WAY TO GO. THEN HE DASHES OFF TO THE RIGHT DOWN TOWARDS SOME FENCING. IT'S ALL SO FAST IT'S HARD TO SEE, ANY WAY HE BASHES DOWN THE FENCE, A PIECE JUST FALLS OUT IN THE MIDDLE. THEN YOU

SEE IS THE GRASS BLURRING DOWN IN FRONT OF HIM. HE SPLASHES THROUGH THE PADDLING POOL, JUMPS OVER THE WHITE TABLE AND OVER A PIECE OF WOOD, HE'S GONE. THEN YOU SEE THE OTHER GUY BELTING AFTER HIM, YOU CAN SEE HIM

FRONT APPEARS FROM ROUND THE CORNER, HE'S IN ANOTHER GARDEN, STRAIGHT INTO THE WOMAN RACING DOWN THE LAWN. HE BANGS RIGHT INTO HER, SHE'S ON HER BACK SUDDENLY, AND THE WATERS SPURTING ALL OVER THE PLACE - FRO

OVER THE CAR BONNET, PACKED JUST THERE. HE'S JUMPING DOWN ONTO THE ROAD, THEN DASHING ACROSS IT, YOU SEE THE GUY BEHIND JUMPING OUT INTO THE CROSS ROADS. THEN HE'S SPEEDING ACROSS THE ROAD. THE TRUCKS COMIN

VE THE GUY'S OFF TO THE RIGHT, SOMEONE PASSES ON A BIKE RIGHT IN FRONT CAN'T SEE ANYTHING ELSE - THEN YOU SEE HIM RUNNING OUT INTO THE CROSS ROADS. THEN HE'S SPEEDING ACROSS THE ROAD. THE TRUCKS COMIN

'S COME AND THE TRUCKS SO BIG, THERE'S ANOTHER BIG — THEY MEET, NEARLY CRASH, THEY JUST SKID ACROSS. ONE OF THE KIDS IS FAINTLY SHOUTING, "LOOK OUT!" HE BELTS BEHIND THE TRUCK - CAN'T SEE HIM FOR A SECOND, THEN

PASSENGER WINDOW. HE'S READING A
D THAT CORNER THERE'S A SANDWICH
CAN ONLY SEE HIS BACK AND ARMS
HE OTHER BLOKE LOOKS IN FRONT THEN
HE DISTANT ENGINES LOUDER, THEN THE
THOUT LOOKING UP, AND COUGHS. HE'S
Y... GET ME TWO..." MAKING A TWO SIGN
ULD I HAVE TWO MEATBALL SANDWICHES,
SEE A CAR PULL UP BEHIND, IT'S QUITE
APPEAR. "HERE, YOURS IS THE ONE THAT
VERY MUCH," HE GRABS THE SANDWICH
S UP AT HIM, SAYING, "I'M SO HUNGRY I
ME THREE OF THESE THINGS." HE TUCKS
AT THE CAR WITH HIS COKE, SUCKING ON
HOP. THE MUSIC BEATS IN. THEY'RE GETTING
OUT OF HIS BACK POCKET. CAN'T SEE THE
GUN RIGHT OUT IN FRONT, ALL BLURRY, MOV-
ALL THE TIME, AIMING THE GUN. THE VOICE
JUST BEFORE HE GETS INTO THE CAR, HE'S
AT THE GUY RUSHING FORWARDS, THEN ONE OF
NG HIM FROM FIRING. THE OTHER GUY YELLS,
FRONT OF HIS FACE, PEOW, PEOW, PEOW, PEOW
RVES OFF, SCREECHING RIGHT THEN LEFT. POWW,
LLET HOLES. THEN THE CAR JUST ZOOMS OFF, REAL-
GUN HARD OUT IN FRONT - DEAD SYMMETRICAL. HE
GO GO!" REALLY YELLING LOUD AS HE CAN. HE'S IN
HE SLAMS THE DOOR SHUT. THE GUY DRIVING LOOKS THIN
OLE SIDE OF THE CAR, FOR A MOMENT ONLY THE REFLEC-
D THREE BLACK SILHOUETTES INSIDE, THE BACK OF THE
IT BECAUSE OF THE CAR BEHIND. THEN IT SWERVES LEFT,
OSS THE TARMAC, THE WHEELS LOCK AND THE SCREECH GETS
ING FORWARDS, BASHED INTO ANOTHER CAR. THE SOUND OF
OOMING FORWARDS, BUT TOGETHER. THE SUN SHINES OFF THE
SLIDING SIDEWAYS. YOU CAN SEE THEM BOTH PROPERLY FROM
PEED ALONG TOGETHER. THEY'RE SQUEALING ROUND THE CORNER,
BEHIND, BRIGHT SUN REFLECTS OFF THE BOOT OF THE WHITE CAR,
SEE A HUBCAP FLYING ACROSS THE TARMAC, DON'T KNOW WHERE IT
WINDSCREEN, VERY PALE, YELLING LIKE CRAZY, YOU CAN SEE RIGHT
IT AND THE SQUEALING BRAKES ON THE TARMAC, YELLING, "OK GIVE
S ACROSS AND YOU SEE THEIR CAR RIGHT THERE ON ITS OWN IN THE
'S ANOTHER RED CAR IN FRONT, LOOKS LIKE THEY'RE GOING TO BASH
NNIKING, "I DON'T SEE THEM, WHERE'D THEY GO?!" YOU CAN JUST
YTHING SHAKES AND IS A SMEAR FOR A MOMENT, THEN SUDDENLY YOU
A SMEARY GREEN SCOOTING THROUGH THE DRIVERS WINDOW. THE PAS-
S ROUND AND ROARS, "I'M NOT LOOSING THEM!" HIS EYES ARE OFF THE
EWAYS LIKE IT'S ICE - THE SOUND OF THE WHEELS SCREAMING ON THE
SIDE OF THE ROAD, AND YOU CAN HEAR HIM SLAMMING THE BRAKES,
AN SEE IS THE PALE BONNET AND THE REAR VIEW MIRROR RIGHT IN THE
OU SEE THE OTHER CAR FROM INSIDE. YOU CAN ONLY TELL IT'S THEIR
"PUNCH IT! PUNCH IT! PUNCH IT!" BUT IT COMES OUT THAT SAME MUF-
! PUNCH IT! PUNCH IT!" THE WINDSCREEN'S ALL SMEARED UP WITH SHIT,
ING OUT OF THE LAYBY, IT'S NOT COMING AT THE WHITE CAR, IT'S COMING
SHIIIIT" BUT YOU CAN'T HEAR HIM. THEN THE CAR INFRONT'S SWERVING A
RE SLIDING ALL OVER THE ROAD IT BLURS. THEN YOU SEE THE PASSENGERS
RDS, "...ON THE LEFT..." BUT YOU CAN'T HEAR MORE - THE ENGINE'S SCREAM-
HEY GO PAST A TRUCK AND IT'S ALL BLURRY AND BLACK. YOU SEE THE BACK OF
YOU CAN HEAR THE GEARS UP AND UP, THEN YOU CAN SEE THE DRIVER OF THE GREY CAR
O MORE SKIMMING PAST, THE ENGINE STRAINS. THEN FROM BEHIND THE OTHER CARS
NG AWAY FROM THE ROAD TO LOOK FOR IT, THEY'RE JUST ABOUT LEVEL. HIS ENGINE
RING ALONG. YOU HEAR IT'S ENGINE REALLY REVVING IT NOW, FOR AN INSTANT IT'S SO
MANY SPARKS, IT'S LIKE THERE'S A FIREWORK GOING OFF UNDER THE CAR. IT SCRAPES
LOWLY, THE FRONT OF THE CAR FLIPS HIGH AS IT ROLLS OVER THE RAMP INTO A GARAGE,
ER JUMPS OUT AND GRABS, PUSHES, SOMEONE OUT OF THE WAY, SHOUTING "BACK OFF
O MAKE WHAT'S GOING ON, LOT'S OF THING'S AT ONCE... EVERYTHING'S BLURRY. THERE'S
THE GUYS RUNS UP BEHIND, GUN IN EACH HAND AND AND SLAMS THE GUY FORWARDS, BASH-
J FRONT. THEN THE SAME GUY PUNCHES HIM IN THE STOMACH WITH THE BUTT OF HIS RIFLE.
TO THEM, "WAIT... WAIT!" THEY LOOK OUT OF THE SIDE WINDOW. THE GUY NEAREST STICKS THE
E FACE. HIS ARMS FLY UP AND HE TRIES TO MASK HIS FACE WITH HIS HANDS. HE'S RUNNING INTO
EN HE FLICKS OPEN A LIGHTER. THE OTHER GUY LOOKS TERRIFIED, HE BACKS OFF, EDGING HIS WAY
R AND CLOSER TO THE PUMP, THEN THE GUY TURNS ROUND AND BELTS IT. THE OTHER GUYS WHITE
INTO THIS HUGE BALL. THEY BURN IN ON EACH OTHER. IT'S BLINDING, THE ENTIRE BACK OF THE CAR SEEMS
EAT HAZE. THE CARS REVVING, THE DRIVER LOOKS ACROSS AND YELLS, "WHAT'S TAKING SO LONG." THEN YOU SEE
IDE TO SIDE, TAKING THE FIRE WITH HIM... HE'S STARING DOWN AT IT, THERE'S NOTHING ELSE, JUST HIM AND THE
OOH." THE ENGINE REVS, "HE'S COMIN... COMIN." THEN YOU SEE HIM OVER BY THE CAR, HE PUTS DOWN THE PIPE
NG OVER THE BONNET, HE THROWS HIMSELF ONTO THE FLAMING MAN HE'S ON HIM, HUGGING HIM FROM BEHIND.
OLLING IN THE OTHER DIRECTION, TOWARDS THE YELLOW CAR. YOU CAN SEE THE YELLOW CAR IN THE BACKGROUND,
THE "PIAOWWW" AND FROM INSIDE THE REAR WINDSCREEN SHATTERS, CAN'T SEE THROUGH IT ANYMORE. THEN IT
G BEHIND THE CAR - HOLDING THE GUN, HE FIRES ANOTHER ONE OFF. THEN SOMEONE YELLS, "LETS GET GOIN." THE CAR
NCHING IT OUT ON THE FORECOURT, BASH BASH, HAPPENING SO FAST, HIS JACKETS FLAMING UP EVEN MORE NOW. THE
HIS JACKET. HE DISAPPEARS INTO THE CLOUD OF SMOKE. THEN HE BELTS IT OUT THE OTHER SIDE, STILL DRAGGING THE FIRE
ORNER OUT IN FRONT. THE GUY IN THE SUIT'S RUNNING ACROSS THE OPEN SPACE, HE'S RUBBING THE FLAMES OFF HIS BACK
VES. A WHITE CAR PASSES BEHIND. THEN YOU SEE THE GUY IN THE JEANS FROM THE SIDE, REALLY BELTING IT, GUN DOWN
HE SKY THEN TURNS BLACK. THEN FROM BEHIND YOU SEE THE GUY IN FRONT, JUST THE BACK OF HIM, HURLING AT THE COR-
HE'S ON THE ROAD AGAIN. IT'S PALE AND HIS FOOTSTEPS SOUND HARD ON THE CONCRETE ROAD. HE STOPS SUDDENLY, LOOKS
YOU CAN HEAR HIS BREATH HARD AND STRAINED. HE'S PUSHING THE SWING AWAY AND RUNNING THROUGH IT, THEN ALL YOU
MING AT YOU, THEN JUST FROM BEHIND, HE BELTS THROUGH THE BASHED DOWN FENCE TO THE PADDLING POOL - THE GUY IN
THE SKY, SHE'S SCREAMING BUT HE'S GONE, JUMPING OVER THE FENCE, HE GRUNTS FROM THE STRAIN THEN HE'S BOUNCING
EN HE'S JUMPING STRAIGHT OVER. SHE'S FLAT TO THE GROUND AGAIN, HE'S JUST A BLUR LEAPING OVER THE NEXT FENCE
S SO BIG, THE RUMBLING ENGINE GETS CLOSER AND CLOSER. IT'S RIGHT THERE. IT'S JUST A BLUR SPROUTING IN FRONT
HERE RUNNING, RUNNING, RUNNING. FROM THE SIDE, NEVER GETTING ANY NEARER, YOU CAN HEAR IT. IT'S THE GUY IN FRONT

H IT!" THE WINDSCREEN'
YBY, IT'S NOT COMING AT
CAN'T HEAR HIM. THEN T
ER THE ROAD, IT BLURS.
FT..." BUT YOU CAN'T HEAI
UCK AND IT'S ALL BLURRY
EARS UP AND UP, THEN YOU CAN
AST. THE ENGINE STRAINS. TH
ROAD TO LOOK FOR IT, THEY'
AR IT'S ENGINE REALLY REVVIN
KE THERE'S A FIREWORK GOIN
THE CAR FLIPS HIGH AS IT RO
RABS, PUSHES, SOMEONE OUT
G ON, LOT'S OF THING'S AT ON(
EHIND, GUN IN EACH HAND AND A
ME GUY PUNCHES HIM IN THE ST

511. Fiona Banner.
Break Point. 1998. Print

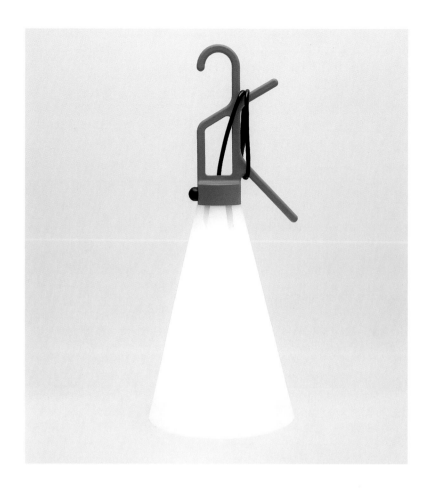

515. Charles Long.
Internalized Page Project.
1997–98. Prints

518. Anish Kapoor.
Wounds and Absent Objects.
1998. Prints

519. Terry Winters.
Graphic Primitives. 1998.
Prints

opposite:
520. Gerhard Richter.
128 Details from a Picture
(Halifax 1978). 1998. Prints

521. Gabriel Orozco.
Horseshit, 1992; I Love My Job,
1998; Melon, 1993; CCCP, 1993.
Photographs

opposite:
522. Christian Boltanski.
Favorite Objects. 1998. Prints

523. Jia Zhang Ke.
Xiao Wu. 1998. Film

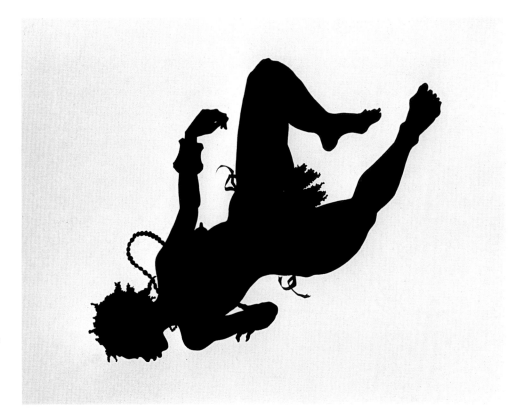

524. Matthew Barney.
C5: Elbocsatas. 1998.
Drawing

525. Kara Walker.
African/American.
1998. Print

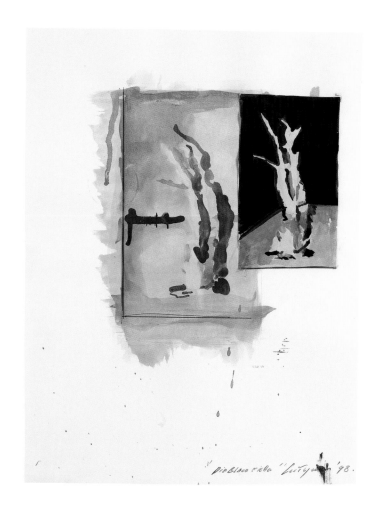

526. Luc Tuymans.
The Blue Oak. 1998.
Drawing

527. John Madden.
Shakespeare in Love.
1998. Film

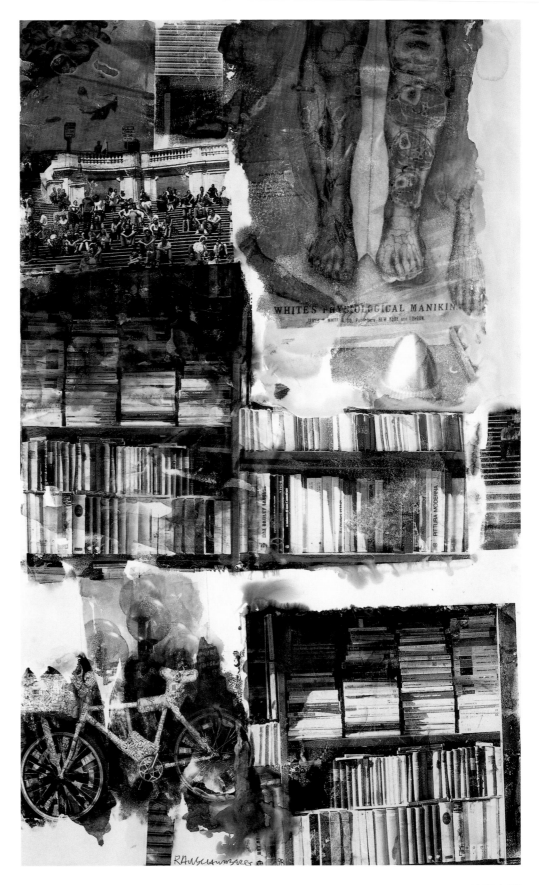

528. Robert Rauschenberg.
Bookworms Harvest. 1998. Painting

529. Chris Ofili.
Untitled. 1998. Drawings

530. Enrique Chagoya.
The Return of the Macrobiotic
Cannibal. 1998. Illustrated book

opposite:
531. Lisa Yuskavage.
Asspicker and Socialclimber.
1996–98. Prints

532. Elizabeth Peyton.
Bosie. 1998. Print

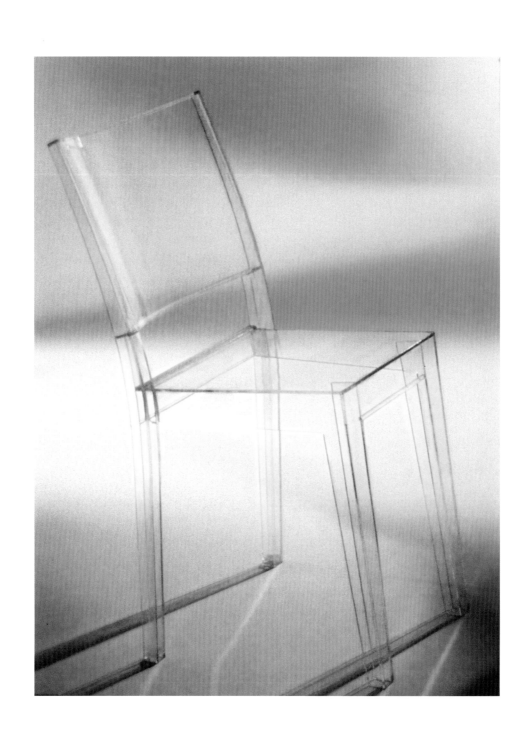

533. Philippe Starck.
La Marie Folding Chair.
1998. Design

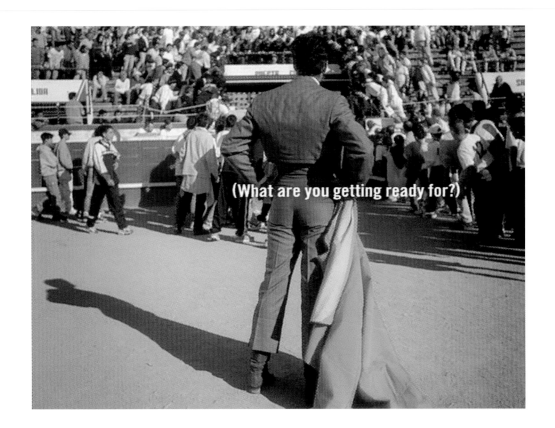

(What are you getting ready for?)

534. Ralph Schmerberg.
"Los Toros," a commercial
for Nike footwear. 1998. Film

535. Mariko Mori.
Star Doll. 1998. Multiple

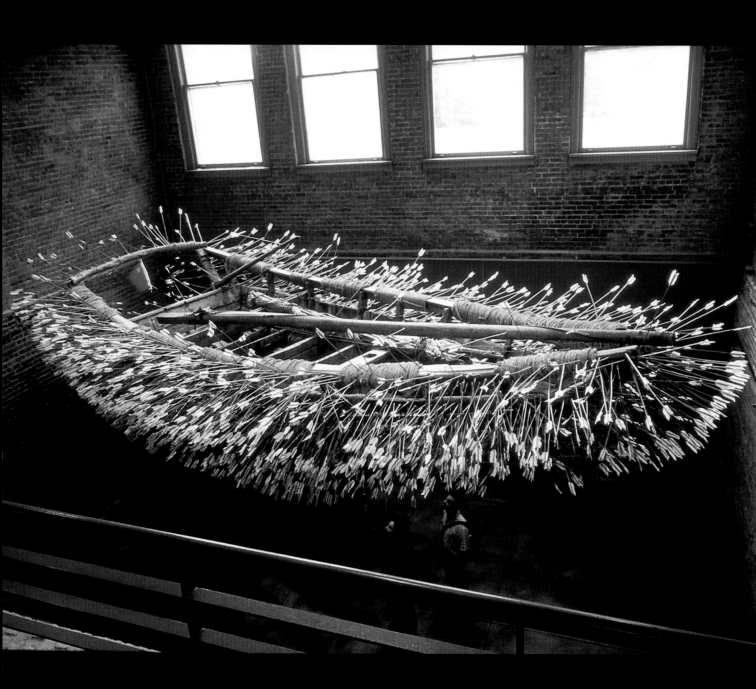

536. Cai Guo-Qiang.
Borrowing Your Enemy's
Arrows. 1998. Sculpture

opposite:
537. Rachel Whiteread.
Water Tower. 1998. Sculpture

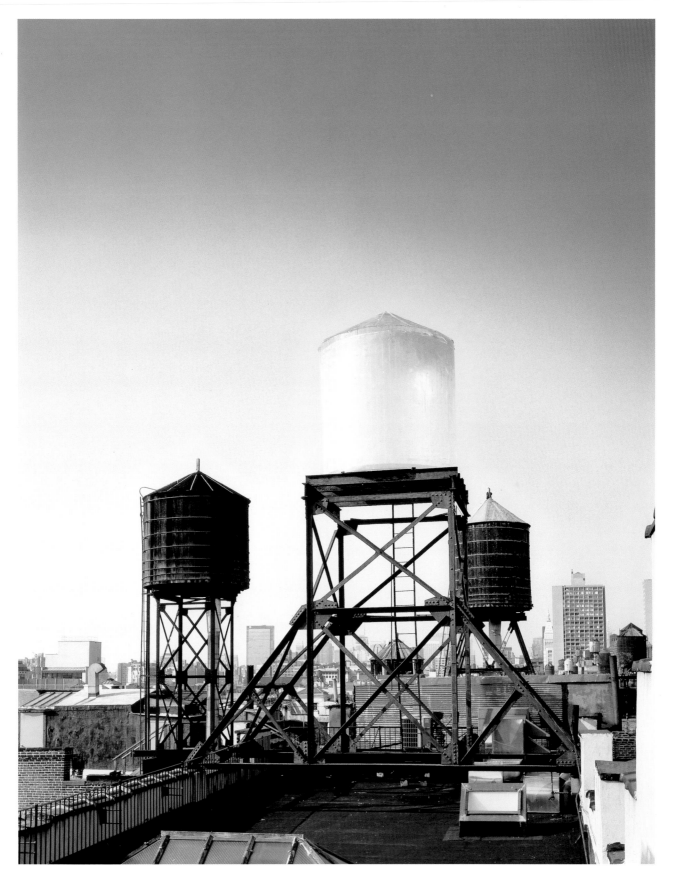

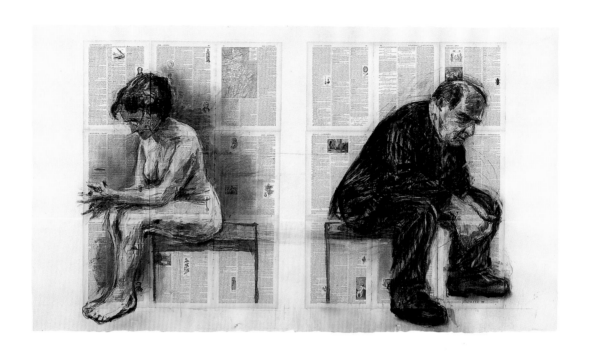

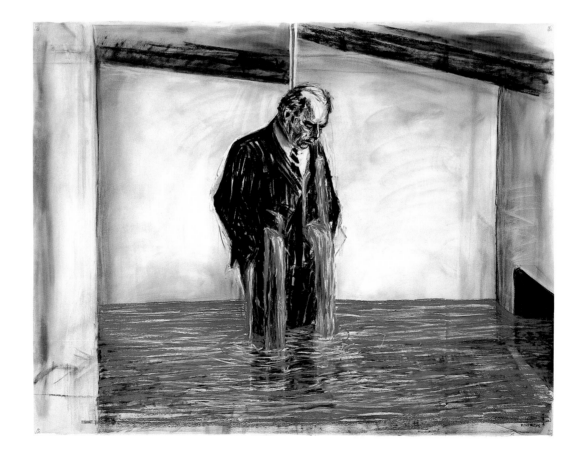

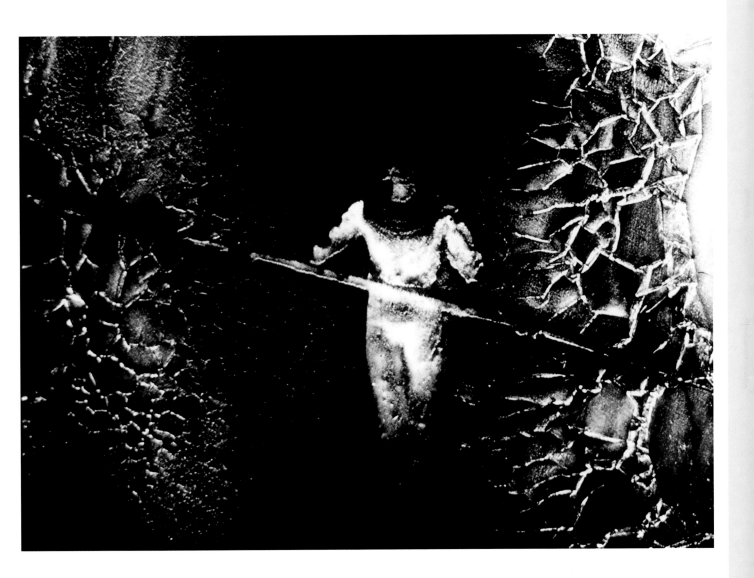

opposite:
538. William Kentridge.
Seated Couple (Back to Back).
1998. Drawing

539. William Kentridge.
Untitled (drawing for Stereoscope).
1998–99. Drawing

above:
540. Phil Solomon.
Twilight Psalm II: Walking
Distance. 1999. Film

541. Julian Opie.
Imagine You Are Driving;
Cars?; Imagine You Are
Walking; Cityscape?; Gary,
Popstar; Landscape?
1998–99. Prints

542. Andreas Gursky.
Toys "Я" Us. 1999.
Photograph

opposite:
543. Barbara Bloom.
A Birthday Party for Everything.
1999. Multiple

**544. Jean-Marie Straub
and Danièle Huillet.**
Sicilia! 1999. Film

above:
545. Carroll Dunham.
Ship. 1979–99. Painting

Damien 5036-23

Steak and Kidney*
Ethambutol Hydrochloride

Tablets
400mg

100 Tablets PIE

Cornedbeef® 200
200 mg Amiodarone Hydrochloride Fr.P.

DAMIEN HIRST

28 Tablets

Cornish 100mg/5ml Pasty

Rifampicin B.P.

To be taken by mouth

Peas CHIPS

100ml Syrup

Salad ™ tablets
Lamivudine

Each coated tablet contains
lamivudine 150mg

60 tablets

HirstDamien

546. Damien Hirst.
The Last Supper.
1999. Prints

Chicken®

Concentrated Oral Solution
Morphine Sulphate

20mg/ml

Each 1ml contains Morphine
Sulphate BP 20mg

120ml

Damien
Hirst

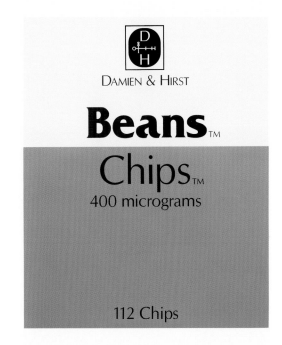

DAMIEN & HIRST

Beans™

Chips™

400 micrograms

112 Chips

Mushroom™

30 tablets
Pyrimethamine
Tablets BP

25mg

PIE

HirstDamien

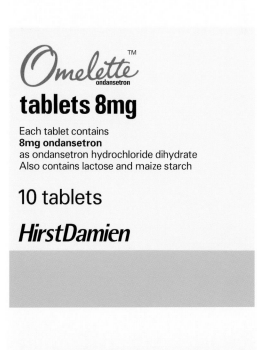

Omelette™ ondansetron

tablets 8mg

Each tablet contains
8mg ondansetron
as ondansetron hydrochloride dihydrate
Also contains lactose and maize starch

10 tablets

HirstDamien

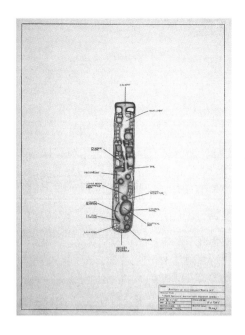

opposite:
547. E. V. Day.
Anatomy of Hugh Hefner's
Private Jet (1–5). 1999.
Prints

right:
548. Chris Ofili.
Prince amongst Thieves.
1999. Painting

549. Richard Serra.
Out of Round XII. 1999.
Drawing

opposite:
550. Richard Serra.
Switch. 1999. Sculpture

551. Shahzia Sikander.
Anchor. 1999. Print

552. David O. Russell.
Three Kings. 1999. Film

553. Laurence Attali.
Baobab. 2000. Film

554. Faith Hubley.
Witch Madness. 2000. Film

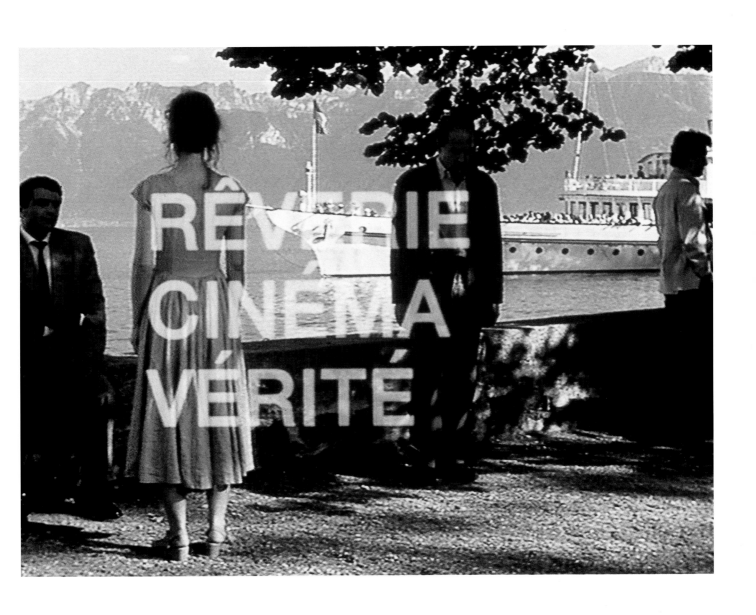

556. Jean-Luc Godard.
The Old Place. 2000. Video

**557. Giulio Iacchetti,
Matteo Ragni, and
Pandora Design.**
Moscardino Disposable
Eating Utensils.
2000. Design

558. Jake and Dinos Chapman.
Exquisite Corpse. 2000. Prints

559. Bertien van Manen.
From a Taxi, Shpingba, Chongqing.
2000. Photograph

560. Glenn Ligon.
Untitled (Stranger in the Village/Crowd) #2.
2000. Drawing

561. Maarten Van Severen.
LCP Chaise Longue. 2000. Design

562. Beatriz Milhazes.
The Mirror. 2000. Print

563. Tokujin Yoshioka.
Honey-Pop Armchair.
2000. Design

564. Michael Wesely.
14 April 1999–11 December 2000,
Herrnstrasse, Munich. April 14, 1999–
December 11, 2000. Photograph

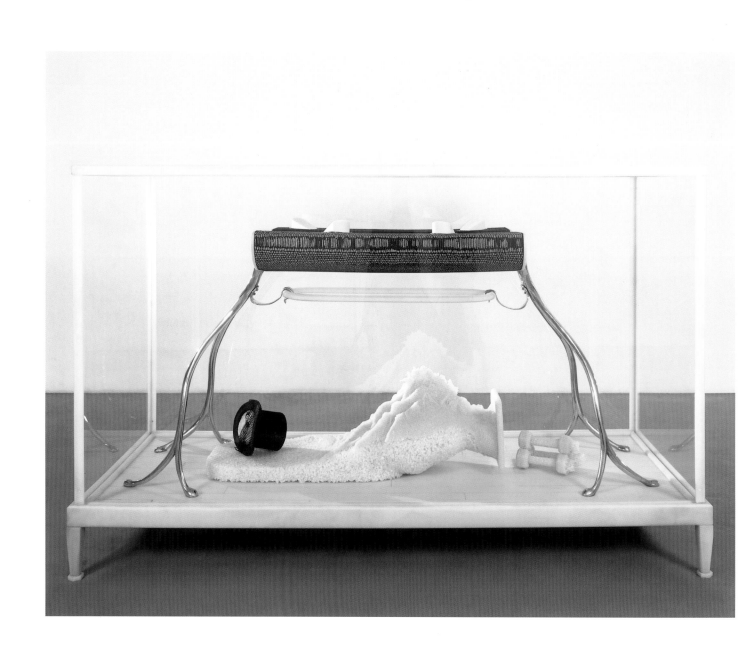

565. Matthew Barney.
The Cabinet of Baby Fay La Foe.
2000. Sculpture

566. Arturo Herrera.
A Knock. 2000. Drawing

567. Shirazeh Houshiary.
Presence. 2000. Painting (detail, right)

568. Peter Fischli and David Weiss.
Things from the Room in the Back.
1999–2000. Installation

569. Jorge Pardo.
Untitled. 2001. Prints

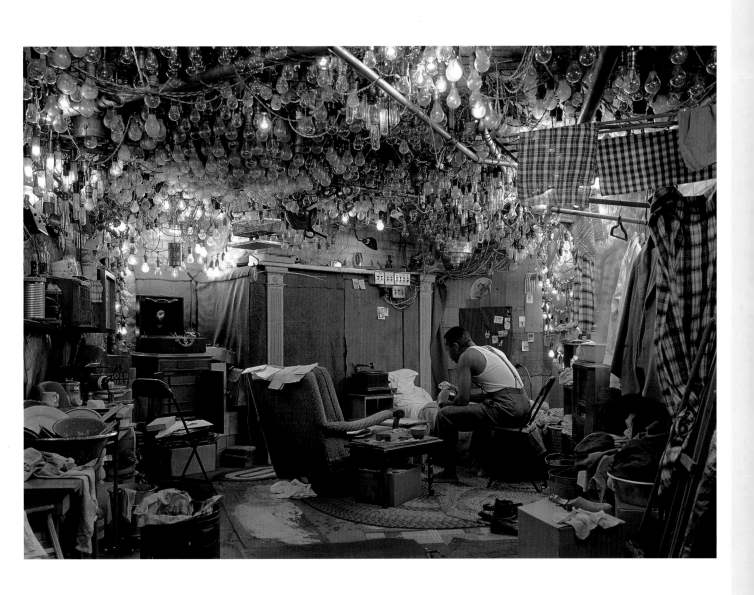

570. Jeff Wall.
After "Invisible Man"
by Ralph Ellison, the
Prologue. 2001.
Photograph

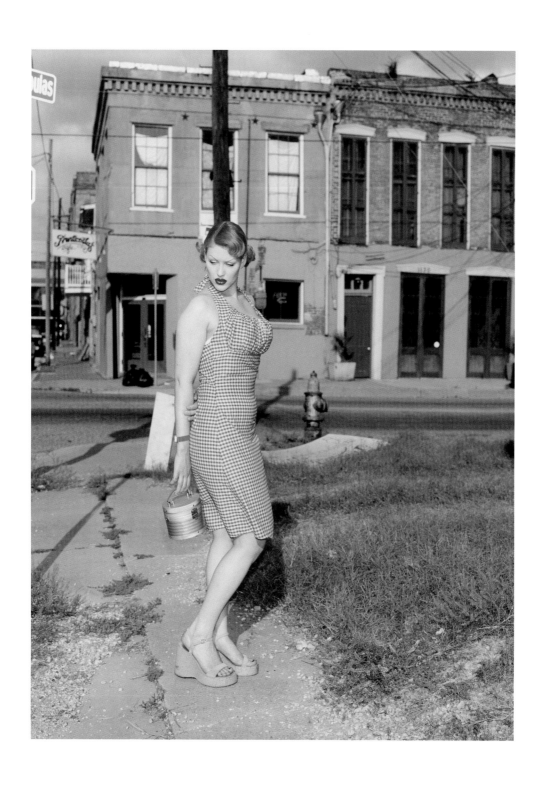

571. Katharina Bosse.
Kitty Crimson. 2001.
Photograph

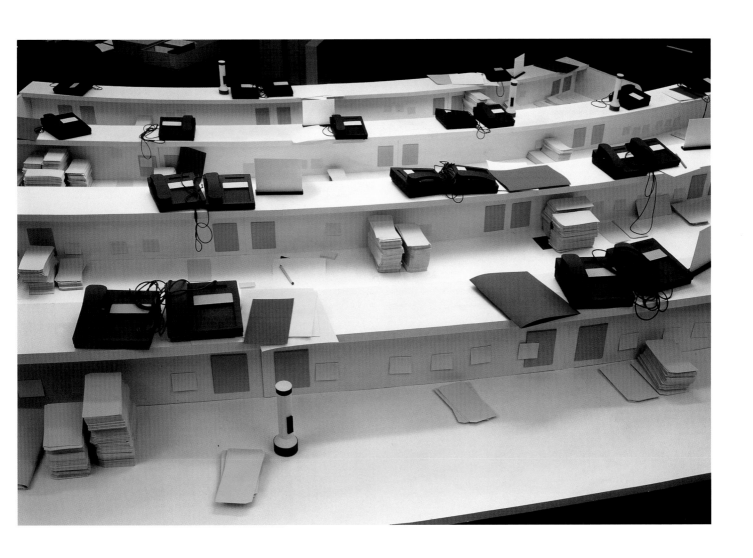

572. Thomas Demand.
Poll. 2001. Photograph

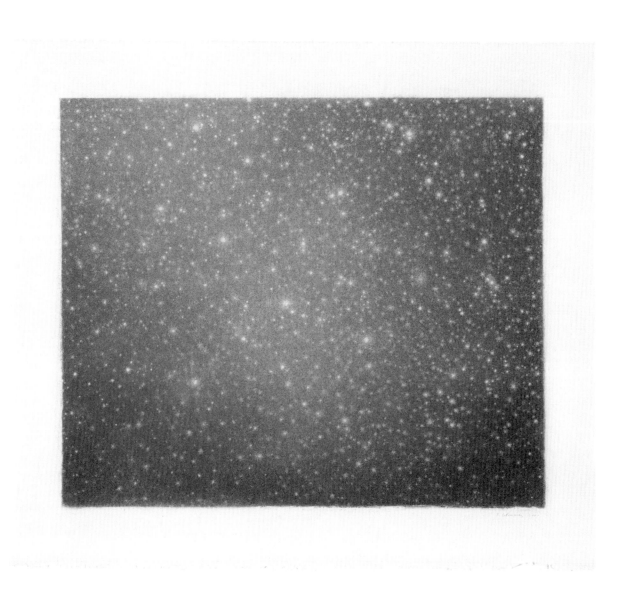

573. Vija Celmins.
Night Sky No. 22.
2001. Drawing

574. Orlando Mesquita.
The Ball. 2001. Film

577. Kim Young Jin.
Virtually Indestructible
Keyboard. 2001. Design

578. npk industrial design b.v.
Dremefa Multibob Child Safety Seat.
2002. Design

579. Edward Ruscha.
Tulsa Slut. 2002. Painting

580. Alessandra Sanguinetti.
Untitled from the series On the
Sixth Day. 1996–2002. Photographs

581. Seoungho Cho.
Cold Pieces 2.
2002. Video

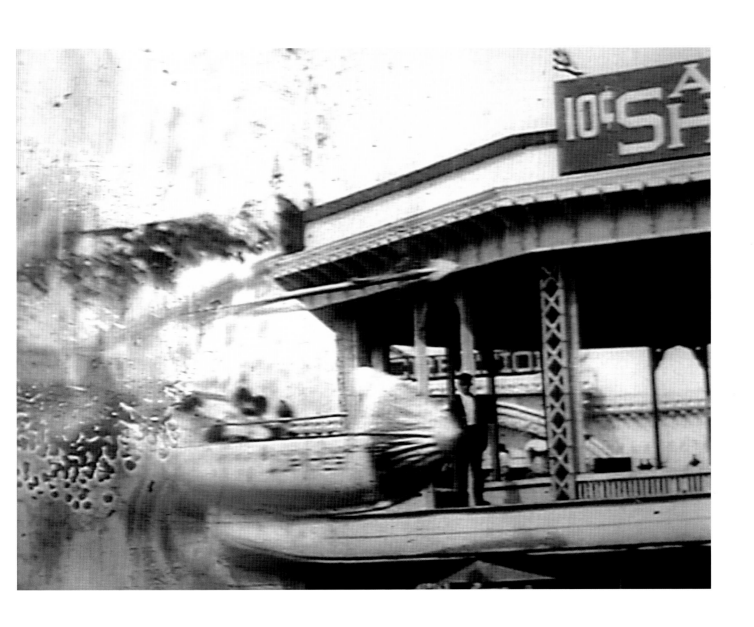

582. Bill Morrison.
Decasia. 2002. Film

583. Yoshitomo Nara.
Become to Thinker;
Green Eyes; N.Y. (Self-Portrait);
Spockie. 2002. Prints

530 | 2002

584. Jürgen Mayer H. and Sebastian Finckh.
Stadthaus Scharnhauser Park, Ostfildern, Germany. Project, 1998–2002. "E.gram" three-dimensional drawing

585. Sarah Lucas.
Geezer. 2002.
Drawing

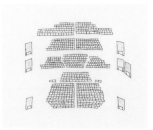

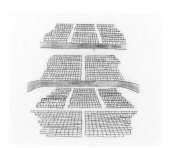

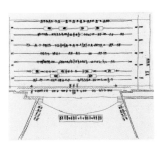

586. Guillermo Kuitca.
Puro Teatro. 2003.
Illustrated book

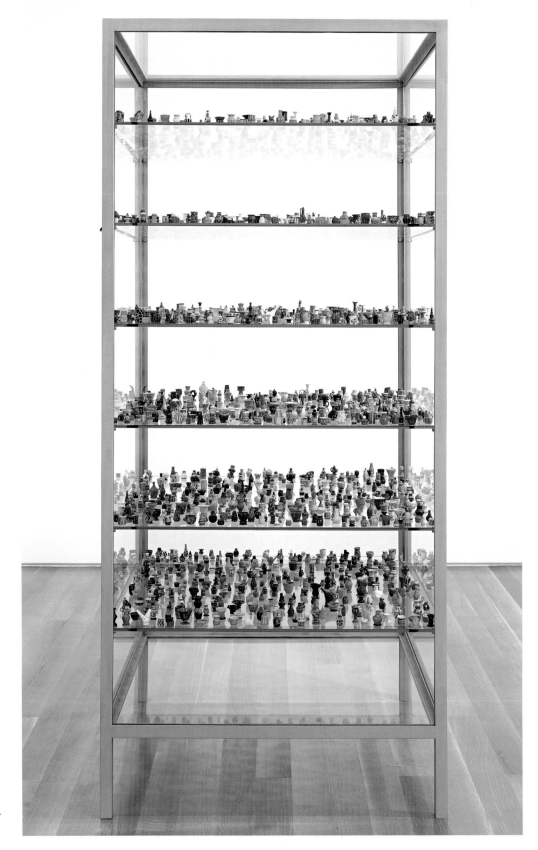

587. Charles LeDray.
Oasis. 1996–2003.
Sculpture

588. Richard Tuttle.
Dawn, Noon, Dusk:
Paper (1), Paper (2), Paper (3).
2001–03. Prints

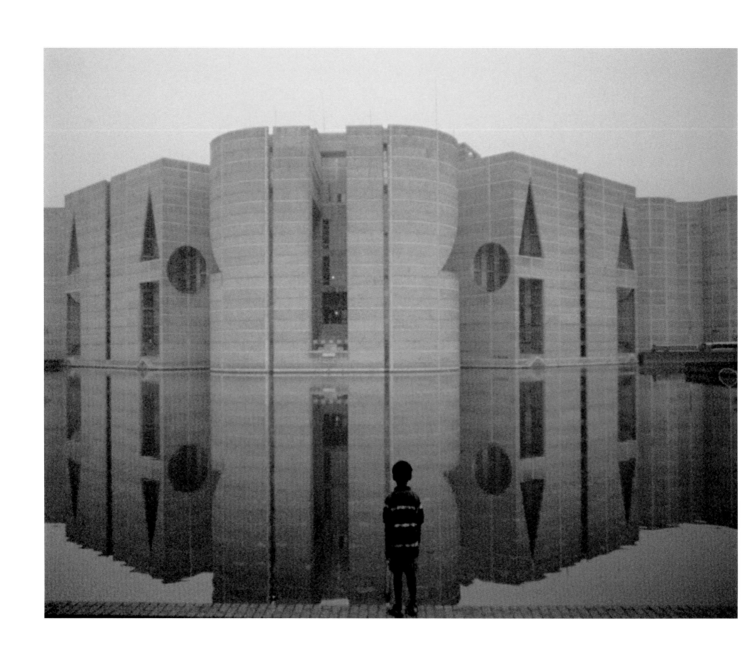

589. Nathaniel Kahn.
My Architect: A Son's Journey.
2003. Film

Checklist of Illustrations

This listing follows the arrangement of the plate section and provides full citations for the works illustrated. Following the plate number and artist, the title and date of the work are given; then the medium and dimensions in feet and inches, and centimeters (or meters); the entry concludes in most cases with a credit line. All works are in the collection of The Museum of Modern Art, New York. The data vary for films and videotapes, and additional information about publication and manufacture is included for prints, architecture, and design. For multiple works by a single artist, see the Index of Illustrations.

1. Stanley Kubrick
The Shining. 1980. Great Britain/USA. 35mm film, color, 146 minutes

2. Cindy Sherman
Untitled Film Still #59. 1980. Gelatin silver print, 6¾ x 9½ in. (17.1 x 24.1 cm). Purchase

3. Cindy Sherman
Untitled Film Still #58. 1980. Gelatin silver print, 6⁵⁄₁₆ x 9⁷⁄₁₆ in. (16 x 24.2 cm). Purchase

4. Cindy Sherman
Untitled Film Still #57. 1980. Gelatin silver print, 6⁹⁄₁₆ x 9⁷⁄₁₆ in. (16.6 x 24.2 cm). Purchase

5. Cindy Sherman
Untitled Film Still #56. 1980. Gelatin silver print, 6⅜ x 9⁷⁄₁₆ in. (16.2 x 24.2 cm). Purchase

6. Cindy Sherman
Untitled Film Still #54. 1980. Gelatin silver print, 6¹¹⁄₁₆ x 9⁷⁄₁₆ in. (17.3 x 24.2 cm). Purchase

7. Vito Acconci
Instant House #2, Drawing. 1980. Color inks and pencil on paper, 18 x 26 in. (46 x 66 cm). Fractional gift of Joyce Pomeroy Schwartz

8. Vito Acconci
20 Foot Ladder for Any Size Wall. 1979–80. Photoetching on eight sheets, overall: 19 ft. 4 in. x 41 in. (589.3 x 104.2 cm). Publisher and printer: Crown Point Press, Oakland, Calif. Edition: 15. Frances Keech Fund

9. Martin Scorsese
Raging Bull. 1980. 35mm film, black and white and color, 119 minutes. Acquired from United Artists

10. Niklaus Troxler
McCoy/Tyner/Sextet. 1980. Poster: offset lithograph, 50⅜ x 35⅝ in. (128 x 90.5 cm). Leonard and Evelyn Lauder Fund

11. Jean-Luc Godard
Sauve qui peut (la vie). 1980. France/Switzerland. 35mm film, color, 88 minutes. Gift of Dan Talbot

12. Rainer Werner Fassbinder
Berlin Alexanderplatz. 1980. West Germany. 16mm film, color, 378 minutes

13. Lino Brocka
Bona. 1980. Philippines. 35mm film, color, 83 minutes. Acquired from Pierre Rissient

14. John Hejduk
A. E. Bye House. Ridgefield, Connecticut. Project, 1968–80. Axonometric projection, color pencil and sepia print, 36¼ x 21¼ in. (92.1 x 53.9 cm). D. S. and R. H. Gottesman Foundation

15. Toshiyuki Kita
Wink Lounge Chair. 1980. Polyurethane foam, welded steel, and Dacron fiber-fill, upright: 40⅝ x 33 x 31⅝ in. (103.2 x 83.9 x 80.3 cm); reclining: 24⅜ in. x 33 in. x 6 ft. 3¾ in. (62 x 83.9 x 192.5 cm); seat height: 14¼ in. (37.5 cm). Manufacturer: Cassina S.p.A., Italy. Gift of Atelier International, Ltd.

16. Philip Guston
Untitled. 1980. Synthetic polymer paint and ink on board, 19⅞ x 30 in. (50.5 x 76 cm). Gift of Musa Guston

17. Philip Guston
Untitled. 1980. Synthetic polymer paint and ink on paper, 23 x 29 in. (58.9 x 76.2 cm). Gift of Musa Guston

18. Philip Guston
Untitled. 1980. Synthetic polymer paint and ink on board, 20 x 30 in. (50.7 x 76.2 cm). Gift of Musa Guston

19. Philip Guston
Untitled. 1980. Synthetic polymer paint and ink on paper, 20 x 30 in. (50.9 x 76.2 cm). Gift of Musa Guston

20. Jörg Immendorff
Cafe Deutschland (Style War). 1980. Oil on canvas, 9 ft. 2¼ in. x 11 ft. 6 in. (280 x 350.7 cm). Gift of Emily and Jerry Spiegel

21. Louis Malle
Atlantic City. 1980. Canada/France/USA. 35mm film, color, 104 minutes. Acquired from Paramount Pictures

22. Shohei Imamura
Vengeance Is Mine. 1980. Japan. 35mm film, color, 128 minutes. Gift of Janus Films

23. Yoji Yamamoto
A River. 1980. Poster: offset lithograph, 40⁹⁄₁₆ x 28⅝ in. (103.1 x 72.8 cm). Gift of the artist and Japan Graphic Idea Exhibition

24. Carlos Diegues
Bye Bye Brazil. 1980. Brazil/France. 35mm film, color, 110 minutes. Acquired from Dan Talbot

25. Leon Hirszman
They Don't Wear Black Tie. 1981. Brazil. 35mm film, color, 120 minutes. Acquired from Dan Talbot

26. Héctor Babenco
Pixote. 1980. Brazil. 35mm film, color, 127 minutes. Acquired from Dan Talbot

27. Seiichi Furuya
Graz. 1980. Gelatin silver print, 14¼ x 9¹⁵⁄₁₆ in. (37.5 x 25.3 cm). Gift of the Edward and Marjorie Goldberger Foundation

28. Seiichi Furuya
Schattendorf. 1981. Gelatin silver print, 14¾ x 10 in. (37.4 x 25.4 cm). Gift of the photographer

29. Peter Hujar
Portrait of David Wojnarowicz. 1981. Gelatin silver print, 14 x 14 in. (35.6 x 35.6 cm). The Fellows of Photography Fund

30. Rainer Werner Fassbinder
Lola. 1981. West Germany. 35mm film, color, 113 minutes. Acquired from the Rainer Werner Fassbinder Foundation

31. Rainer Werner Fassbinder
Lili Marleen. 1981. West Germany. 35mm film, color, 120 minutes. Acquired from the Rainer Werner Fassbinder Foundation

32. James Welling
Untitled #46. May 20, 1981. Gelatin silver print, 9½ x 7½ in. (19.5 x 24.3 cm). Gift of Carole Littlefield

33. Bernard Tschumi
The Manhattan Transcripts. Episode 4: The Block. Project, 1976–81. Ink and photographs on vellum, four of fourteen sheets, each 19 x 31 in. (48.2 x 78.7 cm). Purchase and partial gift of the architect in honor of Lily Auchincloss

34. Frank Gohlke
Aerial View, Downed Forest near Elk Rock, Approximately Ten Miles Northwest of Mount St. Helens, Washington. 1981. Gelatin silver print, 17⅞ x 21¼ in. (45.7 x 55.8 cm). Purchased as the gift of Shirley C. Burden

35. Georg Baselitz
Woman on the Beach. 1981. Woodcut and linoleum cut, comp. and sheet: 31⁷⁄₁₆ x 24¹⁄₁₆ in. (79.8 x 61.1 cm). Publisher: Maximilian Verlag/Sabine Knust, Munich. Printer: Elke Baselitz, Derneburg, Germany. Edition: proof, before edition of 50. Gift of Nelson Blitz, Jr.

36. Georg Baselitz
Drinker. 1981. Linoleum cut, comp. and sheet: 31¹³⁄₁₆ x 23¹¹⁄₁₆ in. (80.8 x 60.5 cm). Publisher: Maximilian Verlag/Sabine Knust, Munich. Printer: Elke Baselitz, Derneburg. Edition: proof, before edition of 50. Gift of Mr. and Mrs. Philip A. Straus

37. Scott Burton
Pair of Rock Chairs. 1980–81. Gneiss, in two parts: 49¼ x 43½ x 40 in. (125.1 x 110.5 x 101.6 cm), 44 x 66 x 42½ in. (111.6 x 167.7 x 108 cm). Acquired through the Philip Johnson, Mr. and Mrs. Joseph Pulitzer, Jr., and Robert Rosenblum funds

38. Lee Friedlander
Untitled. 1980. Gelatin silver print, 18½ x 12⁷⁄₁₆ in. (47.1 x 31.5). Purchase

39. Lee Friedlander
Untitled. 1980. Gelatin silver print, 18⁹⁄₁₆ x 12⅜ in. (47.2 x 31.4 cm). The Fellows of Photography Fund

40. Lee Friedlander
Untitled. 1981. Gelatin silver print, 7¹⁵⁄₁₆ x 12 in. (20.1 x 30.5 cm). Gift in honor of John Szarkowski from the curatorial interns who worked for him

41. Cindy Sherman
Untitled #96. 1981. Chromogenic color print (Ektacolor), 23⁹⁄₁₆ x 48¼ in. (61.1 x 122.1 cm). Gift of Carl D. Lobell

42. Willem de Kooning
Pirate (Untitled II). 1981. Oil on canvas, 7 ft. 4 in. x 6 ft. 4¾ in. (223.4 x 194.4 cm). Sidney and Harriet Janis Collection Fund

43. George Miller
Mad Max 2 (The Road Warrior). 1981. Australia. 35mm film, color, 94 minutes

44. A. R. Penck (Ralf Winkler)
Nightvision from the portfolio *First Concentration I*. 1982. Woodcut, comp.: 35⅜ x 27¼ in. (89.8 x 69.3 cm), sheet: 39⅜ x 30¾ in. (100 x 78.1 cm). Publisher: Maximilian Verlag/Sabine Knust, Munich. Printer: Atelier von Karl Imhof, Munich. Edition: 50. Gift of Nelson Blitz, Jr.

45. Andrzej Pagowski
Wolf's Smile (Usmiech Wilka). 1982. Poster: offset lithograph, 26⅜ x 37 in. (67 x 94 cm). Purchase

46. Vija Celmins
Alliance. 1982. Drypoint, mezzotint, and aquatint, plate.: 10¹⁄₁₆ x 7⁷⁄₁₆ in. (25.5 x 18.9 cm) (irreg.), sheet: 24 x 19⅜ in. (61 x 49.2 cm). Publisher and printer: Gemini G.E.L., Los Angeles. Edition: 48. Mrs. John D. Rockefeller 3rd Fund

47. Werner Herzog
Fitzcarraldo. 1982. West Germany. 35mm film, color, 157 minutes

48. Barbara Kruger
Untitled (You Invest in the Divinity of the Masterpiece). 1982. Unique photostat, 71¾ x 45⅝ in. (182.2 x 115.8 cm), with frame 6 ft. ⅞ in. x 46¾ in. (185.6 x 118.7 cm). Acquired through an anonymous fund

49. Katharina Fritsch
Madonna. 1982. Two multiples of plaster with pigment, each 11¹³⁄₁₆ x 3⅛ x 2⅜ in. (30 x 8 x 6 cm). Publisher and fabricator: the artist. Edition: unlimited. Purchased with funds given by Linda Barth Goldstein

50. Krzysztof Kieslowski
Blind Chance. 1982. Poland. 35mm film, color, 122 minutes. Acquired from Film Polski

51. Ingmar Bergman
Fanny and Alexander. 1982. Sweden/France/West Germany. 35mm film, color, 188 minutes

52. Tina Barney
Sunday New York Times. 1982. Chromogenic color print (Ektacolor), 47½ x 60⅝ in. (120.7 x 154.8 cm). Given anonymously

53. Nicholas Nixon
Chestnut Street, Louisville, Kentucky. 1982. Gelatin silver print, 7¹¹⁄₁₆ x 9¹¹⁄₁₆ in. (19.5 x 24.5 cm). The Family of Man Fund

54. Judith Joy Ross
Untitled from Eurana Park, Weatherly, Pennsylvania. 1982. Gelatin silver printing-out-paper print, 9¾ x 7¾ in. (24.8 x 19.7 cm). Joseph G. Mayer Fund

55. Wayne Wang
Chan Is Missing. 1982. USA. 35mm film, black and white, 80 minutes. Acquired from Dan Talbot

56. Barry Levinson
Diner. 1982. USA. 35mm film, color, 110 minutes. Gift of Warner Bros.

57. Uwe Loesch
Point (Punktum). 1982. Poster: offset lithograph, 33¹¹⁄₁₆ x 46⅞ in. (84 x 119 cm). Gift of the designer

58. William Wegman
Blue Head. 1982. Two color instant prints (Polaroid), left: 24 x 20½ in. (60.9 x 52 cm), right: 24½ x 20½ in. (62.2 x 52 cm). Gift of Mrs. Ronald S. Lauder

59. Paul Rand
IBM. 1982. Poster: offset lithograph, 36 x 24 in. (91.4 x 61 cm). Gift of the designer

60. Ridley Scott
Blade Runner. 1982. USA. 35mm film, color, 114 minutes

61. Joan Fontcuberta
Guillumeta Polymorpha. 1982. Gelatin silver print, 10½ x 8⁹⁄₁₆ in. (26.6 x 21.8 cm). Robert and Joyce Menschel Fund

62. Philip-Lorca diCorcia
Mary and Babe. 1982. Chromogenic color print (Ektacolor), 17⅜ x 23¼ in. (44.1 x 59 cm). Purchased as the gift of Harriette and Noel Levine

63. Paul Bartel
Eating Raoul. 1982. USA. 35mm film, color, 87 minutes. Gift of the artist

64. Stephen Armellino
Bullet-Resistant Mask. 1983. Kevlar and polyester resin, 11 x 6¾ x 3¾ in. (28 x 17.1 x 9.5 cm). Manufacturer: U.S. Armor Corporation, California. Gift of the manufacturer

65. John Canemaker
Bottom's Dream. 1983. USA. Animation cel from 35mm film, color, 6 minutes. Gift of the artist

66. John Divola
Untitled. 1983. Silver dye bleach print (Cibachrome), overall: 10⅞ x 21½ in. (27.8 x 55.6 cm). Purchased with funds given anonymously

67. Jannis Kounellis
Untitled. 1983. Steel beam, steel bed-frame with propane-gas torch, five steel shelves, smoke traces, and steel panel and shelf with wood, dimensions variable, overall: 10 ft. 11½ in. x 17 ft. 7¼ in. x 16¼ in. (333.9 x 536.5 x 41.2 cm). Sid R. Bass, Blanchette Rockefeller, and The Norman and Rosita Winston Foundation, Inc., funds, and purchase

68. Richard Prince
Entertainers. 1982–83. Chromogenic color print (Ektacolor), 61½ x 46½ in. (156.2 x 118.1 cm). Fractional gift of Werner and Elaine Dannheisser

69. Woody Allen
Zelig. 1983. USA. 35mm film, black and white and color, 79 minutes. Acquired from the artist

70. Terry Jones and Terry Gilliam
Monty Python's The Meaning of Life. 1983. Great Britain. 35mm film, color, 103 minutes

71. Swatch
GB 001 Watch. 1983. Plastic and metal, ⅛ x 1⅜ x 9¼ in. (.3 x 3.5 x 23.4 cm). Manufacturer: Swatch AG, Switzerland. Gift of the manufacturer

72. Swatch
GK 100 Jellyfish Watch. 1983. Plastic and metal, ¾ x 1⅜ x 8⅞ in. (.8 x 3.5 x 22.7 cm). Manufacturer: Swatch AG, Switzerland. Gift of the manufacturer

73. Bruce Nauman
Human/Need/Desire. 1983. Neon tubing, transformer, and wires, overall: 7 ft. 10⅜ in. x 70½ in. x 25¾ in. (239.8 x 179 x 65.4 cm). Gift of Emily and Jerry Spiegel

74. Joel Sternfeld
Houston, Texas. 1983. Chromogenic color print, 13⁷⁄₁₆ x 17 in. (34.2 x 43.2 cm). Purchased as the gift of the Joel W. Solomon Estate

75. Joel Sternfeld
Canyon Country, California. 1983. Chromogenic color print, 13½ x 17 in. (34.3 x 43.2 cm). Gift of the photographer

76. Kathryn Bigelow and Monty Montgomery
Breakdown (The Loveless). 1983. USA. 35mm film, color, 82 minutes. Gift of Kathryn Bigelow

77. Edward Ruscha
Hollywood Is a Verb. 1983. Dry pigment on paper, 29 x 23 in. (73.7 x 58.4 cm). Purchased with funds given by Agnes Gund, Mr. and Mrs. James Hedges IV, Ronald S. Lauder, and the General Drawings Fund

78. Martin Scorsese
The King of Comedy. 1983. 35mm film, color, 101 minutes.

79. Federico Fellini
And the Ship Sails On. 1983. Italy/France. 35mm film, color, 128 minutes

80. Nicholas Nixon
C.C., Boston. 1983. Gelatin silver print, 7¾ x 9¹¹⁄₁₆ in. (19.6 x 24.5 cm). Gift of Nicholas Nixon in memory of Garry Winogrand

81. Anselm Kiefer
Der Rhein. 1983. Illustrated book with twenty-one woodcuts (including front and back covers), page: 23¼ x 16½ in. (59 x 42 cm). Publisher and printer: the artist. Edition: 10. Purchase

82. Jan Groover
Untitled. 1983. Platinum-palladium print, 7½ x 9⅜ in. (19 x 23.8 cm). Robert and Joyce Menschel Fund

83. Francesco Clemente
Conversion to Her. 1983. Fresco of plaster on three Styrofoam and fiberglass panels, overall: 8 ft. x 9 ft. ¾ in. x 2¾ in. (244 x 286.7 x 7 cm) (irreg.). Anne and Sid Bass Fund

84. Mike Leigh
Meantime. 1983. Great Britain. 16mm film, color, 90 minutes. Acquired from Gerald Rappaport

85. Lizzie Borden
Born in Flames. 1983. USA. 16mm film, color, 90 minutes. Acquired from the artist

86. Jörg Immendorff
Futurology. 1983. Linoleum cut, comp.: 63¾ x 82⁷⁄₁₆ in. (160.6 x 209.4 cm) (irreg.), sheet: 71⁵⁄₁₆ x 90 in. (180.8 x 228.7 cm). Publisher: Maximilian Verlag/Sabine Knust, Munich. Printer: the artist. Edition: 8. Gift of Nelson Blitz, Jr.

87. Mazda Motor Corporation
MX5 Miata Automobile Taillights. 1983. Double-shot injection-molded acrylic resin, injection-molded polypropylene, and other materials, 6½ x 15 x 5 in. (16.5 x 38.1 x 12.7 cm). Manufacturer: Mazda Motor Corporation, Japan. Gift of Mazda Motor Corporation, California

88. Bill Viola
Anthem. 1983. USA. Videotape, color, sound, 11 minutes 30 seconds. Gift of the Friends of Jane Fluegel

89. Mako Idemitsu
Great Mother Part II: Yumiko. 1983. Japan. Videotape, color, sound, 24 minutes 30 seconds. Gift of Margot Ernst

90. Michael Spano
Photogram—Michael Spano. 1983. Gelatin silver print, 57⅛ x 23¹⁵⁄₁₆ in. (145.2 x 60.8 cm) (irreg.). Robert and Joyce Menschel Fund

91. Jonathan Borofsky
Stick Man. 1983. Lithograph, comp. and sheet: 52½ x 37¾ in. (133.3 x 95.9 cm). Publisher and printer: Gemini G.E.L., Los Angeles. Edition: 27. John B. Turner Fund

92. Frank Stella
Giufà, la luna, i ladri e le guardie from the Cones and Pillars series. 1984. Synthetic polymer paint, oil, urethane enamel, fluorescent alkyd, and printing ink on canvas, and etched magnesium, aluminum, and fiberglass, 9 ft. 7¼ in. x 16 ft. 3¼ in. x 24 in. (292.7 x 495.9 x 61 cm). Acquired through the James Thrall Soby Bequest

93. Sigmar Polke
Watchtower. 1984. Synthetic polymer paints, dry pigment, and oilstick on various fabrics, 9 ft. 10 in. x 7 ft. 4½ in. (300 x 224.8 cm). Fractional gift of Ronald S. Lauder

94. Bruce Nauman
Crossed Stadiums. 1984. Synthetic polymer paint, watercolor, charcoal, and pastel on paper, 53 in. x 72½ in. (134.7 x 184.2 cm). Gift of The Lauder Foundation

95. Claes Oldenburg
Proposal for a Monument to the Survival of the University of El Salvador: Blasted Pencil (That Still Writes). 1984. Etching and aquatint, plate: 6¹⁵⁄₁₆ x 20¹¹⁄₁₆ in. (17.7 x 52.9 cm), sheet: 22¹³⁄₁₆ x 30¼ in. (58 x 76.8 cm). Publisher: Multiples, Inc., New York, for Artists Call Against US Intervention in Central America. Printer: Aeropress, New York. Edition: 35. John B. Turner Fund

96. Sergio Leone
Once upon a Time in America. 1984. USA/Italy. 35mm film, color, 227 minutes

97. Neil Jordan
The Company of Wolves. 1984. Great Britain. 35mm film, color, 96 minutes

98. Gary Hill
Why Do Things Get in a Muddle? (Come on Petunia). 1984. USA. Videotape, color, sound, 33 minutes 9 seconds. Purchase

99. Mary Ann Toots Zynsky
Bowl. 1984. Lead crystal (*filet-de-verre*), 3 x 11 in. (7.6 x 28 cm) diameter. Emilio Ambasz Fund

100. Andy Warhol
Rorschach. 1984. Synthetic polymer paint on canvas, 13 ft. 8¼ in. x 9 ft. 7 in. (417.2 x 292.1 cm). Purchase

101. Anselm Kiefer
Departure from Egypt. 1984. Synthetic polymer paint, charcoal, and string on cut-and-pasted photograph and cardboard, 43⅛ x 33½ in. (109.5 x 85 cm) (irreg.). Gift of the Denise and Andrew Saul Fund

102. Sherrie Levine
Untitled (After Kasimir Malevich and Egon Schiele). from The 1917 Exhibition at Nature Morte Gallery, 1984. 1984. Pencil and watercolor on paper, four of forty sheets, each 14 x 11 in. (36 x 27.9 cm). Gift of Constance B. Cartwright, Roger S. and Brook Berlind, Marshall S. Cogan, and purchase

103. David Goldblatt
Mother and child in their home after the destruction of its shelter by officials of the Western Cape Development Board, Crossroads, Cape Town, 11 October 1984. 1984. Gelatin silver print, 10¹⁵⁄₁₆ x 13¹¹⁄₁₆ in. (27.9 x 34.8 cm). Gift of Wm. Brian Little

104. Judith Joy Ross
Untitled from Portraits at the Vietnam Veterans Memorial, Washington, D.C. 1984. Gelatin silver printing-out-paper print, 9⅗ x 7⅝ in. (24.5 x 19.5 cm). Purchased as the gift of Paul F. Walter

105. Aldo Rossi with Gianni Braghieri
Cemetery of San Cataldo, Modena, Italy. 1971–84. Elevation study: ink and pencil on paper, 7¾ x 29⅝ in. (19.7 x 75.2 cm). Gift of The Howard Gilman Foundation

106. Aldo Rossi with Gianni Braghieri
Cemetery of San Cataldo, Modena, Italy. 1971–84. Aerial perspective: ink and pencil on paper, 29¹³⁄₁₆ x 56⅛ in. (75.8 x 142.6 cm). Gift of The Howard Gilman Foundation

107. Su Friedrich
The Ties That Bind. 1984. USA. 16mm film, black and white, 55 minutes. Acquired from the artist

108. Hou Hsiao-hsien
Summer at Grandpa's. 1984. Taiwan. 35mm film, color, 102 minutes

109. frogdesign, company design
Macintosh SE Home Computer. 1984. ABS plastic casing, 13¾ x 9¾ x 10¾ in. (34.9 x 25 x 27.5 cm). Manufacturer: Apple Computer, California. Gift of the designer and manufacturer

110. Allan McCollum
40 Plaster Surrogates. 1982–84. Enamel on Hydro-Stone, forty panels ranging from 5 x 4⅛ in. (12.8 x 10.2 cm) to 20¼ x 16¼ in. (51.3 x 41.1 cm), overall: 64 in. x 9 ft. 2 in. (162.5 x 279.4 cm). Robert and Meryl Meltzer and Robert F. and Anna Marie Shapiro funds

111. Paul Graham
Crouched Man, DHSS Waiting Room, Bristol. 1984. Chromogenic color print (Ektacolor), 26¼ x 34½ in. (68 x 88.1 cm). Purchased as the gift of Shirley C. Burden

112. John Cassavetes
Love Streams. 1984. USA. 35mm film, color, 141 minutes. Gift of the artist and Cannon Films, Inc.

113. Greta Schiller and Robert Rosenberg
Before Stonewall. 1984. USA. 16mm film, black and white and color, 87 minutes. Gift of Vito Russo

114. Martin Puryear
Greed's Trophy. 1984. Steel rods and wire, wood, rattan, and leather, 12 ft. 9 in. x 20 in. x 55 in. (388.6 x 50.8 x 139.7 cm). David Rockefeller Fund and purchase

115. Robert Ryman
Pace. 1984. Synthetic polymer paint on fiberglass on wood with aluminum, 59½ x 26 x 28 in. (151.2 x 66 x 71.1 cm). Gift of anonymous donor and gift of Ronald S. Lauder

116. Jim Jarmusch
Stranger Than Paradise. 1984. USA/West Germany. 35mm film, black and white, 89 minutes. Acquired from the artist

117. Woody Allen
Broadway Danny Rose. 1984. USA. 35mm film, black and white, 84 minutes. Acquired from the artist

118. Jo Ann Callis
Woman Twirling. 1985. Silver dye bleach print (Cibachrome), 29¼ x 36⁷⁄₁₆ in. (74.3 x 92.6 cm). The Fellows of Photography Fund

119. Robert Frank
Boston, March 20, 1985. 1985. Six color instant prints (Polaroid) with hand-applied paint and collage, each 27¾ x 22¼ in. (70.3 x 56.4 cm). Purchased as the gift of Polaroid Corporation

120. Bernard Tschumi
Parc de la Villette, Paris, France: Four Follies Intersecting North-South Gallery. 1985. Model: acrylic and metal, 6½ x 60 x 15¼ in. (16.5 x 152.4 x 38.7 cm). Gift of the architect

121. Anselm Kiefer
The Red Sea. 1984–85. Oil, lead, woodcut, photograph, and shellac on canvas, 9 ft. 1¾ in. x 13 ft. 11⅜ in. (278.8 x 425.1 cm). Enid A. Haupt Fund

122. Jasper Johns
Summer. 1985. Encaustic on canvas, 6 ft. 3 in. x 50 in. (190.5 x 127 cm). Gift of Philip Johnson

123. Jean-Michel Basquiat
Untitled. 1985. Color oilstick and cut-and-pasted paper on paper, 41½ x 29½ in. (105.4 x 75 cm). Acquired in memory of Kevin W. Robbins through funds provided by his family and friends and by the Committee on Drawings

124. David Salle
Muscular Paper. 1985. Oil, synthetic polymer paint, and charcoal on canvas and fabric, with painted wood, in three parts, overall: 8 ft. 2⅛ in. x 15 ft. 7⅛ in. (249.3 x 475 cm). Gift of Douglas S. Cramer Foundation

125. Sir Norman Foster
Hong Kong and Shanghai Bank, Hong Kong, 1979–85. Exterior perspectives sketch: ink on paper, each sheet: 16½ x 11¹¹⁄₁₆ in. (41.9 x 59.4 cm). Gift of the architect in honor of Philip Johnson

126. James Herbert
River. 1985. USA. 16mm film, black and white and color, 13 minutes. Gift of the artist

127. Philip-Lorca diCorcia
Francesco. 1985. Chromogenic color print (Ektacolor), 16⅛ x 23¼ in. (41 x 59.1 cm). Purchased as the gift of Harriette and Noel Levine

128. Art Spiegelman
Maus: A Survivor's Tale. 1980–85. Two pages from a series of six artist's books, page (approx.), 8¹⁵⁄₁₆ x 6 in. (22.7 x 15.3 cm). Publisher: RAW Books and Graphics, New York. Edition: 5,000–15,000. The Museum of Modern Art/Franklin Furnace/Artist's Book Collection, The Museum of Modern Art Library, New York

129. Claude Lanzmann
Shoah. 1985. France/Switzerland. 16mm film transferred to 35mm, color, 561 minutes. Acquired from Dan Talbot

130. John Schlesinger
Untitled. 1985. Gelatin silver print, 51⅛ x 35½ in. (132 x 90.2 cm). The Family of Man Fund

131. Mike Kelley
Exploring (from "Plato's Cave, Rothko's Chapel, Lincoln's Profile"). 1985. Synthetic polymer paint on paper, 6 ft. 4½ in. x 64 in. (194.3 x 162.6 cm). Gift of the Friends of Contemporary Drawing, The Contemporary Arts Council, and The Junior Associates of The Museum of Modern Art

132. Thomas Florschuetz
In Self-Defense. 1985. Two gelatin silver prints, each 19½ x 19⅝ in. (49.5 x 49.8 cm). E. T. Harmax Foundation Fund

133. Willem de Kooning
Untitled VII. 1985. Oil on canvas, 70 in. x 6 ft. 8 in. (177.8 x 203.2 cm). Purchase, and gift of Milly and Arnold Glimcher

134. John Coplans
Self-Portrait. 1985. Gelatin silver print, 18½ x 17⅞ in. (47.2 x 45.6 cm). Robert and Joyce Menschel Fund

135. Lothar Baumgarten
Untitled (Fish). 1985. Screenprint, comp.: 26⅞ x 39⅜ in. (68.2 x 100.1 cm), sheet: 31½ x 45¼ in. (80 x 115 cm). Publisher: the artist. Printer: the artist. Edition: 35. Purchase

136. Terry Gilliam
Brazil. 1985. Great Britain. 35mm film, color, 142 minutes

137. Jeff Koons
Three Ball 50/50 Tank. 1985. Glass, painted steel, water, plastic, and three basketballs, 60⅝ x 48¾ x 13¼ in. (154 x 123.9 x 33.6 cm). Fractional gift of Werner and Elaine Dannheisser

138. James Casebere
Covered Wagons. 1985. Gelatin silver print, 29½ x 22¾ in. (75 x 57.8 cm). Purchase

139. Trinh T. Minh-ha
Naked Spaces: Living Is Round. 1985. West Africa/USA. 16mm film, color, 135 minutes

140. Susan Rothenberg
Biker. 1985. Oil on canvas, 6 ft 2¼ in. x 69 in. (188.3 x 175.2 cm). Fractional gift of PaineWebber Group Inc.

141. Susan Rothenberg
Boneman. 1986. Mezzotint, plate: 23⅞ x 20⅛ in. (60.6 x 51.2 cm) (irreg.), sheet: 30 x 20⅛ in. (76.2 x 51.2 cm). Publisher and printer: Gemini G.E.L., Los Angeles. Edition: 42. John B. Turner Fund

142. Bill Viola
I Do Not Know What It Is I Am Like. 1986. USA. Videotape, color, sound, 89 minutes. Gift of Catherine Meacham

143. Shiro Kuramata
How High the Moon Armchair. 1986. Nickel-plated steel mesh, 28½ x 37⅜ x 32¾ in. (72.4 x 95 x 83.2 cm). Manufacturer: Vitra International Ltd., Switzerland. Gift of the manufacturer

144. Bernhard and Anna Blume
Kitchen Frenzy. 1986. Five gelatin silver prints, each 66⁹⁄₁₆ x 42½ in. (170 x 108 cm). Gift of The Contemporary Arts Council

145. Robert Gober
Untitled. 1986. Enamel paint on wood, cotton, wool, and down, 36½ x 43 in. x 6 ft. 4⅜ in. (92.7 x 109.2 x 194 cm). Fractional gift of Werner and Elaine Dannheisser

146. Ellsworth Kelly
Three Panels: Orange, Dark Gray, Green. 1986. Oil on canvas, left panel: 8 ft. 8½ in. x 7 ft. 10 in. (265.4 x 238.7 cm), center panel: 7 ft. 4 in. x 8 ft. 2 in. (223.5 x 248.9 cm), right panel: 8 ft. 1½ in. x

9 ft. 11½ in. (247.6 x 303.5 cm), overall: 9 ft. 8 in. x 34 ft. 4½ in. (294.6 x 1047.7 cm). Gift of Douglas S. Cramer Foundation

147. Larry Fink
Pearls, New York City. 1986. Gelatin silver print, 14⅜ x 14⅜ in. (36.5 x 37.1 cm). Gift of Pauline Marks

148. Patrick Faigenbaum
Massimo Family, Rome. 1986. Gelatin silver print, 19½ x 19¼ in. (49.6 x 48.9 cm). Gift of the photographer and Sylviane de Decker Heftler

149. Eugenio Dittborn
8 Survivors. 1986. Screenprint (unfolded) and envelope screenprinted with artist's standard mailing form and collaged documentation label, comp.: 3³⅝₆ in. x 57½ in. (192 x 146.1 cm) (irreg.), sheet (unfolded): 6 ft. 7⅞ in. x 60½ in. (202.9 x 153.7 cm), envelope: 20¹¹⁄₁₆ x 15¹⁵⁄₁₆ in. (52.5 x 40.5 cm). Publisher: the artist. Printer: Impresos Punto Color Limitada, Santiago. Edition: 4. Purchase

150. Bertrand Tavernier
Round Midnight. 1986. France/USA. 35mm film, color, 133 minutes

151. Niklaus Troxler
A Tribute to the Music of Thelonious Monk. 1986. Poster: offset lithograph, 50⅜ x 35⅝ in. (128 x 90.5 cm). Gift of the designer

152. Francesco Clemente
The Departure of the Argonaut by Alberto Savinio (Andrea de Chirico). 1986. (Prints executed 1983–86). Illustrated book with forty-nine photolithographs, page: 25⅝ x 19¹¹⁄₁₆ in. (65 x 50 cm). Publisher: Petersburg Press, London. Printers: plates by Rolf Neumann, Stuttgart; text by Staib and Mayer, Stuttgart. Bound edition: 232, unbound edition: 56. Gift of Petersburg Press

153. James Ivory
A Room with a View. 1986. Great Britain. 35mm film, color, 115 minutes

154. John Frankenheimer
52 Pick-Up. 1986. USA. 35mm film, color, 114 minutes

155. John Baldessari
Untitled. 1986. Black-and-white photograph with colored round stickers overlaid with plastic sheet with color crayon, 9¾ x 7⅜ in. (24.8 x 18.7 cm). Gift of Brooke Alexander and of the artist

156. Bill Sherwood
Parting Glances. 1986. USA. 35mm film, color, 90 minutes

157. Louise Bourgeois
Articulated Lair. 1986. Painted steel, rubber, and metal, overall: 9 ft. 3 in. x 21 ft. 6 in. x 16 ft. 1 in. (281.7 x 655.7 x 555.6 cm). Gift of Lily Auchincloss, and of the artist in honor of Deborah Wye (by exchange)

158. Jeff Koons
Baccarat Crystal Set. 1986. Cast stainless steel, 12¼ in. (31.1 cm) high x 16½ in. (41.7 cm) in diameter. Gift of Werner and Elaine Dannheisser

159. Edward Ruscha
Jumbo. 1986. Synthetic polymer paint on canvas, 6 ft. 10⅛ in. x 8 ft. 2⅛ in. (208.6 x 249 cm). Given anonymously in memory of Nicholas Wilder; Sid R. Bass, Douglas S. Cramer, and Jeanne C. Thayer funds; and gift of The Cowles Charitable Trust

160. Terry Winters
Folio. 1985–86. Three from a portfolio of eleven lithographs, comp. and sheet, each approx. 30¹¹⁄₁₆ x 22⅜ in. (78 x 57 cm). Edition: 39. Printer: Universal Limited Art Editions. Gift of Emily Fisher Landau

161. Robert Breer
Bang! 1986. USA. Animation cels from 16mm film, color, 8 minutes

162. Frank Gehry
Fishdance Restaurant, Kobe, Japan. c.1986. Sketch: ink on paper, 9 x 12 in. (22.9 x 30.5 cm). Gift of Barbara Pine in memory of Morris Goldman

163. Frank Gehry
Winton Guest House, Wayzata, Michigan. 1983–86. Model: wood, plastic, and plaster, 11¾ x 24 x 24 in. (29.8 x 61 x 61 cm). Gift of the architect

164. Anish Kapoor
A Flower, A Drama Like Death. 1986. Polystyrene, plaster, cloth, gesso, and raw pigment, in three parts: 15½ x 28½ x 14½ in. (39.4 x 72.4 x 36.8 cm), 22½ x 44 x 22 in. (54.6 x 111.8 x 55.9 cm), 25 in. x 7 ft. 7½ in. x 22⅝ in. (63.5 x 232.9 x 57.4 cm). Sid R. Bass Fund

165. Gaetano Pesce
Feltri Chair. 1986. Wool felt, polyester resin, and hemp string; cushion: cotton/polyester cover with polyester padding, 55⅛ x 29⅛ x 25⅛ in. (140 x 74 x 64 cm). Manufacturer: Cassina S.p.A., Italy. Gift of the manufacturer

166. Janice Findley
Beyond Kabuki. 1986. USA. 16mm film, color, 10 minutes. Acquired from the artist

167. Andy Warhol
The Last Supper. 1986. Synthetic polymer paint on canvas, 9 ft. 11¼ in. x 21 ft. 11¼ in. (302.9 x 668.7 cm). Gift of The Andy Warhol Foundation for the Visual Arts, Inc.

168. Clint Eastwood
Heartbreak Ridge. 1986. USA. 35mm film, color, 130 minutes. Gift of the artist and Warner Bros.

169. Oliver Stone
Platoon. 1986. USA. 35mm film, color, 111 minutes. Gift of the artist

170. Stanley Kubrick
Full Metal Jacket. 1987. USA. 35mm film, color, 116 minutes

171. David Wojnarowicz
Fire. 1987. Synthetic polymer paint and pasted paper on plywood, in two parts, overall: 6 x 8 ft. (182.9 x 243.8 cm). Gift of Agnes Gund and Barbara Jakobson Fund

172. Bruce Nauman
Dirty Story. 1987. USA. Video installation of two ¾-inch videotape players, two 16-inch color monitors, and two videotapes (color, sound), dimensions variable. Gift of Werner and Elaine Dannheisser

173. Barry Levinson
Tin Men. 1987. USA. 35mm film, color, 110 minutes. Gift of Buena Vista Pictures Distribution, Inc.

174. Jeffrey Scales
12:54, A. Philip Randolph Square. 1987. Gelatin silver print, 19⅛ x 19⅛ in. (48.6 x 48.6 cm). The Family of Man Fund

175. Abigail Child
Mayhem. 1987. USA. 16mm film, black and white, 19 minutes. Acquired from the artist

176. George Kuchar
Creeping Crimson. 1987. USA. Videotape, color, sound, 12 minutes 50 seconds. Purchase

177. Nikita Mikhalkov
Dark Eyes. 1987. Italy. 35mm film, color, 118 minutes. Gift of Janus Films

178. Paolo Taviani and Vittorio Taviani
Good Morning Babylon. 1987. Italy/France/USA. 35mm film, color, 115 minutes. Acquired from Vestron

179. David Hammons
Free Nelson Mandela. 1987. Stencil, comp.: 20⅝ x 23⅝ in. (52.4 x 60 cm) (irreg.), sheet: 28¹¹⁄₁₆ x 28⅜ in. (73.2 x 72.5 cm) (irreg.). Publisher and printer: the artist. Edition: unique. John B. Turner Fund

180. Leon Golub
White Squad. 1987. Lithograph, comp. and sheet: 29¼ x 41¼ in. (74.3 x 104.8 cm). Publisher: Mason Gross School of the Arts, Rutgers University, New Brunswick, N.J. Printer: Rutgers Center for Innovative Print and Paper, New Brunswick. Edition: 60. Gift of Arnold Smoller

181. Christopher Wilmarth
Self-Portrait with Sliding Light. 1987. Steel, bronze, and lead, 53⅝ x 16⅞ x 7¼ in. (136.2 x 42.8 x 18.4 cm). Gift of Susan Wilmarth

182. Alberto Meda
Light Light Armchair. 1987. Carbon fiber and Nomex honeycomb, 29¼ x 15 x 19½ in. (74.3 x 38.3 x 49.5 cm). Manufacturer: Alias S.r.l., Italy. Gift of the manufacturer

183. Eric Fischl
Portrait of a Dog. 1987. Oil on canvas, in four parts, overall: 9 ft. 5 in. x 14 ft. 2¾ in. (287 x 433.7 cm). Gift of the Louis and Bessie Adler Foundation, Inc., Seymour M. Klein, President; Agnes Gund; President's Fund Purchase (1987); Donald B. Marron, President; Jerry I. Speyer; the Douglas S. Cramer Foundation; Philip Johnson; Robert and Jane Meyerhoff; Anna Marie and Robert F. Shapiro; Barbara Jakobson; Gerald S. Elliott; and purchase

184. Tina Barney
Sheila and Moya. 1987. Chromogenic color print, 30½ x 38¾ in. (77.5 x 98.5 cm). Gift of the photographer and Janet Borden

185. Jac Leirner
Lung. 1987. 1,200 Marlboro cigarette packages strung on a polyurethane cord, dimensions variable, length ranges from 14 ft. 5¼ in. (440 cm) to 15 ft. 9 in. (480 cm). David Rockefeller Fund for Latin-American Art and Brazil Fund

186. Tony Cragg
Oersted Sapphire. 1987. Cast aluminum, in six parts: large beaker: 7 ft. 6 in. x 41 in. x 41 in. (228.5 x 104 x 104 cm); small beaker: 50¾ x 20¼ x 20¼ in. (129 x 51.5 x 51.5 cm); round beaker: 22 x 31½ x 37¼ in. (55.8 x 54.5 x 94.6 cm); long test tube: 7½ x 48½ x 7⅛ in. (19.1 x 123.1 x 18.2 cm); short test tube: 8¼ x 38⅝ x 8 in. (21 x 98.6 x 20.3 cm); curved test tube: 8¾ in. x 6 ft. 8½ in. x 43½ in. (22.2 x 204.5 x 110.5 cm); overall: approx. 7 ft. 6 in. x 18 ft. 10 in. x 11 ft. 1 in. (228.5 x 574.1 x 337.8 cm). Fractional gift of Werner and Elaine Dannheisser

187. Frank Gehry
Bubbles Lounge Chair. 1987. Corrugated cardboard with fire-retardant coating, 35 x 28½ x 6 ft.1 in. (89 x 72.5 x 185.5 cm). Manufacturer: New City Editions, California. Kenneth Walker Fund

188. Andy Warhol
Camouflage. 1987. Portfolio of eight screenprints, comp. and sheet: each 37¹⁵⁄₁₆ x 37¹⁵⁄₁₆ in. (96.5 x 96.5 cm). Publisher: the artist. Printer: Rupert Jason Smith, New York. Edition: 80. John B. Turner Fund

189. Nathaniel Dorsky
Alaya. 1976–87. USA. 16mm film, color, silent, 27 minutes (18 frames per second). Acquired from the artist

190. Mary Lucier
Ohio at Giverny: Memory of Light. 1987. USA/France. Videotape, color, sound, 25 minutes. Gift of the Jerome Foundation

191. Anish Kapoor
Untitled (Red Leaf). 1987. Gouache and pencil on paper, 13¾ x 12¼ in. (35 x 31.1 cm). Gift of Patricia and Morris Orden and an anonymous donor

192. John Huston
The Dead. 1987. USA. 35mm film, color, 83 minutes. Acquired from Vestron

193. John Boorman
Hope and Glory. 1987. Great Britain. 35mm film, color, 113 minutes

194. Aleksandr Askoldov
The Commissar. 1967–87. Soviet Union. 35mm film, black and white, 110 minutes. Acquired from Gerald Rappaport

195. Mario Merz
Places with No Street. 1987. Aluminum, wire mesh, stones, twigs, neon tubing, transformer, and wires, dimensions variable,

museum installation 6 ft. 6¾ in. x 21 ft. x 28 ft. (200 x 640.5 x 854 cm). Sid R. Bass and Enid A. Haupt funds

196. Office for Metropolitan Architecture (Rem Koolhaas, Götz Keller, Willem-Jan Neutelings, with Brigitte Kochta, Martin Kohn, Luc Reuse, Ron Steiner, Jeroen Thomas, and Graciella Torre)
City Hall Competition, the Hague, the Netherlands. 1987. Perspective: charcoal on paper, 62 x 6 ft.9 in. (157.5 x 205.7 cm). Purchase

197. Wolfgang Laib
The Passageway. 1988. Beeswax, wood construction, with two electric lightbulbs, exterior dimensions variable, interior dimensions, 10 ft. 11⅜ in. x 6 ft. 1½ in. x 18 ft. 9¼ in. (333.6 x 186.6 x 572.1 cm). Committee on Painting and Sculpture Funds

198. Bernd and Hilla Becher
Water Towers. 1988. Nine gelatin silver prints, each 15¹⁵⁄₁₆ x 12⅛ in. (40.5 x 30.8 cm), overall: 67¹¹⁄₁₆ x 55⅛ in. (172 x 140 cm). Fractional Gift of Werner and Elaine Dannheisser

199. Steven Holl with Bryan Bell, Stephen Cassell, Pier Copat, and Peter Lynch.
American Memorial Library, Berlin, Germany. Project, 1988. Model: concrete, wood, paper, pigment, and steel, 10¼ x 48 x 24 in. (26 x 121.9 x 61 cm). Given anonymously and David Rockefeller, Jr., Purchase Fund

200. Jean-Luc Godard
Puissance de la parole. 1988. France/Switzerland. Videotape, color, 25 minutes. Acquired from France Telecom

201. Christian Boltanski
The Storehouse (La Grande Reserve). 1988. Seven photographs, seven electric lamps, and 192 tin biscuit-boxes containing cloth fragments, overall: 6 ft. 11⅛ in. x 12 ft. 4 in. x 8½ in. (211.2 x 375.8 x 21.6 cm). Jerry I. Speyer, Mr. and Mrs. Gifford Phillips, Barbara Jakobson, and Arnold A. Saltzman funds, and purchase

202. Allen Ruppersberg
Preview. 1988. Series of ten lithographs, comp.: each 21⁹⁄₁₆ x 13³⁄₁₆ in. (54.1 x 33.5 cm), sheet: each 22¹⁄₁₆ x 13¹³⁄₁₆ in. (56.1 x 35.1 cm). Publisher and printer: Landfall Press, Chicago. Edition: 30. John B. Turner Fund

203. Tadanori Yokoo
Japanese Society for the Rights of Authors, Composers, and Publishers. 1988. Poster: screenprint, 40½ x 28⅝ in. (102.8 x 72.5 cm). Gift of the designer

204. David Wojnarowicz
The Weight of the Earth, Part I. 1988. Fourteen gelatin silver prints, overall: 39 x 41¼ in. (99.1 x 104.8 cm). The Family of Man Fund

205. Ashley Bickerton
Tormented Self-Portrait (Susie at Arles). 1987–88. Synthetic polymer paint, bronze powder, and lacquer on wood, anodized aluminum, rubber, plastic, Formica, leather, chrome-plated steel, and canvas, 7 ft. 5½ in. x 68¼ in. x 15¾ in. (227.1 x 174.5 x 40 cm). Purchase

206. Zeke Berman
Untitled. 1988. Gelatin silver print, 27⁹⁄₁₆ x 39⅜ in. (70 x 100.1 cm). The Fellows of Photography Fund

207. Morphosis (Thom Mayne and Kim Groves)
6th Street House Project, Santa Monica, California. 1987–88. Silkscreen and metal foil on paper, 40 x 30 in. (101.6 x 76.2 cm). Given anonymously

208. Richard Artschwager
Double Sitting. 1988. Synthetic polymer paint on composition board and Formica, 6 ft. 3⅝ in. x 67¾ in. (192 x 172.3 cm), including painted wood frame. Fractional and promised gift of Agnes Gund

209. Mike and Doug Starn
Double Rembrandt with Steps. 1987–88. Toned gelatin silver prints, ortho film, wood, adhesive, and Plexiglas, 42½ x 42½ in. (108 x 108 cm). Gift of Barbara and Eugene Schwartz

210. Gerhard Richter
October 18, 1977. 1988. Five of fifteen paintings, oil on canvas, installation variable. Shown: *Funeral (Beerdigung),* 6 ft. 6¾ in. x 10 ft. 6 in. (200 x 320 cm); *Cell (Zelle),* 6 ft. 7 in. x 55 in. (201 x 140 cm); *Hanged (Erhängte),* 6 ft. 7 in. x 55 in. (201 x 140 cm); *Youth Portrait (Jugendbildnis),* 28½ x 24½ in. (72.4 x 62 cm); *Record Player (Plattenspieler),* 24⅜ x 32¾ in. (62 x 83 cm). The Sidney and Harriet Janis Collection, gift of Philip Johnson, and acquired through the Lillie P. Bliss Bequest (all by exchange); Enid A. Haupt Fund; Nina and Gordon Bunshaft Bequest Fund; and gift of Emily Rauh Pulitzer

211. Lawrence Charles Weiner
Rocks upon the Beach/Sand upon the Rocks. 1988. Paint on wall, dimensions variable. Acquisition from the Werner Dannheisser Testamentary Trust

212. Clint Eastwood
Bird. 1988. USA. 35mm film, color, 161 minutes. Gift of the artist and Warner Bros.

213. Bruce Nauman
Learned Helplessness in Rats (Rock and Roll Drummer). 1988. USA. Video installation of Plexiglas maze, closed-circuit video camera, scanner and mount, switcher, two videotape players, 13-in. color monitor, 9-in. black-and-white monitor, video projector, and two videotapes (color, sound); maze: 22 in. x 10 ft. 6 in. x 10 ft. 10 in. (55.9 x 320 x 330.2 cm); overall dimensions variable. Acquisition from the Werner Dannheisser Testamentary Trust

214. Ilya Kabakov
The Man Who Flew Into His Picture from the Ten Characters series.

1981–88. Room installation of painted drywall, composition board, and painted Homasote, containing enamel paint on composition board, ink and color graphite on paper, photographs, watercolor on paper, painted wood doors, wood chair, painted wood shelf, and painted electric lightbulb, dimensions variable, museum installation 8 ft. 8½ in. x 24 ft. 6 in. x 17 ft. 3 in. (265.4 x 746.8 x 525.8 cm). Gift of Marcia Riklis, Jerry I. Speyer Fund, and Michael and Judy Ovitz Fund

215. Stephen Peart and Bradford Bissell
"Animal" Wet Suit. 1988. Molded neoprene, thermoplastic elastomer, nylon jersey, and Derlin zipper, dimensions variable. Manufacturer: O'Neill, Inc., California. Gift of the designers

216. Jeff Koons
Pink Panther. 1988. Porcelain, 41 x 20½ x 19 in. (104.1 x 52.1 x 48.2 cm). Fractional gift of Werner and Elaine Dannheisser

217. Günter Förg
Stairway. 1988. Gelatin silver print, 70¾ x 47¼ in. (180 x 120 cm). Gift of Robert F. and Anna Marie Shapiro

218. Tony Oursler and Constance DeJong
Joyride. 1988. USA. Videotape, color, sound, 14 minutes 23 seconds. Purchase

219. Julie Zando
Let's Play Prisoners. 1988. USA. Videotape, black and white, sound, 22 minutes. Purchase

220. Louise Lawler
Does Andy Warhol Make You Cry? 1988. Silver dye bleach print (Cibachrome), 27¹⁵⁄₁₆ x 39⅜ in. (70 x 100 cm), with a Plexiglas wall label (not shown), 4⅜ x 6⅜ in. (10.2 x 15.1 cm). Gift of Gabriella de Ferrari in honor of Karen Davidson

221. Roy Lichtenstein
Bauhaus Stairway. 1988. Oil and synthetic polymer paint (Magna) on canvas, 7 ft. 10 in. x 66 in. (238.8 x 167.7 cm). Gift of Dorothy and Roy Lichtenstein

222. Matt Mullican
Untitled. 1988. Portfolio of fifteen etchings (twelve with aquatint and one with photogravure) and one aquatint, plate: each 21½ x 14½ in. (54.6 x 36.8 cm), sheet: each 22¹⁄₁₆ x 15⅛ in. (56 x 38.4 cm). Publisher: Carl Solway Gallery, Cincinnati. Printer: Mark Patsfall Graphics, Cincinnati. Edition: 64. Purchase

223. Martin Kippenberger
The World of the Canary. 1988. Pencil on paper, four of 156 sheets, each 5½ x 4⅛ in. (14 x 10.5 cm). Gift of Walter Bareiss and R. L. B. Tobin

224. Marc Newson
Wood Chair. 1988. Fujo wood, 24⅜ x 32¼ x 39¼ in. (62 x 82 x 100 cm). Manufacturer: Cappellini S.p.A., Italy. Gift of the manufacturer

225. Gregory Crewdson
Untitled from the series Natural Wonder. 1988. Chromogenic color print (Ektacolor), 26⅜ x 37¾ in. (67 x 95.9 cm). Purchased as a gift of Barbara Jakobson

226. Adam Fuss
Untitled. 1988. Gelatin silver print, 54⅞ x 49¹⁄₁₆ in. (139.4 x 124.6 cm). Polaroid Foundation Fund

227. Nic Nicosia
Real Pictures #11. 1988. Gelatin silver print, 6 ft. 7 in. x 48⅜ in. (200.7 x 122.9 cm). E. T. Harmax Foundation Fund

228. Paul Thek
The Soul Is the Need for the Spirit. 1988. Synthetic polymer paint on newspaper, 22 x 27 in. (55.9 x 69.9 cm). Purchased with funds given by The Judith Rothschild Foundation

229. Pedro Almodóvar
Women on the Verge of a Nervous Breakdown. 1988. Spain. 35mm film, color, 98 minutes

230. Cindy Sherman
Untitled #197. 1989. Chromogenic color print (Ektacolor), 31¹⁄₁₆ x 20¹⁵⁄₁₆ in. (78.9 x 53.2 cm). Purchase

231. Marlon Riggs
Tongues Untied. 1989. USA. Videotape, color, sound, 55 minutes. Purchase

232. Martin Scorsese
The Last Temptation of Christ. 1989. USA/Canada. 35mm film, color, 164 minutes

233. Richard Sapper and Sam Lucente
Leapfrog Computer. 1989. Carbon-fiber-reinforced plastic, magnesium alloy, ABS, and other materials, 1½ x 10⅝ x 13¾ in. (3.8 x 27 x 35 cm). Manufacturer: IBM Corporation, New York. Gift of the manufacturer

234. Thomas Ruff
Portrait. 1989. Chromogenic color print (Ektacolor), 47¼ x 22⅝ in. (119.6 x 57.5 cm). The Fellows of Photography Fund

235. Edin Velez
Dance of Darkness. 1989. USA. Videotape, color, sound, 54 minutes 57 seconds. Gift of the Jerome Foundation

236. Carroll Dunham
Shadows. 1989. Two from a portfolio of ten drypoints, plate and sheet: each approx. 15½ x 22¹³⁄₁₆ in. (39.3 x 58 cm). Publisher and printer: Universal Limited Art Editions, West Islip, N.Y. Edition: 14. Gift of Emily Fisher Landau

237. Tadanori Yokoo
Fancydance. 1989. Poster: offset lithograph, 40½ x 28⅜ in. (102.8 x 72.5 cm). Gift of the designer

238. Elizabeth Diller and Ricardo Scofidio
Slow House, Long Island, New York. 1989. Model: wood, cardboard, metal, plastic, and twine, 12 x 60 x 30¼ in. (30.5 x 152.5 x 77 cm). Marshall Cogan Purchase Fund, Bertha and Isaac Liberman Foundation Fund

239. Rafael Viñoly
Tokyo International Forum, Tokyo, Japan. 1989. East elevation of theater structures: crayon and graphite on tracing paper, 12 x 31¾ in. (30.5 x 80.6 cm). Gift of the architect

240. Bruce Nauman
Model for *Animal Pyramid II*. 1989. Cut-and-taped photographs, 7 ft. 6½ in. x 60⅛ in. (229.9 x 152.8 cm). Gift of Agnes Gund and Ronald S. Lauder

241. Gilbert and George
Down to Earth. 1989. Fifteen black-and-white photographs, hand colored with ink and dyes, mounted and framed, each 29¾ x 25 in. (74.9 x 63 cm), overall: 7 ft. 4½ in. x 10 ft. 5 in. (224.8 x 317.5 cm). Fractional gift of Werner and Elaine Dannheisser

242. Laurie Simmons
Walking House. 1989. Gelatin silver print, 6 ft.11¾ in. x 47⅜ in. (211.4 x 120.4 cm). Richard E. and Christie Salomon Fund and The Family of Man Fund

243. David Levinthal
Untitled from the series Cowboys. 1989. Color instant print (Polaroid), 24 x 19½ in. (61 x 49.6 cm) (irreg.). The Fellows of Photography Fund and Anonymous Purchase Fund

244. Oliver Stone
Born on the Fourth of July. 1989. USA. 35mm film, color, 145 minutes. Gift of the artist and Universal Pictures

245. Spike Lee
Do the Right Thing. 1989. USA. 35mm film, color, 120 minutes

246. Chris Killip
Untitled. 1989. Gelatin silver print, 22¹¹⁄₁₆ x 18⁷⁄₁₆ in. (57.6 x 46.8 cm). The Family of Man Fund

247. Office for Metropolitan Architecture (Elizabeth Alford, Xaveer de Geyter, Rem Koolhaas, Winy Maas, and Ray Maggiore)
National Library of France (Très Grande Bibliothèque), Paris. Project, 1989. Model: plaster, aluminum, and wood. 41 x 29½ x 33⅛ in. (104.1 x 74.9 x 85 cm). Frederieke Taylor Purchase Fund

248. Kazuo Kawasaki
Carna Wheelchair. 1989. Titanium, rubber, and honeycomb-core aluminum, 33 x 22 x 35¼ in. (84 x 56 x 89.6 cm). Manufacturer: SIG Workshop Co. Ltd., Japan. Gift of the designer

249. Art Spiegelman
Lead Pipe Sunday. 1989. Folded double-sided lithograph, comp. (unfolded): 20 x 28 in. (50.8 x 71.1 cm), sheet (unfolded): 22¼ x 30¼ in. (56.5 x 76.8 cm). Publisher: The Print Club, Philadelphia. Printer: Corridor Press, Philadelphia. Edition: 100. John B. Turner Fund

250. John Woo
The Killer. 1989. Hong Kong. 35mm film, color, 110 minutes

251. Ida Applebroog
Chronic Hollow. 1989. Oil on six canvases, overall: 7 ft. 10½ in. x 9 ft. 8⅛ in. (240 x 295 cm). Acquired with matching funds from The Millstream Fund and the National Endowment for the Arts, and purchase

252. Peggy Ahwesh
Martina's Playhouse. 1989. USA. Super-8mm film, color, 20 minutes. Acquired from the artist

253. Shiro Kuramata
Miss Blanche Chair. 1989. Paper flowers, acrylic resin, and aluminum, 36⅞ x 24⅞ x 20¼ in. (93.7 x 63.2 x 52 cm). Manufacturer: Ishimaru Co., Japan. Gift of Agnes Gund in honor of Patricia Phelps de Cisneros

254. Edward Ruscha
That Is Right and Other Similarities. 1989. Portfolio of twelve lithographs, comp.: each approx. 5⅛ x 6⅞ in. (13.1 x 17.5 cm), sheet: each approx. 9⁵⁄₁₆ x 11 in. (23 x 28 cm). Publisher: the artist. Printer: Edward Hamilton, Los Angeles. Edition: 30. Gift of Jeanne C. Thayer and purchase

255. José Leonilson
To Make Your Soul Close to Me. 1989. Watercolor and ink on paper, 12½ x 9⅜ in. (31.9 x 23.9 cm). Gift of the artist's estate

256. Sadie Benning
Me and Rubyfruit. 1989. USA. Videotape made with Pixelvision camera, black and white, sound, 4 minutes. Purchase

257. Marc Newson
Orgone Chaise Longue. 1989. Fiberglass, 19¹¹⁄₁₆ x 29½ x 70⅞ in. (50 x 75 x 180 cm). Manufacturer: Cappellini S.p.A., Italy. Gift of the manufacturer

258. Joan Jonas
Volcano Saga. 1989. USA. Videotape, color, sound, 28 minutes. Purchase

259. Giuseppe Penone
Thirty-Three Herbs. 1989. Four from a portfolio of thirty-three lithographs and photolithographs, comp.: various dimensions, sheet: each 16½ x 11⅝ in. (41.9 x 29.5 cm). Printer and publisher: Marco Noire Editore, Turin. Edition: 150. Frances Keech Fund

260. Gundula Schulze
Dresden. 1989. Chromogenic color print (Ektacolor), 24¼ x 15½ in. (61.6 x 39.4 cm). The Family of Man Fund

261. Martin Parr
Midsummer Madness, Conservative Party Social Event. 1986–89. Chromogenic color print (Ektacolor), 16¹¹⁄₁₆ x 20⁵⁄₁₆ in. (42.4 x 52.3 cm). The Family of Man Fund

262. Steina Vasulka
In the Land of the Elevator Girls. 1989. Japan. Videotape, color, sound, 4 minutes. Purchase

263. Robert Gober
Cat Litter. 1989. Plaster, ink, and latex paint, 17 x 8 x 5 in. (43.2 x 20.3 x 12.7 cm). Edition: 2/7. Acquisition from the Werner Dannheisser Testamentary Trust

264. Thomas Schütte
Untitled. 1989. Watercolor, ink, gouache, and pencil on paper. Seven watercolors, each 12½ x 9⅜ in. (31.7 x 23.8 cm). Purchase

265. Tadao Ando
Church of the Light, Ibaraki, Osaka, Japan. 1984–89. Plan: lithograph with color pencil, 40½ x 28⅜ in. (102.9 x 72.7 cm). Gift of the architect in honor of Philip Johnson

266. Tadao Ando
Church of the Light, Ibaraki, Osaka, Japan. 1984–89. Interior perspective: color pencil on note paper, 10⅛ in. x 7⅛ in. (25.7 x 18.1 cm). Gift of the architect in honor of Philip Johnson

267. Tadao Ando
Church of the Light, Ibaraki, Osaka, Japan. 1984–89. Model: wood, 7⅛ x 17¾ x 7 in. (18.1 x 45.2 x .6 cm). Gift of the architect in honor of Philip Johnson

268. James Lee Byars
The Table of Perfect. 1989. Gold leaf on white marble, 39¼ x 39¼ x 39¼ in. (99.7 x 99.7 x 99.7 cm). Committee on Painting and Sculpture Funds

269. Steven Holl
Nexus World Kashii, Fukuoka, Japan. 1989. Exterior perspective of housing: watercolor and graphite on paper, 22 x 30 in. (55.9 x 76.2 cm). Gift of the architect in honor of Lily Auchincloss

270. James Turrell
First Light, Series C. 1989–90. Series of four aquatints, plate: each 39⁵⁄₁₆ x 27¼ in. (99.3 x 69.3 cm), sheet: each approx. 42⅓ x 29³⁄₁₆ in. (107.7 x 75.8 cm). Publisher: Peter Blum Edition, New York. Printer: Peter Kneubühler, Zurich. Edition: 30. Gift of Peter Blum Edition

271. Joel Shapiro
Untitled. 1989–90. Bronze, 8 ft. 3¾ in. x 69½ in. x 30 in. (253.5 x 176.5 x 76.2 cm). Edition: 4/4. Sid R. Bass Fund; gift of Jeanne C. Thayer, Anna Marie and Robert F. Shapiro, Agnes Gund, and William L. Bernhard; President's Fund Purchase (1990), Donald B. Marron, President; Jerry I. Speyer Fund; and Emily and Jerry Spiegel Fund

272. Steven Holl
"Edge of a City" Parallax Towers, New York. Project, 1990. Model: wood and paper, 13 ft. 10½ in. x 7 ft. 2 in. (422.9 x 218.5 cm). Given anonymously and David Rockefeller, Jr., Purchase Fund

273. Christopher Wool
Untitled. 1990. Enamel on aluminum, 9 x 6 ft. (274.3 x 182.9 cm). Gift of the Louis and Bessie Adler Foundation, Inc.

274. Martin Kippenberger
Martin, Stand in the Corner and Be Ashamed of Yourself. 1990. Cast aluminum, clothing, and iron plate, 71½ x 29¼ x 13¼ in. (181.6 x 74.9 x 34.3 cm). Blanchette Hooker Rockefeller Fund Bequest; Anna Marie and Robert F. Shapiro, Jerry I. Speyer, and Michael and Judy Ovitz funds

275. John Barnard
Formula 1 Racing Car 641/2. 1990. Various materials, 40½ in. x 7 ft. x 14 ft. 8½ in. (102.8 x 213.5 x 448.4 cm). Manufacturer: Ferrari S.p.A., Italy. Gift of the manufacturer

276. Gary Hill
Inasmuch As It Is Always Already Taking Place. 1990. Video/sound installation of sixteen black-and-white video monitors (all cathode-ray tubes are removed from chassis and extended with wires), sixteen laser-disc players, one audio mixer, and two speakers, recessed in a wall 42 in. (106.7 cm) from the floor, overall: 16 x 53¾ x 68 in. (40.6 x 136.5 x 172.7 cm). Gift of Agnes Gund, Marcia Riklis, Barbara Wise, and Margot Ernst; and purchase

277. General Idea (AA Bronson, Felix Partz, Jorge Zontal)
AIDS projects. 1988–90. *AIDS (Stamps)* for the journal *Parkett 15*. Photolithograph, comp. and sheet: 10 x 8¼ in. (25.4 x 21 cm). Edition: 200. Purchased with funds given by Linda Barth Goldstein. *AIDS (Lottery Ticket)*. 1989. Photolithograph on four sheets, each 4³⁄₁₆ x 6⅜ in. (10.6 x 16.2 cm). Edition: unlimited. Gift of A. A. Bronson. *AIDS (Adhesive-backed Label)*. 1990. Photolithograph, sheet: 6⅜ x 6⅜ in. (16 x 16 cm). Edition: unlimited. Gift of A. A. Bronson. *AIDS (Project for Ohio Dentist)*. 1988. Photolithograph, page 10⅞ x 8¼ in. (27.6 x 20.9 cm). Edition: unlimited. Gift of A. A. Bronson

278. Lari Pittman
Counting to Welcome One's Defrosting. 1990. Synthetic polymer paint and enamel on paper, 30 x 22 in. (76.2 x 55.9 cm). Gift of Hudson

279. Akira Kurosawa
Dreams. 1990. Japan/USA. 35mm film, color, 119 minutes

280. Brice Marden
Cold Mountain Series, Zen Study 1 (Early State). 1990. Etching and aquatint, plate: 20¹¹⁄₁₆ x 27³⁄₁₆ in. (52.6 x 69.1 cm), sheet: 27⅜ x 35¼ in. (69.5 x 89.6 cm). Publisher: the artist. Printer: Jennifer Melby, New York. Edition: 3. Linda Barth Goldstein Fund

281. Brice Marden
Cold Mountain Series, Zen Study 3 (Early State). 1990. Aquatint, plate: 20¹¹⁄₁₆ x 27³⁄₁₆ in. (52.6 x 69 cm), sheet: 27⁷⁄₁₆ x 35⅜ in. (69.7 x 89.8 cm). Publisher: the artist. Printer: Jennifer Melby, New York. Edition: 3. Purchase

282. Thomas Struth
Pantheon, Rome. 1990. Chromogenic color print, 54⅛ in. x 6 ft. 4⅜ in. (137.5 x 194 cm). Fractional gift of Werner and Elaine Dannheisser

283. Thomas Struth
South Lake Apartments 3, Chicago. 1990. Gelatin silver print, 18⁵⁄₁₆ x 22⅜ in. (46.5 x 56.8 cm). Anonymous Purchase Fund

284. Thomas Struth
South Lake Apartments 4, Chicago. 1990. Gelatin silver print, 17¹³⁄₁₆ x 22⅝ in. (45.5 x 57.5 cm). Anonymous Purchase Fund

285. Arata Isozaki
City in the Air: "Ruin of Hiroshima." Project, 1990. Silkscreen, 34¾ in. x 9 ft. 9 in. (88.3 x 297 cm). Gift of the architect in honor of Philip Johnson

286. Arata Isozaki
City in the Air: "Incubation Process." Project, 1990. Silkscreen, 41 x 34¾ in. (104.2 x 87.4 cm). Gift of the architect in honor of Philip Johnson

287. David Hammons
African-American Flag. 1990. Dyed cotton, 56 in. x 7 ft. 4 in. (142.2 x 223.5 cm). Gift of The Over Holland Foundation

288. David Hammons
High Falutin'. 1990. Metal (some parts painted with oil), oil on wood, glass, rubber, velvet, plastic, and electric lightbulbs, overall: 13 ft. 2 in. x 48 in. x 30½ in. (396 x 122 x 77.5 cm). Robert and Meryl Meltzer Fund and purchase

289. Richard Prince
Untitled. 1984 and 1990. Silkscreen, graphite, and spray paint on paper, 40 x 26 in. (101.5 x 66 cm). Gift of the Robert Lehman Foundation, Inc.

290. Joel Sternfeld
An Attorney with Laundry, Bank and Fourth, New York, New York. 1990. Chromogenic color print, 42½ x 33½ in. (107.9 x 85.1 cm). The Family of Man Fund

291. Yvonne Rainer
Privilege. 1990. USA. 16mm film, black and white and color, 103 minutes. Acquired from the artist and Zeitgeist Films

292. Kiki Smith
A Man. 1990. Printed ink on torn and pasted handmade paper. 6 ft. 6 in. x 16 ft. 8 in. (198.1 x 508 cm). Gift of Patricia and Morris Orden

293. Kiki Smith
Untitled. 1987–90. Twelve silvered glass water bottles arranged in a row, each bottle 20½ in. (52.1 cm) high x 11½ in. (29.2 cm) diameter at widest point. Gift of the Louis and Bessie Adler Foundation, Inc.

294. Elizabeth Murray
Her Story by Anne Waldman. 1990 (prints executed 1988–90). Two plates from the illustrated book of thirteen etching and photolithographs, page: 11¼ x 8⅞ in. (28.5 x 22.5 cm). Publisher and printer: Universal Limited Art Editions, West Islip, N.Y. Edition: 74. Gift of Emily Fisher Landau

295. Elizabeth Murray
Dis Pair. 1989–90. Oil and synthetic polymer paint on two canvases and wood, overall: 10 ft. 2½ in. x 10 ft. 9¼ in. x 13 in. (331.3 x 328.3 x 33 cm). Gift of Marcia Riklis, Arthur Fleischer, and Anna Marie and Robert F. Shapiro; Blanchette Rockefeller Fund; and purchase

296. Mike Kelley
Untitled. 1990. Found afghans and stuffed dolls, overall: 6 in. x 20 ft. 5 in. x 52 in. (15.3 x 622.3 x 132.1 cm); length of dolls: 25 in. (63.5 cm), 15 in. (38.1 cm), 16 in. (40.6 cm), 9 in. (22.7 cm). Gift of the Louis and Bessie Adler Foundation, Inc., and purchase

297. John Cage
Wild Edible Drawing No. 8. 1990. Milkweed, cattail, saffron, pokeweed, and hijiki pressed onto paper, 17 x 12 in. (43 x 30.5 cm). Gift of Sarah-Ann and Werner H. Kramarsky

298. Bruce Conner
INKBLOT DRAWING. 1990. Ink on folded paper with circular paper cutouts, 22¼ x 30⅛ in. (57.2 x 76.5 cm). Purchased with funds given by Sarah-Ann and Werner H. Kramarsky

299. Office for Metropolitan Architecture (Elizabeth Alford, Xaveer de Geyter, Rem Koolhaas, Winy Maas, and Ray Maggiore)
Palm Bay Seafront Hotel and Convention Center, Florida. Project, 1990. Model: plaster, aluminum, and goldplate, 5⅝ x 27⅜ x 27⅜ in. (14.3 x 69.6 x 69.6 cm). Gift of the architects in honor of Philip Johnson

300. Felix Gonzalez-Torres
"Untitled"(Death by Gun). 1990. Nine-inch stack of photolithographs, comp.: 44½ x 32½ in. (113 x 82.5 cm), sheet: 44¹⁵⁄₁₆ x 32¹⁵⁄₁₆ in. (114.1 x 83.6 cm). Printer: Register Litho, New York. Edition: unlimited. Purchased in part with funds from Arthur Fleischer, Jr., and Linda Barth Goldstein

301. Agnieszka Holland
Europa Europa. 1990. Germany/France. 35mm film, color, 113 minutes

302. Zhang Yimou and Yang Fengliang
Ju Dou. 1990. China/Japan. 35mm film, color, 95 minutes

303. Jim Nutt
Drawing for Fret. 1990. Graphite on paper, 13 x 13 in. (33 x 33 cm). Purchased with funds given by Richard E. Salomon

304. Stephen Frears
The Grifters. 1990. USA. 35mm film, color, 113 minutes

305. Neil Winokur
Glass of Water. 1990. Silver dye bleach print (Cibachrome), 40 x 30 in. (101.6 x 76.2 cm). Anonymous Purchase Fund

306. Chris Killip
Untitled. 1990. Gelatin silver print, 22¹³⁄₁₆ x 18½ in. (57.9 x 47 cm). The Family of Man Fund

307. Francis Ford Coppola
The Godfather, Part III. 1990. USA. 35mm film, color, 161 minutes

308. Martin Scorsese
GoodFellas. 1990. USA. 35mm film, color, 146 minutes

309. Toshiyuki Kita
The Multilingual Chair. 1991. Fiberglass and steel, 52 x 23⅝ x 23⅝ in. (132.1 x 60 x 60 cm). Manufacturer: Kotobuki Corporation, Japan. Gift of the manufacturer

310. Annette Messager
My Vows. 1988–91. Photographs, color graphite on paper, string, glass, black tape, and pushpins over black paper or black synthetic polymer paint, dimensions variable, museum installation 11 ft. 8¼ in. x 6 ft. 6¾ in. (356.2 x 200 cm). Gift of The Norton Family Foundation

311. Peter Eisenman
Alteka Tower, Tokyo. Project, 1991. Model: wood, acrylic, color tape, 14¼ x 12⅛ x 9½ in. (36.3 x 30.8 x 24.2 cm). Gift of the architect in honor of Philip Johnson

312. John O'Reilly
War Series #34: PFC USMC Killed in Action, Gilbert Islands, 1943, Age 23. 1991. Collage of black-and-white instant prints (Polaroid), 10¹¹⁄₁₆ x 16¼ in. (27.2 x 41.3 cm). Geraldine J. Murphy Fund

313. Boris Mikhailov
Untitled from the series U Zemli (On the Ground). 1991. Gelatin silver print, 4¹³⁄₁₆ x 11⅜ in. (12.2 x 28.9 cm). Anonymous Purchase Fund

314. Boris Mikhailov
Untitled from the series U Zemli (On the Ground). 1991. Gelatin silver print, 5 x 11¹¹⁄₁₆ in. (12.7 x 29.7 cm). Anonymous Purchase Fund

315. Boris Mikhailov
Untitled from the series U Zemli (On the Ground). 1991. Gelatin silver print, 5⅜ x 11¹¹⁄₁₆ in. (13.6 x 29.7 cm). Anonymous Purchase Fund

316. Shimon Attie
Almstadtstrasse 43, Berlin, 1991 (1930). 1991. Chromogenic color print (Ektacolor), 17¹⁵⁄₁₆ x 22³⁄₁₆ in. (45.6 x 56.4 cm). The Family of Man Fund

317. Julie Dash
Daughters of the Dust. 1991. USA. 35mm film, color, 114 minutes. Gift of Kino International

318. Toyo Ito
Shimosuma Municipal Museum, Shomosuma-machi, Nagano Prefecture, Japan. 1991. Model: Plexiglas, aluminum, and lightbulb, 2½ x 47¼ x 23⅝ in. (5.7 x 120 x 60.2 cm). Gift of the architect

319. Warren Sonbert
Short Fuse. 1991. USA. 16mm film, color, 37 minutes. Acquired from the artist

320. Ernie Gehr
Side/Walk/Shuttle. 1991. USA. 16mm film, color, 41 minutes. Gift of the artist

321. Annette Lemieux
Stolen Faces. 1991. Photolithograph printed on three sheets, overall: 30³⁄₁₆ in. x 7 ft. 4 in. (76.7 x 223.5 cm). Publisher: I.C. Editions, New York. Printer: Trestle Editions, New York. Edition: 26. Purchased with funds given by Howard B. Johnson

322. Oliver Stone
JFK. 1991. USA. 35mm film, black and white and color, 188 minutes. Gift of the artist

323. Tom Dixon
S-Chair. 1991. Straw and metal, 39⅜ x 20½ x 16½ in. (100 x 52 x 42 cm). Manufacturer: Cappellini S.p.A., Italy. Gift of the manufacturer

324. Dieter Appelt
The Field. 1991. Thirty gelatin silver prints, each 19½ x 14¼ in. (49.5 x 36.2 cm). Joel and Anne Ehrenkranz Fund, John Parkinson III Fund, and The Fellows of Photography Fund

325. Jean-Michel Othoniel
The Forbidden. 1991. Sulfur print with oil additions, plate: 63⅜ x 38¾ in. (161 x 98.4 cm), sheet: 65³⁄₁₆ x 42⅜ in. (165.5 x 108 cm). Publisher and printer: Centre genevois de gravure contemporaine, Geneva. Edition: 5. Joanne M. Stern Fund

326. Vito Acconci
Adjustable Wall Bra. 1990–91. Plaster, steel, canvas, electrical lightbulbs, and audio equipment, installation variable, each cup 7 ft. 3 in. x 7 ft. 10½ in. x 37 in. (221 x 240 x 94 cm). Sid R. Bass Fund and purchase

327. Felix Gonzalez-Torres
"Untitled" (Perfect Lovers). 1991. Two clocks, each 14 in. (35.6 cm) diameter x 2¼ in. (5.7 cm) deep, overall dimensions variable, museum installation 14 x 28 x 2¼ in. (35.6 x 71.1 x 5.7 cm). Gift of the Dannheisser Foundation

328. Felix Gonzalez-Torres
"Untitled" (Supreme Majority). 1991. Paper, in seven parts, dimensions variable, overall: approx. 61 x 40 x 36 in. (154.9 x 100.6 x 91.4 cm). Fractional gift of Werner and Elaine Dannheisser

329. Felix Gonzalez-Torres
"Untitled" (Placebo). 1991. Silver-cellophane-wrapped candies, endlessly replenished supply, ideal weight 1,000 lbs., dimensions variable, museum installation 2 in. x 12 ft. 4 in. x 20 ft. 4 in. (5 x 375.9 x 619.9 cm). Gift of Elisa and Barry Stevens

330. Felix Gonzalez-Torres
"Untitled." 1991. Printed billboard, dimensions variable, museum installation 10 ft. 5 in. x 22 ft. 8 in. (317.5 x 690.9 cm). Gift of Werner and Elaine Dannheisser

331. Tejo Remy
"You Can't Lay Down Your Memory" Chest of Drawers. 1991. Metal, paper, plastic, burlap, contact paper, and paint, 55½ x 53 x 20 in. (141 x 134.6 x 50.8 cm). Manufacturer: Tejo Remy. Frederieke Taylor Purchase Fund

332. Enzo Mari
Flores Box. 1991. Thermoplastic polymer, 3⅛ x 11¾ x 6 in. (7.8 x 29.9 x 15.2 cm). Manufacturer: Danese S.r.l., Italy. Gift of the manufacturer

333. Abelardo Morell
Light Bulb. 1991. Gelatin silver print, 18 x 22⅜ in. (45.5 x 56.5 cm). Purchased with funds given by Marian and James Cohen in memory of their son Michael Harrison Cohen

334. Zaha M. Hadid
Hong Kong Peak Competition, Hong Kong. 1991. Exterior perspective: acrylic on paper mounted on canvas, 51 x 72 in. (129.5 x 183 cm). David Rockefeller, Jr., Fund

335. Glenn Ligon
Untitled (How it feels to be colored me. . . Doubled). 1991. Oilstick on paper, 31½ x 16 in. (80 x 41 cm). Gift of The Bohen Foundation

336. David Wojnarowicz
Untitled. 1990–91. Photostat, comp.: 27¹⁵⁄₁₆ x 37 ³⁄₁₆ in. (70.9 x 94.4 cm) (irreg.), sheet: 32 x 41 in. (81.3 x 104.2 cm). Publisher: the artist. Printer: Giant Photo, New York. Edition: 10. Purchased in part with funds from Linda Barth Goldstein and Art Matters Inc.

337. Allen Ruppersberg
Remainders: Novel, Sculpture, Film. 1991. Books, cardboard, and oak, overall: 45 x 47½ x 29⅞ in. (114.4 x 120.6 x 75.9 cm). Given anonymously

338. Raymond Pettibon
No Title (Filling In So . . .). 1991. Black and color inks on paper, 13½ x 10⅜ in. (34.2 x 26.3 cm). Gift of the Friends of Contemporary Drawing

339. Raymond Pettibon
No Title (Under My Thumb). 1991. Ink and wash on paper, 18 x 12 in. (45.7 x 30.5 cm). Gift of the Friends of Contemporary Drawing

340. Christopher Wool
Untitled. 1991. Alkyd paint stamped on paper, 52 x 40 in. (132.2 x 101.6 cm). Gift of Charles B. Benenson

341. Frank Gehry
Cross Check Armchair. 1991. Bent-laminated maple, 32¾ x 30½ x 31½ in. (85 x 71.1 x 67.4 cm). Manufacturer: The Knoll Group, New York. Gift of the designer and the manufacturer

342. Brice Marden
Rain. 1991. Black and color ink on paper, 25¾ x 34¼ in. (65.4 x 87.2 cm). Gift of The Edward John Noble Foundation, Inc., and Ronald S. Lauder

343. Robert Gober
Untitled. 1992. Wax and human hair, shoe: 3 x 2⅝ x 7¼ in. (7.6 x 6.7 x 19.1 cm). Edition: 7/15. Gift of the Dannheisser Foundation

344. Robert Gober
Untitled. 1991. Wax, cotton, leather, human hair, wood, and steel, 12½ x 35¼ x 9¼ in. (31.8 x 90.2 x 23.5 cm). Robert and Meryl Meltzer Fund, Anna Marie and Robert F. Shapiro Fund, The Norman and Rosita Winston Foundation, Inc., Fund, The Millstream Fund, and Jerry I. Speyer Fund

345. Robert Gober
Untitled. 1992. Toned gelatin silver print, 16¾ x 12⅝ in. (42.5 x 32.1 cm). Gift of Werner and Elaine Dannheisser

346. Robert Gober
Newspaper. 1992. Multiple of a bundle of photolithographs, tied with twine, from a series of twenty-two, 6 x 16¾ in. x 13¼ in. (15.3 x 42.5 x 33.6 cm). Publisher: the artist. Printer: Derrière L'Étoile, New York. Edition: 10. Gift of the Associates of the Department of Prints and Illustrated Books in honor of Deborah Wye

347. Cindy Sherman
Untitled #263. 1992. Chromogenic color print, 40 x 60 in. (101.6 x 152.4 cm). Purchase

348. Janine Antoni
Gnaw. 1992. 600 lbs. of chocolate before biting; 600 lbs. of lard before biting; phenylethylamine; 45 heart shaped packages made from chewed chocolate removed from Chocolate Gnaw; 400 lipsticks made from pigment, beeswax and chewed lard removed from Lard Gnaw; display cabinet, dimensions variable. Purchase

349. Paul McCarthy
Sketchbook "Heidi." 1992. Illustrated book with nine screenprints and corrugated-cardboard cover, page: 22 x 14¹⁵⁄₁₆ in. (56 x 37.9 cm). Edition: 50. Publisher: Galerie Krinzinger, Vienna. Printer: Edition Schilcher, Graz, Austria. John B. Turner Fund

350. Paul McCarthy and Mike Kelley
Heidi. 1992. USA. Videotape, color, sound, 62 minutes 40 seconds. Purchase

351. Roy Lichtenstein
Interior with Mobile. 1992. Oil and synthetic polymer paint (Magna) on canvas, 10 ft. 10 in. x 14 ft. 3 in. (330.2 x 434.4 cm). Enid A. Haupt Fund; gift of Agnes Gund, Ronald S. Lauder, Michael and Judy Ovitz in honor of Roy and Dorothy Lichtenstein, and Anna Marie and Robert F. Shapiro

352. Christopher Connell
Pepe Chair. 1992. Thermoplastic polymer, 51¾ x 20 x 24 in. (131.5 x 50.8 x 61 cm). Manufacturer: MAP (Merchants of Australian Products Pty., Ltd.), Australia. Gift of the manufacturer

353. Ben Faydherbe
Festival in the Hague (Wout de Vringer). 1992. Poster: offset lithograph, 46¼ x 33 in. (118.2 x 83.8 cm). Gift of the designer through the Netherlands Design Institute

354. Ingo Maurer
Lucellino Wall Lamp. 1992. Glass, brass, plastic, and goose-feathers, 4¼ x 8 x 12¼ in. (11.5 x 20.3 x 31.1 cm). Manufacturer: Ingo Maurer GmbH, Germany. Gift of the designer

355. Guillermo Kuitca
Untitled. 1992. Mixed mediums on canvas, 8 ft. 4½ in. x 6 ft. 1¼ in. (255.7 x 186.1 cm). Gift of Patricia Phelps de Cisneros in memory of Thomas Ammann

356. Willie Cole
Domestic I.D., IV. 1992. Iron scorch and pencil on paper mounted in recycled painted-wood window-frame, comp. (including frame): 35 x 32 x 1⅜ in. (88.9 x 81.3 x 3.5 cm). Printer and fabricator: the artist. Edition: unique. Purchased with funds given by Agnes Gund

357. Arata Isozaki
Convention Hall, Nara, Japan. 1992. Exterior perspective: computer-generated print, 24½ x 40¼ in. (62.2 x 102.9 cm). Gift of the artist

358. Richard Serra
Intersection II. 1992. Cor-Ten steel, four plates, each 13 ft. 1½ in. x 55 ft. 9⅜ in. x 2 in. (400 x 1700 x 5 cm). Gift of Ronald S. Lauder

359. Peter Campus
Burning. 1992. Chromogenic color print, 39¹⁵⁄₁₆ x 50⅜ in. (101.4 x 128 cm). Gift of Paul F. Walter in memory of Mark Kaminski

360. Rudolf Bonvie
Imaginary Picture I. 1992. Gelatin silver print, 34¼ in. x 8 ft. 11⅜ in. (87 x 298 cm). The Fellows of Photography Fund

361. Santiago Calatrava
Alamillo Bridge and Cartuga Viaduct, Seville, Spain. 1987–92. Model: acrylic and mirror glass, 34 in. x 8 ft. 8 in. x 24½ in. (86.3 x 264.2 x 62.3 cm). Gift of the architect

362. Santiago Calatrava
Alamillo Bridge and Cartuga Viaduct, Seville, Spain. 1987–92. Elevations: conté crayon on tracing paper, approx. 17 x 53½ in. (43.2 x 135.9 cm). Gift of the architect

363. José Leonilson
I Am Your Man. 1992. Watercolor and ink on paper, 9 x 12 in. (22.8 x 30.5 cm). Gift of the Friends of Contemporary Drawing

364. Louise Bourgeois
Ste Sebastienne. 1992. Drypoint, plate: 38¹⁵⁄₁₆ x 30⅞ in. (98.9 x 78.4 cm), sheet: 47½ x 37 in. (120.6 x 94 cm). Publisher: Peter Blum Edition, New York. Printer: Harlan & Weaver Intaglio, New York. Edition: unique. Gift of the artist

365. Rody Graumans
85 Lamps Lighting Fixture. 1992. Lightbulbs, standard cords, and sockets, 31½ in. (100 cm) diameter.

Manufacturer: DMD, the Netherlands. Patricia Phelps de Cisneros Purchase Fund

366. Christopher Bucklow
14,000 Solar Images; 1:23 P.M., 13th June 1992. 1992. Gelatin silver print, 13⅞⁄₁₆ x 15⅝ in. (34.5 x 39.7 cm). E. T. Harmax Foundation Fund

367. Terence Davies
The Long Day Closes. 1992. Great Britain. 35mm film, color, 85 minutes. Gift of the artist and Three River Films

368. Sigmar Polke
The Goat Wagon. 1992. Synthetic polymer paint on printed fabric, 7 ft. 2 in. x 9 ft. 10 in. (218.4 x 299.7 cm). Gift of Werner and Elaine Dannheisser

369. Philip-Lorca diCorcia
Marilyn; 28 years old. Las Vegas, Nevada; $30. 1990–92. Chromogenic color print (Ektacolor), 25⁷⁄₁₆ x 37¹⁵⁄₁₆ in. (64 x 96.5 cm). E. T. Harmax Foundation Fund

370. Juan Sánchez
For don Pedro. 1992. Lithograph and photolithograph, with oilstick additions and collage, comp.: 22½ x 30 in. (56.4 x 76.2 cm), sheet: 22⁷⁄₁₆ x 30 in. (56.4 x 76.2 cm). Publisher and printer: Tamarind Institute, Albuquerque. Edition: 22. The Ralph E. Shikes Fund

371. Raymond Pettibon
No Title (The Sketch Is). 1992. Pen and ink on paper, 11⅜ x 7½ in. (28.9 x 19 cm). Gift of the Friends of Contemporary Drawing

372. Rosemarie Trockel
Untitled. 1992. Ink on paper, 13¾ x 13¾ in. (35 x 35 cm). Purchased with funds given by Agnes Gund

373. Mark Steinmetz
Knoxville. 1992. Gelatin silver print, 11¹⁵⁄₁₆ x 17⅛ in. (30.3 x 43.5 cm). Anonymous Purchase Fund

374. Gabriel Orozco
Maria, Maria, Maria. 1992. Erased telephone-book page, 11 x 9⅛ in. (27.9 x 23.2 cm). Gift of Patricia Phelps de Cisneros and the David Rockefeller Latin American Fund

375. Donald T. Chadwick and William Stumpf
Aeron Office Chair. 1992. Glass-reinforced polyester and die-cast aluminum (structure), Hytrel polymer, polyester, and Lycra (pellicle), 43½ x 27 x 19 in. (110.5 x 68.6 x 48.3 cm). Manufacturer: Herman Miller, Inc., Michigan. Gift of the manufacturer

376. Neil M. Denari
Prototype Architecture School, Wilshire Boulevard, Los Angeles, California. Project. 1992. Perspectives: ink, airbrush, and Pantone on Mylar, 24½ x 34½ in. (61.3 x 87.6 cm). Rolf Fehlbaum Purchase Fund

377. Simon Patterson
The Great Bear. 1992. Lithograph, comp. (including frame): 52¾ x 42¾ x 2 in. (134 x 108.6 x 5.1 cm). Publisher: the artist. Printer: Poster Print Limited, London. Edition: 50. Frances Keech Fund

378. Chris Burden
Medusa's Head. 1989–92. Plywood, steel, cement, rock, five gauges of model railroad track, seven scale-model trains, 14 ft. (426.7 cm) diameter. Purchase

379. Clint Eastwood
Unforgiven. 1992. USA. 35mm film, color, 130 minutes. Gift of the artist and Warner Bros.

380. Clint Eastwood
A Perfect World. 1993. USA. 35mm film, color, 137 minutes. Gift of the artist and Warner Bros.

381. Reiko Sudo
Jellyfish Fabric. 1993. Screenprinted and flash-heated polyester, 34 in. x 20 ft. 11 in. (86.4 x 637.5 cm). Manufacturer: Nuno Corporation, Japan; also Kimura Senko Co., Ltd., Japan. Gift of the manufacturer

382. Helen Chadwick
Number 11 from the series Bad Blooms. 1992–93. Silver dye bleach print (Cibachrome), 35½ in. (90.2 cm) diameter. Gift of Barbara Foshay-Miller and Christie Calder Salomon

383. Chris Marker
The Last Bolshevik (Le Tombeau d'Alexandre). 1993. France. Videotape, black and white and color, sound, 116 minutes. Gift of the artist

384. Zacharias Kunuk
Saputi. 1993. Canada. Videotape, color, sound, 30 minutes 30 seconds. Gift of Margot Ernst

385. Anselm Kiefer
Grane. 1980–93. Woodcut with paint additions on thirteen sheets of paper, mounted on linen, 7 ft. 7⁷⁄₁₆ in. x 6 ft.10½ in. (227.1 x 250.3 cm) (irreg.). Printer: the artist. Edition: unique. Purchased with funds given in honor of Riva Castleman by the Committee on Painting and Sculpture, the Associates of the Department of Prints and Illustrated Books, Molly and Walter Bareiss, Nelson Blitz, Jr., with Catherine Woodard and Perri and Allie Blitz, Agnes Gund, The Philip and Lynn Straus Foundation, Howard B. Johnson, Mr. and Mrs. Herbert D. Schimmel, and the Riva Castleman Endowment Fund

386. Glenn Ligon
Runaways. 1993. Four from a series of ten lithographs, comp.: each approx. 10¾ x 8¹⁵⁄₁₆ in. (27.3 x 22.7 cm), sheet: each 15¹⁵⁄₁₆ x 11¹⁵⁄₁₆ in. (40.6 x 30.4 cm). Publisher: Max Protetch, New York. Printer: Perry Tymeson, New York. Edition: 45. The Ralph E. Shikes Fund

387. Rosemarie Trockel
What It Is Like to Be What You Are Not. 1993. Portfolio of eight photogravures and one photolithograph and screenprint, photogravure plates: various, sheet: each 22⅜ x 17½ in.

(57.5 x 44.5 cm); photolithograph and screenprint, comp.: 19⅝ x 13⁵⁄₁₆ in. (49.9 x 33.8 cm) (irreg.), sheet: 19⅝ x 13¹¹⁄₁₆ in. (49.9 x 34.8 cm). Publisher: Helga Maria Klosterfelde Edition, Hamburg. Printer: photogravure by Niels Borch Jensen, Copenhagen; screenprint by Thomas Sanmann, Hamburg; photolithograph by Ulla Pensolin, Hamburg. Edition: 9. Carol O. Selle Fund

388. Brice Marden
Vine. 1992–93. Oil on linen, 8 ft. x 8 ft. 6½ in. (243.8 x 260.3 cm). Fractional gift of Werner and Elaine Dannheisser

389. Herzog & de Meuron Architects
Facade panel from the Ricola Europe Factory and Storage Building. 1993. Architectural fragment: silkscreen on acrylic, framed in aluminum, 6 ft. 6¾ in. x 6 ft. 8½ in. x 1⅝ in. (200 x 203.2 x 4.2 cm). Gift of the architects in honor of Philip Johnson

390. Herzog & de Meuron Architects
Ricola Europe Factory and Storage Building. 1993. Model: wood, plywood, black paint, silkscreen, and polycarbonate, 9¹⁄₁₆ x 53⁷⁄₁₆ x 53⁷⁄₁₆ in. (23 x 135.7 x 135.7 cm). Gift of the architects in honor of Philip Johnson

391. Ellsworth Kelly
Red-Orange Panel with Curve. 1993. Oil on canvas, 8 ft. 8 in. x 7 ft. 3½ in. (269.4 x 222.5 cm). Gift of the Committee on Painting and Sculpture in honor of Richard E. Oldenburg

392. Roni Horn
How Dickinson Stayed Home. 1993. Plastic and aluminum, dimensions variable, museum installation 5 in. x 23 ft. x 16 ft. (12.7 x 701.5 x 488 cm). Gift of Agnes Gund

393. Robert Therrien
No Title. 1993. Painted wood, brass, and steel, 9 ft. 5½ in. x 10 ft. 10 in. x 9 ft. 1½ in. (288.4 x 330.2 x 278.3 cm). Ruth and Seymour Klein Foundation, Inc., Fund and Robert B. and Emilie W. Betts Foundation Fund

394. Derek Jarman
Blue. 1993. Great Britain. 35mm film, color, 79 minutes

395. Fernando Campana and Humberto Campana
Vermelha Chair. 1993. Iron with epoxy coating, aluminum, and cord, 33⅜ x 22⅞ x 29¼ in. (86 x 58 x 74 cm). Manufacturer: Edra Mazzei, Italy. Gift of Patricia Phelps de Cisneros

396. Antonio Citterio and Glen Oliver Löw
Mobil Container System. 1993. Bulk-dyed thermoplastic polymer and chrome- or aluminum-colored steel, two units: 38½ x 19⅝ x 18¾ in. (97.8 x 49.2 x 47.6 cm), and 21⅝ x 19½ x 18½ in. (54.9 x 49.5 x 47 cm). Manufacturer: Kartell S.p.A., Italy. Gift of the manufacturer

397. Jean Nouvel
Cartier Foundation for Contemporary Art. 1992–93. Elevation: serigraphed drawings on Plexiglas, 19⅝ x 35½ x ⅝ in. (49.8 x 90.2 x 1.7 cm). Gift of the architect in honor of Philip Johnson

398. Rachel Whiteread
Untitled (Room). 1993. Plaster, 8 ft. 10⅞ in. x 9 ft. 10 in. x 11 ft. 5¾ in. (271.5 x 299.8 x 350 cm). Robert and Meryl Meltzer, Anna Marie and Robert F. Shapiro, Emily and Jerry Spiegel, The Norman and Rosita Winston Foundation, Inc., and Barbara Jakobson Funds

399. Ian Hamilton Finlay
Artist's book and cards. 1986–93. *L'Idylle des Cerises*. 1986. Artist's book, lithograph with Michael Harvey, page: 5¹³⁄₁₆ x 8¼ in. (14.8 x 20.6 cm). Gift of Gabriella de Ferrari. *Abraham at Santa Clara*. 1991. Accordion-folded card, lithograph with Gary Hincks, overall: 7⅞ x 11½ in. (20 x 29 cm). Walter Bareiss Fund. *An 18th Century Line on a Watering Can*. 1993. Folded card, lithograph with Michael Harvey, overall: 4¹¹⁄₁₆ x 16½ in. (12.6 x 41.9 cm). Walter Bareiss Fund. *A Model of Order*. 1993. Card, lithograph with Gary Hincks, sheet: 7⅜ x 3⅜ in. (18.7 x 8.6 cm), comp.: 7 x 3 in. (17.8 x 7.6 cm). Walter Bareiss Fund. Publisher and printer: Wild Hawthorn Press, Little Sparta, Scotland. Editions: approx. 250

400. Martin Scorsese
The Age of Innocence. USA. 1993. 35mm film, color, 136 minutes. Gift of Columbia Pictures

401. Ximena Cuevas
Bleeding Heart. 1993. Mexico. Videotape, color, sound, 5 minutes. Gift of the Mexican Cultural Institute

402. Charles Ray
Family Romance. 1993. Mixed mediums, 53 x 7 ft. 1 in. x 11 in. (134.6 x 215.9 x 27.9 cm). Gift of The Norton Family Foundation

403. Rirkrit Tiravanija
Untitled (apron and Thai pork sausage). 1993. Multiple of brown-paper apron with string, tape, decal, and Xeroxed recipe, apron: 41¼ x 28⁵⁄₁₆ in. (104.7 x 71.3 cm) (irreg.). Publisher: Brain Multiples, Santa Monica. Printer: the artist. Edition: 25. Purchased with funds given by Linda Barth Goldstein

404. Cheryl Donegan
Head. 1993. USA. Videotape, color, sound, 2 minutes 49 seconds. Gift of Susan Jacoby

405. Jos van der Meulen
Paper Bags Wastebaskets. 1993. Paper (unused billboard posters), dimensions: 35½ x 27¾ in. (90 x 70 cm); 20¾ x 13¾ in. (60 x 35 cm); and 15¾ x 10 in. (40 x 25 cm). Manufacturer: Goods, the Netherlands. Gift of the manufacturer

406. Nam June Paik
Untitled. 1993. Player piano, fifteen televisions, two cameras, two laser-discs and two players, one electric

light and lightbulb, and wires, overall: approx. 8 ft. 4 in. x 8 ft. 9 in. x 48 in. (254 x 266.7 x 121.9 cm). Bernhill Fund, Gerald S. Elliot Fund, gift of Margot Paul Ernst, and purchase

407. Hal Hartley
Amateur. 1994. USA/Great Britain/France. 35mm film, color, 105 minutes. Gift of the artist

408. Quentin Tarantino
Pulp Fiction. 1994. USA. 35mm film, color, 154 minutes. Gift of Miramax Films

409. Lorna Simpson
Wigs (Portfolio). 1994. Portfolio of thirty-eight lithographs on felt, overall: 6 ft. x 13 ft. 6 in. (182.9 x 411.5 cm). Publisher: Rhona Hoffman Gallery, Chicago. Printer: 21 Steps, Albuquerque. Edition: 15. Purchased with funds given by Agnes Gund, Howard B. Johnson, and Emily Fisher Landau

410. Renzo Piano
Kansai International Airport, Osaka, Japan. 1988–94. Passenger terminal, main building: painted brass, 51⅛ x 5⅛ x 6⅞ in. (132 x 13 x 17.5 cm). Gift of the architect in honor of Philip Johnson

411. Takeshi Ishiguro
Rice Salt-and-Pepper Shakers. 1994. Extruded, slip-cast, and molded rice slurry, dimensions variable, from ½ x ¾ in. to 4 x 1 in. (1.3 x 1.9 cm to 10.2 x 2.6 cm). Gift of the designer

412. Kim Jones
Untitled. 1991–94. Pencil and erasures on paper, 24½ x 37½ in. (62.3 x 95.2 cm). Gift of Sarah-Ann and Werner H. Kramarsky

413. Andreas Gursky
Shatin. 1994. Chromogenic color print, 70⅞ x 7 ft. 8½ in. (180 x 235 cm). Anonymous Purchase Fund

414. Mona Hatoum
Silence. 1994. Glass, 49⅛ x 36⅝ x 23⅞ in. (126.6 x 59.2 x 93.7 cm). Robert B. and Emilie W. Betts Foundation Fund

415. Teiji Furuhashi
Lovers. 1994. Japan. Video installation with five laser discs and players, five projectors, two sound systems, two slide projectors, and two computers, overall: 11 ft. 6 in. x 32 ft. 10 in. x 32 ft. 10 in. (3.5 x 10.8 x 10.8 m). Gift of Canon, Inc.

416. Bill Viola
Stations. 1994. USA. Video installation with five laser discs and players, five projectors, nine cloth screens, five granite slabs, and sound system in a 70 in. x 30 ft. (21.3 x 9.1 m) room. Gift of The Bohen Foundation in honor of Richard E. Oldenburg

417. Jenny Holzer
Truisms projects. 1980–94. *Abuse of Power Comes As No Surprise* and *Raise Boys and Girls the Same Way.* 1980–94. Two cotton T-shirts, from a series of six multiples, screenprinted, various dimensions. Printer: Artisan Silkscreen, New York. *Protect Me from What I Want* from the series *Survival Caps.* 1980. One of three multiples of caps, with embroidered label. Manufacturer: Uniforms to You, Chicago. *Money Creates Taste* and *Torture Is Barbaric* from the series *Truisms Golfballs.* Two of six multiples of colored golfballs, printed in letterpress. Manufacturer: Eastern Golf Corp., Hamlin, Pa. *Action Causes More Trouble Than Thought, At Times Inactivity is Preferable to Mindless Functioning,* and *Private Property Creates Crime* from the series *Truisms Pencils.* 1994. Three of eight multiples of pencils, printed in letterpress. Publisher: the artist. Editions: unlimited. Gifts of the artist

418. Robert Gober
Untitled. 1993–94. Bronze, wood, brick, aluminum, beeswax, human hair, chrome, pump, and water, 56 x 37½ x 34 in. (142.2 x 95.2 x 86.3 cm). Given anonymously

419. Ann Hamilton
Seam. 1994. Room installation with two entrances on front wall, laser disc and player, projector, rags, wood, plastic, and three panes of glass, room dimensions 11 ft. 5 in. x 24 ft. 5 in. x 16 ft. (347.9 x 744.2 x 487.6 cm). Louis and Bessie Adler Foundation, Inc., Fund, and Peggy and David McCall Fund

420. Ross Bleckner
Memorial II. 1994. Oil on linen, 8 x 10 ft. (244 x 305 cm). Gift of Agnes Gund in memory of Thomas Ammann

421. Michael Schmidt
U-ni-ty (Ein-heit). 1991–94. Thirty-one from a series of 163 gelatin silver prints, each 19⅛ x 13½ in. (50.5 x 34.3 cm). Anonymous Purchase Fund and purchase

422. Thomas Roma
Untitled from the series Come Sunday. 1991–94. Gelatin silver print, 14 x 18¾ in. (35.6 x 47.6 cm). Lois and Bruce Zenkel Fund

423. Richard Artschwager
Five untitled works. 1994. Wood and metal. From left to right: 26½ in. x 7 ft. 6½ in. x 22½ in. (67.4 x 230 x 57.2 cm); 29½ x 32½ x 42 in. (74.9 x 82.6 x 106.6 cm); 13 ft. 2 in. x 50 in. x 36 in. (401.6 x 127 x 91.5 cm); 46 x 13½ x 16¼ in. (117 x 34.4 x 41.3 cm); 6 ft. 8 in. x 29 in. x 12½ in. (203.2 x 73.8 x 31.6 cm). Gift of Agnes Gund and Anna Marie and Robert F. Shapiro Fund

424. Uta Barth
Ground #35. 1994. Chromogenic color print (Ektacolor), 17⅜ x 20¹⁵⁄₁₆ in. (44.3 x 53.3 cm). E. T. Harmax Foundation Fund

425. Cy Twombly
The Four Seasons: Autumn, Winter, Spring, and *Summer.* 1993–94. Synthetic polymer paint, oil, pencil, and crayon on canvas: *Autumn,* 10 ft. 3½ in. x 6 ft. 2¼ in. (313.7 x 189 cm); *Winter,* 10 ft. 3¼ in. x 6 ft. 2⅞ in. (313 x 190.1 cm); *Spring,* 10 ft. 3½ in. x 6 ft. 2⅞ in. (312.5 x 190 cm); and *Summer,* 10 ft. 3¼ in. x 6 ft. 7⅛ in. (314.5 x 201 cm). Gift of the artist

426. Philippe Starck
Jim Nature Portable Television. 1994. High-density wood and plastic, 15³⁄₁₆ x 4⁹⁄₁₆ x 14¾ in. (38.5 x 37 x 37.5 cm). Manufacturer: Thomson Consumer Electronics, France. Gift of the manufacturer

427. Rineke Dijkstra
Tia, Amsterdam, the Netherlands, 14 November 1994. Tia, Amsterdam, the Netherlands, 23 June 1994. 1994. Two chromogenic color prints, each 15¾ x 11¹³⁄₁₆ in. (40 x 30 cm). Gift of Agnes Gund

428. Marlene Dumas
Chlorosis. 1994. Ink, gouache, and synthetic polymer paint on paper, twenty-four sheets, 26 x 19½ in. (66.2 x 49.5 cm) each. The Herbert and Nannette Rothschild Memorial Fund in memory of Judith Rothschild

429. Hella Jongerius
Soft Vase. 1994. Polyurethane, 10¾ in. (27 cm) high x 6 in. (15 cm) diameter. Manufacturer: DMD, the Netherlands, for Droog Design. Frederieke Taylor Purchase Fund

430. James Turrell
A Frontal Passage. 1994. Fluorescent light installation, dimensions variable, museum installation 12 ft. 10 in. x 22 ft. 6 in. x 34 ft. (391.2 cm x 685.8 cm x 10 m 36.3 cm). Douglas S. Cramer, David Geffen, Robert and Meryl Meltzer, Michael and Judy Ovitz, and Mr. and Mrs. Gifford Phillips funds

431. Jeff Scher
Garden of Regrets. 1994. USA. 16mm film, color, 8 minutes. Gift of the artist

432. Barbara Kruger
Public projects and illustrated book. 1986–94. Covers for *Esquire, MS,* and *Newsweek* magazines. 1992. Three photolithographs, each approx. 10¾ x 9 in. (27.3 x 22.9 cm). Editions: unlimited. Purchase. Untitled, compact disc insert for the rock band Consolidated. 1994. Comp. and sheet, 4¹¹⁄₁₆ x 4¾ in. (11.9 x 12.1 cm). Publisher: London Records, New York. Purchase. *I Shop Therefore I Am.* 1990. Multiple of paper bag, with photolithograph and letterpress, 17¼ x 10¾ x 4⁹⁄₁₆ in. (43.9 x 27.3 x 10.7 cm). Publisher: Kölnischer Kunstverein, Cologne. Edition: 9,000. Gift of Kölnischer Kunstverein. Untitled (matchbooks). 1986. Four of seven multiples of matchbooks, various dimensions. Publisher: Rhona Hoffman Gallery and David Meitus, Chicago. Editions: each approx. 1,000. Given anonymously. *My Pretty Pony* by Stephen King. 1988. Illustrated book with nine lithographs, eight screenprints, page 20 x 13½ in. (50.9 x 34.3 cm). Publisher: Library Fellows of the Whitney Museum of American Art, New York. Edition: 250. The Associates Fund in honor of Riva Castleman

433. Louise Bourgeois
Fenelon. 1994. Spray paint, blue ballpoint pen, and pencil on jigsaw puzzle, 8¾ x 11¾ in. (22.2 x 29.8 cm). Gift of Sarah-Ann and Werner H. Kramarsky and an anonymous donor

434. Bob Evans
Tan Delta Force Fin. 1994. Liquid-cast heat-cured Uniroyal flexible polyurethane, 17 x 11¼ x 4¼ in. (43.2 x 28.6 x 10.8 cm). Manufacturer: Bob Evans Designs, Inc., California. Gift of the manufacturer

435. Roni Horn
Island-Pooling Waters. Vol. IV from the series *To Place.* Cologne, 1994. Two-vol. artist's book, page: 10³⁄₁₆ x 8¼ in. (25.9 x 20.7 cm). Publisher: Verlag der Buchhandlung Walther König, Cologne. Edition: 1,000. The Museum of Modern Art Library

436. Jean Nouvel
Less Table. 1994. Steel, 28¼ x 83¼ x 27¼ in. (71.7 x 211.4 x 69.2 cm). Manufacturer: Unifor S.p.A., Italy. Gift of the manufacturer

437. Alberto Meda
Long Frame Chaise Longue. 1994. Extruded and die-cast aluminum and PVC-coated polyester, 34½ x 21½ x 58 in. (87.7 x 54.6 x 147.3 cm). Manufacturer: Alias S.r.l., Italy. Gift of the manufacturer

438. Glenn Ligon
White #19. 1994. Oilstick on canvas mounted on wood panel, 7 ft. x 60 in. (213.3 x 152.4 cm). Committee on Painting and Sculpture Funds

439. Carrie Mae Weems
You Became a Scientific Profile; A Negroid Type; An Anthropological Debate; A Photographic Subject. From the series From Here I Saw What Happened and I Cried. 1995. Chromogenic color prints and etched glass, each 26⅝ x 22¾ in. (67.6 x 57.8 cm). Gift on behalf of The Friends of Education of The Museum of Modern Art

440. Louise Bourgeois
Ode à ma mère. 1995. Illustrated book, four (frontispiece and three plates) of nine drypoints, one with roulette, plates: various dimensions, page: 11¾ x 11⅞ in. (30.2 x 30.2 cm). Publisher: Editions du Solstice, Paris. Printers: plates by Harlan & Weaver Intaglio, New York; text by PIUF, Paris. Edition: 125. Gift of the artist

441. Marcel Wanders
Knotted Chair. 1995. Carbon and epoxy-coated aramid fibers, 29½ x 19¾ x 25½ in. (75 x 50 x 65 cm). Manufacturer: Marcel Wanders for Droog Design, the Netherlands. Gift of the Peter Norton Family Foundation

442. Tom Friedman
Untitled. 1995. Plastic, hair, fuzz, Play-doh, wire, paint, and wood, 24¼ x 24 x 24 in. (61.5 x 61 x 61 cm). An anonymous fund

443. Peter Halley
Exploding Cell Wallpaper. 1995. Series of nine screenprints on newsprint, printed from digital files, sheet, each 36¼ x 45⅞ in. (92.1 x 116.5 cm). Printer: Fine Art Printing, New York. Edition: unlimited. John B. Turner Fund and Howard B. Johnson Fund

444. Toba Khedoori
Untitled (Doors). 1995. Oil and wax on three sheets of paper, overall: 11 ft. x 19 ft. 6 in. (335.3 x 594.4 cm). Gift of Lenore S. and Bernard Greenberg

445. Ellen Gallagher
Oh! Susanna. 1995. Oil and pencil on paper collage on canvas, 10 x 8 ft. (304.8 x 243.8 cm). Fractional and promised gift of Michael and Judy Ovitz

446. Toyo Ito
Mediathèque Project, Sendai, Japan. 1995. Model: acrylic, 10⅝ x 31½ x 29¼ in. (27 x 80 x 74.3 cm). Gift of the architect in honor of Philip Johnson

447. KCHO (Alexis Leyva Machado)
In the Eyes of History. 1992–95. Watercolor and charcoal on paper, 60 x 49¼ in. (152.4 x 125.1 cm). Purchased with funds given by Patricia and Morris Orden

448. Doris Salcedo
Untitled. 1995. Wood, cement, steel, cloth, and leather, 7 ft. 9 in. x 41 in. x 19 in. (236.2 x 104.1 x 48.2 cm). The Norman and Rosita Winston Foundation, Inc., Fund, and purchase

449. Laurie Anderson
Puppet Motel. 1995. CD-ROM. Designer: Hsin-Chien Huang. Publisher: Voyager, New York. Purchase

450. Joel Sanders
Kyle Residence, Houston, Texas. Project, 1991–95. Model: wood, Plexiglas, resin, and aluminum, 7⅞ x 33¾ x 29½ in. (20 x 85.7 x 75 cm). Peter Norton Purchase Fund

451. Herzog & de Meuron Architects
Signal Box, Basel, Switzerland. 1988–95. Model: copper and painted wood, 41⅝ x 19⅛ x 12⅛ in. (105.7 x 48.6 x 30.8 cm). Purchase

452. Sigmar Polke
Bulletproof Vacation magazine. 1995. Two of seventeen photolithographs, page: 11¹¹⁄₁₆ x 8¹³⁄₁₆ in. (29.6 x 22.4 cm). Publisher and printer: Süddeutsch Zeitung magazine, Munich. Edition: mass-produced. Gift of Haus der Kunst

453. Chuck Close
Dorothea. 1995. Oil on canvas, 8 ft. 6 in. x 7 ft. ⅛ in. (259 x 213.6 cm). Promised gift of Anna Marie and Robert F. Shapiro, Enid A. Haupt Fund, Vassilis Cromwell Voglis Bequest, and The Lauder Foundation Fund

454. Matthew Barney
Cremaster 4. 1994–95. Plastic, satin, fabric, and silkscreened video laser disc in silkscreened onionskin sleeve, 5 x 33¼ x 23¾ in. (12.7 x 84.4 x 60.3 cm). Blanchette Hooker Rockefeller Fund Bequest

455. cyan (Sophie Alex, Wilhelm Ebentreich, Detlef Fiedler, Daniela Haufe, Siegfried Jablonsky)
Foundation Bauhaus Dessau, Events, July–August 1995 (Event Stiftung Bauhaus Dessau, Jul–Aug 1995). 1995. Poster: offset lithograph, 33 x 23⅜ in. (83.8 x 59.3 cm). Gift of the designers

456. Sheron Rupp
Untitled (Bayside, Ontario, Canada). 1995. Chromogenic color print, 25⅞ x 32 in. (65.8 x 81.3 cm). E. T. Harmax Foundation Fund

457. Stan Douglas
Historic set for "Der Sandman" at DOKFILM Studios, Potsdam, Babelsburg, December 1994. 1995. Silver dye bleach print (Cibachrome), 30 x 40 in. (76.2 x 101.6 cm). Nina W. Werblow Charitable Trust

458. Jasper Johns
Untitled. 1992–95. Oil on canvas, 6 ft. 6 in. x 9 ft. 10 in. (198.1 x 299.7 cm). Promised gift of Agnes Gund

459. Inoue Pleats Co., Ltd.
Wrinkle P Fabric. 1995. Polyester, hand pleated and heat set, 59 in. (149.9 cm) wide. Manufacturer: Inoue Pleats Co., Ltd., Fukui. Gift of the manufacturer

460. Luc Tuymans
A Flemish Intellectual. 1995. Gouache on paper, 11½ x 8¼ in. (29.2 x 20.9 cm). Gift of the Friends of Contemporary Drawing

461. Luc Tuymans
The Heritage IV. 1996. Oil on canvas, 6 ft. 6¾ in. x 49⅜ in. (200 x 125.5 cm). Committee on Painting and Sculpture Funds

462. Joel and Ethan Coen
Fargo. 1996. USA. 35mm film, color, 98 minutes. Gift of Joel Coen and Ethan Coen

463. John Sayles
Lone Star. 1996. USA. 35mm film, color, 135 minutes. Acquired from the artist and Maggie Renzi

464. José María Sicilia
Two volumes of *Le Livre des mille nuits et une nuit*. 1996. Two from a series of six illustrated books with twenty-seven lithographs and linoleum cuts, page, 12⅝ x 9⅛ in. (32 x 26 cm). Publisher: Michael Woolworth Publications, Paris. Printer: Michael Woolworth Lithographie, Paris. Editions: 20. Mary Ellen Meehan Fund

465. Flex Development B.V.
Cable Turtle. 1996. Thermoplastic elastomer, 1⅜ in. (3.5 cm) high x 2⁹⁄₁₆ in. (6.5 cm) diameter. Manufacturer: Cleverline, the Netherlands. Gift of the manufacturer

466. Mona Hatoum
Rubber Mat. 1996. Multiple of rubber mat, 1⅛ x 30¼ x 21⅞ in. (3 x 78.3 x 58.1 cm). Publishers: Printed Matter and The New Museum of Contemporary Art, New York. Fabricator: Gheorge Adam, Red Hill, Pa. Edition: 35. Purchased with proceeds from the 1998 Clue event, sponsored by The Junior Associates of The Museum of Modern Art

467. John Armleder
Gog. 1996. Four from a portfolio of thirteen screenprints, each 19¹¹⁄₁₆ x 19¹¹⁄₁₆ in. (50 x 50 cm). Publisher: Editions Sollertis, Toulouse. Printer: Atelier à Paris, Paris. Edition: 25. Gift of The Junior Associates of The Museum of Modern Art

468. David Hammons
Out of Bounds. 1995–96. Dirt on paper, framed, with basketball, 53¼ x 41½ x 11½ in. (131.2 x 105.4 x 29.2 cm). Gift of The Friends of Contemporary Drawing, The Friends of Education, and Peter and Eileen Norton

469. KCHO (Alexis Leyva Machado)
The Infinite Column I. 1996. Wood and metal, 12 ft. 10 in. x 12 ft. 7 in. x 11 ft. 1 in. (391.1 x 383.5 x 337.8 cm). Committee on Painting and Sculpture Funds

470. Gary Simmons
boom. 1996. Chalk on blackboard paint on wall, original installation 28 x 11½ in. (711 x 292 cm). Gift of the Friends of Contemporary Drawing and of The Friends of Education

471. Gabriel Orozco
Light Through Leaves. 1996. Iris print, comp: 20¹⁵⁄₁₆ x 30⅛ in. (53.2 x 76.5 cm), sheet: 22¼ x 32³⁄₁₆ in. (56.2 x 81.8 cm). Publisher: Parkett, Zurich and New York. Printer: Cone-Laumont Editions, New York. Edition: 60. Frances Keech Fund

472. Chris Ofili
North Wales. 1996. Three from a portfolio of ten etchings, plate: each 9¾ x 7⅞ in. (24.9 x 19.9 cm), sheet: each 15 x 11¼ in. (38 x 28.7 cm). Publisher: The Paragon Press, London. Printer: Hope Sufference Studio, London. Edition: 35. Gift of The Young Print Collectors of the Department of Prints and Illustrated Books

473. Jeanne Dunning
Untitled. 1996. Silver dye bleach print (Cibachrome), 42¼ x 28¼ in. (107.3 x 71.8 cm). Gift of Barbara Lee

474. Thomas Demand
Room. 1996. Chromogenic color print, 67¾ x 7 ft. 7⅜ in. (172 x 232.1 cm). Gift of the Nina W. Werblow Charitable Trust

475. Andrea Zittel
A-Z Escape Vehicle: Customized by Andrea Zittel. 1996. Exterior: steel, insulation, wood, and glass; interior:

colored lights, water, fiberglass, wood, papier-mâché, pebbles, and paint, 62 in. x 7 ft. x 40 in. (157.5 x 213.3 x 101.6 cm). The Norman and Rosita Winston Foundation, Inc., Fund and an anonymous fund

476. Werner Aisslinger
Juli Armchair. 1996. Polyurethane integral foam and metal, 29½ x 24¾ x 21⅝ in. (75 x 63 x 55 cm). Manufacturer: Cappellini S.p.A., Italy. Gift of the manufacturer

477. Franz West
Spoonerism. 1996. Suitcases, cardboard, plaster, paint, and gauze, in three parts: 6 ft. 6 in. x 39 in. x 40 in. (198.1 x 99 x 101.6 cm), 69 in. x 6 ft. 6 in. x 22 in. (175.2 x 198.1 x 55.9 cm), 6 ft. 6 in. x 21 in. x 21 in. (198.1 x 53.3 x 53.3 cm); overall dimensions variable. An anonymous fund, and Emily Fisher Landau, Frances R. Dittmer, and Patricia Phelps de Cisneros funds

478. Al Pacino
Looking for Richard. 1996. USA. 35mm film, color, 109 minutes. Acquired from the artist and Fox Searchlight Films

479. Toray Industries, Inc.
Encircling Fishing Net. 1996. Teteron polyester. Knotless mesh net, variable width, (1½ in. contracted / 132 in. expanded) x 278 in. (3.8 / 335.3 x 706.1 cm). Manufacturer: Toray Industries, Inc., Tokyo; also Nitto Seimo Co., Ltd., Tokyo. Gift of Toray Industries, Inc.

480. Ken Jacobs
Disorient Express. 1996. USA. 35mm film, black and white, silent, 30 minutes. Acquired from the artist

481. Igor Moukhin
Moscow, May 9, 1996. 1996. Gelatin silver print, 13¹⁵⁄₁₆ x 20½ in. (35.5 x 52 cm). Gift of The Junior Associates of The Museum of Modern Art

482. Kiki Smith
Constellations. 1996. Lithograph with flocking, sheet: 57¼ x 31⅛ in. (145.5 x 79.8 cm) (irreg.). Publisher and printer: Universal Limited Art Editions, West Islip, N.Y. Edition: 42. Gift of Emily Fisher Landau

483. Raymond Pettibon
Untitled (Justly Felt and Brilliantly Said). 1996. Accordion-folded illustrated book with screenprint, with manuscript additions and pressed flower, produced for the journal *Parkett 47*, page: 9⅝ x 7⅝ in. (24.5 x 19.4 cm), overall: 9⅝ x 6 ft. 4¼ in. (24.5 x 195 cm). Publisher: Parkett, Zurich and New York. Printer: Lorenz Boegli, Zurich. Edition: 60. Monroe Wheeler Fund

484. Kara Walker
Freedom: A Fable or A Curious Interpretation of the Wit of a Negress in Troubled Times. 1997. Artist's book with pop-up silhouettes, page: 9¹⁄₁₆ x 7¹¹⁄₁₆ in. (23 x

19.5 cm). Publisher: The Peter Norton Family, Santa Monica. Printers: text by Timothy Silverlake, Valencia, and Typecraft, Pasadena; pop-up by Eisen Architects, Boston, and Lasercraft, Santa Rosa. Edition: 4,000. Given anonymously

485. Arthur Omar
The Last Mermaid. 1997. Brazil. Videotape, color, 11 minutes

486. Kristin Lucas
Host. 1997. USA. Videotape, color, sound, 7 minutes 36 seconds. Gift of Susan Jacoby

487. Vik Muniz
Mass from the series Pictures of Chocolate. 1997. Two silver dye bleach prints (Cibachrome), each 60 x 48 in. (152.4 x 122 cm). The Fellows of Photography Fund and Anonymous Purchase Fund

488. Fred Tomaselli
Bird Blast. 1997. Pills, leaves, collage, synthetic polymer paint, and resin on wood panel, 60 x 60 in. (152.4 x 152.4 cm). Gift of Douglas S. Cramer

489. Chuck Close
Self-Portrait. 1997. Oil on canvas, 8 ft. 6 in. x 7 ft. (259.1 x 213.4 cm). Gift of Agnes Gund, Jo Carole and Ronald S. Lauder, Donald L. Bryant, Jr., Michael and Judy Ovitz, Anna Marie and Robert F. Shapiro, and Leila and Melville Straus, and purchase

490. Arnulf Rainer
Blue Barn. 1997. Etching and drypoint, plate: 11⅝ x 9½ in. (29.5 x 24.2 cm), sheet: 19⅝ x 25½ in. (50 x 65 cm). Publisher: the artist and Maximilian Verlag/Sabine Knust, Munich. Printer: Kurt Zein, Vienna. Edition: 35. Gilbert Kaplan Fund and purchase

491. Arnulf Rainer
Greens. 1997. Etching and drypoint, plate: 13 x 9¾ in. (33 x 24.8 cm), sheet: 19⅝ x 25½ in. (50 x 65 cm). Publisher: the artist and Maximilian Verlag/Sabine Knust, Munich. Printer: Kurt Zein, Vienna. Edition: 35. Gilbert Kaplan Fund and purchase

492. Arnulf Rainer
Blue Nest. 1997. Etching and drypoint, plate: 13 x 9¾ in. (33 x 24.8 cm), sheet: 19⅝ x 25½ in. (50 x 65 cm). Publisher: the artist and Maximilian Verlag/Sabine Knust, Munich. Printer: Kurt Zein, Vienna. Edition: 35. Gilbert Kaplan Fund and purchase

493. Arnulf Rainer
Red Man. 1997. Etching and drypoint, plate: 12¹³⁄₁₆ x 9¾ in. (32.5 x 24.8 cm), sheet: 19⅝ x 25½ in. (50 x 65 cm). Publisher: the artist and Maximilian Verlag/Sabine Knust, Munich. Printer: Kurt Zein, Vienna. Edition: 35. Gilbert Kaplan Fund and purchase

494. Martin Puryear
Untitled. 1997. Cedar and pine, 68 x 57 x 51 in. (172.7 x 144.7 x 129.5 cm). Promised gift of Agnes Gund and Daniel Shapiro

495. Stan Brakhage
Commingled Containers. 1997. USA. 16mm film, color, 5 minutes. Acquired from the artist

496. Reiko Sudo
Origami Pleat Scarf. 1997. Hand-pleated and heat-transfer-printed polyester, 17⁵⁄₁₆ x 59¹⁄₁₆ in. (43.9 x 150 cm). Manufacturer: Nuno Corporation, Japan; also Takekura Co., Ltd., Japan. Gift of the designer

497. Reiko Sudo
Shutter. 1997. Nylon stitched onto soluble base-fabric (base dissolved), 32⅜ in. (82.2 cm) wide. Manufacturer: Nuno Corporation, Japan. Gift of the manufacturer

498. Daniel Libeskind
Berlin Museum with Jewish Museum, Berlin, 1989–2001, date of the model, 1997). Model: wood on paper, 66 x 11½ in. (167.7 x 29.2 cm) each side of diamond. Gift of the architect in honor of Philip Johnson

499. Willie Cole
Stowage. 1997. Woodcut, comp: 49⁹⁄₁₆ in. x 7 ft. 11¹⁄₁₆ in. (125.9 x 241.5 cm), sheet: 56¼ x 104¾ in. (142.9 x 266 cm). Publisher: Alexander and Bonin Publishing, New York. Printer: Derrière L'Étoile Studios, New York. Edition: 16. Jacqueline Brody Fund and The Friends of Education Fund

500. Kiki Smith
Endocrinology. 1997. Two spreads from an illustrated book with twenty lithographs with collage, page: 20½ x 19½ in. (52.1 x 49.6 cm) (irreg.). Publisher and printer: Universal Limited Art Editions, West Islip, N.Y. Edition: 40. Gift of Emily Fisher Landau

501. William Kentridge
Ubu Tells the Truth. 1996–97. Four from a series of eight etching, aquatint, and drypoints, plate: 9¹³⁄₁₆ x 11¹³⁄₁₆ in. (25 x 30 cm), sheet: 13¾ x 19⅝ in. (35 x 49.8 cm). Publisher: the artist and Caversham Press, Balgowan, South Africa. Printer: Caversham Press, Balgowan, South Africa. Edition: 50. Acquired through the generosity of Agnes Gund

502. John Baldessari
Goya Series: And. 1997. Ink jet and synthetic polymer paint on canvas, 6 ft. 3 in. x 60 in. (190.5 x 152.3 cm). Mr. and Mrs. Thomas H. Lee Fund

503. Rachel Whiteread
Untitled (Paperbacks). 1997. Room installation, containing plaster and steel, dimensions variable. Gift of Agnes Gund; Thomas W. Weisel, Patricia Phelps de Cisneros, Frances R. Dittmer, John Kaldor, Emily Rauh Pulitzer, and Leon Black funds; and an anonymous fund

504. Franz West
Hangarounds. 1997. Synthetic polymer paint, gouache, dry pigment, watercolor pan, tape, and cut-and-pasted printed paper on paper

(two-sided), 39 x 44 in. (100 x 112 cm). Gift of the Friends of Contemporary Drawing

505. Lewis Klahr
Pony Glass. 1997. USA. Animation cel from 16mm film, color, 15 minutes. Acquired from the artist

506. Sue Williams
Mom's Foot Blue and Orange. 1997. Oil and synthetic polymer paint on canvas, 8 ft. 2 in. x 9 ft. (248.9 x 274.3 cm). Carlos and Alison Spear Gómez Fund, Marcia Rilkis Fund, and an anonymous fund

507. Yukinori Yanagi
Wandering Position. 1997. Four from a portfolio of five etchings, sheet: 24¹⁄₁₆ x 20¹⁄₁₆ in. (61.2 x 50.9 cm). Publisher: Peter Blum Edition, New York. Printer: Harlan & Weaver Intaglio, New York. Edition: 35. Frances Keech Fund

508. Zhang Peili
Eating. 1997. China. Video installation with three laser discs and players, and three matching stacked monitors, sound, dimensions variable. Gift of The Junior Associates of The Museum of Modern Art

509. David Williams
Thirteen. 1997. USA. 16mm film, color, 87 minutes

510. Pipilotti Rist
Ever Is Over All. 1997. Video installation with two monitors, dimensions variable. Fractional and promised gift of Donald L. Bryant, Jr.

511. Fiona Banner
Break Point. 1998. Screenprint, comp.: 69¹⁄₁₆ in. x 7 ft. 11¾ in. (176.4 x 243.3 cm), sheet: 71⅝ in. x 8 ft. 1⅛ in. (182 x 246.7 cm). Publisher: Frith Street Gallery, London. Printer: Wallis Screenprint, Kent. Edition: 10. Linda Barth Goldstein Fund

512. Konstantin Greic
May Day Lamp. 1998. Plastic and polycarbonate, 21 in. (53.3 cm) high x 8½ in. (21.7 cm) diameter. Manufacturer: Flos S.p.A, Italy. Gift of the manufacturer

513. Julia Loktev
Moment of Impact. 1998. USA. Videotape transferred to 16mm film, black and white, 116 minutes. Acquired from the artist

514. Paul Winkler
Rotation. 1998. Australia. 16mm film, color, 17 minutes

515. Charles Long
Internalized Page Project. 1997–98. Two from a portfolio of seven Iris prints and seven folders, housed in archival box, comp. and sheet: each 11 x 8½ in. (28 x 21.6 cm), folder: 11½ x 9⁹⁄₁₆ in. (29.8 x 23 cm) (irreg.), box: 10½ x 12½ x 2½ in. (26.7 x 31.6 x 6.4 cm). Publisher and printer: Muse X Editions, Los Angeles. Edition: 15. Acquired through the generosity of Agnes Gund

516. Aleksei German
Khroustaliov, My Car! 1998. France/Russia. 35mm film, black and white, 137 minutes. Acquired from Sodaperaga

517. Richard Serra
Torqued Ellipse IV. 1998. Weatherproof steel, 12 ft. 3 in. x 26 ft. 6 in. x 32 ft. 6 in. (373.4 x 807.7 x 990.6 cm). Fractional and promised gift of Leon and Debra Black

518. Anish Kapoor
Wounds and Absent Objects. 1998. Two from a portfolio of nine pigment-transfer prints, comp.: 17⅝ x 21¹⁄₁₆ in. (44.7 x 53.5 cm), sheet: 20½ x 24¼ in. (52 x 61.5 cm). Publisher: The Paragon Press, London. Printer: Permaprint, London. Edition: 12. Jacqueline Brody Fund and Harry Kahn Fund

519. Terry Winters
Graphic Primitives. 1998. Two from a portfolio of nine woodcuts, comp.: each 17⅞ x 24 in. (45.6 x 60.9 cm), sheet: 20½ x 26⁵⁄₁₆ in. (52 x 66.5 cm). Publisher: Two Palms Press and the artist, New York. Printer: Two Palms Press, New York. Edition: 35. John B. Turner Fund

520. Gerhard Richter
128 Details from a Picture (Halifax 1978). 1998. Two from a portfolio of eight photolithographs, comp.: 24⅝ x 38⅛ in. (62.4 x 98.7 cm), sheet: 25¼ x 39⁹⁄₁₆ in. (64.2 x 100.4 cm). Publisher: Kaiser Wilhelm Museum, Krefeld. Printer: Plitt Druck and Verlag GmbH, Oberhauen. Edition: 60. Lee and Ann Fensterstock Fund and the Howard Johnson Fund

521. Gabriel Orozco
Horseshit, 1992; *I Love My Job,* 1998; *Melon,* 1993; *CCCP,* 1993. Silver dye bleach prints (Ilfochrome), each 12½ x 18½ in. (31.7 x 47 cm). The Family of Man Fund

522. Christian Boltanski
Favorite Objects. 1998. Nine from a portfolio of 264 color Xeroxes, comp.: each approx. 10¾ x 8⁵⁄₁₆ in. (27.4 x 21.1 cm), sheet: each 11 x 8⁹⁄₁₆ in. (28 x 21.7 cm). Publisher: Lycée Française, Chicago. Printer: Lab One and CD Color, Chicago. Edition: 264. Gift of Lee and Ann Fensterstock, in honor of their daughters, Kate and Jane

523. Jia Zhang Ke
Xiao Wu. 1998. China. 35mm film, color, 108 minutes. Acquired from Kit-Ming Li, with funds provided by The Junior Associates of The Museum of Modern Art

524. Matthew Barney
C5: Elbocsatas. 1998. Graphite, synthetic polymer paint, and petroleum jelly on paper in acrylic and Vivak frame, 14 x 12 x 1¼ in. (35.6 x 30.5 x 3.2 cm). Gift of the Friends of Contemporary Drawing

525. Kara Walker
African/American. 1998. Linoleum cut, comp.: 60½ x 46⁵⁄₁₆ in. (153.8 x 117.3 cm), sheet: 60½ x 46⁵⁄₁₆ in. (153.8 x 117.3 cm). Publisher and printer: Landfall Press, Chicago. Edition: 40. Ralph E. Shikes Fund

526. Luc Tuymans
The Blue Oak. 1998. Cut-and-pasted paper, gouache, and pencil on paper, 15½ x 11⅞ in. (39.4 x 30.1 cm). Gift of Linda and Howard Karshan

527. John Madden
Shakespeare in Love. 1998. USA/Great Britain. 35mm film, color, 122 minutes. Gift of Miramax Films

528. Robert Rauschenberg
Bookworms Harvest. 1998. Vegetable-dye transfer on paper on metal, 8 ft. 1½ in. x 61 in. (247.6 x 154.9 cm). Fractional and promised gift of Jerry I. Speyer

529. Chris Ofili
Untitled. 1998. Watercolor and pencil on paper, three of eight sheets, each 9½ x 6⅛ in. (24 x 16 cm). Gift of Martin and Rebecca Eisenberg

530. Enrique Chagoya
The Return of the Macrobiotic Cannibal. 1998. Accordion-folded illustrated book with lithograph, woodcut, and chine collé, page: 7½ x 11¼ in. (19.2 x 27.9 cm), overall: 7½ in. x 7 ft. 8 in. (19.2 x 232.8 cm). Publisher and printer: Shark's, Lyons, Colo. Edition: 30. The Ralph E. Shikes Fund

531. Lisa Yuskavage
Asspicker and *Socialclimber* from the series *The Bad Habits.* 1996–98. Two of five etchings, plate: each 6 x 5 in. (15.2 x 12.7 cm), sheet: each 15¹⁄₁₆ x 11 in. (38.2 x 28.1 cm). Publisher: Marianne Boesky Gallery, New York. Printer: Burnet Editions, New York. Edition: 25. John B. Turner Fund

532. Elizabeth Peyton
Bosie. 1998. Lithograph, comp. and sheet: 29½ x 22½ in. (74.9 x 57.2 cm). Publisher: Gavin Brown, the artist, and Derrière L'Étoile Studios, New York. Printer: Derrière L'Étoile Studios, New York. Edition: 45. Gift of Anna Marie Shapiro

533. Philippe Starck
La Marie Folding Chair. 1998. Polycarbonate, 34½ x 18⅝ x 20½ in. (87.7 x 47.3 x 52.1 cm). Manufacturer: Kartell S.p.A., Italy. Gift of the manufacturer

534. Ralph Schmerberg
"Los Toros," a commercial for Nike. 1998. USA. 35mm film transferred to videotape, color, 1 minute. Gift of the Association of Independent Commercial Producers

535. Mariko Mori
Star Doll. 1998. Multiple of doll, produced for the journal *Parkett 54,* 10¼ x 3¼ x 1⁹⁄₁₆ in. (26 x 8 x 4 cm) (irreg.). Publisher: Parkett, Zurich and New York. Fabricator: Marmitte, Tokyo. Edition: 99. Linda Barth Goldstein Fund

536. Cai Guo-Qiang
Borrowing Your Enemy's Arrows. 1998. Wood boat, canvas sail, arrows, metal, rope, Chinese flag, and electric fan; boat approx. 60 in. x 23 ft. 7 in. x 7 ft. 6 in. (150 x 720 x 230 cm), arrows approx. 24 in. (62 cm) long. Gift of Patricia Phelps de Cisneros in honor of Glenn D. Lowry

537. Rachel Whiteread
Water Tower. 1998. Translucent resin, 12 ft. 2 in. (370.8 cm) high x 9 ft. (274.3 cm) diameter. Given anonymously

538. William Kentridge
Seated Couple (Back to Back). 1998. Charcoal on printed book pages pasted on paper, 42 in. x 6 ft. 3¼ in. (106.7 x 191.1 cm). Gift of the Friends of Contemporary Drawing

539. William Kentridge
Untitled (drawing for *Stereoscope*). 1998–99. Charcoal and pastel on paper, 47¼ x 63 in. (120 x 160 cm). Gift of The Junior Associates of The Museum of Modern Art with special contributions from anonymous donors, Scott J. Lorinsky, Yasufumi Nakamura, and The Wider Foundation

540. Phil Solomon
Twilight Psalm II: Walking Distance. 1999. USA. 16mm film, color, 23 minutes. Acquired from the artist

541. Julian Opie
Imagine You Are Driving; Cars?; Imagine You Are Walking; Cityscape?; Gary, Popstar; Landscape? 1998–99. Six screenprints, various dimensions, from 24 x 20⅝ in. (61 x 53 cm) to 24 x 57⁹⁄₁₆ in. (61 x 145 cm). Publisher: Alan Cristea Gallery, London. Printer: Advanced Graphics, London. Edition: 40. Acquired through the generosity of Andrew Shapiro, in honor of his mother, Anna Marie Shapiro

542. Andreas Gursky
Toys "Я" Us. 1999. Chromogenic color print, 6 ft. 9½ in. x 11 ft. ⅝ in. (207 x 337 cm). Gift of Jo Carole and Ronald S. Lauder

543. Barbara Bloom
A Birthday Party for Everything. 1999. Multiple of pinwheel, paper fan, noisemakers, jelly beans, plastic bottle, pencils, candles, wooden tops, kaleidoscope, Frisbee, paper plates, plastic straws, paper horns, streamers, ribbon, balloons, plastic paddle with rubber ball, puzzle, paper napkins, paper cups, paper place mats, and paper tablecloth, housed in cardboard box, various dimensions. Publisher: I. C. Editions, New York. Edition: unlimited. Gift of Anna Marie Shapiro

544. Jean-Marie Straub and Danièle Huillet
Sicilia! 1999. France/Italy. 35mm film, black and white, 66 minutes

545. Carroll Dunham
Ship. 1997–99. Mixed mediums on linen, 10 ft. ⅛ in. x 13 ft. ⅛ in. (305.1 x 396.5 cm). Paula Cooper, Donald L. Bryant, Jr., and Andreas C. Dracopoulos funds

546. Damien Hirst
The Last Supper. 1999. Eight from a portfolio of thirteen screenprints, comp: various dimensions, sheet: each approx. 60¼ x 40 in. (153.1 x 101.6 cm). Publisher: The Paragon Press, London. Printer: Coriander

Press, London. Edition: 150. Monroe Wheeler Memorial Fund, Roxanne H. Frank Fund, and partial gift of Charles Booth-Clibborn

547. E. V. Day
Anatomy of Hugh Hefner's Private Jet (1–5): Cross-section of Hugh Hefner's Digestive System; Three-Mile-High-Club Proliferation–Stage II; Three-Mile-High-Club Proliferation–Stage III; Three-Mile-High-Club Metastasis; Metastatic Rupture. 1999. Five blueprints, comp.: each 23¼ x 17 in. (58.8 x 43.1 cm), sheet: each 24¹⁄₁₆ x 18⅛ in. (61.1 x 45.9 cm). Publisher: the artist. Printer: Everyday Blueprint, New York. Edition: 8. Roxanne H. Frank Fund

548. Chris Ofili
Prince amongst Thieves. 1999. Synthetic polymer paint, collage, glitter, resin, map pins, and elephant dung on canvas, 8 x 6 ft. (243.8 x 182.9 cm). Mimi and Peter Haas Fund

549. Richard Serra
Out of Round XII. 1999. Oilstick on paper, 6 ft. 7¼ in. x 6 ft. 7¼ in. (201.3 x 201.3 cm). Fractional gift of Leon Black

550. Richard Serra
Switch. 1999. Steel, six plates, each 13 ft. 6 in. x 52 ft. (411.5 x 1585 cm). Fractional and promised gift of Emily Carroll and Thomas W. Weisel

551. Shahzia Sikander
Anchor. 1999. Screenprint, comp: 25⅝ x 32¹¹⁄₁₆ in. (62.5 x 83 cm), sheet: 28¼ x 35 in. (71.7 x 88.9 cm) (irreg.). Publisher: Deitch Steinberg Editions, New York. Printer: Michael Steinberg, New York. Edition: 60. Lee and Ann Fensterstock Fund

552. David O. Russell
Three Kings. 1999. USA. 35mm film, color, 115 minutes. Gift of Warner Bros.

553. Laurence Attali
Baobab. 2000. Senegal. 35mm film, color, 25 minutes. Acquired from the artist

554. Faith Hubley
Witch Madness. 2000. USA. 35mm film, color, 9 minutes

555. Ellen Gallagher
Untitled. 2000. Oil, pencil, and plasticine on magazine page, 13¼ x 10 in. (33.7 x 25.4 cm). Gift of Mr. and Mrs. James Hedges, IV

556. Jean-Luc Godard
The Old Place. 2000. Switzerland. Videotape, color, 50 minutes. Purchase

557. Giulio Iacchetti, Matteo Ragni, and Pandora Design
Moscardino Disposable Eating Utensils. 2000. Mater Bi compound, each: ½ x 3⅛ x 1½ in. (1.3 x 7.9 x 3.8 cm). Manufacturer: La Civiplast Snc di Vittorio e Ciro Boschetti, Italy. Gift of Pandora Design

558. Jake and Dinos Chapman
Exquisite Corpse. 2000. Portfolio of twenty etchings, plate: each 9⁵⁄₁₆ x 7¹⁄₁₆ in. (23 x 18 cm); sheet: each 10¼ x 14¹⁵⁄₁₆ in. (26 x 38 cm). Publisher: The Paragon Press, London. Printer: Hope (Sufferance) Press, London. Edition: 30. Roxanne H. Frank Fund

559. Bertien van Manen
From a Taxi, Shpingba, Chongqing. 2000. Chromogenic color print, 27¹⁵⁄₁₆ x 41¹⁵⁄₁₆ in. (71 x 106.5 cm). Gift of Howard Stein

560. Glenn Ligon
Untitled (Stranger in the Village/Crowd) #2. 2000. Silkscreen, coal dust, oilstick, and glue on paper, 40 x 53¼ in. (101.6 x 135.3 cm). Acquired through the generosity of The Friends of Education of The Museum of Modern Art, and Marie-Josée Kravis

561. Maarten Van Severen
LCP Chaise Longue. 2000. PMMA plastic, 25¼ x 19⅛ x 38⅛ in. (64.1 x 48.6 x 96.8 cm). Manufacturer: Kartell, Italy. Gift of the manufacturer

562. Beatriz Milhazes
The Mirror. 2000. Screenprint, comp.: 40¹¹⁄₁₆ x 23¹⁵⁄₁₆ in. (103.4 x 60.8 cm). Publisher and printer: Durham Press, Durham. Edition: 40. Purchased with funds given by Ricki Conway

563. Tokujin Yoshioka
Honey-Pop Armchair. 2000. Paper, unfolded: 31¼ x 32 x 32 in. (79.4 x 81.3 x 81.3 cm); folded: 31¼ x 36½ x ¾ in. (79.4 x 92.7 x 1.9 cm). Gift of the designer

564. Michael Wesely
14 April 1999–11 December 2000, Herrnstrasse, Munich. April 14, 1999–December 11, 2000. Chromogenic color print, 31½ x 43³⁄₁₆ in. (80 x 110 cm). Gift of Howard Stein

565. Matthew Barney
The Cabinet of Baby Fay La Foe. 2000. Polycarbonate honeycomb, cast stainless steel, nylon, solar salt, epoxy resin, top hat, and beeswax in nylon and plexiglass vitrine, 59 in. x 7 ft. 11½ in. x 38¼ in. (149.8 x 242.6 x 97.2 cm). Purchase

566. Arturo Herrera
A Knock. 2000. Cut-and-pasted printed papers on paper, 70 x 60 in. (177.8 x 152.4 cm). Purchase

567. Shirazeh Houshiary
Presence. 2000. White acquacryl with silverpoint and graphite on canvas, 6 ft. 3 in. x 6 ft. 3 in. (190.5 x 190.5 cm). Committee on Painting and Sculpture Funds

568. Peter Fischli and David Weiss
Things from the Room in the Back. 1999–2000. Painted polyurethane, dimensions variable, approx. 46 in. x 20 ft. 8 in. x 10 ft. 5 in. (116.8 x 629.9 x 317.5 cm). Patricia Phelps de Cisneros and Douglas S. Cramer Funds

569. Jorge Pardo
Untitled. 2001. Three screenprints, comp. and sheet: each 21¾ x 29¾ in. (55.2 x 75.6 cm). Publisher and printer: the artist, Los Angeles. Edition: 44 unique variants. Lily Auchincloss Fund

570. Jeff Wall
After "Invisible Man" by Ralph Ellison, the Prologue. 2001. Silver dye bleach transparency (Cibachrome) on aluminum light box, 7 ft. 2⅝ in. x 9 ft. 6³⁄₁₆ in. (220 x 290 cm). The Photography Council Fund, Anonymous Purchase Fund, Gift of Jo Carole and Ronald S. Lauder, and Gift of Carol and David Appel

571. Katharina Bosse
Kitty Crimson. 2001. Chromogenic color print, 24 x 17¹¹⁄₁₆ in. (61 x 45 cm). Gift of Howard Stein

572. Thomas Demand
Poll. 2001. Chromogenic color print, 71 in. x 8 ft. 6 in. (180.3 x 259.1 cm). Fractional and promised gift of Sharon Coplan Hurowitz and Richard Hurowitz

573. Vija Celmins
Night Sky No. 22. 2001. Charcoal on paper, 18¾ x 22 in. (47.6 x 55.9 cm). Purchase

574. Orlando Mesquita
The Ball. 2001. Mozambique. 35mm film, color, 6 minutes. Acquired from Dominant 7 Productions

575. Ellen Gallagher
They Could Still Serve. 2001. Pigment, paper, and glue on linen, 10 x 8 ft. (304.8 x 243.8 cm). Emily and Jerry Spiegel and Anna Marie and Robert F. Shapiro Funds and gift of Agnes Gund

576. John Currin
The Exwife. 2001. Gouache on prepared paper, 14 x 11¼ in. (35.6 x 28.6 cm). Gift of Oliver Kamm, Linda Kamm, and Lisa Kamm

577. Kim Young Jin
Virtually Indestructible Keyboard. 2001. Silicone, circuits, plastic and metal, ½ x 19¼ x 5⅜ in. (1.3 x 50.5 x 13.7 cm). Manufacturer: GrandTec USA. Gift of the manufacturer

578. npk industrial design b.v. (Janwillem Bouwknegt, Camille van den Brande, Paul Groeneveld, Wolfram Peters, and Robert Sluijter)
Dremefa Multibob Child Safety Seat. 2002. Polypropylene, expanded polypropylene, cotton/polyester upholstery, 26¾ x 19⁵⁄₁₆ x 16⅜ in. (68 x 49 x 41.5 cm). Manufacturer: Dremefa b.v., Holland. Gift of the manufacturer

579. Edward Ruscha
Tulsa Slut. 2002. Synthetic polymer paint on canvas, 64 in. x 6 ft. (162.6 x 182.9 cm). Gift of Jo Carole and Ronald S. Lauder and Committee on Painting and Sculpture Funds

580. Alessandra Sanguinetti
Untitled from the series On the Sixth Day. 1996–2002. Four silver dye bleach prints (Cibachrome), ranging from 20¹³⁄₁₆ x 23⅛ in. (52.9 x 58.8 cm) to 23¼ x 23¼ in. (59.1 x 59 cm). Gift of Howard Stein

581. Seoungho Cho
Cold Pieces 2. 2002. USA. Videotape, color, 6 minutes 30 seconds. Acquired from the artist

582. Bill Morrison
Decasia. 2002. USA. 35mm film, color, 67 minutes. Acquired from the artist

583. Yoshitomo Nara
Become to Thinker. 2002. Etching, aquatint, and drypoint, comp.: 11⅞ x 8¾ in. (30.2 x 22.3 cm), sheet: 19⁵⁄₁₆ x 14¹⁵⁄₁₆ in. (49 x 38 cm); *Green Eyes.* 2002. Etching, aquatint, and drypoint, comp.: 12 x 8⅞ in. (30.5 x 22.5 cm), sheet: 19³⁄₁₆ x 14¹⁵⁄₁₆ in. (48.8 x 38 cm); *N.Y. (Self-Portrait).* 2002. Etching and aquatint, comp.: 11¾ x 8⅞ in. (29.8 x 22.5 cm), sheet: 19¼ x 14¹⁵⁄₁₆ in. (48.9 x 38 cm); *Spockie.* 2002. Etching and aquatint, comp.: 11¹¹⁄₁₆ x 9¾ in. (29.7 x 24.7 cm), sheet: 19⁵⁄₁₆ x 14¹⁵⁄₁₆ in. (49 x 38 cm). Publisher: the artist and Hitoshi Kido, Tokyo. Printer: Hitoshi Kido, Tokyo. Edition: 35. Katsko Suzuki Memorial Fund

584. Jürgen Mayer H. and Sebastian Finckh
Stadthaus Scharnhauser Park, Ostfildern, Germany. Project, 1998–2002. "E.gram" three-dimensional drawing: laser-etched glass, 2⅜ x 3⅞ x 2¾ in. (6 x 9.8 x 7 cm). Patricia Phelps de Cisneros Purchase Fund

585. Sarah Lucas
Geezer. 2002. Oil, cut-and-pasted printed paper, and pencil on wood, 31⅞ x 29½ in. (81 x 74.9 cm). Purchased with funds provided by The Buddy Taub Foundation, Dennis A. Roach, Director

586. Guillermo Kuitca
Puro Teatro. 2003. Four plates from an illustrated book with twelve etchings and aquatints, plate: each 6½ x 7¾ in. (16.5 x 19.7 cm), page: 15¾ x 16 in. (40 x 40.6 cm). Publisher and printer: Edition Jacob Samuel, Santa Monica. Edition: 25. Monroe Wheeler Fund

587. Charles LeDray
Oasis. 1996–2003. Glazed ceramic, glass, and plywood, 8 ft. x 36 in. x 36 in. (243.8 x 91.4 x 91.4 cm). Scott Burton Fund

588. Richard Tuttle
Dawn, Noon, Dusk: Paper (1), Paper (2), Paper (3). 2001–03. Suite of three watermarked sheets of handmade paper with pigment additions, mounted on colored paper in handpainted wood frames, each approx. 13¾ x 15¾ in. (34.9 x 40 cm). Publisher and printer: Dieu Donné Papermill, New York. Edition: 20. Carol and Morton Rapp Fund

589. Nathaniel Kahn
My Architect: A Son's Journey. 2003. USA. 35mm film, color, 116 minutes. Acquired from the artist

Acknowledgments

This publication was produced under unusually severe pressures, and we are therefore doubly grateful to all of those who gave extra quotients of their time, energy, and expertise. Harriet Schoenholz Bee, Managing Editor in the Department of Publications, deserves special thanks for her extraordinarily fine editing work. She was ably assisted in the editing and coordination of the various parts of the book by intern Inés Katzenstein. One of the most crucial and challenging aspects of the publication was its design, and in particular the chronological layout of so many diverse images. This task was brilliantly and sensitively accomplished by Steven Schoenfelder, whose calm good-spiritedness made him a great pleasure to work with. At least as challenging, however, was the task of producing such a complex book from an array of photographs that varied widely in format and quality. For his superb execution of this task, and constant attention to quality, we gratefully thank Production Manager Marc Sapir. We also thank Cara Maniaci for her expert proofreading. The Museum's Publisher Michael Maegraith provided unstinting support of this endeavor from its inception, and Michael Margitich, Deputy Director, External Affairs, secured the funding that made this publication possible.

The daunting task of gathering and trafficking the photography for this book was overseen by Jeffrey Ryan, with invaluable assistance, especially in compiling the photograph credits, by intern Suzanne Perling. Meticulous caption research and timely corrections were carried out, under urgent pressure, by members of each curatorial department, and we are grateful to Pierre Adler, Sally Berger, Mary Corliss, Kathy Curry, Fereshteh Daftari, Terry Geeskin, Judith Hecker, Susan Kismaric, Barbara London, Matilda McQuaid, Elaine Mehalakes, Sarah Hermanson Meister, Peter Reed, Laura Rosenstock, and Sarah Suzuki for their essential contributions. We are also indebted to Chief Fine Art Photographer Kate Keller for her expert coordination and execution, as well as to photographers Kelly Benjamin, John Cross, Thomas Griesel, Paige Knight, Erik Landsberg, Kimberly Pancoast, Erica Stanton, and John Wronn. We thank Mikki Carpenter, Director of the Department of Imaging Services, for her always swift and dependable work in meeting great demands, as well as her staff, Charleen Alcid, Jennifer Bott, Rosa Laster, and Eden Schulz. Thanks also go to Nancy Adelson for advising on reproduction permissions and issues of copyright.

In addition to the individuals already mentioned, we would like to acknowledge two key members of our core team, Amy Horschak and Fereshteh Daftari, who contributed their insights and prudent advice along the way. Madeleine Hensler provided priceless and exacting administrative assistance for this project, and continually propelled us in the right direction. The project was also supported by a group of dedicated interns including Benjamin Lima, Alice Moscoso, David Rodriguez Caballero, Sarah Burton, and Emily Capper. And finally, a debt of gratitude goes to Judith Hecker who, with her unflagging attention to every detail and her tireless dedication to this project, helped guide the publication to completion.

Kirk Varnedoe
Paola Antonelli
Joshua Siegel

In addition to the above, the following individuals have contributed to this revised edition:

In the Department of Painting and Sculpture, John Elderfield, Chief Curator; Joachim Pissarro, Curator; and Claire Henry, Administrative Assistant. In the Department of Film and Media, Mary Lea Bandy, Chief Curator; Steven Higgins, Curator; and Jenny He, Research Assistant. In the Department of Photography, Peter Galassi, Chief Curator, and Dalia Azim, Curatorial Assistant. In the Department of Drawings, Gary Garrels, Chief Curator; Jodi Hauptman, Associate Curator; and Jordan Kantor, Assistant Curator. In the Department of Architecture and Design, Terence Riley, Chief Curator, Christian Larsen, Curatorial Assistant. In the Department of Prints and Illustrated Books, Deborah Wye, Chief Curator. In the Office of the Deputy Director for Curatorial Affairs, Margaret Raimondi, Coordinator. In the Office of the General Counsel, Stephen Clark, Associate General Counsel, and Jane Panetta, Department Manager. In the Director's Office, Diana Pulling, Executive Assistant. In the Department of Development, Rebecca Stokes, Director, Campaign and Development Communications. And in the Department of Publications, Christina Grillo, Production Manager, and Cassandra Heliczer, Associate Editor.

Photograph Credits

© 1980 Vito Acconci: 22; 1977–81: 23; 1990–91: 303.

Courtesy Peggy Ahwesh: 242.

Courtesy Alexander and Bonin: 450–451.

Dave Allison, The Museum of Modern Art: 89; 163; 204; 252; 335.

© 1989 Ida Appelbroog: 241.

Courtesy Dieter Appelt: 301.

© 1996 John Armleder: 425.

© 2004 Artists Rights Society (ARS), New York/ADAGP, Paris: 116; 189, 475; 292.

© 2004 Artists Rights Society (ARS), New York: 267, 315, 351; 74, 92, 163, 204, 231; 329, 468–469, 470, 496, 497; 132, 133, 196, 384; 47, 125; 90; 355.

© 2004 Artists Rights Society (ARS), New York/VG Bild-Kunst, Bonn: 127; 52; 205.

© 2004 Artists Rights Society (ARS)/Pro Litteris, Zurich: 25, 143.

at radical.media: 483 top.

Courtesy Laurence Attali: 500.

© 1986 John Baldessari: 147; 1997: 454.

Ballo: 170.

© 1995 Matthew Barney: 414; 1998: 477.

© 2000 Georg Baselitz: 42.

© 1988 Bernd and Hilla Becher: 186.

Peter Bellemy, New York: 148–149.

© 1987–88 Ashley Bickerton: 193.

Courtesy Kathryn Bigelow: 76–77.

© 1982 The Blade Runner Partnership. All rights reserved: 62.

© 1994 Ross Bleckner: 381.

Courtesy Tanya Bonakdar Gallery: 466.

© 1983 Jonathan Borofsky: 89.

Courtesy Stan Brakhage and Anthology Film Archives: 446.

Courtesy Robert Breer: 153.

Courtesy Cai Guo-Qiang: 484.

© 1992 Chris Burden: 343.

© 1980–81 Scott Burton: 43.

Canon ARTLAB: 375.

© 1998 Enrique Chagoya: 480 bottom.

Courtesy Cheim & Read, New York: 148–149, 332, 395, 400.

Linda Chen, Miramax Films: 367 bottom.

Courtesy Abigail Child: 165 top.

Courtesy Seoungho Cho: 528.

Courtesy Cinematheque Ontario: 33 bottom; 35 bottom right; 167; 220; 240 bottom; 490 top.

© 1983 Francesco Clemente: 83; 1986: 144–145.

Geoffrey Clements, courtesy Robert Gober: 317 top.

© Chuck Close: 443; 1995: 413.

Courtesy Joel and Ethan Coen: 422 top.

Theo Columbe, courtesy 303 Gallery: 458.

© 1990 Bruce Conner: 283.

Courtesy Crown Point Press: 23.

Courtesy Terence Davies: 334 bottom.

Courtesy Day Zero Film & Video: 521.

James Dee, courtesy Ronald Feldman Fine Arts, New York: 205.

© 2004 Thomas Demand, VG Bild Kunst, Bonn: 519.

Courtesy Carlos Diegues: 35 top.

Digital Design Collection Project: Jon Cross and Erica Stanton, Luna Imaging, © 2000 The Museum of Modern Art, New York: 29; 40; 101; 118 top; 195; 230 bottom; 256; 328; 341.

Courtesy Nathaniel Dorsky: 178.

© 1994 Marlene Dumas: 390–391.

© 1989 Carroll Dunham: 228; 1999: 491.

Courtesy Electonic Arts Intermix: 87 bottom; 95 top; 165 bottom; 209 top; 248; 321; 347 top; 364 bottom; 439 bottom; 499.

© 1984 Embassy International Pictures. All rights reserved: 93.

© Rainer Werner Fassbinder: 28 top.

© Rainer Werner Fassbinder Foundation: 38.

Courtesy Janice Findley: 157.

© 1987 Eric Fischl: 170–171.

© 2004 Peter Fischli and David Weiss, courtesy Matthew Marks Gallery, New York: 515.

© 1988 Gunther Forg: 208.

Frameline: 222.

© 1985 Robert Frank: 112–113.

Courtesy John Frankenheimer: 146 bottom.

© 1994 Teiji Furuhashi: 375.

Courtesy Gagosian Gallery, New York: 96; 343; 406.

Courtesy Ernie Gehr: 298.

© 1989 Gilbert and George, courtesy the artists: 232–233.

Courtesy Barbara Gladstone Gallery: 155; 393; 414.